Girls and Literacy in America

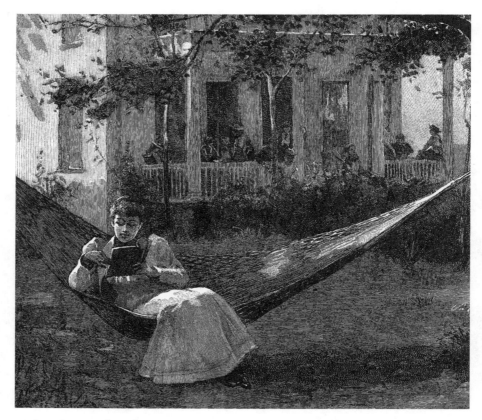

Girl reading, Scribner's Magazine 15, no. 5 (May 1894): 627. Courtesy of Cornell University Library, Making of America Digital Collection.

With special thanks to Miriam Forman-Brunell, professor of history at the University of Missouri at Kansas City, for her integral role in developing this book.

Girls and Literacy in America

Historical Perspectives to the Present

Jane Greer, Editor

A B C C L I O

Santa Barbara, California • Denver, Colorado • Oxford, England

Copyright 2003 by Jane Greer

All rights reserved. No part of this publication may be reproduced, stored in a retrieval system, or transmitted, in any form or by any means, electronic, mechanical, photocopying, recording, or otherwise, except for the inclusion of brief quotations in a review, without prior permission in writing from the publishers.

Library of Congress Cataloging-in-Publication Data

Girls and literacy in America : historical perspectives to the present / Jane Greer, ed.
 p. cm.
Includes bibliographical references and index.
 ISBN 1-57607-666-0 (hardcover : alk. paper) ISBN 1-57607-667-9 (e-book)
 1. Women—Education—United States—History—Sources. 2.
Literacy—United States—History—Sources. I. Greer, Jane, 1964–

 LC1757.G57 2003
 370'.84'22'0973—dc21

 2003006518

06 05 04 03 10 9 8 7 6 5 4 3 2 1

This book is also available on the World Wide Web as an e-book.
Visit abc-clio.com for details.

ABC-CLIO, Inc.
130 Cremona Drive, P.O. Box 1911
Santa Barbara, California 93116-1911

This book is printed on acid-free paper ∞.
Manufactured in the United States of America

To Mrs. Honnold, Miss Ourant,
Miss Hickman, and Mrs. Digges

Contents

Acknowledgments

In studying girls and literacy, I am continually struck by how profoundly young women's lives as readers and writers are shaped by the human relationships and broader support systems that surround them. Parents, grandparents, siblings, teachers, tutors, peers, club leaders, and coworkers all help initiate girls into the wider print culture and serve as important interlocutors who read and write with the girls in their lives. Institutions like schools, churches, clubs, and philanthropic organizations also provide important arenas where young women are exposed to new reading materials and find new purposes and audiences for their writing.

In my own life as a reader and writer, I have been tremendously blessed to encounter many supportive people and organizations. Miriam Forman-Brunell first suggested this project to me, and she has enriched every aspect of this volume with her keen critical insights. Miriam's energy and enthusiasm is helping to create a community of scholars committed to the study of girls' culture, and her generosity, both professionally and personally, is truly remarkable. I would also like to thank the scholars and researchers who have contributed chapters to this volume: E. Jennifer Monaghan, Janet Carey Eldred, Peter Mortensen, Jean Ferguson Carr, Amy Goodburn, Kelly Schrum, Lisa Weems, Paul Miller, Janet Russell, and Andrea Lunsford. Models of professionalism, they have recommended bibliographic sources, helped track down primary documents, and adjusted to shifting deadlines, all with good sense and good humor. The girls (and women) who have graciously shared their yearbooks, poems, and diaries with me and have allowed their texts to be reproduced in this volume deserve a special thanks. I am more than grateful for the opportunity to share with a wider audience the texts of bacon4u, Lucille Booth, Lauren Cannell, Morgan Childs, LouAnn Phelps, and Martina Tepper.

Students in my course on girls and print culture continually call my attention to new sources and ideas. The curiosity and excitement they bring to the study of girls' lives inspires me on a daily basis. In particular, I would like to thank Henri Rix Wood for her insights on

the diaries of Dorothy Allen Brown Thompson; Melanie Warner for introducing me to web diaries; Mary Porto for loaning me her copies of *The American Girl;* and Abby Dubisar for sharing her work on the literacy practices of girls remanded to industrial homes in the middle decades of the twentieth century.

In the summer of 1996, I was fortunate to participate in a National Endowment for the Humanities summer seminar on the history of print culture. Directed by Carl Kaestle at the University of Chicago, the seminar was one of the most rewarding experiences in my academic career, and the special friendships formed there have been an important source of professional support for me. In particular, Megan Benton, Mike Keller, Lisa Gitelman, and James MacDonald continue to enrich my intellectual life with good conversation about books, baseball, and a thousand other topics.

Librarians and staff members at various libraries, archives, historical societies, organizations, and publishing houses have assisted me in locating girls' writing, granted copyright permissions, and helped arrange for sources to be reprinted in this volume. I appreciate the timely assistance offered by the American Antiquarian Society; the Bancroft Library at the University of California, Berkeley; the Black Archives of Mid-America; the Filson Historical Society in Louisville, Kentucky; Girl Scouts, USA; the Kenneth Spencer Research Library at the University of Kansas; *Ladies' Home Journal;* the National Association of Colored Women; Scholastic, Inc.; the State Archives of Missouri; and the Virginia Historical Society.

Here at the University of Missouri at Kansas City, I am indebted to Frank Dalrymple, Robert Ray, Teresa Gipson, Anthony Badgerow, and Marilyn Carbonell of Miller Nichols Library. Without their interest and technical support, *Girls and Literacy* would have been a lesser book. More important, their unstinting commitment to building collections that support the study of girls' culture helps make my institutional home a happy one. David Boutros and staff members at the Western Historical Manuscript Collection in Kansas City have been equally liberal with their time and expertise. I am also grateful to the University of Missouri at Kansas City for a faculty research grant that provided crucial financial support for this project.

Other supportive colleagues and friends in Kansas City have good-naturedly listened to me bubble over with excitement after reading a newly discovered girl's diary or collection of school essays, and they have tactfully helped me untangle preliminary drafts of my own writing. Thanks go to Melanie Burdick, Gayle Levy, LouAnn Schmedding, Jennifer Phegley, and Linda Voigts. Their interest in my

work has made this volume a better book, and their friendship has made me a better person.

Finally, I would like to acknowledge the tremendous debt I owe to Mrs. Honnold, Miss Ourant, Miss Hickman, and Mrs. Digges, my high school English teachers in Chillicothe, Ohio. Because they helped this bookish girl realize that a lifetime spent studying language, literature, and literacy would be a lifetime well spent, I dedicate this book to them.

<div align="right">

Jane Greer

</div>

While an intrinsic ardor prompts to write,
The muses promise to assist my pen;
'Twas not long since I left my native shore
The land of errors, and *Egyptian* gloom:
Father of mercy, 'twas thy gracious hand
Brought me in safety from those dark abodes.

—Phillis Wheatley
"To the University of Cambridge, in New-England," 1767

Indeed, the being at a boarding school, is to our young lady the
"Open Sesame," to all the wealth of education. She will have no more
difficulty with Grammar, and Mathematics will be divested of all in-
tricacy. . . . in two years must be condensed the study of all those im-
portant branches which would require at least five of intense applica-
tion. To these must be added, Music, French, Drawing and all those
accomplishments which are so desirable. . . . After the daughter has
been taken through by this pushing process, she returns home with a
smattering of several studies, and a thorough knowledge of none. But
she has been to a boarding-school, and of course, is styled, "the ac-
complished Miss. Such a one."

—Albana C. Carson,
"Imperfections of Female Education," A Composition for the
Examination of 1851, Science Hill Academy, Shelbyville, Kentucky

I am studying and reading and trying to catch up with things. I have
hardly read anything for three days. History is so interesting. By the
way, that reminds me. I intend to establish a secret society. This one is
something new and extremely secret. No one, in fact knows anything
about it but me. . . . Even the other members are not to know of their
membership, especially as some are dead. . . . I shall call it The Order
of the Scroll because it is through books and reading that we know
each other. I want one member from each century, at least one. She
may have any country or any station. She may be a queen or a scrub-
woman. The character may be real or fictitious. The only requirement
is that she be one who has done some one thing that "helped." The
number who may belong is unlimited. The watch-word of the Order
is that which is said of Dorcas, "She hath done what she could."

—Dorothy Allen Brown Thompson
Diary Entry, January 27, 1912

This historical resource volume serves as a starting point for studying the reading and writing practices of girls in the United States from the colonial era to the present. How have girls used their skills with the written word to enter adult worlds and claim authority over their own lives? What roles do parents and other adults play in girls' development as readers and writers? How do schools, churches, clubs, the mass media, and other institutions both enable and inhibit girls as they work to develop a wide repertoire of literate abilities? How do girls read and write in extracurricular settings or in zones that are free of adult intervention? How can studying girls and literacy sharpen our sense of the nation's social, cultural, and political history, as well as our understanding of the current historical moment?

As the epigraphs above reveal, such questions do not have simple answers. Sold as chattel on the Boston docks in 1761, eight-year-old Phillis Wheatley's early literacy lessons resulted from the evangelistic impulses of the family that purchased her. The Wheatleys wanted their household slaves to be able to read the Bible and other sacred texts. Phillis began composing her own accomplished poetry by the age of fourteen, and her verses, like the lines above that were directed to rambunctious Harvard students, reflect the central place that Christianity occupied in the young slave's construction of a public identity. Over eighty years later Albana C. Carson, like many other girls from financially secure families, enrolled in one of the growing number of female academies or boarding schools. Written for her 1851 examination at the Science Hill Academy in Shelbyville, Kentucky, "Binnie" Carson's composition denounces the limitations of female boarding schools while at the same time suggesting that she profited greatly from the tutelage of Julia Tevis and other Science Hill instructors. Not merely an "accomplished Miss Such a One," Carson has learned to be a skillful writer, capable of appropriating the authority of culturally sanctioned forms of argumentation while also undermining received wisdom with her own sharply ironic wit—all in an effort to persuade her readers that girls could profit from rigorous intellectual challenges. As with Wheatley and Carson, reading and writing were for Dorothy Allen Brown Thompson important activities that fostered a sense of self and allowed her to engage with the wider world. For Thompson, the more private space of her diary served as a site where she could create a community for herself: the Order of the Scroll, which eventually included among its members Joan of Arc, Maid Marian, Rebecca of Sunnybrook Farm, and Queen Victoria. The membership roster of Thompson's secret society can serve as a starting point for scholars interested in excavating how

feminine models of behavior are transmitted through the generations, and careful study of Thompson's diary can reveal how a girl creatively constructs her own identity in relation to a wider textual community of women.[1]

Readers unfamiliar with discussions that have been unfolding in the field of literacy studies in recent years may be initially startled by the range of issues—identity, authority, appropriation, community—that come into view when texts by girls like Wheatley, Carson, and Thompson are examined closely. More than a simple decoding and encoding skill, literacy has come to be viewed as a "cultural practice," a way of constructing identities, creating social networks, enabling economic activities, and distributing power.[2] As literacy scholars like Shirley Brice Heath, Harvey Graff, Deborah Brandt, John Trimbur, Anne Ruggles Gere, and others have demonstrated, an individual's acquisition of various forms of literacy involves processes of authorization, assistance, intimidation, and even coercion from an array of agencies that underwrite literacy in our society—families, schools, churches, employers, advertisers, retailers, financial institutions, legislative bodies, activist groups, social service agencies, and so on. Even so, individuals do exert their own authority and help shape the literacy landscape as they buy or boycott specific books and periodicals, write editorial letters to local newspapers and national magazines, post opinions on websites, create résumés, join book clubs and Bible study groups, and use the written or printed word in countless ways during their daily lives.[3]

Because literacy so often serves as a means of brokering power and shaping lives in our print-rich culture, studying how children and youth in various historical contexts have developed as readers and writers makes it possible to track deeply rooted cultural concerns about family structures, morality, social class, race, the body, and gender. More particularly, the reading and writing practices of girls have drawn the attention of not only parents and educators but also physicians, religious authorities, social service professionals, cultural pundits, and savvy marketing executives. Existing in a liminal space between infancy and womanhood, girls are both intriguing and unsettling. They can be both innocent and sexual, little mothers and nascent temptresses, living dolls who idly adorn drawing rooms and potential workers, irrepressible optimists and victims of toxic cultural influences, preservers of tradition and agitators for change. As Lynne Vallone and Claudia Nelson astutely surmise, the figure of the Girl has "a protean quality . . . as simultaneous subject, object, and opponent of . . . classification."[4] Not surprisingly, cultural authorities

and public institutions throughout the centuries have attempted to manage the complexities of the Girl by managing her interactions with the written word.

"Appropriate" Literacy

As early as the seventeenth century, when the first schools were opened by Europeans emigrating to the North American colonies, girls have received instruction in appropriate reading and writing habits to reinforce dominant social norms. The catechistical literacy lessons offered in New England dame schools, charity schools, and town and district schools reflected the religious and political agendas of the Puritans. After mastering her hornbook and primer, a girl would move on to a Psalter and the Bible. (See Part 2 for a photograph of three hornbooks from the colonial era and excerpts from *The New-England Primer.*) She would be deemed a good scholar (and a good girl) not based on her interpretive skills or original insights but instead on her ability to memorize and recite the religious texts that were sanctioned within the Puritan community.[5]

An example from the final decades of the nineteenth century also demonstrates how girls' lessons in appropriate literate activities helped support the dominant belief systems of the wider culture. From 1870 through the 1890s, the United States was troubled by social instabilities that were caused by emerging economic disparities between wealthy industrialists and an impoverished and increasingly restive working class. In her 1887 book, *A Bundle of Letters to Busy Girls on Practical Matters,* philanthropist Grace Hoadley Dodge subtly reinforced existing socioeconomic class structures by counseling working girls to avoid books that made them feel their lives were "very hard and uncomfortable" and created a desire for "some prince" to come and take them away from life's drudgery.[6] Instead, Dodge recommended they read inspirational biographies and histories, which often underscored the nobility of poverty, the importance of humility, and the virtues of personal sacrifice.

More recently, Melinda L. de Jesús has written of how the intensive program of social engineering carried out by the United States in the Philippines in the early part of the twentieth century included replacing Filipino educational models with an Americanized curriculum.[7] For young Filipinas like de Jesús's mother, the Nancy Drew mysteries, which were sanctioned by school teachers and public librarians, became much-beloved girlhood reading. Steeped in European-American, middle-class values and proffering a normative vision

In the library,
Progressive Club.
Scribner's
Magazine *15, no. 5*
(May 1894): 623.
Courtesy of Cornell
University Library,
Making of America
Digital Collection.

of heterosexual femininity, the Nancy Drew mystery stories partic-
ipated in the U.S. government's policy of "benevolent assimilation."
After emigrating to eastern Pennsylvania, de Jesús's mother trans-
mitted her affection for the titian-haired girl detective to the
daughter she raised in the 1970s. As an academically trained femi-
nist and adult, de Jesús has come to see how this most appropriate
reading of her childhood involved complex processes of self-era-
sure and internal colonization for herself and other girls of color,
but as a girl, de Jesús's love for Nancy Drew allowed her to connect

with her mother as well as her parochial school classmates, most of whom were white. She describes the communal experiences of swapping copies of the mysteries, carrying Nancy Drew lunch boxes, and reveling in the various adventures of the teen detective and her chums.

Although adults and the various institutions they represent have often worked to provide girls with lessons in appropriate forms of reading and writing, girls themselves have long recognized the dangers of overstepping the boundaries of proper literate activity as defined by the authorities in their lives. In the diary she kept as a student at St. Mary's Academy in Notre Dame, Indiana, fifteen-year-old Etta Luella Call describes the uproar created when a popular student, Mamie, was "expelled for corresponding with a boy whom she had never seen." Call seems to have internalized the messages about illicit contact with the opposite sex and the need to control one's writerly and sexual impulses that the Catholic institute sought to instill in its students. Writing on November 25, 1881, Call notes: "This ought to be an example to the other girls and teach them not to put such confidence in boys, for the boy whom Mamie wrote to showed the sisters the letters himself."[8] The middle school girls that Margaret J. Finders studied in the early 1990s expressed a similar awareness of the constraints placed upon their literacy lives and the ways in which they were schooled in proper literate behaviors. One student, Cleo, privately expressed a desire to write controversial, issue-oriented papers on topics like women's rights and gun control, but she submitted only personal experience essays to her seventh-grade language arts teacher because that was "what you're supposed to write."[9]

Demonstrating their acceptance of the sanctioned norms for reading and writing can be a crucial means by which girls establish their understanding of the social order and earn the right to participate in it. A New England girl in 1725 memorizing a Psalm and a Filipina American girl reading a Nancy Drew mystery in 1970 were both likely to secure the approbation of parents, teachers, and peers. For young female writers, the consequences of indiscriminately wielding a pen can be painful. As the popular Mamie learned in the 1880s, using one's textual talents in inappropriate ways can lead to formal expulsion from one's community. For Cleo, the subtle social ostracism to which she was subjected when she did write about feminism was no less painful. As Finders reports, Cleo's seventh-grade classmates referred to her as "the one who wrote that woman lib stuff last year," based on a single paper she had written in the sixth grade.[10]

When literacy is thus used to corroborate entrenched social practices and positions, reading and writing lessons can shepherd girls into an adult world that they may have little ability to challenge or change. Far from empowering girls, lessons in reading and writing can become exercises in compliance.

Appropriating Literacy

Although girls throughout the centuries have been schooled—both formally and informally—in appropriate reading and writing habits as means of perpetuating existing social structures, young women in a variety of historical contexts have also been encouraged to use their literacy skills to script new roles for themselves. Parents, teachers, club sponsors, employers, and others have prompted girls to read and write in ways that disrupt the status quo.

In letters to his young daughter, Harry S. Truman sought to foster Margaret's intellectual aspirations and to encourage her to accept no limits on the goals she might set for herself. Writing from Washington, D.C., when Margaret was eleven, then-Senator Truman recalls with pride her early childhood and how she "learn[ed] to read by picking out letters on the Kansas City headlines. . . . And learn[ed] to write."[11] In a later letter, Truman reminisces that his aspirations for his daughter were somewhat different than those of his wife:

> Your mamma was wondering if you'd have straight legs and curly hair and I was hoping you'd have a good brain—which you have. Now you must use it and put everything into it while it is young and active. When you have a head full of learning no one can take it away from you. Money and property and position you can lose but a well developed brain never.[12]

Not surprisingly, then, Margaret's childhood was punctuated with dozens of letters from her father urging her to do well in school, read widely, and attend to the lessons of ambition, fortitude, and persistence that could be found in the lives of historical figures like Robert E. Lee, Hannibal, Alexander the Great, and Julius Caesar. As an adult, Margaret Truman made her mark as a classically trained concert singer (appearing at Carnegie Hall and on Ed Sullivan's *Toast of the Town*), as a broadcast journalist, and as an author.

More recently, a number of researchers and educators have been seeking to revise school curricula and teaching methods in an attempt to help girls emerge from their schooling experiences as confident

young women who feel empowered to choose their own paths in life.[13] For example, Sharon Frye, who teaches English and history at a high school in Portland, Oregon, assigns texts with female protagonists, uses small groups in class so that girls can have more intimate relationships with peers, and makes daily journals a requirement so that those students who are uncomfortable speaking up in class can still express their thoughts and opinions. Maureen Barbieri, a language arts teacher at a private girls' school in northeastern Ohio, encourages her middle school students to make their voices heard through a variety of techniques: "writing practice," the production of class newsletters, the use of diary keeping in the study of history, and free-choice reading periods.[14] Such contemporary educators are following in the footsteps of educational pioneers like Susanna Rowson, Catharine Beecher, Emma Willard, Gertrude Buck, Vida Scudder, Hallie Quinn Brown, Hilda Worthington Smith, and countless others who worked tirelessly in previous decades to provide girls and young women with meaningful opportunities for the advanced academic training in reading and writing necessary for members of the female sex to participate fully in our democratic society.

Outside the classroom, third-wave feminists, riot grrrlz, and other activists encourage young women to push against barriers and to use their skills as readers and writers to pursue personal, social, and political goals. In her introduction to *Manifesta: Young Women, Feminism, and the Future,* Jennifer Baumgardner addresses girls, telling them, "I hope that after you read it [*Manifesta*] you'll go and create a zine or a broadsheet or a film or music or an article for the paper or write a *book.*" Along with her coauthor, Amy Richards, Baumgardner offers a "To-Do List for Everyday Activists" at the end of *Manifesta.* The list features activities such as writing letters to advertisers about offensive ad campaigns; corresponding with local legislators and elected officials about pending governmental actions; and purchasing books from independent, feminist bookstores, rather than large chain bookstores and e-tailers.[15] For Baumgardner and Richards, literate activities can be a vital expression of girls' strength and agency in the world. By buying books, writing letters, and creating zines, girls can defy tradition, rise to new challenges, and realize their full potential.

But even adults and institutions that have sought to encourage girls to stretch toward new horizons must be prepared to watch girls use their reading and writing skills in unanticipated ways. Historically, girls have co-opted the literacy lessons they have been offered in wonderfully energetic, creative, and thoughtful ways. Textbooks, novels, newspapers, magazines, letters, and other materials become

the raw material that girls rewrite, reread, revise, and critique. For Clara Solomon, a Jewish girl living in New Orleans during the Civil War, diary keeping served not only as a way to record typical anxieties about school exams and flirtations with attractive young men; she also used her diary to stage her own rebellion against the Union Army's occupation of her hometown and against various periodicals that recounted the occupation. After perusing a Union sympathizer's account of the capture of New Orleans in the *Delta,* Solomon writes:

> As I read, my Southern blood was fired up, & the blush of indignation glowed on my cheeks, & my pulse throbbed high. . . . They were but joking when they said "We were confident of success, for our faith was in our leaders & that Providence who favors the cause of right & justice." Yes, that same righteous God says "Vengeance is *mine* & I will repay." A new flag was raised on the Customhouse & saluted by Butler and his staff, uncovered. Not long may they enjoy their glory.[16]

Solomon's thoughts of revenge were also directed toward the local *Bee,* which was able to continue publication only by withdrawing its advocacy of a scorched earth policy in response to General Butler's bombardment. After reading the *Bee*'s retraction, Solomon writes, "Oh! How my spirit rebelled at such conduct," and she applauds local merchants who withdrew their subscriptions to the newspaper.

In her study of unmarried mothers in the first half of the twentieth century, Regina Kunzel found that reading and writing could also serve as a battleground where "problem girls" challenged middle-class notions of morality expressed by social workers in maternity homes. Kunzel writes:

> Unmarried mothers' attachment to popular confessional magazines like *Real Love, Thrilling Love,* and *Sweetheart Stories* drove maternity home workers to distraction. Offended by the reading habits of one Door of Hope resident, the matron told her "about better reading being available" and advised her of "the damage such trashy reading could do her." She warned her that reading pulp magazines would "keep her emotions stirred up, that she would meet a problem in having had aroused in her all the feelings, emotions, and passions of an adult woman before she is mature enough to know how to handle them." Giving her a copy of a respectable novel, she arranged to meet with the woman later to find out "if she liked it better than the cheap magazines."

When they met to discuss it, however, the unmarried mother reported that she preferred her magazines to the book and continued to read them over the matron's protests.[17]

Kunzel postulates that the confessional magazines acknowledged the power of female sexual desire and gave girls a vocabulary for expressing their own physical pleasures.[18] In these private and public performances, girls use their reading and writing abilities to express their own sense of identity and their independence from authorities who would monitor their literacy lives. Whether insisting upon their right to choose the texts that will fully engage their attention or talking back to texts they find troublesome, girls appropriate literacy and actively participate in the wider print culture.

Researching the Literacy Lives of Girls

Until recently, little specific attention has been paid to the rich complexity of girls' experiences as readers and writers. Scholars committed to the important project of regendering history have typically focused on the accomplishments and contributions of adult women. More particularly, feminist scholars in rhetoric, composition, and literacy studies have begun to produce an invaluable body of historical scholarship on the ways in which women have used their reading, writing, and speaking abilities to traverse the fluid boundaries between public and private spaces.[19] From Aspasia to Ida B. Wells, Margery Kempe to Meridel Le Sueur, Margaret Fuller to Hélène Cixous, a pantheon of powerful female readers and writers is emerging, but little attention has been paid to the girls that these women once were.

Fortunately, groundbreaking research in the field of "girls' studies" is unfolding. Psychologists Carol Gilligan and Lyn Mikel Brown have positioned the strength, resiliency, and self-confidence that is often present in the voices of young girls as a useful contrapuntal element in social and cultural orchestrations that silence women and adolescent girls.[20] Scholars like Joan Jacobs Brumberg, Dawn H. Currie, Susan Douglas, Miriam Forman-Brunell, Sherrie Inness, Mary Celeste Kearney, and Claudia Nelson and Lynne Vallone have produced excellent studies that reveal the social, political, and economic mechanisms that have helped to produce "girlhood" in various historical contexts.[21]

Like the scholars listed above, the contributors to Part 1 of this volume bring both tremendous sympathy and exacting critical judg-

ment to the specific project of studying girls and literacy. In her chapter on girls' uses of literacy in colonial America, E. Jennifer Monaghan offers portraits of four young reader-writers—Katy Mather, Jane Turell, Anna Green Winslow, and Phillis Wheatley—to illustrate how colonial girls engaged in a range of literacy activities to suture themselves into a web of familial and spiritual relationships. Janet Carey Eldred and Peter Mortensen document how the civic rhetoric in the early national period of the eighteenth and early nineteenth centuries benefited girls, but largely those from white, middle-class, Protestant families. They offer an in-depth case study of one girl, Eliza Southgate Bowne, as a representation of the many daughters of privilege who obtained tantalizing glimpses of the possibilities of education during their typically brief tenure at female academies prior to marriage.

Focusing on the nineteenth century, Jean Ferguson Carr describes how a growing population of girls with sophisticated literacy skills became a recognized social reality. By analyzing representations of the girl as reader and writer in novels, periodicals, textbooks, and other cultural artifacts, Carr documents how nineteenth-century girls entered newly open public spaces (e.g., schools, lyceums, the periodical press, philanthropic organizations), even as some educators, religious leaders, journalists, and pundits expressed concern about feminine trespasses into traditionally masculine arenas. As Carr suggests, girls in the nineteenth century found that even as they had greater opportunities as readers and writers, their literacy lessons were often designed to prepare them for their future roles as wives and mothers.

Amy Goodburn directs our attention to the Progressive Era and the educational opportunities available to Native American girls at off-reservation boarding schools at the turn of the twentieth century. Drawing upon the records of the Genoa Indian School (GIS) in Nebraska, Goodburn traces the way progressive concerns and initiatives (e.g., disciplining the body, domestic science) took on special force within the context of the government's project of "Americanizing" Indians. She offers insightful readings of a range of texts produced by Native American girls to reveal how the voices of GIS students skillfully shift between respectful and rebellious registers.

By the middle decades of the twentieth century, the mass media and commercialism helped create teenage culture. In her chapter, Kelly Schrum moves deftly between the newly minted fiction and magazines that addressed teenagers and the diaries, school essays, and other texts in which girls documented their ongoing dialogue with an expanding media market that targeted them in increasingly specialized ways. Schrum untangles the teen magazines' mixed messages that

encouraged high school girls to study hard but also to devote significant attention, time, and money to enhancing their personal appearance and popularity at school. Although often expressing their commitment to the types of "self-improvement" advocated by the magazines, girls also read and wrote in ways that challenged what they perceived to be misrepresentations of their lives.

In the final chapter of Part 1 of this volume, researchers Lisa Weems, Paul Miller, Janet Russell, and Andrea A. Lunsford take up crucial issues surrounding girls' abilities to use reading and writing to make sense of a twenty-first-century society in which science and technology play increasingly important roles. Weems, Miller, Russell, and Lunsford report on the year-long, ethnographic research study they conducted at an all-girls high school in a midwestern city. Moving away from the textbooks, lectures, and worksheets that are common features of many high school science classrooms, the team of researchers asked girls to use web-based software as they studied a popular weight loss drug and then composed a patient advisory letter based on their findings. With opportunities for both inquiry and interpretation, this project held out to girls the promise that scientific methods, data, and technologies could be integrated into their own gendered identities and practices as young women in the twenty-first century.

Taken as a collective narrative, these six chapters represent a history of girls' literacy, one that is partial, contingent, and waiting for the inclusion of still more voices. Researchers eager to contribute to the conversation can turn to these essays as models for their own scholarly endeavors. With energy and creativity, Monaghan and Eldred and Mortensen make the most of the limited archival records that are available for the earliest years of the American colonies and the United States. In their case studies, one can trace the ways in which "close in" studies of individual girls can help build analytical frameworks that make it possible to interpret the literacy lives of other young women. Drawing upon a wide range of texts (novels, magazine editorials, textbooks, tracts, diaries, letters, memoirs, etc.), Carr demonstrates how one can recreate and analyze the vast literacy landscape of a previous century. Such panoramic visions are crucial as researchers begin to pose important questions about the specific cultural and material circumstances that allow girls and their reading and writing habits to emerge and recede from public consciousness. Goodburn and Schrum both gracefully orchestrate conversations between individuals and institutions. In her work on the Genoa Indian School, Goodburn demonstrates the importance of

documenting the interplay between the "official" voices of textbook and curricula and the often less privileged voices of students that can be heard in essays, letters, and school newspapers. In Schrum's work, one finds a model for how scholars can move from large, seemingly impersonal institutions, like the magazines that targeted a nationwide audience of teenaged girls, and the "private," seemingly insignificant diaries of individual girls. Both Goodburn and Schrum illuminate how processes of empowerment and entrapment can unfold simultaneously when institutional imperatives and individual desires collide. Finally, Weems, Russell, Miller, and Lunsford use ethnographic methodologies, or what educators often term "action research," to study the lives of contemporary girls. Drawing upon a variety of sources (e.g., interviews, surveys, and classroom artifacts), these researchers are able to construct a detailed portrait of contemporary girls and their relationships to science education.

In the Part 2 of this volume, readers will find many of the historical texts that inspired the work accomplished by the contributors to Part 1—excerpts from the diaries of Anna Green Winslow, poetry by Phillis Wheatley, selected letters from Eliza Southgate Bowne, essays from the Genoa Indian School, book reviews from teen magazines, and written assignments from science classes. Other documents pertinent to the history of girls and their literacies are also included here. Ranging from excerpts from Eliza Farrar's 1836 book, *The Young Lady's Friend,* to letters written by girls remanded to an industrial home in the 1930s, from the editorial Prudence Withers wrote for her high school newspaper in 1898 to the signatures in Lucille Booth's 1954 yearbook from Elkins High School, from Eugenia Stout's 1853 school composition "Mystery" to bacon4u's web diary in 2002, these documents point toward the diversity of materials that are relevant to the study of girls as readers and writers. The documents have been organized by genre (e.g., instructional texts, classroom compositions, school newspapers, diaries, etc.) rather than chronology to suggest yet another pathway for research. Studying how, for example, making scrapbooks or writing letters is enacted at different historical moments opens up provocative questions about how literacy practices are renewed and revised as they are passed from generation to generation and how girls respond to the immediate social exigencies with which they are faced. The headnotes that introduce each set of primary documents are intentionally brief. Seeking not to trump the voices of girls themselves or to limit how readers might interpret the documents, the headnotes provide background information and direct readers toward other relevant resources and documents.

The final section of this volume, a comprehensive bibliography, will assist researchers in locating an even wider array of documents and resources that bear on the literacy lives of girls. The bibliography features significant scholarly works from a number of disciplines, including English studies, education, history, media studies, medicine, psychology, sociology, and women's studies. Researchers interested in locating primary documents will also find that the bibliography contains a number of published primary resources that are readily available in large public and university libraries. These range from the diaries of nineteenth-century girls like Julia Cowles and Sarah Morgan Dawson to more recent works by girls like Sara Shandler (*Ophelia Speaks,* 1999) and Katherine Tarbox (*Katie.com: My Story,* 2000). Aging copies of nineteenth-century textbooks, conduct manuals, and periodicals can also be found on the shelves of many college and university libraries, and an increasing number of texts relevant to the study of girls' literacies are becoming available online at sites like Cornell University's Making of America (http://cdl.library.cornell.edu/moa/), which allows users to search a wide range of nineteenth-century texts and periodicals; the University of Pittsburgh's digital collection of nineteenth-century schoolbooks (http://digital.library.pitt.edu/nietz/); and the nineteenth-century girls' series page (readseries.com/index.html), which features full-text versions of girls' books like Sophia May's *Little Prudy* (1864) and Josephine Franklin's *Nelly's First School-Days* (1860). The websites of state historical societies and libraries are also increasingly able to provide full-text access to their collections. Using online resources, my own students have been able to complete fascinating research projects on topics ranging from letters written by young girls to Eleanor Roosevelt during the Great Depression (http://newdeal.feri.org/eleanor/index.htm) to the diary of Abbie Bright (www.kshs.org), a young woman who homesteaded in Kansas during the 1870s. Other students have visited state archives, museums, and local historical sites, where they have always found helpful staff eager to assist them with their work. Beyond libraries and other official repositories, though, the history of girls and literacy can also be found in attics, basements, and closets, where generations of women have kept their love letters, diaries, prize-winning school essays, and scrapbooks. Some of the finest classroom research projects completed by my students have begun with an afternoon spent rummaging through old keepsake boxes with a grandmother, an aunt, a sister, or a family friend.

My hope is that the research presented in this volume will be useful to those studying girls' experiences as readers and writers and that the voices of the young women whose writing is included here

will inspire more students and researchers to pursue the study of girls' culture. In classrooms across the nation, students and teachers at all levels and in a variety of disciplines are taking up important questions about gender, sexism, and social equity. Understanding girls' lives and their literacies is crucial to this enterprise, and this volume is intended as an invitation to readers to use their own talents to help write new histories of girls and their literacies.

Notes

1. E. Jennifer Monaghan's discussion of Phillis Wheatley in this volume, along with Phillip M. Richards' "Phillis Wheatley and Literary Americanization," *American Quarterly* 44 (1992): 163–191, have greatly influenced my perception of Wheatley's poetry. I am also indebted to Peter Mortensen and Janet Carey Eldred for sharing with me the essays of Albana C. Carson and her classmates at the Science Hill Academy. Henri Rix Wood first called my attention to the presence of Dorothy Allen Brown Thompson's girlhood diaries at the Miller Nichols Library. Longer excerpts from Wheatley, Carson, and Thompson can be found in Part 2 of this volume.

2. John Trimbur, ed., *Popular Literacy: Studies in Cultural Practices and Poetics* (Pittsburgh: University of Pittsburgh Press, 2001), p. 5.

3. See especially Deborah Brandt, "Sponsors of Literacy," *College Composition and Communication* 49 (1998): 166–167.

4. Lynne Vallone and Claudia Nelson, "Introduction," pp. 1–10 in *The Girl's Own: Cultural Histories of the Anglo-American Girl, 1830–1915,* edited by Claudia Nelson and Lynne Vallone (Athens: University of Georgia Press, 1994), p. 5.

5. E. Jennifer Monaghan, "Literacy Instruction and Gender in Colonial New England," pp. 53–80 in *Reading in America: Literacy and Social History,* edited by Cathy N. Davidson (Baltimore: Johns Hopkins University Press, 1989).

6. Grace Hoadley Dodge, *A Bundle of Letters to Busy Girls on Practical Matters* (New York: Funk and Wagnalls, 1887), p. 128. In organizing one of the first Working Girls' Societies, the wealthy Grace Hoadley Dodge had a complex relationship to working-class girls and women. As Priscilla Murolo notes in her excellent study, *The Common Ground of Womanhood: Class, Gender, and Working Girls' Clubs, 1884–1928* (Urbana: University of Illinois Press, 1997), genteel reformers were motivated by sincere desires to ameliorate social inequities and improve the lives of the working class, but they often failed to recognize their own class privileges.

7. Melinda L. de Jesús, "Fictions of Assimilation: Nancy Drew, Cultural Imperialism, and the Filipina/American Experience," pp. 227–246 in *Delinquents and Debutantes: Twentieth-Century American Girls' Cultures,* edited by Sherrie A. Inness (New York: New York University Press, 1998), p. 231.

8. Suzanne Bunkers, ed., *Diaries of Girls and Women: A Midwestern American Sampler* (Madison: University of Wisconsin Press, 2001), p. 67.

9. Margaret J. Finders, *Just Girls: Hidden Literacies and Life in Junior High* (New York: Teachers College Press, 1997), p. 120.

10. Finders 1997, p. 112.

11. Harry S. Truman, August 16, 1935, Letter to Margaret Truman,

http://www.trumanlibrary.org/whistlestop/study_collections/personal/large/folder1/marg91437.htm (accessed August 1, 2002).

12. Harry Truman, September 14, 1937, Letter to Margaret Truman, http://www.trumanlibrary.org/whistlestop/study_collections/personal/large/folder1/marg91437.htm (accessed August 1, 2002).

13. American Association of University Women, *How Schools Shortchange Girls* (Washington, DC: American Association of University Women Educational Foundation, 1992); Myra Sadker and David Sadker, *Failing at Fairness: How America's Schools Cheat Girls* (New York: Charles Scribner's Sons, 1994); Peggy Orenstein, *School Girls: Young Women, Self-Esteem, and the Confidence Gap* (New York: Doubleday, 1994).

14. Sharon Frye, "'What Does *She* Like?' Choosing a Curriculum for Girls," pp. 17–28 in *"We Want to Be Known": Learning from Adolescent Girls,* edited by Ruth Shagoury Hubbard, Maureen Barbieri, and Brenda Miller Power (York, ME: Stenhouse Publishers, 1998); Maureen Barbieri, *Sounds from the Heart: Learning to Listen to Girls* (Portsmouth, NH: Heinemann, 1995).

15. Jennifer Baumgardner and Amy Richards, *Manifesta: Young Women, Feminism, and the Future* (New York: Farrar, Straus, and Giroux, 2000), pp. xxi; 381–382.

16. Clara Solomon, *The Civil War Diary of Clara Solomon: Growing Up in New Orleans, 1861–1862,* edited by Elliott Ashkenazi (Baton Rouge: Louisiana State University Press, 1995), pp. 391–392.

17. Regina Kunzel, *Fallen Women, Problem Girls: Unmarried Mothers and the Professionalization of Social Work, 1890–1945* (New Haven, CT: Yale University Press, 1993), p. 98.

18. Kunzel 1993, pp. 105–106.

19. Andrea A. Lunsford, ed., *Reclaiming Rhetorica: Women in the Rhetorical Tradition* (Pittsburgh: University of Pittsburgh Press, 1995); Catherine Hobbs, ed., *Nineteenth-Century Women Learn to Write* (Charlottesville: University Press of Virginia, 1995); Cheryl Glenn, *Rhetoric Retold: Regendering the Tradition from Antiquity through the Renaissance* (Carbondale: Southern Illinois University Press, 1997); Anne Ruggles Gere, *Intimate Practices: Literacy and Cultural Work in U.S. Women's Clubs, 1880–1920* (Urbana: University of Illinois Press, 1997); Shirley Wilson Logan, *"We Are Coming": The Persuasive Discourse of Nineteenth-Century Black Women.* (Carbondale: Southern Illinois University Press, 1999); Carol Mattingly, *Well-Tempered Women: Nineteenth-Century Temperance Rhetoric* (Carbondale: Southern Illinois University Press, 1998); Jacqueline Jones Royster, *Traces of a Stream: Literacy and Social Change among African American Women* (Pittsburgh: University of Pittsburgh Press, 2000); Susan Kates, *Activist Rhetorics and American Higher Education, 1885–1937* (Carbondale: Southern Illinois University Press, 2001); Katherine H. Adams, *A Group of Their Own: College Writing Courses and American Women Writers, 1880–1940* (Albany: State University of New York Press, 2001); Carol Mattingly, *Appropriate[ing] Dress: Women's Rhetorical Style in Nineteenth-Century America* (Carbondale: Southern Illinois University Press, 2002); Nan Johnson, *Gender and Rhetorical Space in American Life, 1866–1910* (Carbondale: Southern Illinois University Press, 2002).

20. Lyn Mikel Brown and Carol Gilligan, *Meeting at the Crossroads: Women's Psychologies and Girls' Development* (Cambridge, MA: Harvard University Press, 1992); and Lyn Mikel Brown, *Raising Their Voices: The Politics of Girls' Anger* (Cambridge, MA: Harvard University Press, 1998).

21. Joan Jacobs Brumberg, *The Body Project: An Intimate History of American Girls* (New York: Random House, 1997); Susan J. Douglas, *Where the Girls Are: Growing Up Female with the Mass Media* (New York: Times Books, 1994); Dawn H. Currie, *Girl Talk: Adolescent Magazines and Their Readers* (Toronto: University of Toronto Press, 1999); Sherrie Inness, ed., *Nancy Drew and Company: Culture, Gender, and Girls' Series* (Bowling Green, OH: Bowling Green State University Press, 1997); Miriam Formanek-Brunell, *Made to Play House: Dolls and the Commercialization of American Girlhood, 1830–1930* (New Haven, CT: Yale University Press, 1993); Claudia Nelson and Lynne Vallone, eds., *The Girl's Own: Cultural Histories of the Anglo-American Girl, 1830–1915* (Athens: University of Georgia Press, 1994); Lynne Vallone, *Disciplines of Virtue: Girls' Culture in the Eighteenth and Nineteenth Centuries* (New Haven, CT: Yale University Press, 1995).

Part 1: Historical Overview

1

The Uses of Literacy by Girls in Colonial America

In the American colonies, women—and, of course, girls—suffered from a lack of political, economic, and educational power. They could not vote, let alone hold any kind of official position in the townships or colonies at large. If they inherited money, it would not long remain their own: once they married, they became what was called a *feme* [sic] *couverte,* or "covered woman," which meant that their property and money belonged to their husbands and would only return to them if they were widowed. Girls were not admitted to the handful of colleges in the colonies or to the town-supported Latin grammar schools that prepared their brothers for college. Not until the early eighteenth century would some girls gain access to the elementary, town-supported schools of New England. In general, women (and so, by definition, girls) were considered inferior to men, intellectually and emotionally as well as physically.

Reading Instruction

The one sphere in which girls were believed to be equal to boys was the spiritual. Girls had souls, it was held, just as boys did. At a time when the vast majority of colonial Americans were religious, and most of the religious were Protestant, Protestants insisted that the devout must be taught to read the Bible as a step toward possible salvation. The seventeenth-century reading sequence led through religious texts, from the hornbook, primer, Psalter, and New Testament up to its climax, the entire Bible. Children could be taught to read at ages as early as three, and their teachers were usually women because it was thought that reading was an easy subject to teach.

Because of the link between reading and religion and religion and society, laws—now known as the "Poor Laws" because they were aimed at poor children and designed to prevent indigence—were

passed by the most devoutly Puritan New England colonies: Massachusetts in 1642 and Connecticut in 1650 required that all children, girls as well as boys, be taught to read. These laws laid the responsibility for this reading instruction on parents or, if children were living in someone else's house as apprentices, masters. When these same New England colonies passed laws a few years later requiring townships to pay for a schoolmaster, his primary responsibility was to teach writing and advanced reading, and children's attendance was not compulsory. He needed to teach only those who chose to come. In theory, girls could have attended these seventeenth-century elementary schools; in practice, they did not.[1]

Whether reading instruction was conducted at home or in a school setting, its task was to transmit the culture of the colonists, particularly their religious beliefs. The evangelical nature of reading instruction may be seen again in the context of attempts to convert the indigenous Indians to Christianity. In the little island of Martha's Vineyard, which lay off the coast of Massachusetts Bay Colony, a missionary effort was launched in 1643 to convert the Wampanoag Indians to Christianity. The introduction of religious texts, including the entire *Indian Bible* (1661–1663), the *Indian Primer* (1669), and the *Massachuset Psalter* (1709), all translated into the Massachusett language, was part of this effort. On the Vineyard, schools were opened for the converts.

The evidence suggests that the Indian converts welcomed the addition of literacy to their culture. One little Wampanoag girl born about 1702, named Bethia, had no school nearby, an illiterate mother, and a busy father, so she turned to her neighbors for help learning to read: "[T]ho the Circumstances of the Family to which she belonged, were such that she could scarcely be spared long enough from it to go and read a Lesson or two in a Day, yet she would by her great Industry redeem time." She was so motivated that she "learned to read better than many do who have a School to go to, and time to attend it." Because virtually all the texts available to the Wampanoags were religious ones, reading was inevitably undertaken as a Christian exercise. Books provided spiritual consolation in times of crisis. When Abigail Kenump lay dying at the age of sixteen, too ill to be able to read for herself, she asked her friends "to read some portion of God's Word to her."[2]

Writing Instruction

If reading was regarded as the vehicle for transmitting the values of the dominant culture, writing was viewed much more prosaically, as an economic survival skill for boys. Writing instruction was legally re-

quired for boys as early as 1660 in New Haven (then a separate colony) and in 1710, as a revision of the Poor Law, in Massachusetts. It was not mandated by law for girls in Massachusetts until 1771: the survival skill for girls was sewing. Mathematics was closely linked to writing instruction, and writing masters routinely taught bookkeeping. Although many women owned stores in colonial America, no law was passed in any colony that required girls to learn mathematics.

Writing instruction was defined as penmanship, not composition. (The male focus of this word is not a coincidence: writing masters were almost exclusively male.) The emphasis was on teaching children to write "a legible hand." Most children did not begin to learn to write until about seven years of age, when their reading was well under way and they were judged capable of handling the intractable quill pen. By the eighteenth century, the secretary script of the preceding century had yielded to the round hand, admired for its clarity and its usefulness in commercial transactions at a time when so many documents were handwritten.

Known throughout the colonies for the quality of its writing instruction was Boston, which opened three free writing schools between 1680 and 1720: the Writing School in Queen Street, the North Writing School, and the South Writing School. The masters there taught a careful sequence of scripts: the round hand, a gothic script, roman and italic print, a second gothic, and so on. Their students began each script by forming its individual letters. Then they copied, usually six times, a one-line moral precept, such as "Quiet minds commonly enjoy much Content"; next, they advanced to copying poems (valuable because of their controlled line length); and finally the best of the boys penned as many as eight different scripts within tight geometrical shapes such as octagons and ovals. The girls who came to these schools did so as private pupils when the boys left school for a meal: usually for an hour each at eleven and five o'clock. Normally girls were taught only round hand.[3]

Formal composition instruction in schools was strikingly absent from all this. When it arrived, it would be in the guise of composing letters. In his 1747 proposals for an English academy in Pennsylvania, Benjamin Franklin was radical in suggesting that students write letters at school and summarize and paraphrase what they read. Otherwise, the only practice in composition we are sure took place occurred in the Latin grammar schools, where boys composed essays in Latin and sometimes Greek.[4]

In this climate in which writing instruction was so targeted at boys, the eighteenth century saw a change in the attitude toward

writing instruction for girls. In 1715, two girls' names appear for the first—but not the last—time on a list of forty children attending a school for poor children in the city of New York funded by an Anglican missionary organization, the Society for the Propagation of the Gospel. The school was taught by a master, so the girls now had access to writing instruction. In many New England townships founded in the 1740s, girls began to attend the elementary town schools where they learned to write.

Several factors promoted the private writing instruction of girls. One was that writing masters needed pupils. This was true even of the writing masters whose salaries were paid by the town, as was the case for the three writing schools of eighteenth-century Boston. Writing masters skillfully promoted the idea that writing was a genteel female accomplishment, just as important as sewing and embroidering, and more so than playing a musical instrument or learning to dance. Second, the sheer usefulness of writing encouraged caring parents who could afford it to make sure that their daughters were taught to write as well as read. We can surely infer from all this that if teaching reading was part and parcel of civilizing the child, teaching writing fostered some form of self-definition. This impression is reinforced by the instruction given in the very few schools for slaves in the 1760s: the enslaved children there were taught only to read, never to write.

The increasing impetus in the eighteenth century to teach girls to write affected all social classes. For instance, when in 1739, the charismatic English evangelist George Whitefield founded a school for orphans called Bethesda twelve miles from Savannah, Georgia, its teachers taught all the children in their care to write as well as read. After Whitefield had returned home to England, the children wrote letters to him from school. "Dear and Reverend Sir," ten-year-old Rebecca wrote in March of 1741, "I have found great Concern about my poor Soul since your leaving us, God has shown me more and more of the Hardness and Wretchedness of my Wicked Heart."[5] Although not all orphans were necessarily poor, the example shows how some girls in the lower social classes were gaining access to the fullest form of literacy, writing as well as reading.

Nevertheless, evidence from signatures (as opposed to marks) on documents reveals how much the ability of women to write remained behind that of men throughout the entire colonial period, even while the signing rates of both sexes rose steadily over time—at least in New England. In seventeenth-century Virginia, white men's signing of their wills had risen to 67 percent by 1710 and stayed at

that level, but women signed at half that rate. Even in Massachusetts, which had a much stronger commitment to education, men in its eastern counties signed about 70 percent of their wills by 1710; women signed only 40 percent. These figures improved over the eighteenth century. In general, both male and female literacy correlated positively with wealth and urban living. By 1790, male signing of wills reached nearly 90 percent in much of New England. Because adult signing reflects an education that occurred at least a quarter century earlier, close to universal minimal literacy was attained by boys by the time of the American Revolution. What is more, somewhere in the last third of the eighteenth century, again in New England, the ability of white girls to write was catching up to that of boys: girls born after 1765 signed deeds at an 80 to 90 percent rate. It should be remembered, however, that an inability to write should not necessarily be interpreted as an inability to read: because of the oral nature of reading instruction and because reading was always well in hand before writing instruction was begun, many could read in colonial America who could not write.[6]

Examples of the Uses of Literacy

Within the general context of girls' expanding access to writing in the eighteenth century, it is useful to look at some specific examples. That they all come from Boston, Massachusetts, is a pity, but it is the inevitable consequence of a dearth of sources on girls in the colonial period. Because Boston was for a long time the premier city for publishing, some memoirs printed there have survived. The first two examples of literate girls are the daughters of Boston ministers filling Congregational ("Puritan") pulpits: Katy Mather, born in 1689, and Jane Turell, born in 1708. They were therefore children of the most highly educated group—clergymen—in the colonies. Then comes Anna Green Winslow, born in 1759. She, too, was a member of the elite. Her father, Joshua Winslow, was commissary-general to the British forces stationed in Nova Scotia, and he sent Anna to Boston at the age of eleven to complete her education. In contrast to these white girls of high social standing, Phillis Wheatley, our final example, was an enslaved African brought to Boston in the ship *Phillis* at the age of about eight, in 1761.

Katy Mather was the daughter of Cotton Mather, who served as the minister of the North Church of Boston. Mather himself was the most literate man in colonial America, publishing some 450 books and pamphlets during his lifetime. He took a keen interest in promot-

ing the literacy of his children. Katy was his eldest surviving child and held a special place in his heart: her next sibling, Abigail, was five years younger than she.[7]

When Katy succumbed to tuberculosis in 1716 at the age of twenty-seven, Mather wrote a memorial of her and had it published under the title *Victorina*. He placed her education squarely in the context of gentility: she was, he wrote, "happy in an Education, that was polite and agreeable to the Circumstances of a *Gentlewoman*." Immediately after remarking on her "Accuracy at her Needle," Mather praised her ability to write—her "Dexterity at her Pen." Her other talents included housekeeping skills, singing, playing an instrument, and sculpting waxwork.[8]

Katy was literate not only in English but in Hebrew, which she had been taught as a child, and to some extent in Latin. She also had a good grasp of the geography of places mentioned in the Bible. Her father, who was clearly responsible for getting her this advanced instruction, also involved himself in her writing. He used to set her and her younger siblings the equivalent of "short answer" essays, requiring them to respond to such questions as "What will be the best Manner and Method of my spending my Time in the World?" Even when Katy was an adult, he would ask her to write "brief Essayes of Piety, on such agreeable Subjects, as I may from Time to Time assign unto her."[9]

Her father's report of Katy's literacy indicates that she used it largely in the service of her faith. One of the texts she read was a manuscript by a Mrs. Chandler of Woodstock, who was in the habit of writing down a brief, pious meditation each night in prose or verse. Her manuscript had come into Mather's hands, and he had underlined certain passages in pencil and asked Katy to copy them. Katy had long been taught by her father that copying "Treasures" into "Blank Books" was a good means of improving herself spiritually, so she had complied. According to her father, "This *Fine Work* of PIETY, thus drawn by a *Female Pen,* pleased her mightily: And she exactly *Copied* it."[10]

The passages that Katy copied included such sentiments as "I have cast my Soul at His Foot for *Mercy,* and devoted my Self unto His *Service* forever."[11] One of Mrs. Chandler's offerings was a piece of "Good Advice" addressed to "Virgins." It cautioned against the temptations to girls—naughty books, ballroom dancing, and card playing—that were available in early eighteenth-century Boston:

Let not *Vile Books* your blooming Years deprave;
But Books of Truth let your perusal have.
Rather to *Churches* than to *Balls* repair;

Perfume your *Closets* too with daily Pray'r.
Foul *Cards* let your fair *Hands* throw by with Scorn,
But *Write* & *Work* as for high purpose born.[12]

To "work" in this context meant to sew, the primary task facing girls. To have the act of writing set ahead of sewing was an indication of the importance of writing for girls in this genteel context.

In short, encouraged by her father, Katy used her literacy as a means of consolidating her own religious beliefs. Like the Native Americans before her and the Georgia orphans after her, her reading was devotional or scriptural. Her writing, if it has been represented fairly by her father, similarly revolved around her faith—although here a hint of an alternative and secular culture may be seen, as she dutifully copied warnings against dancing and "*Vile Books.*"[13]

Our next example is that of Jane Turell, who experienced a literacy that expanded its scope to embrace literature. She too, like Katy Mather, was the oldest child of a minister in Boston, and she too died at the age of twenty-seven. As Katy had been, she was memorialized by her father, but she was also remembered in print by her widower, Ebenezer Turell, pastor of the church of Medford, Massachusetts. Jane's father was Benjamin Colman, who served as minister to the Boston Brattle Street Church. The memoirs, published in 1735, were enriched by the inclusion of many of Jane's own writings. Like the Mather family, this household was one in which the mother was almost invisible in the records but the father featured strongly. As was true of the Mather household, in the Colman home the elder daughter profited from not having an older brother to be the focus of her father's attention, from having a male parent who had much time at his disposal, from being relieved (apparently) of all housework because the domestic arrangements included enslaved Africans, and from having access to her father's ample ministerial library, rich in literary as well as theological works.

Jane had been so ill as a child of eighteen months that, even though she recovered, the illness left her very weak. Her reduced ability to take part in physical activities encouraged her parents to concentrate on her spiritual development, and because reading was so intertwined with religion, her parents made it "our daily Pleasure, and her Diversion, to learn [teach] her *Letters,* and *Prayers* to God her Maker."[14] Before she was two, she could "speak distinctly, knew her Letters, and could relate many Stories out of the Scriptures to the Satisfaction and Pleasure of the most Judicious."[15] This advanced instructional diet helped Jane become both literate and de-

vout at an early age. Even before the age of four, she had learned by heart most of the Assembly of Westminster catechism, many of the Psalms, and several hundred lines of what her widower called "the best Poetry." She was also able to "read distinctly and make pertinent Remarks on many things she read."[16] Jane's precocity in reading was matched by her ability to write: she was writing competent letters by the age of ten.

It is not clear how much formal instruction Jane had. She presumably attended private schoolmasters at some point because she thanked her father for sparing no expense in her education. However, much of her education was obtained at home, in what we would today call "home schooling." Her father took a leading role in this, instructing her daily. The result was that Jane reached adult literacy by the age of eleven, when she began to compose poetry as well as prose. By the age of eighteen, "she had read, and (in some measure) digested all the English *Poetry,* and polite Pieces in *Prose,* printed and Manuscripts in her Father's well furnish'd Library, and much she borrow'd of her Friends and Acquaintance."[17] She would spend nights as well as days reading.

Several themes emerge from Jane's use of her accomplished literacy. The first is that she used it as a vehicle for growing closer to her father, sharing her writing with him of both prose and poetry. She wrote her first poem, a hymn dated January 4, 1718, before her eleventh birthday:

> I fear the Great *Eternal One* above,
> The God of Grace the God of Love:
> He to whom *Seraphims* Hallelujah's sing,
> And Angels do their Songs and Praises bring. [18]

This first attempt inspired her father to respond with his own verses, and they clearly display the use of writing to speak the affection between father and daughter:

> *Joy of my Life!* Is this thy lovely Voice?
> Sing on, and a fond *Father's* Heart rejoyce.
> 'Twas nobly dar'd, my charming Child! a Song
> From a *Babes* Mouth of right to *Heaven* Belong.[19]

By the time Jane was seventeen, she was composing poems on a variety of subjects. One was a poem to her father in 1724, when he was selected to be the president of Harvard College; others were

paraphrases of Psalms from the Old Testament. To most of these, her father answered in kind.

A second use of Jane's writing was her positioning of herself as a poet. She was well aware of the fact that poetry was not expected of her gender. In her usual meter of iambic pentameters, she commented on a poem written by a Mrs. Singer attacking (male) vice. Jane wrote:

> Surpriz'd I view, wrote by a *Female* Pen,
> Such a grave Warning to the Sons of Men . . .
> A *Woman's* Pen strikes the curs'd *Serpents* Head,
> And lays the Monster gasping, if not dead.[20]

This poem displayed a sharp reversal of the usual Adam and Eve motif. In the biblical version it is Eve, the prototypical woman, who is beguiled by the serpent to disobey God and who persuades Adam to do likewise. In Jane's version, a woman forestalls sin by attacking the evil serpent before it can insinuate its way into her confidence.

In another poem Jane, like Homer and Virgil, invoked the muse to aid her in her attempts to write verse:

> Come Gentle *Muse,* and once more lend thine aid,
> O bring thy Succour to a humble Maid! . . .
> Instruct me in those secret Arts that lie
> Unseen to all but to a *Poet's* Eye.[21]

Her poetry showed an easy familiarity with neoclassical metrics and the Greek and Roman poets in translation: she invoked Greek names such as Sappho, Orinda, Philomela, and Parnassus. That this was a self-conscious attempt to write in a manner above that expected of young women was noted by her husband: as he put it, "I find she was sometimes fir'd with a laudable Ambition of raising the honour of her *Sex.*"[22] Her gifts were also appreciated by her father. He told her that if she had received the advantages of the education he himself had obtained in school and college, "your Genius in Writing would have excell'd mine."[23] Her husband, who first met her when she was just eighteen, said he was surprised and charmed to find her so accomplished: "I found her in a good measure Mistress of the politest Writers and their Works."[24]

Jane's third use of her writing was more prosaic—and in prose. She liked to order her life by writing things down. In her fourteenth year, she began a secret diary that displayed many of the characteris-

tics of the typical devotional diary of the time: self-scrutiny, admission of sinfulness, anticipation of death, and prayers for salvation. It also drew lessons for her own life from important events. She penned one entry just after she had attended the burial of a young friend: "I this Day follow'd to the Grave a true and faithful *Friend*. Lord sanctify her Death to me: Awaken in me proper tho'ts of my own Frailty and Mortality. I might have been taken away and she spar'd."[25]

In addition to her diary, Jane attempted an autobiography. She numbered her comments, and she set down six reasons why she considered herself blessed. The fifth was her "Polite as well as Christian Education." Another numbered list concerned her requirements for a potential suitor. He was to be (1) the son of pious parents; (2) morally upright; (3) a diligent businessman; (4) one who attended divine services regularly; and (5) of a "Sweet and agreable *Temper*." If he lacked the fourth quality, she said, even someone with all the other qualifications would make her life uncomfortable.[26] Ebenezer Turell fit the bill on all these counts. They were married when she was eighteen, and she continued to educate herself at her new home in Medford in divinity, history, medicine, and theological controversies, as well as poetry.

In addition to her prolific letter writing, there was one last use to which Jane turned her pen: she had written "some Pieces of *Wit* and *Humour*, which if publish'd would give a brighter Idea of her to some sort of Readers," recalled her widower. Unfortunately for us, he decided to omit them because she wrote more frequently on "graver and better Subjects."[27] The acknowledgment that a girl was writing witty pieces in the mid-1720s is so unusual that we can only regret their loss.

Our third example is that of Anna Green Winslow. Two generations after Jane Turell, Anna's literacy reveals an easy embrace of both religious belief and secularism in the form of books for children. She was eleven when she was sent to Boston to live with her father's sister, the forthright Aunt Deming. Anna went there to complete her education at the best schools Boston had to offer: the sewing school of Mrs. Smith, the dancing school of Master Turner, and the writing school of Master Samuel Holbrook, master of Boston's South Writing School. Although, as a free writing school, it was for boys only, Anna attended it as a private pupil "out of hours," for an hour each in the morning and late afternoon when the boys were not there.

Anna's attendance at writing school is evidence of the anomalies and contradictions of colonial writing instruction. The school's emphasis on penmanship, on form over function, entailed that Anna was attending a writing school when, if judged by modern standards, she

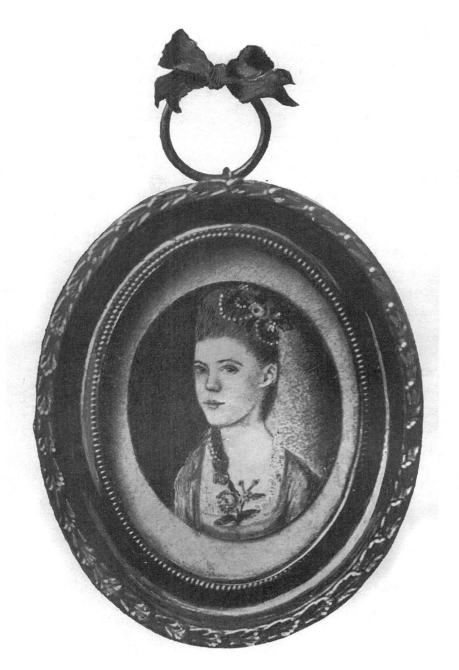

*Portrait of Anna
Green Winslow.*
(Diary of Anna
Green Winslow, A
Boston School
Girl of 1771.
*Edited by Alice
Morse Earle. Boston:
Houghton Mifflin,
1894.)*

could already write very well. Her spelling is not wholly conventional, but her script is clear and well formed. Anna herself had a very keen sense of the discord between the school and family's focus on her penmanship and her own conception of writing as communication. Sometimes she tried hard to live up to the standards expected. When her mother made a comment on the physical formation of her letters, Anna wrote: "I am glad Hon'd madam, that you think my writing is

better than it us'd to be—you see it is mended just here. I dont know what you mean by *terrible margins vaze*. I will endeavor to make my letters even for the future."[28] At other times she was much more cavalier: "My aunt Deming says, it is a grief to her, that I don't always write as well as I can, *I can write pretily.*"[29]

Anna's surviving journal (it begins and ends abruptly) was kept by her from November 1771 to the end of May 1773. She turned twelve years old shortly after the diary began, so most of the journal was written in her thirteenth year. She mentions other pieces of writing: her so-called text journal, which seems to have been the place where she made notes on the sermons she heard at the Old South Church twice every Sunday and the lectures she attended every Thursday evening. She also wrote formal little notes to her friends, all girls, to invite their attendance at the little "assemblies" (dances) that parents hosted for their daughters. But Anna's most sustained writing was done in her journal, usually daily.

The journal was not a private document but an open, running letter addressed to her parents. Every so often, she would wrap up large portions of it and send it off to her parents and her young brother back in Cumberland, Nova Scotia. Her parents would respond and comment on the journal in their letters to her. Anna had a keen sense of audience. When her father failed to make any reference to it, she was quick to berate him in an entry aimed at her mother:

> My Hon'd Papa has never signified to me his approbation of my journals, from whence I infer, that he either never reads them, or does not give himself the trouble to remember any of their contents, tho' some part has been address'd to him, so, for the future, I shall trouble only you with this part of my scribble.[30]

Beginning in June 1772, her parents were in Boston, so the sense of them as listeners to the journal vanishes. Anna either failed to make any entries or did so much more briefly. The tone changes again in May of the following year, after they departed: the journal resumed its function as an ongoing letter, and the entries once again become lengthy and discursive.

The best single characterization of the journal is perhaps that it was an open site for family communication. True, it also certainly served the purposes conventionally associated with diary keeping: it recorded important events, which in Anna's case often involved social occasions and her choice of dress: "I was dress'd in my yellow coat, black bib & apron, black feathers on my head, my past[e] comb, & all my past[e] garnet marquesett & jet pins, together with my silver

plume."[31] It also served one of the purposes for the devout of writing, the recording of sermons. Anna conscientiously wrote down the text of each sermon and the admonishments of the preacher. Mr. Hunt, she wrote, "said that there was nothing properly done without a rule, & he said that the rule God had given us to glorify him by was the bible. How miraculously (said he) has God preserv'd this blessed book."[32] But the journal's most important function was to serve as a place where family members could be drawn closer and share news of each other.

This feature may be seen in the fact that the journal was available to all comers. Aunt Deming regularly read it and sometimes added pithy little remarks about its surface features. Hers is the handwriting that makes the comment, using Anna's voice, "N.B. my aunt Deming dont approve of my English & has not the fear that you will think her concernd in the Diction."[33] Visitors were treated to oral readings from it, occasionally to Anna's discomfiture: "I have just been reading over what I wrote to the company present, & have got myself laughed at for my ignorance."[34] Visiting clergymen were informed of it. When Mr. Hunt was told how often his name and words appeared in her journal, "He laugh'd & call'd me Newsmonger, & said I was a daily advertiser."[35]

Anna's journal was indeed a conduit for messages and news: "I saw Mrs. Whitwell very well yesterday, she was very glad of your Letter."[36] "Aunt bids me give her love to pappa & all the family & tell them that she should be glad of their company in her warm parlour."[37] A long entry gives a vivid description of how her uncle Ned broke his leg when he was tossed out of his vehicle after the horse drawing it fell down an icy hill. Anna spent several entries keeping her parents updated on the scandalous activities of the notorious Betty Smith, thief, frequenter of the workhouse, and soon jailbird. Finally this newsworthy story came to a close: "Last Wednesday Bet Smith was set upon the gallows. She behav'd with great impudence."[38]

The journal was also a place for the sharing of poetry. Anna copied out one poem about the mayor of London and another found in her late grandmother's pocketbook. The latter began, "Dim eyes, deaf ears, cold stomach shew, / My dissolution is in view / The shuttle's thrown, my race is run, / My sun is set, my work is done."[39] The death of an acquaintance inspired the inclusion of a poem, "Stoop down my Thoughts, that use to rise, / Converse a while with Death."[40] Another poem, which had served as the model for a penmanship piece at her writing school, expressed suitable appreciation for the expenses her genteel education had incurred:

"Next unto *God,* dear Parents I address
["]Myself to you in humble Thankfulness,
"For all your Care & Charge on me bestow'd;
"The means of Learning unto me allow'd.[41]

Yet another instance of the journal's openness is Anna's ability to criticize her own writing immediately after she had penned it—and include that criticism in her diary. In most cases, she focused on surface features. Sometimes she corrected her own spelling: "We made four couple at country dansing; danceing I mean."[42] "I went to Mrs. Whitwell's last wednessday—you taught me to spell the 4 day of the week, but my aunt says that it should be spelt Wednesday."[43] But at other times, she was more attuned to content: "I think I have been writing my own Praises this morning. Poor Job was forced to praise himself when no *man* would do him that justice. I am not as he was."[44] Today we would call this an ability to think metalinguistically—to think about writing as an object outside the writer.

If Anna's writing served to knit the family together as a site for interchange, so too did much of Anna's reading. She was completely fluent in the Bible, and she often read chapters aloud to her aunt in the evenings. She also read works of entertainment, living as she did in a period when the children of the elite finally had access to imported works targeted at children. Some of these were abbreviated versions of books for adults, such as *Gulliver's Travels* or Henry Fielding's novel *Joseph Andrews.* Her aunt permitted her to read the former on the grounds that it was "perfecting" her in reading a variety of compositions. Others were classics, such as *Pilgrim's Progress.* Still others were works written specifically for children: they included stories printed by the firm of John Newbery of London and his successors, such as the *Mother's Gift,* the *Puzzling Cap,* and the *History of Goody Two Shoes,* along with a work designed for a purely female audience, the *Female Orators.* Many of these were shared in the family by being read aloud. Anna and a cousin read aloud the *Generous Inconstant* and embarked upon Samuel Richardson's *Sir Charles Grandison* (both presumably in the abbreviated versions). And, of course, Anna read aloud her journal. Reading, like writing, was an experience to share with those she loved.[45]

Our final example is that of Phillis Wheatley, an enslaved African purchased on the Boston docks in 1761 by John Wheatley, a wealthy Boston merchant, to serve his wife Susanna. The eight-year-old Phillis entered a household with other enslaved Africans and with the twin children of the Wheatleys, a boy and a girl. Mary, the daughter, taught Phillis to read as part of the family effort to introduce her to Christianity.

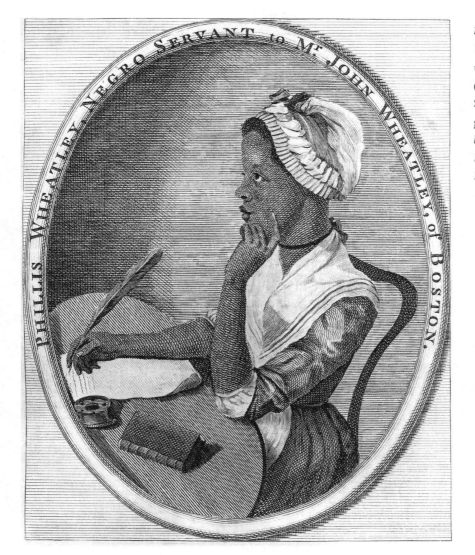

Portrait of Phillis Wheatley at her writing desk. (Poems on Various Subjects, Religious and Moral by Phillis Wheatley, Boston: Cox and Berry, 1773.)

It was soon clear to the Wheatleys that Phillis was gifted: she acquired English rapidly and learned to read "Without any Assistance from School Education, and by only what she was taught in the Family," according to John Wheatley. Within sixteen months she was able to read "the most difficult Parts of the Sacred Writings, to the great Astonishment of all who heard her." She might not have been taught to write if she hadn't insisted on it: "her own Curiosity led her to it," said John Wheatley.[46] She began to learn Latin and she read classical poetry in translation as well as the works of contemporary English poets. A few years later, she was writing poetry herself.

Perhaps more than for any other of our examples, literacy for Phillis was her key to self-definition. It was her personal voice proclaiming her own identity in a culture that defined her as a chattel, a

thing to be bought and sold with no voice of its own. She had become an evangelical Christian, and much of her poetry was aimed at converting others. In one of her earliest poems, written (but not published) in 1767 at the age of fourteen, was addressed to the students of Harvard College—that is, to boys of her own age, in an era when students entered college at a much younger age than they do today. Significantly, she had chosen as her topic an institution that would have barred her from entering it on the grounds of her gender, let alone her race. She urged the boys to appreciate their education: "Improve your privileges while they Stay: Caress, redeem each moment." She contrasted her own experience with theirs. She had been brought by God's "Powerfull hand" into "Safety from the dark abode" of Africa; but they were being introduced to the bright realms of astronomy.[47]

The first of Phillis's poems to be published appeared that same year in the *Newport Mercury,* a Rhode Island newspaper. Phillis continued to write poetry, and three years later one of her poems was published as a broadside in Boston. It was an elegy for the Reverend George Whitefield. Whitefield had become famous throughout the American colonies for his evangelical tours from 1738 on, and he had just died of an asthma attack while on yet another New England tour. Phillis captured Whitefield's unrivaled skill at addressing huge crowds:

> Hail happy Saint on thy immortal throne! . . .
> We hear no more the music of thy tongue,
> Thy wonted auditories [audiences] cease to throng.
> Thy lessons in unequal'd accents flow'd!

Phillis alluded to Whitefield's ecumenical appeal to all, to the colorblindness and egalitarianism of Christ, and to his promises of spiritual power to the politically marginalized:

> Take HIM, [Christ] "my dear AMERICANS,"
> he [Whitefield] said,
> Be your complaints in his kind bosom laid:
> Take HIM ye *Africans,* he longs for you;
> Impartial SAVIOUR, is his title due;
> If you will chuse to walk in grace's road,
> You shall be sons, and kings, and priests to GOD.[48]

Revisions of this and other poems were published in London as a book in 1773.

In part because of her status as an enslaved African, Phillis, along with her neoclassical poetry, has attracted much scholarly ink. Some

commentators have been critical of her for absorbing white cultural values. As Phillip Richards puts it, they have come to "value Wheatley as a poet [only] to the degree that she expresses an African identify, apart from (or even adversary to) eighteenth-century Anglo-American culture."[49] A more balanced assessment, like that of Richards, is to see Wheatley as creating what he calls "legitimating strategies" that permitted her to take advantage of the religious and political themes of the prevailing culture "to assert her legitimacy as an evangelical or political poet."[50]

In terms of her literacy, Phillis had a marvelously clear conception of what the skill of writing could do for her. She turned writing into creation, and through it she created herself. Her white Christian family had fully appreciated this aspect of her literacy and had been crucial in her search for publication, the most public form of identity construction. In the fall of 1773, John Wheatley emancipated her. By the time of the American Revolution, she was writing a poem to George Washington. No longer identified as "slave" or "Negro servant," as she had been in earlier publications, she was now billed as "*the famous* Phillis Wheatley, *the African Poetess.*"[51] Her transformation through the writing of poetry was complete. If, in the end, she freed herself only to enter the marginalized life of so many freed slaves, it was because of the wider culture of institutionalized racism that no poetry could then alter.

Katy Mather, Jane Turell, Anna Green Winslow, and Phillis Wheatley were all elite girls—for even Phillis was given the education of the elite. Katy and Jane, by virtue of being the eldest children of ministers, enjoyed an education that was rare even among the elite. The literacy experiences of Phillis were unique for an enslaved female African. Anna's education was probably the nearest to being typical of her social standing. So there are limits to how far we can generalize from their experiences. That said, perhaps the most important conclusion to be drawn is that each of them appropriated her literacy to her own uses and needs. As far as reading was concerned, the girls were not necessarily confined by the religious thrust of reading instruction that dominated the seventeenth century. The three born in the eighteenth century increasingly had access to secular texts, particularly literary ones. They acquired other languages, read the works of contemporary poets and of the classical authors in translation, and by the 1770s they were reading British novels being imported into the American colonies, along with the new books published by the Newbery firm and specifically designed for the pleasure of children.

If their reading was becoming liberated, their writing liberated them. Katy was apparently the most constrained in her writing, often

copying the words of others or responding to questions others had set, but the girls born after her wrote words that were all their own. Anna Green Winslow was a free spirit who needed little liberation; instead, she used her writing as a site for knitting her family and friends together. In contrast, Jane Turell and Phillis Wheatley both carved out a space for themselves with their poetry. They laid claim to their self-definition—Jane in private but Phillis in the public spotlight of publication, in a strategy that aided her manumission.

In a more general sense, we can infer from these few examples the varied possibilities that writing and reading provided some girls during the colonial period. In particular, as the eighteenth century progressed, elite girls were able to use their literacy to build and sustain relationships, both familial and spiritual, by engaging in a broad spectrum of literacy activities that ranged from reception to production. They shared texts with family and friends as they read aloud, wrote, copied, or paraphrased the prose and poetry of others. They kept their own journals, wrote letters, composed prose and poetry, and commented on the larger world of fashion, polite society, literature, and even political events. As adults, some living in major port cities would organize literary salons where both men and women would exchange poems, journals, and letters, and engage in discussions on "polite" subjects.[52]

Girls from "middling" families, particularly urban ones, also saw their educational horizons expand in the eighteenth century. Robert Seybolt found more than 200 newspaper advertisements between 1722 and 1776 for private schools targeted at "young ladies." The notices specified instruction in reading, writing, arithmetic, accounts, needlework, vocal and instrumental music, advanced reading, English grammar, letter writing, Latin, French, other romance languages, and geography. Meanwhile, even girls of the "lower sort" were increasingly being taught to write. As we saw earlier, the Massachusetts Bay law of 1771, which finally legislated that girls apprenticed under the Poor Laws be taught to write as well as read, signaled the widespread acceptance in colonial culture of the necessity of teaching girls of every social rank to write.[53]

This strong emphasis on writing from which girls benefited related to an increasing interest during the eighteenth century in writing instruction as commerce expanded; the correspondingly enhanced prestige of writing masters; a proliferation in the quantity and quality of writing materials; a rising desire among middling folks for gentility; and, after 1750, the expansion of letter-writing among all groups, male and female, young and old, elite and middling, as a

means of identity construction, self-improvement, and cementing family bonds.[54]

As a result, even in a culture so heavily biased in favor of their brothers, a few girls were able to take part in an evolution from the private to the public realm that would soon, in the early republic, take the form of publishing novels.[55] When, as writing adults, they began to pose a threat to male control over what should be read, they would suddenly find themselves excoriated as "scribbling women." But for a brief moment in American history, girls could bask in the use of literacies sanctioned by the approval of family and friends.

<div style="text-align: right;">E. Jennifer Monaghan</div>

Notes

1. E. Jennifer Monaghan, "Literacy Instruction and Gender in Colonial New England," pp. 53–80 in *Reading in America: Literature and Social History,* edited by Cathy N. Davidson (Baltimore: Johns Hopkins University Press, 1989).

2. Experience Mayhew, *Indian Converts: Or Some Account of the Lives and Dying Speeches of a Considerable Number of the Christianized Indians of Martha's Vineyard, in New-England* (London: for S. Gerrish, 1727), pp. 255–256, 236–237; see E. Jennifer Monaghan, "'She loved to read in good Books': Literacy and the Indians of Martha's Vineyard, 1643–1725," *History of Education Quarterly* 30 (1990): 493–521.

3. E. Jennifer Monaghan, "Readers Writing: The Curriculum of the Writing Schools of Eighteenth-Century Boston," *Visible Language* 21 (1987): 167–213. See also Tamara Plakins Thornton, *Handwriting in America: A Cultural History* (New Haven, CT: Yale University Press, 1996).

4. Benjamin Franklin, *Proposals Relating to the Education of Youth in Pensilvania* [sic] (Philadelphia: n.p., 1747), pp. 16–17; Robert Middlekauff, *Ancients and Axioms: Secondary Education in Eighteenth-Century New England* (New Haven, CT: Yale University Press, 1963), pp. 83–88. Middlekauff points out the limitations of "making Latin" on p. 88.

5. George Whitefield, *An Extract of the Preface to the Reverend Mr. Whitefield's Account of the Orphan-House in Georgia. Together with an Extract of Some Letters Sent Him from the Superintendents of the Orphan-House, and from Some of the Children* (Edinburgh: T. Lumisden and J. Robertson, 1741), p. 18. For Whitefield's promotional activities, see Frank Lambert, *Pedlar in Divinity: George Whitefield and the Transatlantic Revivals, 1737–1770* (Princeton, NJ: Princeton University Press, 1996).

6. Kenneth A. Lockridge, *Literacy in Colonial New England: An Enquiry into the Social Context of Literacy in the Early Modern West* (New York: W. W. Norton, 1974), pp. 74, 92; Joel Perlmann and Dennis Shirley, "When Did New England Women Acquire Literacy?" *William and Mary Quarterly* 48 (1991): 50–67; and Monaghan 1989. For a comprehensive review of studies that have evaluated literacy by counting those who could sign their names on documents as opposed to just marking them, see Janet Carey Eldred and Peter Mortensen, "'A Few Patchwork Opinions': Piecing Together Narratives of U.S. Girls' Early National Schooling," Chapter 2 of this

volume, note 8. See also Ross W. Beales and E. Jennifer Monaghan, "Literacy and Schoolbooks," pp. 380–387 in *The Colonial Book in the Atlantic World,* vol. 1 of *A History of the Book in America,* edited by Hugh Amory and David D. Hall (Cambridge, UK: American Antiquarian Society and Cambridge University Press, 2000).

7. E. Jennifer Monaghan, "Family Literacy in Early Eighteenth-Century Boston: Cotton Mather and His Children," *Reading Research Quarterly* 26 (1991): 342–370.

8. Cotton Mather, *Victorina. A Sermon Preach'd on the Decease and at the Desire of Mrs. Katharin Mather, by Her Father. Wherunto There Is Added, a Further Account of That Young Gentlewoman, by Another Hand* (Boston: D. Henchman, 1717), p. 50.

9. Cotton Mather, *Diary of Cotton Mather,* Vol. 2, 1709–1724, edited by Worthington Chauncey Ford (New York: Frederick Ungar, 1957), pp. 84, 94.

10. Mather 1717, p. 59.

11. Mather 1717, p. 58.

12. Mather 1717, p. 61.

13. For alternative book cultures in the seventeenth and eighteenth centuries and the role of peddlers in hawking a range of books, see Hugh Amory and David D. Hall, eds. *A History of the Book in America,* vol. 1, *The Colonial Book in the Atlantic World* (Cambridge, UK: American Antiquarian Society and Cambridge University Press, 2000), pp. 127, 335, 385–387, 391, 588 n.64.

14. Benjamin Colman, *Reliquiae Turellae, et Lachrymae Paternae. Two Sermons Preach'd at Medford, April 6, 1735 . . . To Which Are Added, Some Large Memoirs of Her Life and Death, by Her Consort, the Reverend Mr. Ebenezer Turell* (Boston: J. Edwards and H. Foster, 1735), pp. 50, 61.

15. Colman 1735, p. 61.

16. Colman 1735, p. 61.

17. Colman 1735, p. 78.

18. Colman 1735, p. 63.

19. Colman 1735, p. 64.

20. Colman 1735, p. 73.

21. Colman 1735, p. 74.

22. Colman 1735, p. 78.

23. Colman 1735, p. 69.

24. Colman 1735, p. 79.

25. Colman 1735, p. 65.

26. Colman 1735, pp. 76–77.

27. Colman 1735, p. 86.

28. Anna Green Winslow, *Diary of Anna Green Winslow, A Boston School Girl of 1771,* edited by Alice Morse Earle (Williamstown, MA: Corner House Publishers, [1894] 1974), p. 5.

29. Winslow [1894] 1974, p. 48.

30. Winslow [1894] 1974, p. 18.

31. Winslow [1894] 1974, p. 17.

32. Winslow [1894] 1974, p. 24.

33. Winslow [1894] 1974, p. xxiii.

34. Winslow [1894] 1974, p. 72.

35. Winslow [1894] 1974, p. 49.

36. Winslow [1894] 1974, p. 4.

37. Winslow [1894] 1974, p. 29.

38. Winslow [1894] 1974, p. 65.

39. Winslow [1894] 1974, p. 22.

40. Winslow [1894] 1974, p. 44.

41. Winslow [1894] 1974, p. 47.

42. Winslow [1894] 1974, p. 6.

43. Winslow [1894] 1974, p. 9.

44. Winslow [1894] 1974, p. 1.

45. Winslow [1894] 1974, pp. 13, 34, 40, 60, 64, 70.

46. Phillis Wheatley, *The Poems of Phillis Wheatley,* rev. and enlarged ed. Edited by Julian D. Mason, Jr. (Chapel Hill: University of North Carolina Press, 1989), p. 47.

47. Wheatley 1989, p. 117.

48. Wheatley 1989, pp. 133, 134.

49. Phillip M. Richards, "Phillis Wheatley and Literary Americanization," *American Quarterly* 44 (1992): 168.

50. Richards 1992, p. 174.

51. Wheatley 1989, p. 164.

52. David S. Shields, "Eighteenth-Century Literary Culture," in Amory and Hall 2000, pp. 461–464.

53. Robert F. Seybolt, *Source Studies in American Colonial Education: The Private School* (New York: Arno Press [1925] 1971), ch. 6; Robert F. Seybolt, *Apprenticeship and Apprenticeship Education in Colonial New England and New York* (New York: Teachers College, Columbia University, 1917), p. 47.

54. For the role of letter writing, see Konstantin Dierks, *Letter Writing, Gender, and Class in America, 1750–1800,* Ph.D. Diss., Brown University, 1999.

55. See Cathy N. Davidson, *Revolution and the Word: The Rise of the Novel in America* (New York: Oxford University Press, 1986).

2

"A Few Patchwork Opinions": Piecing Together Narratives of U.S. Girls' Early National Schooling

It was obvious from the start that the new U.S. nation would be a republic of letters. The Revolution began and ended with scripted eloquence, and the Constitution that followed ascribed sovereignty to persons presumed able to thrive, whatever their material conditions, in the enlightened realm of the word. Yet how this literate enlightenment was to be achieved and sustained was not established in the nation's founding documents, but in the pedagogical documents they inspired. Seizing the revolutionary spirit, women argued that the literacy of the republic's sons and daughters was their responsibility and that consequently a new age for girls' education had dawned. Was it so? The answer, as we shall see, depends on whose stories from that time we listen to, what confirming evidence of actual practice we can recover—and how, two centuries on, we choose to interpret what we find.

Let us begin with Hannah Webster Foster, who tells a brightly optimistic story of women's literacy after the Revolution. In her 1798 "novel" textbook *The Boarding School,* she writes, "Thrice blessed are we, the happy daughters of this land of liberty, where the female mind is unshackled by the restraints of tyrannical custom, which in many other regions confines the exertions of genius to the usurped powers of lordly man! Here virtue, merit, and abilities are properly estimated under whatever form they appear."[1] Similarly, Judith Sargent Murray effusively proclaims that "Female academies are every where establishing. . . . The younger part of the female world have now an inestimable prize put into their hands."[2] According to Murray and other proponents of female education, the American Revolution created unprecedented opportunities for growth of a literate citizenry. Critical to this growth would be young women, whose responsibility it would be to acquire the literacy necessary to school their sons to be effective citizens. The "plan of female education" had been "enlarged"

for a national purpose, as had the nature of women's civic participation.[3] True patriots of the new nation, whether male or female, needed to grasp the importance of achieving this expanded, educated, and enlightened citizenry. Citizens needed to understand the crucial responsibility that young U.S. women—future *republican* mothers—would assume. Writers such as Foster and Murray borrow revolutionary political language to urge their female contemporaries to undertake ambitious plans of study. As Irene Fizer summarizes, "the American Revolution offered the daughters of Columbia a realignment of identity. They were women sprung into a 'present age.' To mark their revolutionary birthright, young women of the Republic claimed a language of republicanism of their own."[4] But were early U.S. women's words a record of fact or imagination? History or myth? Was this a case of thinking-makes-it-so or just wishful thinking?

Whether female education (or female citizenship) was "enlarged" enough to match the exalted civic rhetoric of the times is debated by historians.[5] It appears, however, that at least some early U.S. women (predominantly white, predominantly Protestant, predominantly of middling status) benefited from the young nation's commitment to a literate citizenry. As Tamara Plakins Thornton points out in her study of handwriting in America, historical surveys of literacy in the late eighteenth century and again on the eve of the Civil War suggest that the percentage of fully literate adults had increased dramatically over the decades and that there is good evidence that much of the difference can be ascribed to rising female literacy.[6] In *Knowledge Is Power,* Richard Brown surveys much the same data as Thornton and describes how the postrevolutionary period narrowed the "literacy gap" between U.S. men and women. Before the Revolution, he argues, "social convention had been relatively indifferent if not actually hostile to female learning." After the new nation was established, "a new convention was formulated that required literacy and encouraged schooling for girls." The change was so profound, Brown observes, that "by 1830 northern women in various ranks closed the literacy gap that had often divided their mothers and fathers in the past."[7] Before the Revolution, most women received some instruction in reading, but for writing depended on access to district schools or private tutors. However, diaries and letters reveal that some women with means and access to a father's or a brother's library were self-taught or schooled privately.[8]

There is, then, empirical evidence to support the notion that, at least for certain groups of women, the prospects of gaining and holding literacy increased after the Revolution. But just how—and how

much—women's literacy changed at the turn of the nineteenth century remains the subject of much scholarly discussion. For in the absence of widespread formal schooling of women, especially in the decades around 1800, it is not possible to turn to the durable institutional histories that have helped compose a nuanced picture of men's literacy and rhetorical education in the new republic. Yet evidence can be assembled from other sources, including accounts of women's reading and writing in the very books they read and wrote for publication, as well as in the writing they did for much more circumscribed audiences in letters, memoirs, and diaries. It is these sources that tell us that Foster's "we" in "thrice blessed are we" is a more exclusive category than she imagined, though not so exclusive as to prevent us from arguing that for some women, a door to learning, even advanced learning, opened at the close of the eighteenth century. When we survey the available evidence, then, what we and other scholars can piece together is a complex narrative of change responsive to myriad forces of personality, culture, politics, and economy that interacted in wonderful variety in the new nation, just as they do now.

If indeed ever-increasing numbers of women became literate after the Revolution, it is important to know something substantial of the quality of that literacy, as well as of the cultural complexity in which it was enmeshed. As we completed research for our book, *Imagining Rhetoric: Composing Women of the Early United States,* we sought to learn about women's literacy and its complexity from sources heretofore untapped: for example, from the courses of study for young women that are embedded in novels and advice books written by women for a female readership in the early national period.[9] The typical course of study detailed in these books is actually manifest in the records of a few well-publicized female seminaries, as well as a scattering of published diaries, letters, and memoirs. Taking all of these sources into account, published and not, fictional and not, we get a picture of female academies that by 1800 are slowly—very slowly—transforming from finishing schools into preparatory schools, the institutions that lay the foundation for an extended course of study outside the home.[10]

As scholarship, *Imagining Rhetoric,* like most of our work, is situated in the area of rhetoric and composition, which examines writing within its cultural, institutional, situational, and personal contexts. Rhetoric and composition scholars study the uses people make of writing and look at the claims people make for writing's potential to transform individual consciousness and social life. They look, in other words, at how, with others, individuals are taught writing, how they

learn to write, how they imagine they will put that writing to use, and how they actually do so. Until late in the twentieth century, most studies of rhetoric focused on writing instruction in ancient times and traced that tradition through British literature and philosophy; then James Berlin's groundbreaking book, *Writing Instruction in Nineteenth-Century American Colleges,* was published in 1984.[11] Not long after, feminist scholars of rhetoric began taking up nonfiction published by women in the mid- to late nineteenth century and searching the archives of postbellum colleges and women's clubs.[12] Because, as we have noted, there was no educational structure in the early nation comparable to what we recognize today (a succession of schooling at elementary, middle, secondary, and postsecondary levels), many assumed that before the Civil War young women received no formal higher education, no advanced formal instruction in writing, unless by aid of private tutors.

And yet, as early as the mid-1880s, a modest effort to recover evidence of early U.S. women's literacy had begun. In that historical milieu, the recovery had much to do with establishing that the early national years had been a "golden age" for American culture, unstained by intersectional conflict and devastating industrialization. If we can set aside the golden-age sentiment and appreciate these late-nineteenth-century acts of recovery for the preservation they enabled, then we afford ourselves the opportunity to peer into documents that record what writing and reading—what literacy—meant to a select number of young women whose generation was the first to come of age after the Revolution. As our central object of study, we take up a revolutionary-era collection of letters by Eliza Southgate Bowne that was published in 1887. Eliza penned the letters from 1797, while she was an adolescent away at school, to 1809, when, at age twenty-five, complications of childbirth claimed her life. Eliza's letters help us construct a conceptual framework within which to analyze the performance of and attitudes toward literacy in letters and diaries composed by other young women of her time.

Revolutionary Changes in Women's Schooling

Our research for *Imagining Rhetoric,* prompted by findings in the archives of Kentucky's Science Hill Female Academy (founded in 1825), began with the hypothesis that at least some young women in the new republic were the beneficiaries of female seminaries or academies in which they learned lessons similar to elements of today's elementary, secondary, and postsecondary curricula.[13] Subsequent inquiry

confirmed that this hypothesis largely holds true after the turn of the nineteenth century and is increasingly valid in the later antebellum years. But what of the earliest decades after the Revolution? We learned that in these years an important "extracurriculum" was at work, a precursor to the literate activities Anne Ruggles Gere documents in *Intimate Practices* (1997), a fascinating study of clubwomen's reading and writing at the turn of the twentieth century. This extracurriculum was spelled out in epistolary and novel forms follow-

ing the Revolution and, we contend, was implemented selectively at that time.[14]

Prior to the Revolution, some young women may have achieved the depth of learning that becomes more evident in the late eighteenth century, but that achievement was typically without obvious order and could sometimes be described as accidental. Hannah Adams, glancing back at her education during the period 1760–1775, notes that she acquired "the rudiments of Latin, Greek, geography, and logic" from "gentlemen who boarded at my father's." Even then, she writes, she "felt the want of a more systematic education, and those advantages which females enjoy in the present day."[15] In "the present day," the early 1800s, Adams had watched systematic education for women grow, both in its curricular manifestations and its extracurricular ones.[16] Adams's impression of change is confirmed by educational historian Thomas Woody, who used school, town, and publishing records to trace the development of women's "higher" education from its beginnings in "finishing schools" to the more serious-minded female seminaries arising in the early national and antebellum years to the establishment of women's colleges after the Civil War.[17] Had Eliza Bowne remained single and lived the full life afforded Hannah Adams, she might well have reflected in her letters upon the very changes documented by Woody. Unfortunately, Eliza did not survive the birth of her first child, and so her observations about schooling and life were limited to a little more than a decade. Yet the range of Eliza's letters is still remarkable; she comments on exactly the curricular *and* extracurricular learning with which we are concerned.

Eliza came of age when, as Murray put it, schools for young women were "every where establishing." True, she visited the venerable Moravian Female Seminary, which had been in operation since 1742, but she ended up attending precisely the schools established later that were the subject of Murray's remark.[18] Eliza's countless peers at these institutions matured into the generation that, by the 1840s, was making a living by the pen. The publishing careers of Murray, Foster, Adams (a historian of New England), Mercy Otis Warren (a historian of the Revolution), and Susanna Haswell Rowson (a novelist) foretold the possibilities that lay before Eliza and other girls of her age and circumstance.[19]

The diaries, letters, and biographies that we studied suggest that women's tenure in school during the early national period was variable, with terms ranging from a few months to a few years.[20] For her part, Eliza seems to have been "finished" in the conventional, ornamental way. She certainly began her schooling with that intention.

Written on January 23, 1797, her first collected letter echoes much of the sentiment depicted in U.S. boarding school fiction. "I have a great desire to see my family," Eliza writes, "but I have a still greater desire to finish my education."[21] Still, as we have suggested, young women's learning in the new republic did not stop when they left school—at least not ideally. Early national proponents of female schooling worked diligently to change the language used to describe that ideal. Instead of merely "finishing" or "polishing"—words that describe an ornamental goal—academies labored to be seen as places where women were able to, in Eliza's words, "drink freely of the fountain of knowledge."[22] But fearful of evoking the specter of female pedantry, such knowledge, wherever learned, was almost always immediately classified as "useful," in ways that to us today (and perhaps even then) seem comical, even derisive. When Martha Laurens Ramsay, another young woman whose personal writing from this period has been collected, asked her father to buy her two globes of the world, he supplied them but made the point that her learning should be useful with this clever pun, "When you are measuring the surface of this world, remember you are to act a part on it, and think of a *plumb* pudding and other domestic duties."[23] Young women leaving early national academies were being schooled to spend the brief time before taking on the demands of adulthood storing their minds with "useful" knowledge that could be employed in managing households, assisting a spouse or parent in business, and most important, rearing sons, the true heirs to enfranchised citizenship and leadership. Because economic concerns were unstable in the new nation, white women of a certain status had to be prepared for reversals of fortune. They had to be schooled both to manage a household run by hired or slave labor and to pick up a needle, harvest crops, or educate their own children in the very likely event that their fortunes should rise or fall.

Roughly nine months after beginning her term of study at Mrs. Wyman's boarding school, Eliza writes to her parents, pressing them to allow her to stay longer: "You say that you shall regret so long an absence; not more certainly than I shall, but a strong desire to possess more useful knowledge than I at present do, I can dispense with the pleasure a little longer of beholding my friends and I hope I shall be better prepared to meet my good parents."[24] After one year at Mrs. Wyman's, Eliza writes of her plans to come home—but encloses, as she does so, information about Mrs. Rowson's boarding school, which she is permitted to attend a few months later.[25] From Mrs. Rowson's in Boston, Eliza writes her parents that she is "again placed

at school under the tuition of an amiable lady, so mild, so good, no one can help loving her; she treats all her scholars with such a tenderness."[26] Eliza's learning, however, seems to come to an abrupt end with her last tuition payment. Although she continues to board at Mrs. Rowson's, she writes her father, begging him to allow her to come home:

> Do, my Father, as soon as you receive this send for me as soon as possible, for my quarter at Mrs. Rawson's was out last Saturday. . . . I beg of you to send for me home directly, for I only board at Mrs. Rawson's now, for I am in expectation of seeing or hearing every day and therefore I have not begun any more work. My time is spending without gain. . . . Time hangs more heavy than ever it did before.[27]

Eliza's words reinforce the sense of urgency felt by early U.S. women—and the intensity of the learning experience at academies. The time that women had to devote to learning was short, curbed by impending female duties. The little time before marriage had to be used wisely.

Eliza's educational experience is illustrative; she seems to have lived through the transition boarding schools were making during this period, and as such her letters and journal entries draw both from the discourses of "finishing" and "life-long study." She began school, as we have seen, with the not-so-lofty goal of being finished, and seems to have completed her years with Mrs. Wyman and Mrs. Rowson with little change in values. In fact, a little under two years after her term at Rowson's school, Eliza becomes for a short time just the petty kind of boarding school graduate that critics, including Rowson, feared. Eliza's letters from this period focus on social gatherings and fashion issues—wigs, gowns, balls, and the like. Yet all is not lost. Indirectly and crucially, Mrs. Rowson manages to continue schooling Eliza, to monitor her ex-pupil. Mrs. Rowson is able to achieve this monitoring (she might have called it "mentoring") because Eliza's younger sister Octavia is now at the school. Eliza learns, much to her chagrin, that Mrs. Rowson skims her boarders' correspondence and censors it. This censorship prompts Eliza to write to her mother in a manner reminiscent of the bad girls of boarding school fictions: "I don't know what I shall do about writing Octavia, as Mrs. Rawson told her I wrote on an improper subject when I asked her in my letter if Mr. Davis was paying attention to Eleanor Coffin." Eliza reports that Mrs. Rowson will not permit Octavia to answer her query about Mr. Davis and Eleanor Coffin, and so she continues her complaint: "This is *refin-*

ing too much, and if I can't write as I feel, I can't write at all."[28] She tries to persuade her mother to side against Mrs. Rowson:

> Never did I write a line to Octavia but I should have been perfectly willing for you or my Father to have seen. You have always treated me more like a companion than a daughter, and therefore would make allowance for the volatile expressions I often make use of. I never felt the least restraint in company with my Parents which would induce me to stifle my gaiety, and you have kindly permitted me to rant over all my nonsense uncorrected, and I positively believe it has never injured. I must bid you good-night. . . . Pray don't forget to send some more shirts.[29]

It is unclear how Eliza's parents responded, but readers of fiction would recognize the danger of the overindulged, pampered child who seeks friendship from her family rather than maternal guidance, who values shirts over proper sentiment.[30] In this case, life imitates art: just as in a boarding school fiction, the exemplary preceptress wins. Within just a few months of this last letter, Rowson's former pupil becomes the advocate of a different concept, the idea of a "plan of study," a concept, as Murray pointed out, thought critical to women's success as good republican mothers. Eliza's correspondence with her sister Octavia is now quite serious. She no longer reflects upon such burning questions as whether Mr. Davis is courting Miss Coffin; her letters now recite the appropriate post–boarding school learning creed, emphasizing that the time young women can devote to study is too precious to be wasted:

> I think, my dear sister, you ought to improve every moment of your time, which is short, very short to complete your education. In November terminates the period of your instruction. The last you will receive perhaps ever, only what you may gain by observation. You will never cease to learn I hope, the world is a volume of instruction, which will afford you continual employment,—peruse it with attention and candor and you will never think the time thus employed misspent. I think, Octavia, I would not leave my school again until you finally leave it. You may—you will think this is harsh; you will not always think so; remember those that wish it must know better what is proper than you possibly can.[31]

One can safely assume that this last letter to Octavia passed the preceptress's gaze.

Despite the fact that Eliza was a student of the novelist Rowson, her letters evince many more similarities with Foster's *The Boarding*

School.[32] *Mentoria,* Rowson's educational fiction, was published in the United States in 1794, a year after she emigrated with her husband; it first appeared in England in 1791, where Rowson had been forced to move during the Revolutionary War. Unlike *The Boarding School,* which underscores many of the concerns regarding women's literacy in the new nation, *Mentoria* worries most about educating women in a way suited to their station in life or, put differently, educating women within their class. Again and again in *Mentoria* we learn that things go awry when women are educated beyond the "stable" class boundaries central to Britain's success. Indeed, Mentoria's best qualification for her job as mentor (she is actually a governess, an Anglo-tinged term Rowson deftly avoids) is that she refuses to marry above her station when the opportunity presents itself.[33] Foster's *The Boarding School* represents a new kind of schooling fiction that includes teachers and a number of boarders.[34] It describes the ideal female academy for the new nation, complete with imagined students and an idealized curriculum. In *Mentoria,* boarding schools are not often mentioned, but when they are, they are usually painted as the kind of place where girls learn silly or dangerous habits. Eliza's letters, however, like Foster's text, provide explicit support for boarding schools and for the opportunities they open up for women in the new republican nation:

> A boarding-school, I know, my dear Sister, is not like home, but reflect a moment, is it not necessary, *absolutely necessary* to be more strict in the government of 20 or 30 young ladies, nearly of an age and different dispositions, than a private family? Your good sense will easily tell you it is. . . . Surely, Octavia, you must allow that no woman was ever better calculated to govern a school than Mrs. Rawson. She governs by the love with which she always inspires her scholars. You have been indulged, Octavia, so we have all.[35]

Just as Eliza counsels her sister, women in postrevolutionary years were urging other women to use the time after school and before adult commitments to learn through observation and independent study— but, most important, to learn through epistolary correspondence circulated to extended family, friends, and former schoolmates.[36] This curriculum of independent study was tied not so much to personal development, which gave rise to arguments about educating women out of their sphere, but to national purpose: the success of the new nation depended on a literate, educated citizenry, and women, as the educators of the very young, played crucial roles. As Eliza argues to Moses Porter, a skeptic about the value of women's

education, "How few understand the true art of managing children, and how often is the important task of forming young minds left to the discretion of servants who caress or reprove as the impulse of the moment compels them. Here are we convinced of the great necessity that Mothers, or all ladies should have cultivated minds, as the first rudiments of education are always received from them, and at that early period of life when the mind is open to every new impression and ready to receive the seeds which must form the future principles of the character."[37]

In her correspondence with her cousin Moses, Eliza also explicitly defends the project of female education, which she defines as a plan of study that would "enlarge" her mind. Moses seems to have initiated the debate or at least raised its heat by asserting that female education will only turn out women who are not content with their lot. According to him, "'the enlargement of the [female] mind will inevitably produce superciliousness and a desire of ascendancy.'" In her response to Moses, Eliza makes the rhetorical turn crucial to the success of female education in the early national period: she contends that such a supercilious attitude would spring from "an ignorant, uncultivated mind," that a "plan of education" for women "will render one a more dutiful child, a more affectionate wife." The educated women she imagines are more tractable children, more loving wives, and more effective mothers because they are not given over to excessive emotion; instead, their hearts are guided by "principle," or reason. Knowledge is also necessary, she posits, for self-reflection, for "perceiving our weakness." Further she asserts, "a mind that has never been exerted knows not its deficiencies."[38] An educated woman, a Christian woman, according to Eliza, knows her parents, her husband, her children, and her own heart. She governs her home and instructs her children through "principle"; she exhibits the kind of rational behavior essential to democracy—and instructs her children to act likewise.

Women writing letters or memoirs in the early republic were keenly aware that they were representing themselves, creating a reputation for an extended group of family members and acquaintances. Eliza's letters reflect her acute sense that they will be shared with an audience broader than the individuals to whom they are addressed. This sense of the shared nature of letters is highly conventional. "I have written generally to Octavia, but as I meant my letters for the family, 'tis not much matter to whom they were directed."[39] She pens her journals with the same awareness: "Tell Octavia and Horatio I shall write them soon, but as I keep a particular journal which they shall all see, 'tis not so material," a sentiment that surely impressed

Clarence Cook, her late-nineteenth-century editor, who valued the idea of a written account of life's events over a face-to-face recapitulation.[40] The writing here precedes and takes precedence over face-to-face conversations, which, given geography and travel time, might occur long after the memory of an event had faded. In fact, Eliza notes that she keeps her journal to "assist my memory in relating my adventures."[41] All these examples demonstrate the broader social use for "private" letters and journals. Occasionally, a writer—particularly a young girl—might make the mistake of thinking that letters are truly private. Yet we need only to see how Eliza handles ostensibly confidential correspondence to recognize that private letters were rarely so. She writes to Moses, "I told you I would show you some of Martha's letters; I had one from her since I wrote you, in which she says I must on no condition whatever show her letters,—however, I will read you some passages in some of them. You *shall* see some parts . . . indeed I know she would not object."[42] Apparently in Martha's case, no means yes—or so Eliza interprets—and thus Moses expects her to be forthcoming.

For reasons evident in this transaction, Hannah Webster Foster suggests that engaging in "private" correspondence is one of the most potentially damaging things young girls can do. In her lecture on composition, she uses as an illustration the story of two indiscreet female correspondents who write about a male acquaintance, Silvander. Silvander happens upon the letter and, upset to discover "[h]is name was used with so much freedom," retaliates by passing the letters—with his name excised—to all his friends.[43] The young women's reputations are destroyed. As a result, one of the young women dies "in melancholy, regret, and obscurity."[44] The lesson is clearly stated, "Your characters during life, and even when you shall sleep in the dust, may rest on the efforts of your pens. Beware then how you employ them."[45] And there is little sympathy for the young women: "no adequate excuse can be offered for the young ladies, who dishonored their pens and their talents by a most improper and unbecoming use of both."[46] They should have known the golden rule, and Eliza certainly did: "Reputation undoubtedly is of great importance to all, but to a female 'tis every thing;—once lost 'tis *forever* lost."[47] To compose a letter, then, is to compose and preserve reputations—one's own as well as those of others.

Elsewhere in her letters, Eliza shows awareness of the proprieties necessary for correspondence. Even when Moses tries to draw her into gossip, she resists, perhaps recalling Rowson's monitoring, though the recollection is not altogether complete. Eliza articulates her resistance to her cousin:

I recollect in a former letter you asked why I did not say more of particular characters, and among my acquaintances select some and give you a few characteristic sketches. The truth is—I felt afraid to, I did not know but you might mention many things which would make me enemies. I am always willing to speak my opinion without reserve on any character, because I should take care that I spoke it before those who would not abuse the frankness; but letters may be miscarried, may fall into hands we know not of.[48]

As Bruce Burgett argues in *Sentimental Bodies,* "this anxiety concerning the circulation of letters once out of 'hand' or . . . between 'hands' is certainly understandable." He cites Richard B. Kielbowicz's work on the post during colonial and early national times:

> The quality of colonial post roads varied greatly, and postal riders could be hired by different groups with different ends in mind. . . . [I]n 1774, for example, agents of the Tory press in the United States exploited these irregularities by intercepting, publishing, and parodying [John Adams's] letters to [his wife] Abigail. . . . The anxiety produced by such unauthorized publications only intensified after the outbreak of war with England.[49]

Eliza's letters were not likely to incite political scandal; still, even later in her life, writing as a married woman, Eliza censors her prose. Worried that her father has entered into unwise financial ventures, she begins obliquely to criticize him but then abruptly stops, "I must check my pen—I am too much interested in this subject."[50] Until the ventures actually fail, we hear no more about his ill-advised loans. Self-censorship was a significant principle in letter writing, especially (though not exclusively) for women.[51]

Eliza seems to have quite thoroughly taken in the kind of composition lesson that Foster's imaginary preceptress delivers. That reputation is everything for women—particularly when they write—is one of the key lessons. Another, of course, is the necessity of continued study, particularly before adult duties set in. As Miss Southgate, Eliza has time for an extended, thoughtful correspondence with her cousin. She has time to travel and to digest the experience. She thinks seriously about her course of study and spends considerable time trying to figure out how to access and organize knowledge. But this does not mean that she is unobstructed in her quest to educate herself, and further, she knows that the obstacles she encounters are rooted in gender distinctions. Women lack true leisure, a luxury necessary for scholarship, nor do they have solitude:

Now at this moment imagine your friend Eliza half-double with the cold, two children teazing and playing round the table, sister and nurse talking all the time, and you will then be prepared to receive a letter abounding with sound reasoning, profound argument, elegant language, and a profusion of sublime ideas; but do not stare if I intersperse, by way of relieving your mind, a few little Jackey Horner stories.[52]

She writes when she can: "I have written home a number of times, which together with my journal take up all my leisure time, and that is stolen from the hrs. devoted to sleep."[53]

Eliza also finds that society expects women to be "mediocre" and judges learned women quixotic. She is surprised when in Albany she meets a "little, smart-looking woman, very *learned* . . . understands the dead languages." More striking, however, than the woman's learning is the fact that she is "not pedantic" but instead "rather reserved."[54] This woman, it turns out, is unusual. More common is Miss Rice, who "possesses no quality above mediocrity, and yet is just what a female ought to be."[55] In letters to Moses (who, we know, is not sympathetic to Eliza's aspirations to learn), Eliza speaks of ambition, of the fantasies she allows herself, and the fears that finally constrain them:

> I have often thought what profession I should choose were I a man. I might then think very differently from what I do now, yet I have always thought if I felt conscious of possessing brilliant talents, the *law* would be my choice. . . . I thank Heaven I was *born* a woman. . . . I should not be content with moderate abilities—nay, I should not be content with mediocrity in any thing, but as a woman I am equal to the generality of my sex.[56]

Although it may be simply modesty that keeps Eliza insisting on her mediocrity, there is evidence that whenever she does exhibit her learning—or even her yearnings to learn—she is quickly brought down. When Eliza attends her first boarding school, she routinely sends examples of her work home to her family, seeking their approval. To her brother she writes, "You speak of my writing and you think that I have improved. I am glad of it."[57] Her father, though, is less impressed with her writing, not because it is bad, but because it is good. Eliza has improved so much that her father imagines her prose is "purloined," an accusation that deeply bothers his daughter.[58] Judith Sargent Murray would certainly understand Eliza's distress. In *The Gleaner,* Murray writes a long essay on plagiarism accusations—or more precisely, unfair accusations of plagiarism—which, if one critic is correct, were with greatest frequency leveled at women authors.[59]

Although Moses thought his cousin's education too extensive, Eliza lived with the belief that her education was incomplete, even given her boarding school training. In writing to Moses, she frequently laments her feeling that she is overpowered, intimidated by his learning, by the fact that she cannot build the argument she wishes to make: "Now what I would give for a little *Logic,* or for a little skill to support an argument."[60] She goes to great lengths to argue that it is not the female mind that is faulty but female education. There are differences between men's and women's minds, she believes, though she speculates that these differences have little to do with "nature": "As to the qualities of mind peculiar to each sex, I agree with you that sprightliness is in favor of females and profundity of males. Their education, their pursuits would create such a quality even tho' nature had not implanted it."[61] One long passage is particularly striking because it so self-consciously assesses what she believes has been faulty in her education and ends with an appeal to Moses for help. After confessing that she feels intimidated writing to Moses because her education is so inferior to his, she continues:

> Yet I believe I possess decent talents and should have been quite another being had they been properly cultivated. But as it is, I can never get over some little prejudices which I have imbibed long since, and which warp all the faculties of my mind. . . . I found the mind of a female, if such thing existed, was thought not worth cultivating. I disliked the trouble of thinking for myself and therefore adopted the sentiments of others. . . . I cared but little about the mind. I learned to flutter about with a thoughtless gaiety—a mere feather which every breath had power to move. I left school with a head full of something, tumbled in without order or connection. I returned home with a determination to put it in more order; I set about the great work of culling the best part to make a few sentiments out of—to serve as a little ready change in my commerce with the world. But I soon lost all patience . . . for the greater part of my ideas I was obliged to throw away without knowing where I got them or what I should do with them; what remained I pieced as ingeniously as I could into a few patchwork opinions,—they are now almost worn threadbare, and as I am about quilting a few more, I beg you will send me any spare ideas you may chance to have.[62]

Moses's response is not what she hoped for; he is certainly not willing to pass along his "spare ideas." On the contrary, he is horrified by her plan to "enlarge" her mind. As Fizer notes, he defines error "in a way profoundly different" from Eliza, for she "saw her errors as dis-

cursive: faulty transitions, lack of a sustained argument." In contrast, for Moses, "her errors stemmed from her incipient feminism."[63] Such errors can only be remediated through abdication; he urges her to give up her plan for further study, which she does: "I quit it forever, nor will I again shock your ear with a plan which you think has nothing for its foundation either just or durable." She does not give up, however, without first explaining for him what it means for women to give up learning. His response has jeopardized their epistolary relationship, one they have both presumably enjoyed, one that certainly allowed her to think in revolutionary terms about women's schooling. If she writes serious prose, she explains to Moses, "You undoubtedly think I am acting out of my sphere." And yet, if she were to write about the kind of "female trifles" she knows best, he will dismiss them as "clack."[64] Moses actually seems to have preferred to read gossip, the very kind of prose that Eliza recognizes would put her reputation at risk. After giving up her "plan" to improve her mind, a plan Moses has judged neither "just" nor "durable," she picks up her pen the next morning and continues her letter, giving details about a ball and various scandals. Whether Eliza would have continued to correspond with Moses in this more "acceptable" way—one that she believed placed her at risk, one that certainly did not allow her to pursue the plan of study she imagined—we do not know. This is her last letter to Moses before he dies of yellow fever. We do know, however, that she surprises herself by how quickly her feelings of grief for him pass.

After the correspondence with Moses ends, Eliza continues her journals and, when she has occasion to travel, her letters home. Finally, though, none of this correspondence matches the depth of learning or yearning revealed in her correspondence with her cousin. After she marries, any plan of study is completely forgotten, for nothing seems to finish female education in the early nation quite like marriage, a point made with increasing emphasis in antebellum schooling fictions but presaged in early national letters and memoirs.[65] According to Fizer, "Marriage brought an epistolary closure (even if letter-writing continued) because it closed down the dynamic self-inquiry of the adolescent girl."[66] As Mrs. Bowne, then, Eliza has little opportunity for learning as before. Initially, a good deal of her time is spent anticipating the details of "setting up house" in New York City. The city itself proves an obstacle, not just because of its wider array of social activities but also because of the difficulty of finding "suitable" housing. (For some years, the Bownes rent a series of houses before building a home of their own.) The newly married couple also travels with some frequency, sometimes suddenly to escape the pox

or the fever, sometimes because they are paying marriage visits, and sometimes because it is just customary for people in their social class to spend the summers in resort locations rather than the city.[67] Her husband is apparently attentive and caring; he provides for her well, and his Quaker family makes her welcome. She has more than she needs both materially and emotionally—but not intellectually. Now that she is married, the fact that there is little time to write the kinds of long, thoughtful letters she composed to her cousin Moses does not escape Eliza's notice: "Well," she writes her family, "what have I not wrote about? A little of everything but sentiment; a dash of that to complete. I am most tired of jaunting; the mind becomes satiated with variety and description and pants for a little respite of domestic tranquility. I've done; I have most forgot how to write sentiment. I have had no time to think since I was married."[68]

Despite the revolutionary-era promise of female education in the new nation, women like Eliza struggled to make their aspirations real, to gather the "few patchwork opinions" they received in school into some sort of larger, more coherent, more organic design. Eliza's letters and journal represent a remarkable legacy, one that showcases her extraordinary talents (and ambitions) as well as her common, "mediocre" features: she presents a portrait of a young woman of means who was schooled and, sadly, prematurely finished in the early years of the United States.

Finding and "Reading" the Evidence of Girls' Schooling in the Early United States

Eliza Southgate Bowne's letters and journal constitute a special narrative inheritance, one originally offered to the late-nineteenth-century reading public as "factual," the words of an innocent young woman truthfully recording her life experiences in the new nation. As such, the letters might seem to carry more validity than other documents we have also chosen to examine—for example, works of fiction like Foster's *The Boarding School*. Yet the history of Eliza's letters show how central literary scholarship can be to historical literacy studies. A look here at the letters' textual history—even the very little we know— reveals the problematic nature of their "factual" status. Did Eliza write the letters? Presumably, yes. But only presumably because this is a story of letters passed down from generation to generation, though not in a neat temporal line and not in the neat collected form published. Mary Bowne (later Mrs. John W. Lawrence), who was newborn when her mother died, received some of the letters from the

great aunt who raised her, Miss Caroline Bowne, a woman whose life typifies the kinds of domestic obligations single women frequently assumed. It makes sense that even in early national times, perhaps especially then, the image of a model republican girl and later mother would be carefully preserved and cherished. The trope of books, of printed material, serving in place of an absent mother is common in these works and certainly operates in Caroline Bowne's decision to preserve Eliza's writing for the infant Mary. Correspondence between mothers and daughters, separated by distance, are a common staple of schooling fiction. Many of the parcels Mary received from her great aunt were thus not surprisingly pieces of correspondence between Eliza and her mother. To this bundle of correspondence, Mary added other letters and journals she was able to find: "They came to her in a sad state," the introduction to the volume explains, "from much reading and passing about from hand to hand; and to preserve their contents she copied the whole collection, with the greatest care, in her neat, methodical handwriting, into two small books, and these, in her turn, she bequeathed to her children, as her grandmother had bequeathed the originals to her."[69] This factual record, then, has been carefully and faithfully preserved by an archivist with a very strong interest in projecting a certain image, a "sacred" image of her mother. They have been copied and also perhaps in that process corrected, edited, selected, and censored. They have been arranged into a narrative that tells a certain story, complete with portraits, silhouettes, and engravings that enhance the desired image. They have been lovingly wrapped in thoughtful sentiment.[70] And so, although it may be true that Eliza Southgate Bowne was not a literary talent, her letters are nonetheless rendered "literary." They evince important hallmarks of nineteenth-century fiction: an unreliable sentimental narrator, a didactic purpose, and a shaped narrative trajectory that supports particular values about girlhood and womanhood.[71]

Letters such as Eliza's provide a good record of the extended curriculum crucial to the formulation of republican motherhood. Evidence can also be found in private archives; a few published anthologies; published memoirs and fiction; and texts available on microfilm, microcards, and increasingly, because of electronic projects such as those sponsored by the University of Virginia and Alexander Street Press, on the Internet.[72] Obviously, the evidence to support a clear, detailed picture of women's early schooling in writing is made more difficult by the dispersed and varied nature of archives. For example, for Kentucky's Science Hill Female Academy, we located a few student essays, as well as some graduation bulletins, some advertisements, and

some memoirs of schooling at the academy published long after its founding. Clearly these materials, although suggestive and valuable, provide an incomplete and idiosyncratic record. In weaving our account, we faced the methodological problem of how to piece together the histories of women and other groups whose historical records are not well preserved—that is, how to make the most of scant archival resources.[73] Fortunately, in the last two decades of the twentieth century, scholars across disciplines have addressed the question of how to compose solid, ethical histories based on fragmentary evidence. Our task and the task of others studying girls' literacy in the early United States is to make sense of the fragments that have been left to us.[74]

Janet Carey Eldred and Peter Mortensen

Notes

We wish to thank Dale Bauer for responding to an early draft of this chapter.

1. Hannah Webster Foster, *The Boarding School* (Boston: Thomas and Andrews, 1798), p. 31. *The Boarding School* is unusual in that it is neither clearly a novel nor a textbook. In it, Foster imagines an ideal curriculum—detailed enough to be realized—in the context of a fictional boarding school.

2. Judith Sargent Murray, *The Gleaner* (Boston: Thomas and Andrews, 1798), reprint (3 vols. in 1), with an introduction by Nina Baym (Schenectady, NY: Union College Press, 1992), p. 703. Before collecting her work in three volumes as *The Gleaner* (1798), Murray published her writing regularly in *The Massachusetts Magazine*. Murray is particularly eloquent on the subject of literacy in the new nation (see Janet Carey Eldred and Peter Mortensen's introduction to *Imagining Rhetoric: Composing Women in the Early United States* [Pittsburgh: University of Pittsburgh Press, 2002]) and is credited with best articulating the theory of republican motherhood. The phrase itself, "republican motherhood," was coined by Linda Kerber in her influential book *Women of the Republic: Intellect and Ideology in Revolutionary America* (Chapel Hill: University of North Carolina Press, 1980). For more concerning republican motherhood, see Amelia Howe Kritzer, "Playing with Republican Motherhood: Self-Representation in Plays by Susanna Haswell Rowson and Judith Sargent Murray," *Early American Literature* 31 (1996): 150–166; and Ronad J. Zboray, "Antebellum Reading and the Ironies of Technological Innovation," pp. 180–200 in *Reading in America: Literature and Social History*, edited by Cathy N. Davidson (Baltimore: Johns Hopkins University Press, 1992). Critics have challenged Kerber's formulation, among them Jeanne Boydston, "The Woman Who Wasn't There: Women's Market Labor and the Transition to Capitalism in the United States," pp. 23–47 in *Wages of Independence: Capitalism in the Early American Republic,* edited by Paul A. Gilje (Madison, WI: Madison House, 1997); and Margaret A. Nash, "Rethinking Republican Motherhood: Benjamin Rush and the Young Ladies' Academy of Philadelphia," *Journal of the Early Republic* 17 (1997): 171–191.

3. Murray [1798] 1992, p. 703.

4. Irene Fizer, "Signing as Republican Daughters: The Letters of Eliza Southgate and *The Coquette*," *Eighteenth Century: Theory and Interpretation* 34 (1993): 243.

5. See Boydston 1997; Joan Hoff, *Law, Gender, and Injustice: A Legal History of U.S. Women* (New York: New York University Press, 1991); Linda Kerber, "'History Can Do It No Justice': Women and the Reinterpretation of the American Revolution," pp. 3–42 in *Women in the Age of the American Revolution,* edited by Ronald Hoffman and Peter J. Albert (Charlottesville: University Press of Virginia, 1989); Kerber 1980; Mary Beth Norton, *Liberty's Daughters: The Revolutionary Experience of American Women, 1750–1800* (Boston: Little, Brown, 1980); Anne Firor Scott, "The Ever Widening Circle: The Diffusion of Feminist Values from the Troy Female Seminary, 1822–1872," *History of Education Quarterly* 19 (1979): 3–25; Thomas Woody, *A History of Women's Education in the United States,* 2 vols. (New York: Science Press, 1929).

6. Tamara Plakins Thornton, *Handwriting in America: A Cultural History* (New Haven, CT: Yale University Press, 1996), p. 59.

7. Richard D. Brown, *Knowledge Is Power: The Diffusion of Information in Early America, 1700–1865* (New York: Oxford University Press, 1989), p. 163.

8. Precisely how much progress women made toward literacy in the early national and antebellum years is subject to debate. See Kenneth A. Lockridge's foundational work, *Literacy in Colonial New England: An Enquiry into the Social Context of Literacy in the Early Modern West* (New York: W. W. Norton, 1974), for estimates of women's literacy as late as 1787–1795. Lockridge argues that more than half of New England's female population was illiterate in the late eighteenth century, a finding based on counting signatures (indicating literacy) and marks (indicating illiteracy) on wills. Reviewing an important study by Linda Auwers suggests that New England women in the late eighteenth century were more literate than Lockridge surmised. See "Reading the Marks of the Past: Exploring Female Literacy in Colonial Windsor, Connecticut," *Historical Methods* 13 (1980): 204–214; Ross W. Beales, Jr., "Studying Literacy at the Community Level: A Research Note," *Journal of Interdisciplinary History* 9 (1978): 93–102; Gloria L. Main, "An Inquiry into When and Why Women Learned to Write in Colonial New England," *Journal of Social History* 24 (1991): 579–589; William J. Gilmore, *Reading Becomes a Necessity of Life: Material and Cultural Life in New England, 1780–1835* (Knoxville: University of Tennessee Press, 1989) and "Elementary Literacy on the Eve of the Industrial Revolution: Trends in Rural New England, 1760–1830," *Proceedings of American Antiquarian Society* 92 (1982): 87–178; and Joel Perlmann and Dennis Shirley, "When Did New England Women Acquire Literacy?" *William and Mary Quarterly,* 3d ser., 48 (1991): 50–67. More recently, Joel Perlmann, Silvana R. Siddali, and Keith Whitescarver, in "Literacy, Schooling and Teaching among New England Women," *History of Education Quarterly* 37 (1997): 117–139, have documented women's schooling and teaching experiences in New England in the decades preceding the Revolution. Meanwhile, efforts have been made to broaden our understanding of women's literacy in the early United States. Ruth Wallis Herndon, "Research Note: Literacy among New England's Transient Poor, 1750–1800," *Journal of Social History* 29 (1996): 963–965, has studied literacy among New England's poor women and men. In "Reading for the Enslaved, Writing for the Free: Reflections on Liberty and Literacy," *Proceedings of the American Antiquarian Society* 108 (1998): 309–341, E. Jennifer Monaghan treats literacy and attitudes toward it in the early nineteenth-century South. Her earlier work on colonial literacy is of exceptional importance: see "Literacy Instruction and Gender in Colonial New England," pp.

53–80, in *Reading in America,* edited by Cathy N. Davidson (Baltimore: Johns Hopkins Press, 1989); "Family Literacy in Early Eighteenth-Century Boston: Cotton Mather and His Children," *Reading Research Quarterly* 26 (1991): 342–370. And Keith Whitescarver, in "Creating Citizens for the Republic: Education in Georgia, 1776–1810," *Journal of the Early Republic* 13 (1993): 455–479, has examined the prospects for women's and men's literacy in postrevolutionary Georgia. See Linda L. Arthur, "A New Look at Schooling and Literacy: The Colony of Georgia," *Georgia Historical Quarterly* 84 (2000): 563–588, for a discussion of these prospects before the Revolution. For discussions of literacy as it relates to patterns of schooling, see Carl F. Kaestle, *Pillars of the Republic: Common Schools and American Society, 1780–1860* (New York: Hill and Wang, 1983); Lawrence A. Cremin, *American Education: The National Experience, 1763–1876* (New York: Harper and Row, 1980); Harvey J. Graff, *The Legacies of Literacy: Continuities and Contradictions in Western Culture and Society* (Bloomington: Indiana University Press, 1987); and Lee Soltow and Edward Stevens, *The Rise of Literacy and the Common School in the United States: A Socioeconomic Analysis to 1870* (Chicago: University of Chicago Press, 1981). Finally, it is worth noting a number of recent works that seek a broader context for the research findings we have just mentioned; see, for example, Joyce Appleby, *Inheriting the Revolution: The First Generation of Americans* (Cambridge, MA: Harvard University Press, Belknap Press, 2000); Joseph F. Kett, *The Pursuit of Knowledge under Difficulties: From Self-Improvement to Adult Education in America, 1750–1990* (Palo Alto, CA: Stanford University Press, 1994); Harvey J. Graff, *Conflicting Paths: Growing Up in America* (Cambridge, MA: Harvard University Press, 1995); and Catherine Hobbs's introduction to *Nineteenth-Century Women Learn to Write* (Charlottesville: University Press of Virginia, 1995).

9. Janet Carey Eldred and Peter Mortensen, *Imagining Rhetoric: Composing Women of the Early United States* (Pittsburgh: University of Pittsburgh Press, 2002).

10. Although we consciously listened for minority voices in the stories we read, particularly those of African Americans, the archival resources we consulted revealed educational plans composed largely by and for white Protestant women of precarious middling status. (We hasten to add that some of these women promoted literacy for all inhabitants of the new nation, including servants, slaves, immigrants, and Indians.) Of course, it is not that African Americans were not writing and reading: Elizabeth McHenry's important work shows how such literacy was fostered through active literary societies in the North, though these groups tended to thrive in the antebellum decades after those we focus on in this chapter. See "'Dreaded Eloquence': The Origins and Rise of African American Literary Societies and Libraries," *Harvard Library Bulletin,* n.s., 6, no. 2 (1995): 32–56; "Forgotten Readers: African-American Literary Societies and the American Scene," pp. 149–172 in *Print Culture in a Diverse America,* edited by James P. Danky and Wayne A. Wiegand (Urbana: University of Illinois Press, 1998); and Elizabeth McHenry and Shirley Brice Heath, "The Literate and the Literary: African Americans as Writers and Readers, 1830–1940," *Written Communication* 11 (1994): 419–444. See also Harry C. Silcox, "Delay and Neglect: Negro Public Education in Antebellum Philadelphia, 1800–1860," *Pennsylvania Magazine of History and Biography* 97 (1973): 444–464. Unfortunately, commentators such as Murray did not include these societies in their descriptions of the new female academies. They instead remarked on academies founded and run by women like themselves, the

academies that laid the groundwork for the advent of normal schools, teaching associations, and women's colleges later in the nineteenth century. And in a move that may have been more strategic than principled, many women who led academies in the early national and antebellum periods opposed the abolition of slavery, claiming that outlawing it would imperil the nation's fragile democracy. Giving similar reasons, the same academy leaders also railed against women's right to vote and to speak in public to audiences of men as well as women. They may well have believed that the survival of democracy depended on restrictive roles for African Americans in the South and white women throughout the Union, but it is also clear that they feared that their own goal of "school suffrage"—a term that emerged some time later—was threatened by association with more "radical" causes. Generally, antebellum academy leaders remained focused on the specific goal of establishing schools and an extended plan of serious study for women. They tried to keep education separate and distinct from the painful politics of the day.

We are indebted to Elizabeth Morley, "'A Female College of the Highest Grade'" (Department of Educational Policy and Evaluation, University of Kentucky photocopy, 2001), whose work on Hamilton Female College—established in Lexington, Kentucky, as Hocker Female College in 1869—brought the notion of school suffrage to our attention. In 1908, Luella Wilcox St. Clair, president of Hamilton, gave a public lecture entitled "School Suffrage for Women."

11. James Berlin, *Writing Instruction in Nineteenth-Century American Colleges* (Carbondale: Southern Illinois University Press, 1984). Other histories followed, creating a fuller critical narrative of U.S. composition instruction. See Nan Johnson, *Nineteenth-Century Rhetoric in North America* (Carbondale: Southern Illinois University Press, 1991); Gregory Clark and S. Michael Halloran, eds., *Oratorical Culture in Nineteenth-Century America: Transformations in the Theory and Practice of Rhetoric* (Carbondale: Southern Illinois University Press, 1993); Winifred Bryan Horner, *Nineteenth-Century Scottish Rhetoric: The American Connection* (Carbondale: Southern Illinois University Press, 1993); Mariolina Rizzi Salvatori, ed., *Pedagogy: Disturbing History, 1819–1929* (Pittsburgh: University of Pittsburgh Press, 1996); Robert J. Connors, *Composition-Rhetoric: Backgrounds, Theory, and Pedagogy* (Pittsburgh: University of Pittsburgh Press, 1997); Sharon Crowley, *Composition in the University: Historical and Polemical Esssays* (Pittsburgh: University of Pittsburgh Press, 1998), Dorothy C. Broaddus, *Genteel Rhetoric: Writing High Culture in Nineteenth-Century Boston* (Columbia: University of South Carolina Press, 1999); Charles Paine, *The Resistant Writer: Rhetoric as Immunity, 1850 to the Present* (Albany: State University of New York Press, 1999); and Lucille M. Schultz, *The Young Composers: Composition's Beginnings in Nineteenth-Century Schools* (Carbondale: Southern Illinois University Press, 1999).

12. See Patricia Bizzell, "Opportunities for Feminist Research in the History of Rhetoric," *Rhetoric Review* 11 (1992): 50–58; Hobbs 1995; and Nicole Tonkovich, *Domesticity with a Difference: The Nonfiction of Catharine Beecher, Sarah J. Hale, Fanny Fern, and Margaret Fuller* (Jackson: University Press of Mississippi, 1997) and "Rhetorical Power in the Victorian Parlor: *Godey's Lady's Book* and the Gendering of Nineteenth-Century Rhetoric," pp. 158–183 in *Oratorical Culture in Nineteenth-Century America: Transformations in the Theory and Practice of Rhetoric,* edited by Gregory Clark and S. Michael Halloran (Carbondale: Southern Illinois University Press, 1993).

13. The Science Hill Female Academy was founded by Julia Ann (Hierony-mous) Tevis in Shelbyville, Kentucky, in 1825. The school, which enrolled students between the ages of six and twenty-one, held annual sessions thereafter for over a century. For much of the nineteenth century, Science Hill was affiliated with the Methodist Episcopal Church, but the school's curriculum and financial affairs remained in Tevis's hands through 1880 (see "Science Hill Female Academy," in *The Kentucky Encyclopedia,* edited by John Kleber [Lexington: University of Kentucky Press, 1992], p. 803). See also Jo Della Alband, "A History of Education of Women in Kentucky," M.A. thesis, University of Kentucky, 1934; and Julia A. Tevis, *Sixty Years in a School-Room* (Cincinnati: Western Methodist Book Concern, 1878).

14. Anne Ruggles Gere, "Kitchen Tables and Rented Rooms: The Extracur-riculum of Composition," *College Composition and Communication* 45 (1994): 75–92, and *Intimate Practices: Literacy and Cultural Work in U.S. Women's Clubs, 1880–1920* (Urbana: University of Illinois Press, 1997). Cathy N. Davidson discusses such ex-tracurricular groups in the context of an 1814 novel by Sarah Savage, *The Factory Girl,* in which the heroine organizes a study group of her fellow workers (David-son, *Revolution and the Word: The Rise of the Novel in America* [New York: Oxford Uni-versity Press, 1986], p. 12). Reading and writing groups seemed to have actually emerged slowly in the early nineteenth century, but the idea of them was strongly present early on.

15. Hannah Adams, *A Memoir of Miss Hannah Adams, Written by Herself* (Boston: Gray and Bowen, 1832), pp. 8–9.

16. For more on adventure schools, see Norton 1980, pp. 259–260; Woody 1929, vol. 1, p. 330.

17. Woody draws on a formidable—and instructive—array of sources to "tell the story of changes that have taken place in ideals, practices, and institu-tions": school catalogs, minutes of meetings, laws, court records, student writing, newspapers, books, pamphlets, and periodicals (Woody 1929, vol. 1, pp. viii–ix).

18. Sarah Pierce's Litchfield Female Academy, established in 1792, was ex-emplary of the new schools. See Lynn Templeton Brickley, "Sarah Pierce's Litch-field Female Academy, 1792–1833," Ph.D. diss. (Cambridge: Harvard University, 1985), on the academy, as well as published excerpts from Pierce's students' di-aries and letters in a two-volume chronicle edited by Emily Noyes Vanderpoel, *Chronicles of a Pioneer School* (Cambridge, MA: University Press, 1903) and *More Chronicles of a Pioneer School* (New York: Cadmus Book Shop, 1927).

19. See Nina Baym, *Feminism and American Literary History: Essays* (New Brunswick, NJ: Rutgers University Press, 1992), pp. 115–118.

20. Among the most accessible of the diaries and letters we consulted are Anna Green Winslow, *Diary of Anna Green Winslow, A Boston School Girl of 1771,* ed-ited by Alice Morse Earle (Boston: Houghton Mifflin, 1894); and Julia Cowles, *The Diaries of Julia Cowles: A Connecticut Record, 1797–1803,* edited by Laura Hadley Moseley (New Haven, CT: Yale University Press, 1931). For bibliographic infor-mation on women's published and unpublished diaries and letters, see Cheryl Cline, *Women's Diaries, Journals, and Letters: An Annotated Bibliography* (New York: Garland, 1989); Joyce D. Goodfriend, *The Published Diaries and Letters of American Women: An Annotated Bibliography* (Boston: G. K. Hall, 1987); Laura Arksey, Nancy Pries, and Marcia Reed, *American Diaries: An Annotated Bibliography of Published Amer-ican Diaries and Journals,* vol. 1, *Diaries Written from 1492 to 1844* (Detroit: Gale,

1983); and William Matthews, *American Diaries in Manuscript, 1580–1954: A Descriptive Bibliography* (Athens: University of Georgia Press, 1974).

21. Eliza Southgate Bowne, *A Girl's Life Eighty Years Ago: Selections from the Letters of Eliza Southgate Bowne,* edited by Clarence Cook (New York: Charles Scribner's Sons, 1887), p. 3.

22. Bowne 1887, p. 4.

23. Martha Laurens Ramsay, *Memoirs of the Life of Martha Laurens Ramsay,* 2d ed. (Boston: Armstrong, 1814), p. 56, emphasis added.

24. Bowne 1887, p. 11.

25. Bowne 1887, p. 16.

26. Bowne 1887, p. 17.

27. Bowne 1887, p. 19. Eliza routinely spells Rowson as Rawson—perhaps a phonetic rendering of the preceptress's name.

28. Bowne 1887, p. 27.

29. Bowne 1887, p. 28.

30. As Fizer notes, "The republican daughter became a subject of intense scrutiny and attack in the 1790s. The reaction of moralists to this perceived threat to the new nation—daughters who had become unfamilial, pursuing their pleasure with ardor—was immediate" (Fizer 1993, p. 251). This scrutiny certainly manifests itself in boarding school fiction well through the early national and antebellum periods.

31. Bowne 1887, pp. 29–30.

32. In her extended analysis of Eliza's letters, Fizer (1993) similarly chooses Foster's work, but she selects *The Coquette* as her basis of comparison.

33. As a governess, or mentor as Rowson would have it, Mentoria also works as a counterbalance to the governess fiction popular at the time. In such fiction, typically, foreign governesses (usually French) serve as the third (and disturbingly, threateningly sexual) presence in a marriage. For an intriguing account of governess fiction, see Teresa Mangum, "Sheridan Le Fanu's Ungovernable Governess," *Studies in the Novel* 29 (1997): 214–237.

34. According to Sharon Harris in *American Women Writers to 1800* (New York: Oxford University Press, 1996), "The popularity of this novel, *The Boarding School* (1798), is evident from the numerous times it is mentioned in diaries. Julia Cowles, for instance, notes that she read it in 1799 while she was attending Sarah Pierce's Academy" (p. 402, n. 1).

35. Bowne 1887, pp. 30–31.

36. In Eliza's day, social pressure to marry was immense, for, as Nancy Cott puts it, "marriage had several levels of political relevance, as the prime metaphor for consensual union and voluntary allegiance, as the necessary school of affection, and as the foundation of national morality" (Nancy F. Cott, *Public Vows: A History of Marriage and Nation,* Cambridge, MA: Harvard University Press, 2000, p. 21). For more on marriage in the United States, see Hendrik Hartog, *Man and Wife in America: A History* (Cambridge, MA: Harvard University Press, 2000).

37. Bowne 1887, pp. 109–110.

38. Bowne 1887, pp. 104–105.

39. Bowne 1887, p. 162.

40. Bowne 1887, p. 127.

41. Bowne 1887, p. 131.

42. Bowne 1887, p. 53.

43. Foster, 1798, p. 35.

44. Foster 1798, p. 35.

45. Foster 1798, p. 33.

46. Foster 1798, p. 35.

47. Bowne 1887, p. 50. Bruce Burgett, too, reads the conflation of epistolary writing and sexuality (*Sentimental Bodies: Sex, Gender, and Citizenship in the Early Republic* [Princeton, NJ: Princeton University Press, 1998]). Fizer posits a different interpretation. She sees Eliza's letters as a "sphere which she resolutely refused to compromise" (Fizer 1993, p. 252). She continues, "For literate women in the eighteenth century, the letter always provided an outlet for private expression. For a young woman in the Republic, the letter became even more consequential. It was the first forum in which she could exercise her liberty, test her autonomy. The vocabulary of republicanism undergirded her narrative authority: her letters could become declarations of independence, by which she signed her governance over herself" (Fizer 1993, p. 252). Our point (and Burgett's) is that letters did not constitute an arena separate from the public; hence the rigid and emphatic lessons on the necessity of self-censorship and reputation.

48. Bowne 1887, p. 48.

49. Burgett 1998, p. 82.

50. Bowne 1887, p. 201.

51. William Merrill Decker, *Epistolary Practices: Letter Writing in America before Telecommunications* (Chapel Hill: University of North Carolina Press, 1998), pp. 18–56. Decker makes the case that the genre of the letter in the nineteenth century was hardly so stable as might be imagined today. He notes that letter writers and readers from the earliest years of the republic openly negotiated in their letters what was acceptable epistolary form and content. And as the genre of the letter evolved, so too did the material conditions that made communication by letter possible. In addition to increasing availability of affordable writing paper and ink, the means of transmitting letters—the nation's postal service—developed rapidly in the nineteenth century. It did so, as Richard R. John explains, not so much because letter writers demanded expansion, but because the publishers of newspapers were able to capitalize on the favorable terms of postal law to "spread the news" across a nation fast growing westward from its coastal roots. Indeed, the distribution of news by post anticipated the network of railroads that would, by midcentury, enable the distribution of all manner of reading material across the land. See *Spreading the News: The American Postal System from Franklin to Morse* (Cambridge, MA: Harvard University Press, 1995), pp. 25–63; see also Zboray 1989, pp. 191–194.

52. Bowne 1887, pp. 86–87.

53. Bowne 1887, pp. 137–138.

54. Bowne 1887, p. 133.

55. Bowne 1887, p. 58.

56. Bowne 1887, p. 102.

57. Bowne 1887, p. 12.

58. Bowne 1887, p. 15.

59. Murray 1798, pp. 463–470. See Laura J. Rosenthal, "The Author as Ghost in the Eighteenth Century," pp. 29–56, in *1650–1850: Ideas, Aesthetics, and*

Inquiries in the Early Modern Era, edited by Kevin L. Cope and Laura Morrow, vol. 3 (New York: AMS Press, 1997) and *Playwrights and Plagiarists in Early Modern England: Gender, Authorship, Literary Property* (Ithaca, NY: Cornell University Press, 1996); and Elaine Hobby, *Virtue of Necessity: English Women's Writing, 1649–88* (Ann Arbor: University of Michigan Press, 1989). For more on plagiarism in the early nation and Judith Sargent Murray's response to it, see chapter 2 of our book *Imagining Rhetoric* (Eldred and Mortensen 2002).

60. Bowne 1887, p. 58.

61. Bowne 1887, pp. 58–59.

62. Bowne 1887, pp. 55–57.

63. Fizer 1993, p. 256.

64. Bowne 1887, p. 105.

65. And nothing seems to jumpstart a plan of study better than a change in marital or economic circumstances. The biographies of women authors attest that often women were writing to support themselves or a family because a husband had become ill, had accrued great debt, or had died. Eliza dies within a few years after her marriage, so marriage in her case does represent the end of her academic learning.

66. Fizer 1993, p. 235.

67. Eliza recounts meeting "a woman full broke out with the small-pox; I was within a yard of her before I perceived it; the first sensation was terror, and I ran several paces before I recollected myself" (Bowne 1887, p. 166). Although she reports having been inoculated for "kine-pox," she and her husband leave town during the epidemic, in part because businesses had already relocated outside the city (Bowne 1887, p. 166).

68. Bowne 1887, p. 181.

69. Bowne 1887, p. ix.

70. It is necessary here to place the adjective "thoughtful" before "sentiment" because modern criticism has been unrelenting in separating the two terms, insisting on the oxymoronic relationship between thought and female sentiment. For accounts of this critical issue, see Suzanne Clark, *Sentimental Modernism: Women Writers and the Revolution of the Word* (Bloomington: Indiana University Press, 1991); Baym (1992); and Janet Carey Eldred, "Modern Fidelity," *Fourth Genre* 3, no. 2 (2001): 55–69.

71. The problems of "fact" posed by Eliza's letters are not unusual. Consider, for example, another text, the *Memoirs of the Life of Martha Laurens Ramsay* (Ramsay 1814). The book went through a number of editions after its first printing, and each reprinting presents the possibility that changes were made in its textual or visual representation. But even before these printings, Ramsay's memoirs were heavily edited by her husband, David. Indeed, "edited" in this case might be too weak a word. They were overwritten or rewritten with the goal of creating a positive public representation. For more on Ramsay, see Joanna Bowen Gillespie, *The Life and Times of Martha Laurens Ramsay, 1759–1811* (Columbia: University of South Carolina Press, 2001).

72. For anthologies, see Harris (1996) and Rosetta Marantz Cohen and Samuel Scheer, eds., *The Work of Teachers in America: A Social History through Stories* (Mahwah, NJ: Lawrence Erlbaum Associates, 1997). URLs for the websites are http://etext.lib.virginia.edu and http://www.alexanderst.com.

73. Patricia Bizzell argues that conventional scholarship has overlooked the

role of women as writers and readers because historical records of their activities are often difficult to access and assess, especially when it is perceived that humanistic knowledge must be arrived at by way of "supposedly value-neutral logical demonstration." If, instead, we grant that such knowledge cannot "ever be established above debate," it is appropriate to engage a research process that "may require the avowal of values" rather than, as is more often the case, the conventional suppression of them ("Feminist Methods of Research in the History of Rhetoric: What Difference Do They Make?" *Rhetoric Society Quarterly* 30, no. 4 [2000]: 11). This is not to say that there is no such thing as fact or that facts are unimportant or that a scholar can invent facts apart from evidence. Rather, this approach highlights the origin and nature of the facts under scrutiny and underscores the narrative interpretations or inferences that scholars use to compose instructive fact-based histories. Bizzell cites the work of Jacqueline Jones Royster, an historian of African American women's reading and writing practices, as exemplary of what can be accomplished. In *Traces of a Stream,* Royster uses what she calls "critical imagination" to connect the literacy practices of nineteenth-century African American women with the rhetorical practices of their foremothers, practices evident in cultural traditions not separable from the emotional response they evoke (even in the researcher). She is thus able to draw convincing connections between pasts recent and distant, even in the absence of traditional documentary evidence (*Traces of a Stream: Literacy and Social Change among African American Women* [Pittsburgh: University of Pittsburgh Press, 2000], p. 83). "Abstract patterns of belief and action" inform the "ancestral connections" that form the basis for understanding "ancestral voice" as the narrative inheritance of nineteenth-century African American women writers and their twenty-first-century interpreters (Royster 2000, pp. 82, 87). The validity of such interpretation resides not solely in the evidence—Bizzell and Royster would argue that evidence does not speak for itself—but in the consensus within a community of scholars that a certain piece of evidence, a certain strand of argument, establishes a provisional truth, contingent on the ceaseless critical reevaluation to which all humanistic knowledge is (or should be) subject.

74. In the field of rhetoric and composition, revisionist researchers began by asking questions about traditional forms of evidence, such as course materials and textbooks, and about traditional methods of inquiry premised on the availability of abundant evidence. For example, many historical accounts of writing instruction were based on old composition textbooks. But do textbooks, some ask, really offer an accurate representation of what was taught in class? Can we assume that an instructor structured his or her classes around a textbook? A textbook, after all, might merely serve as a resource, a work in the background. Moreover, not all of a textbook is necessarily assigned; not all assigned reading is read. For a discussion of using textbooks to construct histories of writing, see Robert J. Connors, "The Rise and Fall of the Modes of Discourse," *College Composition and Communication* 32 (1981): 444–455; Gere (1994); Shirley Brice Heath, "Toward an Ethnohistory of Writing in American Education," pp. 25–45 in *Variation in Writing: Functional and Linguistic-Cultural Differences,* edited by Marcia Farr Whiteman, vol. 1 of *Writing: The Nature, Development, and Teaching of Written Communication* (Hillsdale, NJ: Lawrence Erlbaum Associates, 1981); Susan Miller, "The Feminization of Composition," pp. 39–53 in *The Politics of Writing Instruction: Postsecondary,* edited by Richard Bullock and John Trimbur (Portsmouth, NH: Boynton/Cook, Heinemann, 1991);

Stephen North, *The Making of Knowledge in Composition: Portrait of an Emerging Field* (Portsmouth, NH: Boynton/Cook, Heinemann, 1987); and Robin Varnum, "The History of Composition: Reclaiming Our Lost Generations," *Journal of Advanced Composition* 12 (1992): 39–55.

3

Nineteenth-Century Girls and Literacy

The nineteenth century was an age of growing access to literacy for U.S. girls, especially Anglo-American girls of the middle classes. Earlier exclusions from formal schooling, publishing, and public forums gave way to many opportunities, institutional programs, and venues both in and outside of school. An eighteenth-century constriction of female education to "decorative arts" or practical domestic skills exploded into a much wider array of literacy instruction. Girls were taught to compose letters, journals, and essays; to read, take notes, and keep commonplace books; to declaim and recite poetry; and to spell and parse sentences. They took part in reading circles and library groups, attended lectures, and listened to sermons; they memorized poetry, recited dramatic speeches, and played numerous word games. Schoolbooks in various language arts abounded, many explicitly marketed for girls or "young ladies" and designed for the growing number of private girls' academies, coeducational common schools, and public high schools. A flourishing market in gift books signaled the growing popularity of literary culture as a pastime and sign of middle-class affluence. Adults gave girls letter-writing guides and blank books to serve as journals or diaries. Anthologies of poetry, collections of moral maxims, and leather-bound versions of stories recirculated materials often designated for more adult or male readers or for readers of another generation.

By the 1830s, girls could strive to enter the newly established female seminaries and, by the 1880s, the women's or coeducational colleges. They could continue their education in one of the many women's reading circles, lyceums, or literary societies. They could read and aspire to write for the "ladies' cabinets" of mainstream magazines or for one of more than 100 women's periodicals launched in the nineteenth century, including such influential magazines as *The Ladies' Companion* (1834–1844, edited by Ann Stephens, Lydia Sigourney, and

others) and *Godey's Lady's Book* (1830–1898, edited by Sarah Josepha Hale). The development of such institutions as public libraries, churches, and tract societies, as well as cheaper and more widespread modes of print publication, made reading materials accessible to girls at almost every level of society and in every corner of the nation. Stationer's stores and mail-order catalogs sold a dazzling array of literacy equipment for ladies, as distinct from those marked for "college and professional penmen": pens, pencils, pencil boxes, sharpeners and pen wipes, packets of dry ink, book covers and markers, envelopes and bordered letter-paper, and seals and sealing wax. Publishers' book series were designed to capitalize on new female readers, and the "girl reader" became a familiar trope in instructional literature of the day.

Such material changes in girls' access to literacy materials and instruction were framed by a growing interest in literacy activity as a measure of girls' worth and character. Nineteenth-century periodicals advised girls how to make book covers and to organize a home library, and their serial fictions featured girls sending stories out for publication or designing gift books for their families. Whereas an earlier era might have measured a girl's worth by her piety, skill with the needle, or ability to dance, in nineteenth-century texts a female character's value often depended on her ability to compose letters, read a text with the appropriate feeling or sensibility, or order her feelings through journal writing. Literacy was an exterior demonstration of both individual and collective values, and literacy instruction became a lifelong project for girls, as it had been in earlier generations for their male counterparts. Even socially conservative institutions depended on girls' literacy to further moral and political agendas. Proposing young women as the future teachers of the nation and as the guardians of value, books issued by religious and civic organizations encouraged girls to mind their letters and care for their books. Girls were encouraged to use literacy for the social good, for temperance reform, or to extend domestic values into the public arena.

One sign of the rise in value of female literacy throughout the century is the emergence of women writers as eminent figures, celebrated in biographies in magazines like *Godey's* and *Scribner's,* illustrated tours of their homes, literary anthologies like Rufus Griswold's 1847 *Female Poets of America,* and gold-embossed volumes like the 1884 *Our Famous Women: An Authorized Record of Their Lives and Deeds.* Such materials circulated literacy success stories, replete with details about favorite books, early writing experiences, and the trials and tribulations of publishing. The popular writer Isabella Alden, for ex-

ample, who published over eighty books for children under the pen-name of "Pansy," reported a childhood of early literacy efforts and considerable parental support for reading and writing and even for precocious publication of her work. She began to write little papers "from her babyhood," which she called "compositions," intended for her parents only. Like many middle-class girls of her time, she kept a daily journal, which her parents read and commented on. She composed long letters to her absent sister, and by age ten had written a story privately printed for circulation among her family and friends. By age twenty, she won a prize competition for her first publicly printed book, *Helen Lester* (1865) and soon launched a Sunday School magazine for boys and girls called *Pansy* (1873–1896) that offered fiction, as well as other genres of writing. This glowing account of girlhood literacy emerges in an 1885 book by Sarah Knowles Bolton, *How Success Is Won,* which also celebrates the precocious success of Mary Virginia Terhune ("Marion Harland"), who published her first story at age fourteen, appeared in *Godey's* by age sixteen, and published her first novel by age twenty-one.[1]

Such adulatory volumes created a respectable market for the publication of women's own accounts of their literacy experiences in the many diaries, journals, and letters composed but previously kept "private." Of course, women's documents were never fully private, since such materials were read, sometimes edited, and often expressly sent to parents or teachers. A recently discovered journal written by seventeen-year-old Rachel Van Dyke in 1810 carries the marginal marks made by the male teacher with whom she exchanged journals. By the 1830s, it was not uncommon for middle-class parents to give their female, as well as their male, children blank books to serve as journals or diaries and to offer advice and instruction about the entries. In 1835, for example, Jacob Elfreth, a Quaker bookkeeper living in Philadelphia, instructed his children (two boys, age nine and six, and two girls, age seven and four) on how to use the blank book he offered them "to improve in [their] writing and keep memorandums of passing events."[2] The shared family book includes responding letters from both parents, as well as such instructional pages as a carefully handwritten alphabet for the children to copy.

Ellen Emerson's famous father Ralph Waldo (himself a noted journal keeper and social critic) urged his daughter to write a journal of her school experiences and send it to him so he could "read" a text of her growth and learning. Although he corrects her spelling and challenges her taste, the "assignment" also seems to provide father and daughter with a way of corresponding in far more equal ways than

they might have in person. Ellen's journals, transformed into letters to her father, are engaging and frank. She writes about expected topics (her lessons, her reading, compositions, lectures she has attended), but she also criticizes the conventionality of school assignments and assumes he will enjoy rather than censure her list of school slang. She shares with her father a pleasure in her own compositions, not needing to conceal from him concerns about spelling or style: she writes, for example, about showing Mr. Thoreau Emerson's "teak, teek, tique, tiek, teik cane" and adds in parenthesis, "I hope one of these is right."[3] Charlotte Forten Grimké, whose five journals span her school years as a free black in Boston, her training as a teacher at the Salem Normal School, and her experiences teaching freed slaves in the post–Civil War years, walks a complicated line between composing a proper self and using her journals to explore less expected or conventional interests. She extends appropriate topics, like the weather and travel, to express her emerging political views and her desires to be free from the limitations of racism. She compares her journal entries with those of her teacher, using the composed text to measure their relative positions, values, and assumptions. Young girls were often given volumes of letters and "female lives" to read, and they were encouraged to keep textual accounts of their daily activities, thoughts, and experiences that they could then reread for pleasure and self-reflection. As Grimké announces in her opening journal entry (May 1854): "keeping a diary will be a pleasant and profitable employment of my leisure hours, and will afford me much pleasure in other years. . . . Besides this, it will doubtless enable me to judge correctly of the growth and improvement of my mind from year to year."[4]

Literacy was depicted in nineteenth-century texts as a suitable activity for young girls, one that helped them learn mental and moral discipline and that allowed their friends and families to monitor their inner thoughts and desires. The pictorial iconography of girlhood in the nineteenth century often took literacy as its topic. Girls in contemporary illustrations displayed their virtue by busily writing letters rather than sewing or knitting, or revealed their family ties by reading to a younger sibling or participating in the evening reading circle. Schoolbooks like McGuffey's *Eclectic Readers* depicted reading as a daily, even casual, activity for girls, offering illustrations that included girls as schoolchildren but also showing them reading in hammocks and grottoes and curled up on sofas. Novels frequently included a self-reflective illustration of a girl reading or composing a scene for the story. Literacy was also a staple scene or reference, ranging from the roman à clef about an emerging writer (Fanny Fern's 1855 novel

Ruth Hall) to scenes of reading, schooling, letter-writing, playing charades, and deciphering anagrams. Cathy Davidson argues that "virtually *every* American novel written before 1820" includes "a discourse on the necessity of improved education" or "a comment on the educational levels and reading habits of the hero and even more so the heroine."[5] This preoccupation with learning and literacy and the sense that fiction had an instructional mission persists throughout the nineteenth century. Many fictions of the period show girls struggling to develop expertise in writing, benefit from their reading, and articulate public positions on subjects as diverse as industrial reform, temperance, friendship, and the beauty of the landscape. Stories about girls print sample compositions and letters or offer detailed accounts of novel reading. Elizabeth Stuart Phelps's 1866 children's book *I Don't Know How* opens with a characteristic frontispiece showing a girl reading or, more precisely, a girl distracted from her book by the view out her window. The book offers didactic scenes to help children determine the relative worth of "fairy stories" and "Sunday books," and it closes with an extended description of the pleasures of leisure reading for girls:

> a cosey, quiet place, quite shut off from the rest of the house; it had a window, which let in plenty of wind and sunlight, and there was a broad, old-fashioned window-sill, large enough to hold two or three persons. On this window-sill Ellen was curled up with a fairy-book. The golden afternoon sunlight was dancing on the pages, shadows of leaves were dancing out of doors, and the wind was laden with the sweet, strong perfume of some late day-lilies in the garden. Altogether, it was a most charming place in which to read a fairy-book; and it was evident that Ellen had chosen it to be alone and undisturbed.[6]

Literacy becomes a more complex seduction in books about older girls. The adventuresome heroines found in nineteenth-century serial fiction and novels model diverse and effective literacy activity, although their skills are often criticized by being linked with other forms of "boyish" behavior like physical exertion, lack of delicacy or manners, and outspokenness. Such fictions present elaborate depictions of the range of literacy events in which girls could partake, foregrounding events like school spelling bees, public recitations, and parlor dramas and often providing detailed depictions of scenes of reading and writing. Louisa May Alcott's Jo March, of the 1869 novel *Little Women,* launches what becomes a career as a writer by immersing herself in literary and theatrical performances as a child. She puts

on splendid melodramas (as well as Shakespeare in cross-dressing), writes stories and letters, and reads and writes for a New York story paper *(The Weekly Volcano)*. Given a copy of Bunyan's *Pilgrim's Progress*, Jo uses her diverse collection of books to shape her own "progress" through life and work. Many stories work through the restraints against girls' literacy and the conflicts about appropriate genres and styles, public performance, and power of the imagination. Catherine Sedgwick's 1830 story, "Cacoethes Scribendi," for example, pits a scribbling mother against her reluctant daughter in a fable about female authorship. Alice's "honest" interest in being "charmed" by the literary world vies with her mother's more ambitious emergence as an author, and the two struggle over the terms of "easy writing" and "hard reading," public exposure of private lives, and realism and artifice.[7]

Even less insistently literary heroines are often represented in the act of composing letters, journal entries, or school compositions. Gypsy Breynton, the title character of Elizabeth Stuart Phelps's 1866–1867 series, goes off to school with a trunk packed full of clothes, accessories, fans, jewelry, and a long list of the writing materials she expects to use: "slates, books, paper, pencils, ink, . . . chalk."[8] The novel shows her negotiating competing kinds of reading *(Harper's Weekly,* Virgil lessons, a borrowed romance, Sabbath day books), and it details her struggles with school compositions. It reproduces letters, drafts, and finished essays and offers a sample of school slang, which Gypsy's mother corrects. Gypsy worries about plagiarism, assigned essay topics, and literary style. The process of school writing is seen as burdensome, arbitrary, and pointless. Lost amid the expected phrases and sentiments, the girls cast about for things to say and language with which to say it. The wit and energy with which they write letters, speak in slang, and enjoy their "secret" books are constrained by parents and school, but the novel itself offers these traits space to operate.

Gypsy's literacy experiences reproduce a familiar set of associations for girls and literacy in the nineteenth century: in many fictions of the day, girls are represented through the cataloging of literacy "possessions," parental admonishment about their language or literacy excesses, or the conflict between novel reading and more proper pursuits (Sunday books, "serious" books, "definite aims in reading," "hard study"). School is often represented as an unhelpful discipline, offering artificial and contrived assignments that contrast with more inventive wordplay or acts of imagination. Many of these stories reproduce a gentler version of British writer Charlotte Brontë's 1849 novel *Jane Eyre,* with its harsh schoolteacher, ritual humiliations about lan-

guage use, escapist reading scenes, and vivid acts of imagination. Others recall the seductive power of letters made popular by Susanna Rowson's 1791 novel of letters, *Charlotte Temple,* or Samuel Richardson's novels *Pamela* (1740) and *Clarissa* (1747).

One of the most widely distributed novels for girls in the United States in the nineteenth century, Susan Warner's novel *The Wide, Wide World* (1850), shows how a girl goes out alone to face "the wide world," using literacy (as Alcott does in *Little Women*) to structure a female *Pilgrim's Progress*. Ellen Montgomery's dying mother provides her with advice and supplies to sustain her through the rest of the novel's trials. Along with the more expected clothing, sewing materials, and religious guides, Ellen is outfitted with an elaborate array of literacy materials, a proper Bible, and a fully equipped writing desk. Warner details the selection and arrangement of these literacy materials, suggesting in the exchange between mother and daughter how such materials should be best put to use. Ellen is steered away from the "tempting confusion" of children's books to buy a Bible. But Warner does not stop with a simple moral opposition. The lengthy scene about selecting the appropriate Bible, which will be purchased as a text but also will become a treasured object, organizes a powerful allegorical lesson about reading and life choices. The many available Bibles challenge Ellen's aesthetic sense and her notions about literacy and self-worth. She is intrigued by the abundance of physical books, by their "various kinds and sizes . . . varieties of type and binding," by the necessity to weigh "the comparative advantages of large, small, and middle-sized; black, blue, purple, and red; gilt and not gilt, clasp and no clasp." Under the guise of debating the book's physical attributes, Ellen and her mother compare different uses of reading, different postures and expectations. When Ellen mistakenly chooses a large, very fine Bible, her mother counters that "it is rather inconveniently large and heavy for everyday use. It is quite a weight upon my lap. I shouldn't like to carry it in my hands long. You would want a little table on purpose to hold it." When Ellen brings out a "beautiful miniature edition in two volumes, gilt and clasped," her mother explains it is not suitable because of the small size of the type that would make it hard to read "when your sight fails." Reading is thus proposed to girls as a daily and lifelong activity: books need to be portable, accessible, and legible, as well as attractive and affordable. Bombarded by her mother's powerful strictures, Ellen (wisely) picks a red Bible (not too small, not too big, with not too fine print), valued because it will remind her of her mother's Bible.[9]

Nineteenth-century narratives use literacy as an exemplary case to work out the boundaries between acceptable and unacceptable

behavior, to determine how girls can negotiate the complexity of their social positioning. Like the detailed descriptions of appropriate dress and domestic skills, literacy serves to mark a girl's class standing, upbringing, and obedience. Sometimes such scenes confirm in simplistic ways the stated desires of society, offering lists of censored books and practices or rewarding "good" girls for dutiful expression. Yet many texts mine such conventional scenes for more complex negotiations about girls' lives, struggles, and authority. Literacy scenes become a forum for exploring the challenges girls must surmount to make their way in the world, survive financial loss, and defend themselves against predators and false authority. E. D. E. N. Southworth's daring heroine Capitola (*The Hidden Hand,* 1859) makes her way through the streets of New York City dressed as a newsboy and armed with a powerful— and shocking—multiplicity of literacy skills. Capitola's strength comes from her ability to shift discourses, to use street language and slang as well as high literary quotation to powerful effect. In a novel that hinges on hidden wills, encoded initials, lost letters, and legal language, Capitola's chameleon linguistic powers are as crucial to survival as they are surprising coming from a girl. Educated through the sensational newspaper she hawks in the streets, she knows street slang for prisons and crimes, but she also knows how to draw on the learning of "school exhibitions," Romantic poetry, and popular culture. Her discursive facility is contrasted to that of a male character, who knows only the more conventional academic literacies of his day (Latin, algebra, and Sabbath school Bible lessons) and speaks in a received language that the novel marks as borrowed or stale ("he whispered assurances of his 'true love,' and his boyish hopes of 'getting on,' of 'making a fortune,' and bringing 'brighter days' for her!").[10]

In historical narratives like *Incidents in the Life of a Slave Girl* by Harriet Jacobs (1861), girls' literacy becomes an even more urgent concern. Jacobs, who writes under the pseudonym "Linda Brent," apologizes to her readers for "deficiencies" in her writing, attributing them with considerable understatement to "circumstance." That she writes at all has to be authorized by an introduction from Lydia Maria Child, a white author and abolitionist, who confirms that Jacobs is indeed literate and that her text is genuine. In elegantly balanced periodic sentences, high diction, and strategic narration, Jacobs describes the dangers of knowing how to read and write as a slave girl. Instead of opening doors or offering liberation, literacy serves as one more means by which she can be assaulted by her owners. As they did for Richardson's fictional heroines Pamela and Clarissa, letters become part of a threatening sexual battle, alluring and exposing. Jacobs's

lecherous owner, Mr. Flint, on catching her learning to write, capitalizes on the occasion to "advance his favorite scheme" by slipping lewd notes to Jacobs. "I would return them," Jacobs explains, "saying, 'I can't read them, sir.' 'Can't you?' he replied; 'then I must read them to you.' He always finished the reading by asking, 'Do you understand?'" Jacobs's literacy threatens her master ("He knew that I could write, though he had failed to make me read his letters; and he was now troubled lest I should exchange letters with another man"), but the difficulty of refusing to read stands in allegorically for the other relations Jacobs tries in vain to refuse.[11] Despite the danger to which literacy exposes her, Jacobs also uses her own literate powers as a measure of worth, contrasting her refined speech with her master's crude propositions and the vulgar illiteracy of an assaulting mob. The mob steals her grandmother's silver candlesticks, her master steals her body, her mistress steals her sleep, but Jacobs persists in "owning" her superior literacy as an enduring sign of her value.

The rise of women as readers and writers in the nineteenth century prompted frequent warnings about their trespass into previously all-male terrain and about their need to be careful as they ventured into the public sphere. Periodicals printed frequent articles laying down guidelines for the "lady reader" or marking the permitted boundaries for the "female author." In 1793, the *Ladies' Magazine* printed an editorial entitled "On Female Authorship," "confessing" that "many female pens are wielded with an ability that would by no means discredit the most enlightened understanding; nor has the world been slow in bestowing the tribute of applause so justly due to their writing."[12] By 1851, an article by A. W. Abbot in the *North American Review* announced that "female authorship is quite too common in these latter days to strike the world agape."[13] And by 1867, the columnist Fanny Fern could write in the *New York Ledger:* "A woman who wrote used to be considered a sort of monster. At this day it is difficult to find one who does not write, or has not written, or who has not, at least, a strong desire to do so."[14] Mary Torrans Lathrap could insist in her presidential address of 1888 before the Woman's Christian Temperance Union that "women are growing too wise and strong to use either tears or tirade as weapons of defense."[15] The news of women's ascendancy into the literate world reached even to all-male enclaves like Yale University, where its president, Noah Porter, wrote elaborate instructions for the untrained "lady reader," whose reading time must be "snatched by fragments from onerous family cares and brilliant social engagements." Given such constraints, the lady reader must be particularly attentive to expert advice on

what and how to read. She should follow "definite ends and purposes" for her reading and develop the habit of "calling [herself] to account for [her] reading, and the consideration of it in the light of wisdom and duty."[16]

Although female literacy was becoming something of a commonplace, a "fact" of nineteenth-century social history, it persisted across the century as a favorite target for jest, satire, monitorial concern, and polemic. Cartoons about the female "bluestockings" and comic sketches about literary housewives neglecting their duties frequented popular papers, and a novel could discredit a female character by giving her elevated diction or showing her overreaching in her scholarly aspirations. Abbot's 1851 review, "Female Authors," rehearses a collection of cultural tropes about female literacy, depicting the "scribbling women" as dabbling in ink, scolding, and exhibiting Amazonian mania and vixenish tongue-wagging. It charges them with "temerity" for writing to a public and for selling books "at the bookseller's counter" and utters concerns for "our fair friends," whose tender sensibilities and lack of familiarity with the public realm make them "risk more than a man." Yet even as the review chides women who read and write and seems to close female literacy off from the public sphere, it suggests a recognition of what it means to be so excluded. In what seems a remarkably modern analysis of marginalization, the review narrates the frustrating exchange of a woman writer with "a smiling school-committee man" who offers praise, "after a whispered agreement, that with some pruning and a little more thought, it would be really a surprising achievement *for a girl*."[17] The review's italics remind readers how girls' literacy was held to a different standard, still new enough to be surprising, still contentious enough to be noted. The 1793 editorial in the *Ladies' Magazine* worries over the appropriate kinds of writing and learning for females and the degree to which their literacy would reduce their estimation as women. "Few men would (I imagine) wish their wives and daughters to prefer Horace and Virgil to the care of their families," its author warns, "or a sedulous pursuit of intricate points in Epictetus, to a prudent management in domestic affairs."[18] Such articles designate when and how women should use their literate powers; they delineate boundaries and propose appropriate genres and topics. The 1793 editorial insists on reading and writing as a "pleasing employment" for females' "vacant hours," and the 1851 review distinguishes between public literacy and "an earnest and holy spirit and true aim" that would limit letters to domestic uses.[19] The double valuation of female literacy is evident in the treatment of such famous fictional lan-

guage users as Louisa May Alcott's Jo and Lucy Montgomery's Anne of Green Gables, whose exuberant compositions and oratorical forays are met with admiration and censure. Both characters are alternately punished and rewarded for their prowess, Jo becoming a successful published author and Anne being admired for her eloquence in reciting poetry, but both are also ultimately steered toward "safer" careers as teachers.

Despite transformations in the culture of literacy for girls, their ability to read, write, and speak continued to be linked with domestic values, with their socially constructed roles as teachers, helpmeets, or "mothers-in-training." When in 1857, McGuffey's *Fifth Eclectic Reader* included a story entitled "The Good Reader," it was not surprising to find a girl out-competing two boys for the accolade. Yet even as the narrative promotes a girl for her ability to read with sensitivity and "natural" ease, it restricts her skills to the ability to assist others, speak for the poor or elderly, read feelingly and from the heart, and refuse any advancement or reward for her literacy achievements. Girls were encouraged to read as part of their family obligations, to comfort the sick and elderly, to reinforce socially sanctioned narratives and law, and to pronounce on proper virtues and aspirations. Taught to read long before it was thought they needed to learn to write, girls were positioned to receive cultural messages rather than to compose or translate them. Their training as writers was confined by model letters, advice about composing diaries and commonplace books, assigned composition topics, and the regular surveying of their production by their elders. A 1927 history of the American Sunday-School Union regrets the limitations placed on women, despite their "prominent service" in the movement's teaching force and in contributing "so largely to the preparation of its literature":

> It seems remarkable that [women] did not become more conspicuous in some organized capacity. . . . In most of the churches it was not popular for women to speak in public or to attempt to interpret the sacred Word. . . . Women accepted the humbler but no less important sphere of instructing the race in its formative period and giving the young some knowledge of the rudiments of religion, laying a foundation upon which the church could safely build.[20]

Such limitations on women's literate activities demonstrate what Nan Johnson has argued, that the "performance of conventional femininity" remained an effect of rhetorical codes and practices, especially for middle-class white women. Johnson sees rhetorical instruction in

such "parlor" literacies as etiquette, elocution, and letter writing as reinforcing a limited rhetorical role for females as wives and mothers.[21] The Sunday school limitation suggests how such domestic roles operated in public spheres. Not only were the ends or uses of literacy restrained; indeed literacy practices could be seen as carrying out domestic agendas for girls. Young girls were thought to demonstrate their potential as housekeepers or mothers by keeping their writing desks in order or by writing without spattering ink on their copybooks or their bodies. They showed their propensity for domestic economy by recording purchases in neat columns or by keeping a record of how they spent their time. Reading and writing thus served, in many ways, as public activities that kept idle hands busy and that focused girls' attentions on appropriate interests.

Yet literacy venues for girls and women also capitalized on these valued social roles, proposing literacy's value for reform or civic purposes. Anne Ruggles Gere discusses how women's literary clubs allowed them public activities that were "consonant with rather than in opposition to their domestic roles."[22] Carol Mattingly assesses how complex forms of literacy training and practice were sponsored by the temperance movement. Periodicals emerged in the century to provide outlets for women's thoughts on reform, politics, and even their more private lives. Anne Royall, for example, who had been sentenced to punishment for being a "common scold," found a more acceptable outlet for her observations in the newspapers *Paul Pry* (1831–1836) and *The Huntress* (1836–1854). Writers such as Jane Grey Swisshelm, Frances Wright, and Ida B. Wells wrote on public matters for newspapers; others, like Lydia Maria Child, Fanny Fern, Grace Greenwood, and Gail Hamilton, had regular columns in which they discussed social concerns and mores.

Even conservative venues like religious institutions often valued literacy in the service of faith and self-reflection. In Newcombe's *Young Lady's Guide to the Harmonious Development of Christian Character* (1843), girls are encouraged both to question and follow the "learned and pious men whom God has raised up for the instruction of his people."[23] In what seems otherwise a very conservative, enforcing book, with sections on "how to avoid a controversial spirit," the "nature and effects of true religion," and "charity," the advice about reading and writing is remarkable, with extensive instruction in reading, cultivating one's mind, keeping a journal, and organizing time. The book struggles to help its readers negotiate the tension between accepting others' opinions about texts and forming their own judgments, encouraging them not to "take the opinions of men upon trust" but to

"compare them diligently with the word of God." Warned to "be not too confident in your own understanding; and be ever ready to suspect your judgment, where you find it opposed by the opinions of the mass of learned and pious men whom God has raised up for the instruction of his people,"[24] they are also encouraged to read with independence and active reflection:

> When you read, do not make your mind a mere reservoir, to hold the waters that are poured into it; but, when you read the thoughts which others have penned, think them over, and make them your own, if they are good, or mark their defects, and reject them, if they are bad. And, when you read history or intelligence, let it always be accompanied with reflections of your own.[25]

Unlike much of the school instruction of the day, which favored imitation and carefully proscribed compositions, this guide sets out an extensive program of self-culture in which girls were to read carefully and critically (what the guide calls "profitable reading"), to reflect on their reading, and to write and revise thoughtful discussions.[26] Young ladies are advised to select "practical" rather than "abstract subjects" for their compositions, to "take time . . . and rein up your mind to it," rather than indulging "the absurd notion that you can write only when you *feel like it*." They are encouraged to proceed in a systematic and orderly way, to set aside their drafts and go on to another topic—"after this, review, correct, and copy, the first one." They are encouraged to keep at it, despite error or failure, and to "preserve all [their] manuscripts" so as to be able to gauge their "progress in improvement." They are even encouraged to send out essays for publication as "a stimulus to effort."[27] Although their topics for writing are monitored in this book as they would be in a school setting, the emphasis on developing a reasoned position and on being cautious about accepting authoritative positions without careful consideration seems a mode of composition instruction considerably more advanced than that offered by many of the college-level textbooks of the day. This book is not, strictly, a countercultural book or a book of a different political order from most college schoolbooks, but its focus on the problems of educated Christian young ladies produces surprising results. Its interest in religion allows it to teach girls to suspect mortal authorities, even while they are taught to regard God's word as an "unerring standard."

Girls and women were encouraged in the nineteenth century to engage in reading, writing, and even to some degree public speaking

in the service of causes such as abolition, temperance, or industrial reform. They were urged to read "actively" and to inscribe their names and on occasion verses or responses in their books as a sign of ownership or mastery. Cathy Davidson reports, for example, on the elaborate book plate and penned designs written by a girl in the covers of a cheap 1802 copy of Rowson's *Charlotte Temple*.[28] Even literate activities that seem completely contained, sentimental, or domestic were often linked with more public and political activities. The cloyingly sweet stories about children's pets, for example, that are found in every school reader and children's magazine of the period can be seen as preparing girls to participate in the antivivisection movement. Elizabeth Stuart Phelps, a noted author, wrote many stories and political pamphlets decrying cruelty to animals in service of medical research. Stories about cheerful girls who make do with nothing and know how to keep a bevy of brothers and sisters happy can be seen as preparing girls for broader careers in social work or teaching and helping them negotiate potential economies in their own households. Literacy skills for such fictional girls as Alcott's Jo March, Polly Pepper (in Margaret Sidney's *Five Little Peppers and How They Grew,* 1878), Nelly (in Helen Hunt Jackson's *Nelly's Silver Mine,* 1878), or Katy Carr (in Susan Coolidge's *What Katy Did,* 1872) have the potential of improving their families' precarious financial situation. Lydia Maria Child's preface to her 1831 reader, *The Girl's Own Book,* suggests the link between childhood literacy instruction and the social realities of life: "In this land of precarious fortunes, every girl should know how to be *useful*."[29] In a book full of pleasant games, crafts, songs, charades, and stories, Child also offers practical advice on plain sewing ("to some it is an employment not only useful but absolutely necessary"[30]), mending, and bee keeping, and its longest story tells the adventures of Mary Howard, whose wealthy parents die suddenly, leaving her an orphan who must fend for herself.

The conventional domestic constraints on girls' literacy do not fully describe the experience of all girls in the nineteenth-century United States, nor do the official limitations represent all that girls read or wrote. The frequency of disciplinary essays about female literacy in the publications of the day suggests, in fact, that there remained considerable cultural anxiety about how effective these strictures were. Rather than generalize such limitations into a "cult of domesticity" or "cult of true womanhood" in which all females participated, it is important to see the ways in which literacy differed for girls in different class situations, regions, and religious contexts. And it is important to see how girls adapted genres and styles to purposes

other than those for which they were designed. Susan Miller has teased out such differences for upper-class girls, demonstrating the ways in which gendering of instruction and rhetorical practice commingled with "anxieties about class standing,"[31] so that concerns about "ladylike" speech and "proper" literate behavior enforced both class and gender boundaries. Working closely with the commonplace books kept by well-to-do young ladies in Virginia, Miller demonstrates that although "traditional differences in schooling for boys and girls curtailed the number and limited the quality of texts written by females," girls of a certain class nonetheless participated in public discussions and literary exchanges.[32] *Traces of a Stream: Literacy and Social Change among African American Women* by Jacqueline Jones Royster (2000) distinguishes the many different literacies and forms of literacy instruction among African American females of the nineteenth century. Despite the many legal and economic restrictions on African American literacy under slavery, slaves working in a house had some opportunity to "pick up" literacy in ways they were legally disallowed to do. Royster argues that slaves—"surrounded by the artifacts of literacy," seeing "reading taking place," and seeing "notes, letters, diaries, newspapers, books, business records and documents"—would have understood much of the "significance of this material culture" and could have learned from association with a "literate environment."[33]

Royster's discussion of African American girls "going against the grain" (as she titles her chapter on the acquisition and use of literacy) is a reminder not to associate formal instructional barriers with lack of literacy.[34] African American girls in the north had access to literacy materials and instruction through Sabbath schools, religious tract libraries, and the "books and libraries of employers and friends."[35] Girls excluded from formal schooling could find advanced literacy opportunities through the Sunday school movement and its many day schools, correspondence programs, and publishing ventures. Despite official sanctions against women as public speakers or interpreters of scripture, most Sunday school teachers were women, and many women writers began their publishing careers by printing stories in one of the many children's periodicals. Women also found opportunities for publication and public speaking in reform movements. Carol Mattingly has demonstrated that women engaged in nineteenth-century temperance movements exhibit a highly skilled level of rhetorical literacy "despite their lack of formal rhetorical training."[36]

Indeed, although nineteenth-century girls were certainly regulated by parlor rhetoric, they also could "pick up" other kinds of literate practices, trading on their very invisibility and domestic positioning to

eavesdrop on males' literate activities. Girls read books designated for them, but they also read books left behind by older brothers. They were formally limited in the kinds of texts they might compose, yet they gained experience by copying others' documents and serving as secretaries to their fathers or employers. As eighteenth-century women had learned to read by whispering cues to all-male theatrical troops or by helping set type in the family printing shop, so many girls extended the spheres to which they were—officially—relegated. Lucy Larcom, the eminent poet who wrote about life in the Lowell Mills, credits her childhood self with an impressive range of inventive or re-sistant literacy practices, the product of what she calls "my critical little mind."[37] Although she dutifully read Aesop's fables, for example, she "invariably skipped the 'moral' pinned on at the end, and made one for myself, or else did without"; similarly she read the assigned hymn and Bible passages but "took from both only what really belonged to me."[38] She continued to "edit" valued cultural texts to locate passages that ap-pealed to her and to forestall other cultural effects. She snipped out the "anecdote column and the poet's corner" from her father's "antiquarian treasure" stock of filed newspapers and read a "tattered copy of John-son's large Dictionary" for the "examples of English versification which I found in the Introduction." She was similarly "disobedient" in her writing. Offered a "neat little writing-book" by her sister and ordered not to "make a mark in it," Larcom "disobeyed her injunction, and dis-figured the pages with tell-tale blots."[39]

Literacy in the nineteenth century was thus a complex negotia-tion between sanctioned or approved literary forms and instruction and a wider range of practices made possible by girls' greater physical mobility, the affordable distribution of reading materials, the found-ing of public libraries and common schools, and girls' access to vari-ous social institutions (church and Sabbath schools, temperance soci-eties, reform groups) that valued literacy for other purposes. Although elite publications and institutions continued to proscribe what girls should write, read, speak, and think, their many injunc-tions often describe a world gone by, a past era of restricted possibil-ity and access.

The importance of literacy as a social measure of a girl's value is demonstrated by the burgeoning industry of textbooks focusing on reading, writing, and language arts—from advice books and letter-writing guides to instruction on public speaking, gesture, and recita-tion. Books like *The Young Gentleman and Lady's Monitor and English Teacher's Assistant* (1803) marked literacy as available to both boys and girls. By the 1830s, textbooks like McGuffey's *Eclectic Readers* included

both boys and girls as potential students, although marked by differences in interests and expectations. Stories about boys engaged in outdoor play compete with sketches about little girls playing inside with their dolls. Boys are often depicted as rough, exuberant, and needing to be warned about teasing siblings and pets. Girls are often occupied with domestic enterprises—nursing dolls, mending clothes, cleaning, and cooking. These books adapted earlier masculinized aims of literacy (to prepare boys for the expected professions of the law, clergy, and politics) to suggest literacy's value in daily life, in the ability, for example, to appreciate the natural world, express sentiments, moderate grief and anxiety, and cultivate an educated and reflective self. Such concerns have come to be seen as "feminine" and are derogated by modern critics as "sentimental," but in much of the nineteenth century they were a widely shared value for both male and female.

Although many of the literacy textbooks would have been called "eclectic" in their day in terms of gendered instruction, intermixing selections for targeted learners with more generalized lessons, in other cases, gendered distinctions shape the design of the textbook itself. The 1850 text *American Lady's and Gentleman's Modern Letter Writer: Relative to Business, Duty, Love, and Marriage* demonstrates the shared yet divided literacy instruction available. This little book prints in one volume sixty-four pages of model letters for ladies, followed by a newly paginated sixty-four-page section for gentlemen. Both sections include letters written home from school, letters about illness, courtship, social engagements, and family. Indeed, many topics appear in both sections, showing the different inflection necessary to instruct a potential "lady" or "gentleman" on how to accept an invitation or break off a correspondence. The gentlemen's section offers more "public" documents, especially letters about how to negotiate finance and debt. Although the ladies' section focuses more of its attention on the complications of domestic and social concerns, girls were also expected to learn to correspond with the public in particular cases, such as employing servants or dealing with tradespeople.

Throughout the nineteenth century, publishers also issued textbooks aimed particularly at girls. As early as 1791, Caleb Bingham had published *The Young Lady's Accidence: or a Short and Easy Introduction to English Grammar*. By the 1830s, most of the successful textbook companies addressed the growing number of female academies by offering separate versions of their reading books for girls. In 1847, for example, the McGuffey textbook enterprise produced the *Hemans Reader for Female Schools*, recycling much of the educational apparatus prepared for the earlier McGuffey *Readers*. Many of these textbooks

reprinted the same materials and lessons offered to more general audiences, but others focused on particular literacy concerns for girls. Books like *Young Ladies' Class Book* by Ebenezer Bailey (1831), *The Girl's Own Book* by Lydia Maria Child (1831), *The Girl's Reading-Book* by Lydia Sigourney (1837), *Young Ladies' Elocutionary Reader* by Anna and William Russell (1846), *The Young Ladies' Reader* by Charles W. Sanders (1855), and *The Ladies' Reader* (1859) and *The Junior Ladies' Reader* (1860), both by John Hows, suggest the steady interest in female instruction during the century. Books were authorized by association with eminent women poets (Mrs. Hemans), essayists (Harriet Martineau), and educators (Mrs. Barbauld, Maria Edgeworth). They often combined literacy instruction with other forms of female education, such as etiquette, crafts, practical arts, music, games, and housekeeping lore, but others were largely indistinguishable from the more general textbook fare. By the end of the nineteenth century, as women became more identified with elementary instruction, language arts textbooks were often composed by women educators like Ellen M. Cyr, whose series of readers flourished in the 1890s.

Women like Lydia Sigourney compiled textbooks for girls—both for use in the academies and at home. The preface of *The Girl's Reading-Book* opens with a careful argument for the purposes of female literacy:

> To read well is a high accomplishment. It is not only graceful in a female, but its results rank among the virtues. It enables her to impart both instruction and pleasure. She may thus make the evening fireside delightful, or the wintry storm pass unheard. She may comfort the sick, and cheer the darkness of the friend whose eye age has dimmed, and instill into the unfolding mind lessons of wisdom.[40]

Its anthologized selections of prose and poetry negotiate the delicate space between the educated female and her domestic responsibilities. Lessons on education, for example, warn girls to maintain a proper balance between learning and domestic knowledge. Citing the case of the "lady who read many books, yet did not know if her dress was in a proper condition, and could not always find her way home, when she went abroad," it notes that "it is possible to possess learning, and be ignorant of necessary things." Proposing a "different kind of training" for its young female reader than that which would prepare a boy for the "sphere of action," it promotes education as a way to make us "contented with our lot," able to "moderate our desires," "make a right use of time," and "promote the happiness of others."[41] Yet other

selections seem to offer more scope for girls, as in the essay titled "Easy Studies," in which the narrator meditates on the value of disciplined intellectual work. An essay titled "Female Energy" announces that it is a "pity that females should ever be brought up in a helpless manner."[42] Selections offer expected moral lessons for young girls on such virtues as "perseverance" and "obedience," but there are also intriguing entries that suggest the harsher realities girls in the 1830s needed to address—loss of fortune, the problems of alcoholic spouses, the homeless, the care of the sick, death.

The rise of literacy among girls in this period depended on and prompted significant changes in formal and informal schooling. In the early nineteenth century, girls were often educated at home, as they had been in the previous century. By the 1830s, however, many girls attended the newly flourishing common schools, and more well-to-do girls enrolled in female academies. Despite continuing arguments against women's education by such male experts as the Boston doctor Edward Clarke, who wrote as late as 1872 that advanced education was dangerous to women's health, girls attended public schools and the private academies in growing numbers, so that by the end of the century girls outnumbered men two to one in public high schools. Educators like Zilpah Grant, Mary Lyon, Lydia Sigourney, Eliza Leslie, Emma Willard, and Catharine Beecher launched academies for girls, such as Troy Seminary (1821), Ipswich Female Academy (1828), and Mount Holyoke Female Seminary (1837), where Emily Dickinson studied. Catharine Beecher, who in 1823 founded the Hartford Female Seminary, stressed the importance of moral philosophy for young women training to be teachers. In her *Suggestions Respecting Improvements in Education, Presented to the Trustees* (1829), she proposes a school in which

> the formation of personal habits and manners, the correction of the disposition, the regulation of the social feelings, the formation of the conscience, and the direction of the moral character and habits, are united, objects of much greater consequence than the mere communication of knowledge and discipline of the intellectual powers.[43]

Citing their authority as educators, women like Sigourney and Beecher developed textbooks and reading materials that would help girls negotiate the larger world of letters and argued for the value of female education to the girls, their families, and the wider public. Indeed, such was the cultural currency of the female educator that it afforded women a creditable motive for breaking into print. Many

women's prefaces cite educational motives as a justification for publication, or they adopt the guise of a teacher or mentor to narrate their book, as did Susanna Rowson in *Mentoria* (1791), a series of instructional letters for girls narrated by a governess who breaks into print at the urging of her "friends."

Female academies offered girls a wide range of subjects, including botany, mental philosophy, modern languages, history, and geography, with particular emphasis on literacy instruction. The Albany Female Academy, for example, founded in 1836 and "designed to be useful and practical," offered multiple levels of language instruction, such as rhetoric, composition, criticism, grammar, parsing, elocution, reading, and orthography, organized by a variety of language textbooks. In the first level, the "rudiments of education are commenced," and in the second level, "regular instruction in writing commenced." Working with a grammar, a first reader, geography and natural history textbooks, and a catechism, students focused on basic literacy acquisition: "As an exercise in the definition and use of words, and the structure of language, the pupils are daily required to incorporate in sentences, to be written by them, words given to them by their teachers." In the more advanced levels, students began "exercises in the journal and letter form," prepared compositions, and finally studied rhetoric, criticism, classics, and mental philosophy. Composition remained a focus for even the most advanced students ("critical attention is paid to composition, in which there are frequent exercises").[44]

The academies' emphasis on literacy and its relationship to other desired lessons is worked out in considerable detail in a book published by J. M. D. Mathews, principal of the Oakland Female Seminary in Cincinnati. *Letters to School Girls* (1853) was published by the Methodist Episcopal Church and dedicated "to those ladies who have at any time been the pupils of the author."[45] Based on lectures Mathews gave in 1848 and 1849 at Oakland, the letters offer advice on a range of literacy practices, topics, contextual concerns, and opportunities, beginning with letters on study and reading and offering sections on conversation, manners, dancing, religion, prayer, the Sabbath, health, temperance, missions, marriage, and duties to parents. Citing the influence of a mother who taught him, Mathews announces strongly, "I am in favor of extensive female education." He encourages the girls to see literacy training as a lifelong activity, fostering a habit of critical skepticism about what they read ("don't believe every thing you read, merely because the book says so").[46] Mathews advises that literacy is the antithesis of the decorative arts often associated with female learning at the time. He warns against treating learning casually

or as mere show, encouraging them by "hard study" to aim for a more sophisticated understanding of their lessons:

> Some would be glad to have the knowledge, but they dislike to perform the labor. They slight their lessons, endeavor to cheat the teachers at recitation, and pass through the session without understanding any thing well. . . . Be not like those idle girls, who care not whether they understand their lessons or not, provided difficult things come to other members of the class, and they can get along without missing at recitation.[47]

He argues against offering girls "a smattering of knowledge" rather than concentrating their focus on a few significant subjects at a time and opposes what was a common instructional practice of the time, the commitment of lessons to memory, advocating instead that girls "endeavor to understand the meaning of your lesson, so that you can express the ideas of the author, not in the words of the book but in your own language." Mathews goes so far as to argue that the girls cannot be sure that they "have the idea correctly" until they can express it in their "own way."[48] The book offers a warning chapter on plagiarism, a recurrent problem among nineteenth-century school-children forced to write about unfamiliar set topics. And it also advises its schoolgirls about the material conditions of literacy, telling them to keep their books clean: "Do not tear them, nor double them back, nor scribble in them. It is a shame to abuse books as some lazy careless girls do."[49]

Mathews's book both chronicles and disseminates a growing attention to girls' education and literacy. He reports that the number of schools for girls is increasing and expects that "many that enjoy such advantages will probably read the present series of talks."[50] His students attend school for six hours a day, are assigned two hours of homework each evening, and have eight hours of leisure time that Mathews—and other educators like him—are eager to see filled with "wholesome" activities. The strong emphasis on directed forms of reading and writing—monitored by the keeping of commonplace books and journals and the establishment of children's periodicals, book clubs, and writing contests—suggests a social anxiety about the occupation and preoccupation of this leisured class. Mathews calls for a program of "useful reading" that would emulate the kinds of texts included in schoolbooks and approved anthologies of the day.[51] He warns extensively against the practice of reading novels because they "injure both the intellectual and moral nature" with a style "so fascinating, and the love-stories they contain so exciting, that girls who

read them at all are apt to become excessively fond of them." In what was a cultural commonplace, reading novels is compared to "feeding children on sweetmeats and candies," which causes readers to "lose their relish for wholesome food" and to have their health "injured or destroyed."[52] (A comparable warning appears in the widely distributed *American Woman's Home,* written in 1869 by the educator and domestic expert Catharine Beecher and her famous sister, the novelist Harriet Beecher Stowe. In the chapter entitled "Health of Mind," the authors warn against undisciplined reading and "indulgence of the imagination" for young girls. The kind of "castle-building" encouraged by reading novels, "unless counterbalanced by physical exercise, not only wastes time and energies, but undermines the vigor of the nervous system.")[53] Mathews substitutes for the riskier novels a more suitable list of books for young ladies with time on their hands, offering in particular Rollins's *Ancient History,* fables about Ferdinand and Isabella, and the history of Charles V. "Do you inquire what you shall read?" Mathews asks rhetorically, since young ladies would have had little control of their book selection. "You may be improved by reading history, biography, travels, or poetry. If you once acquire a taste for such reading, you will find it quite as interesting as novel reading, and vastly more profitable. You will be conscious that you are making additions to your stock of knowledge, and strengthening your mental faculties."[54]

A growing number of middle- and even working-class girls had more opportunity for formal schooling. Girls were admitted to public high schools in Worcester, Massachusetts, in 1824. In 1826, a high school for girls was established in Boston to complement the Boys' English Classical School (which had opened in 1821 and offered a more "practical" curriculum to less well-to-do boys than did the older, more prestigious Boston Latin), but the girls' school was dissolved a few years later because of its "alarming success" in attracting more girls than could be accommodated.[55] The Female High School in New York City opened in 1826, a year after the high school for boys, and by 1827 it enrolled 374 students. High schools for girls became more urgent to fulfill the growing need for teachers, and they often overlapped with normal schools designed to train female teachers. The Philadelphia Girls' High and Normal School, founded in 1848, shows the professional path envisioned for girls attending school beyond the elementary level. An educational critic from Sweden wrote in 1853 that such a girls' school was needed before a city "attains her highest eminence. Educate the girls properly, and the world will soon see a better and nobler race of men."[56]

Schooling opportunities also grew for African American students and were often associated with mission or religious institutions or masked as caretaking efforts. Jackie Jones Royster names Katy Ferguson's School for the Poor in New York City (founded in 1793) as one of the first schools open to African American girls, followed by schools established in Georgetown (1820), Philadelphia (1820), Connecticut (1832), Washington, D.C. (1851), and Augusta, Georgia (1866).[57] Female seminaries opened for Native American girls, such as the Cherokee Female Seminary, founded in 1848 in Oklahoma and renowned for its literary magazine, *Cherokee Rose Buds*.[58]

Historian Linda Kerber describes the years from 1833 (marking the admission of women to Oberlin College) to the turn of the century as an era of "women's increasing access to institutions of higher education," an era marked by the founding of women's colleges (Vassar, 1865; Wellesley and Smith, 1875; Spelman, 1881; Bryn Mawr and Randolph-Macon, 1884; Mississippi State College for Women, 1884; and Barnard, 1889); the admission of women to liberal arts and state colleges, as well as to universities; and, by 1875, the admission of black women to such colleges as Oberlin, Wilberforce, Antioch, Fisk, Howard, and Atlanta.[59] In 1858, the regents of the University of Michigan warned that admitting women would be seen as a "very dangerous experiment . . . certain to be ruinous to the young ladies who should avail themselves of it . . . and disastrous to the Institution which should carry it out," but the 1870 shift to coeducation was applauded by *Godey's Lady's Book* as ending "the Oriental system of separating the sexes."[60] The issue of women's intellect and educational ambitions was a hot topic, debated in periodicals, collegiate forums, and private social circles. The question of women's education (and whether there should be coeducation) was a fairly common debate topic in nineteenth-century all-male colleges, where privileged young men disputed the question of gender difference and opportunity.

Working girls, such as the renowned operatives of the Lowell textile mills, were encouraged to see literacy as a wholesome and productive activity, a way of helping them better themselves socially and intellectually. Although the conditions of their work (long hours and low pay) could not have afforded them much leisure or health for study, they participated in an extraordinary variety of literacy activities: they attended improvement circles, evening school, and lectures; composed their own literary magazines; and borrowed books from boarding house visitors. The Lowell corporation sponsored a lending library, school, and well-publicized lyceum series of twenty-five lectures per season for a price of 50 cents. An 1835 diary entry by Mary

Hall records her pleasure in attending lyceum lectures on such diverse topics as ancient Rome and phrenology. Periodicals like the *Lowell Offering* (1840–1845) or *Operatives Magazine* (1841–1842), novels like *Lights and Shadows of Factory Life in New England* ("written by a Factory Girl," 1843), and memoirs like Lucy Larcom's *A New England Girlhood* (1889) and Harriet Hanson Robinson's *Loom and Spindle* (1898) disseminated an ideal of working-class literacy for girls both at home and abroad. Foreign visitors toured the mills to celebrate the signs of the girls' interest in education and culture, and Lowell was lauded as an exemplary environment for young girls. Although reading was forbidden in the mills themselves, Lowell operatives circumvented such bans, pasting "their spinning frames with verses to train their memories."[61] In an article published in 1881 in the *Atlantic Monthly*, Lucy Larcom recalled: "It has already been said that books were prohibited in the mills, but no objection was made to bits of printed paper. . . . It was a common thing for a girl to have a page or two of the Bible beside her thus, committing its verses to memory while her hands went on with their mechanical occupation."[62] Robinson, echoing Herman Melville's claim about the educational value of the whaling industry for boys, called the cotton mill her "Alma Mater."[63] Her reading list included many of the same texts treasured by middle-class literary culture (the poem "Lalla Rookh," books of travels and history, Longfellow), but she was also exposed to a more eclectic array of materials than a more sheltered girl would have been. To Larcom, the mill girls' literacy was both incredible and a fact: "That they should write was not stranger than that they should study, or read, or think. And yet there were those to whom it seemed incredible that a girl could, in the pauses of her work, put together words with her pen that it would do to print."[64]

The experience of the mill girls underscores a double reality about girls' literacy in the nineteenth century: it continued to be a social reality, and it remained, to many, an incredible change. Even as girls entered newly opened public spaces—schools, lyceums, publishing venues, and reading circles—their education and forms of expression continued to be objects of public scrutiny and concern. Literacy was valued for its ability to organize girls' inner lives and to occupy in useful ways their "free" time. The sentences copied in a commonplace book or journal were visible signs of industry and attentiveness; the text "performed" with feeling and proper emphasis indicated that the reader understood socially approved sensibilities. Such literacies allowed girls to "compose" an appropriate—and legible—self, for their own reflection and scrutiny and for the approval of parents and

guardians. Literacy thus served as an approved public activity and forum in which girls could learn to behave and interact, and its lack—like a lack of wealth, material objects, or mannered expertise—marked distinctions in privilege and class standing. But heightened literacy also allowed girls to make and maintain wider contacts and to engage more fully with the outside world and with each other. Changing economic circumstances for girls in the nineteenth century created a need for correspondence that went well beyond brief courtesy or sympathy cards and for varied skills in reading and even speaking. Literacy became a valuable mechanism for conducting household business, hiring and firing servants, or arranging for the delivery of household goods. As young women moved from the country to the city for work or took jobs in the cloth mills of the Northeast, as they emigrated from Europe or traveled to the West, letter writing became a way of maintaining family connections and negotiating the strangeness of new places. Girls had far greater outlets for self-expression, voicing opinions, and registering their responses. They read and marked their books, recited and critiqued authorized (and unauthorized) texts, and took part—even though in ways marked by their gender—in the nation's burgeoning culture of letters.

Jean Ferguson Carr

Notes

1. Sarah Knowles Bolton, *How Success Is Won* (Boston: D. Lothrop, 1885), pp. 77–89, 90.

2. Susan Winslow Hodge, ed., *The Elfreth Book of Letters* (Philadelphia: University of Pennsylvania Press [1835] 1985), p. 23.

3. Ellen Emerson, letter to R. W. Emerson, September 19, 1859, in *The Letters of Ellen Tucker Emerson,* vol. 1, edited by Edith E. W. Gregg (Kent, OH: Kent State University Press, 1982), p. 196.

4. Charlotte Forten Grimké, *The Journals of Charlotte Forten Grimké,* edited by Brenda Stevenson (New York: Oxford University Press [1854] 1988), p. 58.

5. Cathy N. Davidson, *Revolution and the Word: The Rise of the Novel in America* (New York: Oxford University Press, 1986), p. 66.

6. Elizabeth Stuart Phelps, *I Don't Know How* (Boston: Henry A. Young, 1866), pp. 122, 249.

7. Catharine Sedgwick, "Cacoethes Scribendi," in *Provisions: A Reader from Nineteenth-Century American Women,* edited by Judith Fetterley (Bloomington: Indiana University Press [1830] 1985), pp. 52–57.

8. Elizabeth Stuart Phelps, *Gypsy's Year at the Golden Crescent* (Boston: Graves and Young, 1867), p. 1.

9. Susan Warner, *The Wide, Wide World* (Reprint, New York: Feminist Press [1850] 1987), pp. 29–36.

10. E. D. E. N. Southworth, *The Hidden Hand; or, Capitola, the Madcap* (Reprint, New York: Oxford University Press [1859; first published as a book 1888] 1997), p. 89.

11. Harriet Jacobs, *Incidents in the Life of a Slave Girl,* edited by Jean Fagan Yellin (reprint, Cambridge, MA: Harvard University Press [1861] 1987), pp. 1, 31, 40.

12. "On Female Authorship," *Ladies' Magazine* 2 (January 1793): 69.

13. A. W. Abbot, "Female Authors," *North American Review* 72 (January 1851): 163.

14. Fanny Fern, "The Women of 1867," *New York Ledger* (August 10, 1867), reprinted in *Ruth Hall and Other Writings,* edited by Joyce W. Warren (New Brunswick, NJ: Rutgers University Press, 1986), p. 342.

15. Mary Torrans Lathrap, "Presidential Address to Michigan State Women's Christian Temperance Union" (1888), quoted in Carol Mattingly, *Well-Tempered Women: Nineteenth-Century Temperance Rhetoric* (Carbondale: Southern Illinois University Press, 1998), p. 58.

16. Noah Porter, *Books and Reading; or, What Books Shall I Read?* (New York: Scribner, Armstrong, 1870), pp. 41–42, 45.

17. Abbot 1851, vol. 72, pp. 151, 153, 163.

18. "On Female Authorship" 1793, vol. 2, p. 69.

19. "On Female Authorship" 1793, vol. 2, p. 69; Abbot 1851, vol. 72, p. 153.

20. Edwin Wilbur Rice, *The Sunday-School Movement and the American Sunday-School Union, 1780–1927,* 2d ed. (Philadelphia: Union Press, 1927), pp. 209–210.

21. Nan Johnson, *Gender and Rhetorical Space in American Life, 1866–1910* (Carbondale: Southern Illinois University Press, 2002), pp. 10, 14.

22. Anne Ruggles Gere, *Writing Groups: History, Theory, and Implications* (Carbondale: Southern Illinois University Press, 1987), p. 41.

23. Harvey Newcombe, *The Young Lady's Guide to the Harmonious Development of Christian Character* (Boston: Philips and Sampson, 1843), p. 33.

24. Newcombe 1843, p. 33.

25. Newcombe 1843, p. 194.

26. Newcombe 1843, pp. 191–195.

27. Newcombe 1843, pp. 191, 192, 193.

28. Davidson 1986, p. 74.

29. Lydia Maria Child, *The Girl's Own Book* (Boston: Carter, Hendee, and Babcock, 1831), p. iii.

30. Child 1831, p. 203.

31. Susan Miller, *Assuming the Positions: Cultural Pedagogy and the Politics of Commonplace Writing* (Pittsburgh: University of Pittsburgh Press, 1998), p. 172.

32. Miller 1998, p. 149.

33. Jacqueline Jones Royster, *Traces of a Stream: Literacy and Social Change among African American Women* (Pittsburgh: University of Pittsburgh Press, 2000), p. 136.

34. Royster 2000, p. 108.

35. Royster 2000, p. 139.

36. Carol Mattingly, *Well-Tempered Women: Nineteenth-Century Temperance Rhetoric* (Carbondale: Southern Illinois University Press, 1998), p. 1.

37. Lucy Larcom, *A New England Girlhood: Outlined from Memory* (Reprint,

Boston: Northeastern University Press, [1889] 1986), p. 70.

38. Larcom [1889] 1986, pp. 101, 66.

39. Larcom [1889] 1986, p. 67.

40. Lydia Sigourney, *The Girl's Reading-Book* (New York: J. Orville Taylor, 1837), p. 5.

41. Sigourney 1837, pp. 9–10.

42. Sigourney 1837, pp. 47, 130.

43. Catharine Beecher, *Suggestions Respecting Improvements in Education, Presented to the Trustees of the Hartford Female Seminary, and Published at Their Request* (Hartford, CT: Packard and Butler, 1829), p. 2.

44. *Albany Female Academy: Circular and Catalogue, 1836,* pp. 1591–1593 in *Education in the United States: A Documentary History,* vol. 3, edited by Sol Cohen (New York: Random House 1973).

45. J. M. D. Mathews, *Letters to School Girls* (Cincinnati, OH: Methodist Publishers, 1853), p. 4.

46. Mathews 1853, p. 18.

47. Mathews 1853, pp. 15–16.

48. Mathews 1853, pp. 16–17.

49. Mathews 1853, p. 25.

50. Mathews 1853, p. 26.

51. Mathews 1853, p. 27.

52. Mathews 1853, p. 22.

53. Catharine Beecher and Harriet Beecher Stowe, *American Woman's Home* (Reprint, Hartford, CT: Stowe-Day Foundation [1869] 1987), pp. 255–262.

54. Mathews 1853, p. 27.

55. Thomas Woody, *A History of Women's Education in the United States,* vol. 1 (New York: Science Press, 1929), p. 520.

56. Pehr Siljestrom, quoted in Woody [1929] 1966, vol. 1, p. 524.

57. Royster 2000, pp. 137–139.

58. Devon A. Mihesuah, *Cultivating the Rosebuds: The Education of Women at the Cherokee Female Seminary, 1851–1909* (Urbana: University Press of Illinois, 1993).

59. Linda K. Kerber, *Toward an Intellectual History of Women* (Chapel Hill: University of North Carolina Press, 1997), pp. 249, 230.

60. Dorothy Gies McGuigan, *A Dangerous Experiment: 100 Years of Women at the University of Michigan* (Ann Arbor, MI: Center for Continuing Education of Women, 1970), title page, pp. 29–30.

61. Edith Abbot, quoted in *The Factory Girls,* edited by Philip S. Foner (Chicago: University of Illinois Press, 1977), p. xix.

62. Lucy Larcom, "Among Lowell Mill-Girls: A Reminiscence," *Atlantic Monthly* (November 1881), reprinted in Foner 1977, p. 23.

63. Harriet H. Robinson, *Loom and Spindle; or, Life among the Early Mill Girls* (Reprint, Kailua, HI: Press Pacifica [1898] 1976), p. 25.

64. Larcom [1889] 1986, p. 223.

4

Girls' Literacy in the Progressive Era: Female and American Indian Identity at the Genoa Indian School

The Progressive Era (1870–1930) is marked by several forces that shaped U.S. girls' literacies, including the success of the common school movement (and coeducational high schools in particular), the progressive reform movement (especially in terms of progressive educators), new technologies of literacy and print media, women's leadership in social welfare legislation, and the proliferation of women's clubs and civic groups. All these forces shaped girls' reading and writing practices in both constraining and empowering ways. In this chapter, I examine girls' literacy experiences in the Progressive Era within the context of one group of American Indian girls who attended the Genoa Industrial Indian School (GIS), a federal off-reservation government boarding school in Genoa, Nebraska, which operated from 1884 to 1934. In analyzing the Genoa girls' literacies, I argue that although the dominant ideologies of the GIS and the progressive reform movement in general shaped the production and consumption of their texts, the girls also used literacy to write against and resist these ideologies. Thus, the GIS girls' literacy practices can be viewed as a case study for understanding how girls in the Progressive Era in general used literacy to secure material gains in their own lives.

By the end of the nineteenth century, the success of the U.S. common school movement had greatly affected girls' literacy experiences and practices. Priscilla Ferguson Clement notes: "Advocates sold citizens on the worth of the common school by appealing to accepted religious, political, and economic beliefs."[1] Their success was reflected in the fact that nearly universal school enrollment for elementary-age children was achieved by 1890: "In 1890, almost 80 percent of American children ages ten through fourteen already attended school sometime during the year; by 1910, 88 percent did so."[2] This rise of formal schooling helped to alleviate disparities in girls' and boys' literacies: "by 1870 women had nearly equaled men in basic lit-

eracy, with women's illiteracy rates only one percentage point above men's 9 percent."[3] By 1900, coeducational high schools were the norm, with girls outnumbering boys by nearly a third in public high schools and women accounting for about one in five college students.[4] By the end of the nineteenth century, boys and girls were generally integrated within public high school classrooms, and they studied the same academic curriculum.

Riding on the heels of the common school movement was the progressive reform movement, spurred by the increasing social pressures of industrialism, urbanization, and immigration in the second half of the nineteenth century. This reform movement depended mainly on women, especially those of the middle class, who began extending their power in the public sphere by being "social housekeepers."[5] Their work not only led to organized efforts in improving child welfare, sanitation, housing, and recreation but also connected neatly to the suffragist cause.[6] As Nancy Woloch suggests, "Progressives endorsed a battery of electoral reforms and believed that all social problems could be solved by legislation. . . . enfranchising women would double the middle-class, educated, fair-minded electorate who would support other progressive reforms."[7] Oftentimes, reformers advocated government intervention as a means of controlling and disciplining other social groups (e.g., immigrants, American Indians, etc.) "supported by the rationale that families who did not adhere to middle-class definitions of domesticity and virtue were a threat to the American nation."[8]

Within educational contexts, progressive reformers viewed schools as the primary site for addressing social inequality. Progressive educators sought to broaden the program and function of schools to include direct concern for health, vocation, and the quality of family and community life.[9] The movement to educate and assimilate American Indian schoolchildren was a natural extension of progressive reformers' views that education could be an equalizing force in U.S. society. By the late 1800s, the federal government was grappling with what came to be called the "Indian question." With most of the American Indian population forced onto reservations, the government turned away from military force and toward education as a means of promoting American Indian assimilation. Thus the U.S. government created a system of day schools, reservation schools, and off-reservation boarding schools across the country to educate and assimilate American Indian children. The off-reservation boarding schools were modeled after the Carlisle Indian School in Pennsylvania, founded by Colonel Richard Pratt in 1879 and based on the philoso-

phy, "kill the Indian, save the man." Although specific institutional histories differ, for the most part scholars of American Indian education concur that the boarding school experience was and continues to be a seminal moment for generations of Indian families and communities.[10] It is against this social backdrop that the GIS girls' literacy practices can be read.

The Genoa Indian School

The Genoa Industrial Indian School was the fourth and one of the largest of the government Indian boarding schools built in the United States. Originally built for Pawnee children before the tribe moved from Genoa to Oklahoma in 1875, the GIS grew to encompass a 640-acre campus with over thirty buildings, sixty teachers and staff, and almost 600 students from over thirty different tribes.[11] As with other federal off-reservation schools, the earliest GIS students were recruited (and in many cases forcibly removed) from their reservation homes by school superintendents. GIS students were drawn primarily from reservations in Nebraska and South Dakota, but they also came from as far away as Canada and Michigan. Students as young as four years old were enrolled at the school, and they often stayed for ten or more years. Because school policies required that students stay three years before visiting home and because many families could not afford to fund student travel back and forth to the school, many students did not see family members (other than siblings also enrolled) for several years. In later years, many students chose to attend the GIS, either because of the school's reputation or because of the tradition of other family members attending. By 1934, when the school closed, several generations of family members claimed alumni status.

Although public schools during the late nineteenth century focused mainly on academic subjects such as reading, math, spelling, penmanship, and geography, government Indian schools focused heavily on vocational work (a predecessor to the vocational movement within the progressive movement).[12] The early GIS curriculum followed the "half and half" model instituted by Federal Indian Commissioner Thomas Morgan in 1890. Under this model, pupils studied traditional subjects half the day and then worked the remainder on vocational details in campus buildings such as the harness shop, the dairy barn, the printing shop, the bakery, and the laundry room. Because the GIS was underfunded—with the federal government allotting only $167.00 per student per year—the students' vocational duties were vital for sustaining the school's operation and usually took

precedence over academic studies.[13] Students made their own uniforms, grew their own crops, raised livestock, and performed daily work such as laundry, cooking, and cleaning.

Similar to public schools in which immigrant girls were placed in "sink-or-swim" English-only immersion classes, GIS girls' literacy instruction emphasized speaking and writing only in English.[14] Students were forbidden to speak native languages, even outside the classroom. Commissioner Morgan's views about the role of English in assimilation were the cornerstone of language instruction at all Indian schools:

> The Indian dialects are numerous, and in them there have come down the stories and traditions of their ancestors. . . . [which] have a tremendous force to keep them out of the tide of modern civilization.
>
> Give these young Indians a knowledge of the English language, put them into a great current of thought which is expressed in the English language and it will break that up.[15]

For Morgan and other educators, literacy in English was a vehicle for the transmission of "American" culture. In its early years of operation, GIS educators adhered to this privileging of "English only." In 1888 GIS superintendent Horace Chase wrote that he was especially fortunate because he had a corps of teachers "who are in thorough sympathy with the rule prohibiting the use of the Indian tongue" and that he had "as far as possible dispensed with interpreters, thus forcing all new-comers to quickly learn enough English to at least express their wants."[16] GIS teachers also used peer pressure and rewards to divide students between those who did and didn't speak only English:

> Tuesday was Mr. Backus's [the superintendent's] birthday. The girls who had not talked Indian for a month had their treat of nuts and candy up in the parlor, while those who had to pay the penalty were sent to their rooms with the privilege of listening to the merry-making of those who were enjoying themselves.[17]

Four months later, GIS administrators reported that girls who had not been able to speak "a word of English, are now making excellent progress, while reporting a roll-call for talking Indian grows decidedly less. With the exception of two or three new girls, all are prepared to say 'no' to speaking their home languages."[18]

In addition to speaking English, the GIS heavily promoted reading and writing. In 1886, the principal teacher, Bessie Johnston, wrote

an addendum to the yearly narrative report that "two Friday evenings each month we have exercises consisting of compositions, recitations, singing, &c."[19] A 1913 school calendar illustrates that literary society meetings were held every other week, and the 1931–1932 school handbook describes the library as holding 2,942 volumes and 51 different periodicals, with 300 additional volumes in the first six grades of the school.

In keeping with the importance of transmitting culture through reading, literature was considered a primary route for furthering students' assimilation. In an annual report to the commissioner, one teacher wrote: "We hope to obtain some story-books and pictorial papers for our boys and girls to read. They enjoy them thoroughly, and I am sure that it will broaden their views of life and give them a greater desire to live and be 'like a white man.'"[20] Although classes were coeducational, there were differences that shaped the girls' literacy practices, particularly with respect to constructions of female and American Indian identity. One such factor was the use of conduct fiction.

Conduct Fiction and *Stiya*

GIS educators' views about the value of reading literature for assimilation were, in part, an outgrowth of the legacy of conduct fiction. Throughout the eighteenth and nineteenth centuries, conduct fiction (in the form of tracts, letters, and novels) was a primary form of education for girls that participated in the cultural and social production of "girlhood" more broadly.[21] As Barbara Sichermann notes, "literature in general and fiction in particular have been critically important in the construction of female identity. . . . The scarcity in life of models for nontraditional womanhood has prompted women more than men to turn to fiction for self-authorization."[22] Conduct novels such as Martha Finley's *Elsie Dinsmore* (1867) or Faith Gartney's *Girlhood* (1863) usually affirmed the value of education and stressed the sentimental and social value of literacy, promoting the "social goals for the progress of the Republic."[23] In the Progressive Era, changing economic and social conditions of the late nineteenth century led to new markets for girls' conduct novels, which averaged fifty etiquette books per decade during the last thirty years of the nineteenth century.[24] To meet the reading demands of the expanding middle class, a juvenile literature market also emerged that "was increasingly segmented by gender."[25]

In keeping with conduct novels designed to teach middle-class girls how to behave, novels also were written expressly for girls who

represented disenfranchised social groups, including American Indians. K. Tsiana Lomawaima has noted how educators in off-reservation boarding schools were charged with teaching "Indian girls new identities, new skills and practices, new norms of appearance, and new physical mannerisms."[26] GIS teachers promoted this remaking of girls' identities through the reading of literary texts explicitly written for Indian youth. One literary text used to accomplish these aims was *Stiya,* a book written by Marianna Burgess (1891), a teacher and superintendent of printing at the Carlisle Industrial Indian School in Pennsylvania who frequently visited the GIS to give lectures. *Stiya* demonstrates dominant cultural ideologies about female and American Indian identity and offers a glimpse into the institutional ideology of the GIS more broadly.

As a conduct book, *Stiya: A Carlisle Indian Girl at Home* purports to be a realistic depiction of the transition between boarding school and reservation life, "founded on the author's actual observations." The plot revolves around Stiya, an Indian girl who attends Carlisle and then returns to her pueblo, where she becomes dissatisfied with her family and their way of life. Upon returning home, Stiya refuses to "dress Indian," engage in the family's domestic practices, or participate in a mandatory tribal dance. Stiya's refusal to dance results in her family's arrest, public whipping, and rejection by the community. But her courage in the face of this hardship inspires her father to take a job hauling coal for the railroad so that he can build his family a bigger home. In the end, Stiya's example transforms her entire family, which is confirmed by a visit from two former Carlisle teachers.

GIS students were frequently encouraged to read *Stiya,* as the May 22, 1891, edition of the *Pipe* illustrates:

> One of our teachers has received a copy of "Stiya," an account of an Indian girl's experience at her home after a few years at Carlisle. The story is written by one of the Carlisle teachers, and is replete with interesting facts, giving a very graphic description of the trials of a young girl and the strength and fortitude with which she met the barbarism and cruelty of her own people, and nobly stood up for the right. It should be read by every Indian girl and boy.[27]

Two weeks later, the June 5, 1891, *Pipe* further emphasized the importance of reading *Stiya* with an endorsement from the GIS superintendent: "Monday evening Superintendent Backus gave the children an interesting and instructive talk, using 'Stiya' for a text. It is a subject that cannot be too thoroughly discussed before the Indian children."[28]

As a conduct novel, *Stiya* reinforced assimilationist ideologies es-poused by government boarding schools and modeled strategies that girls could use to resist future "temptations" they might encounter after leaving these schools. American Indian girls were often ill pre-pared to return to reservation life after having spent years in govern-ment boarding schools, and educators worried that the money spent on educating and "civilizing" Indian youth would be wasted if they re-turned to the social and cultural practices of their communities. Samuel Tappan, GIS superintendent in 1885, described reservation life as having "the horrible and disgusting features of Mormonism, so-cialism, and kindred evils."[29] Similarly, 1887 GIS superintendent Ho-race Chase wrote in his annual report: "The difficulty lies not so much in the school children as in their parents and homes. . . . Struggle as they may they find the battle at home overwhelming and themselves almost helpless. . . . They must either return to school or drop down to the parents' level."[30]

Given these educators' attitudes, *Stiya* was a useful text for rein-forcing GIS assimilationist ideologies. One strategy that *Stiya* models is reading others' identities via their physical appearances and making judgments about their culture from these readings. For instance, upon returning home from Carlisle, Stiya views her parents with shock and surprise:

> "My father? My mother?" cried I desperately within. "no,"
> "never . . ."
> I had forgotten that home Indians had such grimy faces.
> I had forgotten that my mother's hair always looked as though it
> had never seen a comb.
> I had forgotten that she wore such a short, queer-looking black
> bag for a dress, fastened over one shoulder only, and such
> buckskin wrappings for shoes and leggings.[31]

Stiya emphasizes the importance of veiling such negative re-sponses while remaining determined to transform family members' appearances and daily practices. Stiya constantly monitors her inward feelings about her family, so as not to offend them but also to resist their values. In a conversation with a friend who has also recently re-turned home, Stiya advises rejecting parental advice about wearing native clothing: "It is best to obey our fathers and mothers, but, Annie, I think we know so much more than they do now that if we are kind to them we ought at the same time to do what we know is right, even if it is contrary to what they wish."[32]

Stiya served as an assimilationist handbook for GIS students' behavior both at and beyond the school campus. Stiya states that not to live the white man's way is to be unappreciative of the schooling that she received and thus she pledges to remain ever vigilant about her identity transformation: "Do you think I would be so ungrateful after the Government has spent so much time and money to educate me as not to use the knowledge I have obtained? . . . I mean to beat out the Indian ways, if such a thing is possible, and I believe it is possible."[33]

Thus, Stiya taught GIS girls not only to remake themselves and their bodies—through the adoption of western dress, manners, and habits—but also to remake their families and communities. When her mother tells Stiya that she will get used to washing clothes on rocks instead of a washboard, Stiya internally responds, "'never! I shall never wash this way again,' and I never did." Stiya then critiques her father, whose trousers come only below the knees: "A man among civilized people would not be called dressed if he wore such trousers."[34] The next day, Stiya uses the forty-seven dollars she has saved at Carlisle to refurbish her parents' home with cooking and cleaning supplies, a bed and mattress, dinnerware, and clothing, including a "white man's hat" for her father.[35] Throughout the book, Stiya remains purposeful in transforming herself and her parents according to the "civilized" ways espoused at Carlisle.

Of course, attention to the remaking of girls' bodies was not only a concern for GIS educators. As Joan Jacobs Brumberg describes, the Progressive Era saw increasing attention to the policing of U.S. girls' bodies, especially with respect to home hygiene. Departing from Victorian attitudes about beauty as derived from spiritual, internal qualities, Brumberg notes:

> in the first two decades of the twentieth century, women began to think about beauty and the self in ways that were more external than internal. Because of the introduction of many new kinds of cultural mirrors, in motion pictures and popular photography, in mass market advertising in the women's magazines. . . . girls began to subject their face and figure to more consistent scrutiny.[36]

The remaking of Indian girls' bodies was even more intense because it focused on them not only as individuals but as members of the larger Indian communities from which they came. And, of course, this project was explicitly directed by the educators, not the girls themselves. The literacy technologies that Brumberg describes as shaping girls' attitudes are reflected by the literacies that Genoa girls

consumed. For instance, *Stiya* uses pictorial rhetoric that contrasts Stiya's home and school lives to persuade readers that Indian boarding schools were transforming American Indian students. As Lonna Malmsheimer suggests, "before and after" photographs taken of Indian students served as "iconic representations of the cultural transformation that was the central aim of the school."[37] These photographs, sold to the public in the form of postcards and posters, functioned as evidence that the schools were fulfilling their assimilation mission. Photographs and advertisements published within the GIS's *Indian News* further reflect this attention to remaking American Indian girls' bodies. In the June 1915 edition, one page focuses on girls' hygiene with the heading, "Clean Teeth Lend a Glow of Sunshine to Your Smile."[38] Pictured above this heading are four Indian girls dressed in school uniforms and brushing their teeth. On the bottom of the page is a second photograph of a young Indian girl standing over a bowl, engaged in some kitchen activity. Beside this photograph is the following statement: "Personal cleanliness is a spiritual and physical development. To be clean of person is to be wholesome in the sight of those who are your neighbors, and to be at peace with your Maker." Another photograph published in the *Indian News* shows two pairs of GIS girls sitting together, with each pair composed of a girl dressed in a school uniform and the other dressed in native clothing. The girls in uniform are wearing their hair up, whereas the other two are wearing their hair in braids with feathers. The placement of the girls and their facial expressions suggest that the girls in uniform are caring for or protecting the other girls, who are clearly in need of being transformed.

GIS girls were also asked to participate in the construction of such identities by writing to school patrons about the values they were being taught at the school. For instance, Lucy Lasley's essay, "The Dress of the Genoa Students," illustrates how the social norms of the late nineteenth and early twentieth century regarding girls' physicality and appearance were connected to the "civilizing mission" of the federal government schools. Lasley's essay emphasizes similarities in fashion sense between Indian girls and "their White sisters":

> The [GIS] girls are dressed in the modern fashion of the day. They are dressed appropriately for school, work, and all social affairs. This being an industrial school, the students are not lavishly dressed at any time.
> The Indian girls, like their White sisters love pretty clothes, sheer silk hoses, and high heel pumps. Their knowledge of cosmetics is in evidence every day.[39]

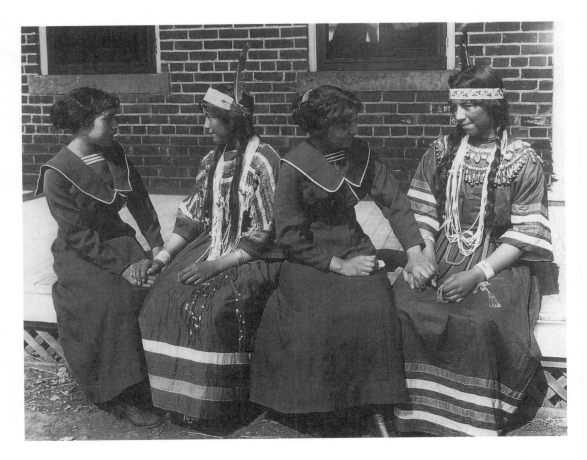

Native American girls (National Archives)

It is difficult to assess how conduct novels such as *Stiya* and the assimilationist images described above shaped GIS girls' perceptions because few written responses to them exist.[40] But one can examine how Genoa girls negotiated these discourses in relation to their female and American Indian identities via their classroom-based expository writing. Lucille M. Schultz documents how nineteenth-century reforms shifted the emphasis in classroom-based writing from abstract and depersonalized topics to the "experience-based essay," in which students "write about their own socially and historically and culturally situated lives."[41] In keeping with this shift, the May 1908 commencement issue of the *Indian News* showcases several eighth-grade persuasive essays, written on topics such as "Shall the Indian Tongue be preserved?" and "Should Indians be absorbed into the white race?" In analyzing the different approaches that GIS girls take in their classroom-based expository writing, one can read how GIS girls accepted, co-opted, and remade the GIS assimilationist ideology within their own lives.

In keeping with the ways American Indian culture was represented to them, many GIS girls compared their identities as Indian schoolchildren to that of immigrants from other countries. They de-

scribe themselves as competing not against whites but with other immigrants who share similar difficulties with speaking English. Despite this shared assumption about their foreignness, however, GIS girls do not agree upon the value of retaining their own native languages. Some girls assert that native languages can be maintained while learning English, but others argue that their native languages will keep them down from the "civilizing forces" of English. And although all assume that English is the social discourse of power, some do not believe that native languages need to be lost altogether. For instance, Zoe Lamson maintains that Indians should be encouraged to speak native languages and English so that they can move between them:

> I think the Indians should always be able to spea [sic] their own language whatever comes. They could also learn the English as most all of them do. . . . Nearly all the Indians can speak both languages even though they speak the English most of the time, they almost entirely forget their own speech. Most all the foreigners that come from their own countries can not speak English: but after they are over here awhile they almost forget their languages but when they go home it comes back to them very easily. The same with the Indians, when the boys and girls come to school and mix with the whites they almost forget the Indian languages. But when they go back again it all comes back to them and should be remembered.[42]

Lamson's essay speaks to the fears of GIS educators that students returning home will abandon English for their native languages. Besides pointing out how easily "it all comes back to them," Lamson asserts that such languages "should be remembered," a direct criticism of GIS's language policy that privileged English. Lamson's text resists the premises of the GIS language policy and asserts the value of her native language.

GIS girls' essays also speak to the question of assimilation. Not surprisingly, all the essays published assert that students should be assimilated. Yet their essays reflect different attitudes toward assimilation. Rather than participating in the discourse of blaming themselves for the "Indian situation," these girls lay responsibility for their situations squarely on the shoulders of the white people who displaced them. This naming of white responsibility usually occurs in the opening paragraph, before the girls then argue that Indians need to accept such conditions. For instance, the opening paragraph of Mary Rutledge's essay asserts the unfairness with which Indians have been treated: "In the first place the Indians owned this country, and they were gradually driven off their lands, by other nations, so we find

reservations where they are packed together."[43] Clara A. Livermore asserts: "Before the white people took possession of this country the Indians owned it; it was not right for the white people to take it by force; if they wanted the land why didn't they ask or buy it from the Indians. Sure they ought to to [sic] have bought it from them in the first place and not take it by force."[44]

Not all the girls' writing reflects resistance to GIS ideology, of course. Some students' texts reflect the GIS's ideologies almost wholesale. For instance, Ida McNamara argues that English is the more civilized language and thus should be privileged:

> The Indian boys or girls ought to learn the English language so well that they will not go back to their Indian language; for probably within a few years from now the Indian will not speak it, and why should they want to preserve it? The English language is far ahead of the Indian languages. . . . This world is not standing still but is growing more civilized every day, and I am sure the ambitious Indian boys or girls do not want to speak one language all the days of their life while there are so many foreigners coming to this country who are grasping the English language and are so ambitious to learn and why not the Indians take the same chance that is given to them?[45]

McNamara's appeals to progress and the civilizing forces of English echo Rutledge's essay, in which she writes: "I am sure the white people will never regret what they have done for the Indians. It is true the Indians are slow at learning, but if they are helped along they will one day know as much as their white brothers and sisters and make splendid citizens."[46]

Beyond expository essays, themes of resistance can also be read in the girls' more creative writing. For instance, a short story written by Nettie Worth and read at the girls' Victoria Society literary club mirrors the alienating experience that many GIS girls faced in government boarding schools. In the story, "The Mouse," a family of mice live happily in a field. As the mice grow older, the mother "often warned us to always be on the look-out lest those great big giants they call people may happen to run across us and then there would be no hope for us." One day the mother tells the mice to go out into the world and make a living. The siblings find a school building in which to make their home, where they discover the giants about whom they had been warned. As the narrator describes, one giant:

> was speaking in a language that I could not understand then I noticed that different ones got up and spoke in the same language,

then I knew that the giant who was in front of all the others must be the teacher and the others [sic] pupils that she was teaching.

After almost being caught by the giants while eating corn, the mouse "passed out of sight in a hurry and . . . never made another attempt at that corn since."[47]

Although written as a fictional account from a mouse's perspective, this story can also be read ironically as a commentary on the writer's experiences at the GIS and perhaps even as a response to conduct fiction like *Stiya*. *Stiya* laments the conditions of her childhood home, whereas the mouse reminisces about the "very nice home" and "kind" mother that attended to it. Instead of learning from the English language lessons, the mouse hides during these times: "somehow or other I was always able to escape unharmed." And in the final scene, when the mouse "saw these giants with their hands which were about three or four times as large as I . . . reaching out toward me," the mouse ran away. This scene can be read as a GIS girl's rejection of the school's assimilationist mission.

Gender, Race, and the Domestic Science Curriculum

Although the progressive education movement did not explicitly address gender in its social reform efforts, it did have important consequences for girls' education, particularly in terms of its vocational emphasis.[48] Spurred by social efficiency theory, progressive reformers called for more direct relationships between curriculum and students' work beyond school. Because girls' life opportunities beyond high school were still conceptualized primarily in terms of marriage and motherhood, the new vocational emphasis spurred a gender-differentiated curriculum, one in which girls were routed into courses in the "domestic sciences" that "elevated women's work to the status of nation building through the 'construction' of the country's citizens."[49] For progressive educators, courses in home economics were a logical extension of the ideology of true womanhood. The curricular message to middle-class girls "was that they should approach their studies from the perspectives of futures wives and mothers most certainly, and perhaps as teachers, office workers, or domestics."[50] As Knopp Biklen suggests, "higher education could be used not to advance the careers of economically independent women, but rather to create professional homemakers and mothers."[51] Thus, the domestic science curriculum was de-

signed not only to make housework more efficient but also to elevate its status to a "profession" so that girls could reconcile the tension between becoming economically independent and retaining a feminine image.

In contrast to the common academic subjects that boys and girls normally took together, the domestic science curriculum was typically for girls only. Beyond courses in sewing and cooking, the American Home Economics Association (1908) described domestic sciences as "the study of family consumption (or household economics), nourishment, family relations (calling upon psychology and sociology) and personal hygiene."[52] Although the domestic science curriculum for middle-class girls sought to professionalize the vocation of homemaking, its goals were decidedly different for girls in other ethnic and social classes. For the GIS girls, the domestic science curriculum reinforced the half-and-half curriculum that was already a staple of Indian boarding schools and further perpetuated racist attitudes of educators who "favored consigning whole groups to preparation for lowly work."[53] Because Indian girls were assumed to have inherited a "lower level of physical organization and mental capacity" than white girls, their domestic science curriculum focused on obedience to authority, subservience, and training as domestic workers.[54]

The impact of the domestic science curriculum—and its underlying assumptions about Indian girls' abilities to learn—can be seen in GIS girls' school writing. The June 1919 *Indian News,* for instance, published sixteen different girls' paragraphs about their domestic science work. These paragraphs describe the various tasks in which GIS girls engaged within the curriculum, such as baking cakes and breads and cooking chickens. These passages also illuminate how GIS girls attempted to combat the notion that they were inferior by emphasizing how hard they were trying to succeed. For instance, Annie Arrow Side writes, "I am entered on my first year Vocational in the Domestic Science Department, and am studying the different kinds of cooking. I am trying to make my work fine and correctly done. I am trying to be a good girl in working."[55] Similarly, Eloise Rave writes, "We have been trying our best . . . in our first year, trying to take great interest in our work. We are following right along with the course of study and trying to do as much work as we can do each day. We have to learn how to cook and we can't all go through life without learning how to do things." [56]

The domestic science curriculum also created a visible shift in the girls' academic writing. To advance the vocational component, the off-reservation boarding schools were encouraged to rely more heavily on practical demonstrations of student learning. One mechanism for making this change was the replacement of the "usual composition

contest" with a contest for demonstrations of students' industrial work.[57] This new focus on demonstrations shaped the essays that Genoa girls produced. Essays from the June 21, 1907, GIS senior program are typical. They average from thirteen to fifteen paragraphs and focus on the origins of the materials or ingredients that the girls were using in their demonstration—such as making an apron or a cake. After reading these essays aloud, the girls would then demonstrate their particular skills for audience members.

Beyond describing the specific types of domestic work in which GIS girls engaged, these essays also illustrate how the girls were taught to view their educational work in concert with federal Indian policies regarding land allotment and the increased use of commercial agriculture throughout the Great Plains.[58] In keeping with the school's assimilationist mission, these essays often make reference to the national project of manifest destiny, affirming the inevitable progress of western expansion through agriculture (and, implicitly, the right and inevitable loss of land and communal practices of Native American peoples). As Carolyn A. Haynes states, "The rhetoric of manifest destiny predicted and celebrated a divinely ordained spread of democracy, individualism, capitalism, and civilization throughout the North American continent." This rhetoric was especially important in the assimilation of Indian students because the "triumph of the nation could only be accomplished through the concomitant removal, acculturation, or elimination of nonwhite peoples."[59] Such rhetoric is evident in the GIS girls' writing. For example, Mabel Davis wrote and read from an essay about the origins and production of cotton before demonstrating her ability to make an apron. The initial paragraphs of the essay are similar to a research essay, providing a historical context for her topic on the origins of cotton: "We are told that cotton was unknown in the most ancient times and not until about 450 years before Christ. It was for the first time mentioned by Herodotus the ancient historian. This is the first record of the use of cotton, but undoubtedly it was used many years before he wrote."

Davis then invites readers (and listeners) to imagine those involved in the production of cotton:

> Let us take an imaginary trip down to South Carolina, and visit one of these beautiful fields. . . . we discover that nearly all the work on the plantation is hand labor and is performed by the negroes. We notice them with bags tied about their necks or waists in which they put the cotton, and then empty it into a large basket, when filled they place the basket on their heads and carry it to the place where it is ginned.[60]

One can read Davis's essay in terms of support of manifest destiny, in which the agricultural production of cotton is a sign of progress and civilization for the United States at large. Ironically, she focuses on another marginalized group, African Americans, instead of American Indians as laborers in this national project. Davis's writing then shifts into a performative mode whereby she demonstrates her sewing abilities: "there are many varities [sic] of cloth made from cotton, we can only notice one, and here is a piece of the finished material which I will use to demonstrate in cutting of an apron." Mamie Stewart's essay, "From Field to Kitchen," follows a similar rhetorical model in describing the origins of wheat prior to her demonstration of how to make dropcakes. Like Davis, Stewart's essay emphasizes the "civilizing" force of European-style agriculture, "When the inhabitants of a country sow wheat we know that civilization is there, for it makes the people stay and build their homes."[61] She then tells the story of a young girl who compares the ocean to the "beautiful sight" of "the waving ocean of grain at home." Both essays contextualize the girls' domestic labor in terms of the civilizing importance of manifest destiny in their own lives and the country at large.

But not all GIS girls' writing can be read as simply the internalization of dominant ideologies. The questioning of ideologies of domesticity and manifest destiny can be read in Rosalie Sherman's class essay summarizing the class of 1907's experiences. Sherman begins with the traditional tropes regarding the march of progress represented by the country at large and then represents her own experiences (and those of the other five girls graduating) as participating in this civilizing project:

> We have traced the history of the English people from their earliest barbarous days to the present, where we find them a mighty nation, having all that civilization can give. Taking the subject of our manual training, I think we have accomplished enough to work our way through life. We girls can all make our own dresses and cook a nice meal, and also have learned to take care of our homes. We would be glad to have you come and make us a visit some day in our own little houses, and then you can see for yourselves what we have accomplished in school.[62]

But Sherman's essay complicates this reading by suggesting that she and other girls have not acquired all that they need from the GIS. She notes, "We don't say that we have learned all that there is to learn, because we know none of us have gotten to the point where we can say we know it all. We do not think that because we have gotten

over the little obstacles that have come in our way, we can now go on smoothly. No, there are larger obstacles to over come and conquer yet." One struggle that Sherman describes is the difficulty of retaining students for graduation, foregrounding the high failure rate of federal Indian boarding schools to educate their pupils: "As a class we have struggled to keep together. A year ago there were eleven of us but as you all can see some have dropped out, and now there are only six of us that have worked our way through so far."[63] Even among those six, Sherman writes, "Three of us feel that we have not accomplished all there is in store for us and so have decided to attend school again."[64] So although Sherman's essay seems to affirm the model espoused by *Stiya*—that visits to their own homes would reflect their school accomplishments—one can also read it in terms of critique about the failure of the GIS to prepare her as well as it might have.

Extracurricular Writing

A final site for analyzing GIS girls' literacy is in the myriad forms of public writing—what Anne Ruggles Gere describes as the "extracurriculum"—in which they engaged.[65] As Schultz suggests, the extracurriculum of students' literacy practices includes "letters, memoirs, and diaries; and . . . the border space between the classroom and home, [where] they wrote for their school newspaper or literary journal."[66] Although Schultz views these forms of writing as generally "self-sponsored," in the case of the GIS girls, this writing was often directed by GIS teachers or written in response to school policies. For instance, GIS girls used writing to promote public relations about the school and to request changes in school policies. Public relations were critical in persuading government officials and school patrons to donate money and resources to the school. Consequently, GIS girls were often asked to write about their school experiences to community residents. For instance, the senior high school girls wrote a set of essays on topics such as "Academic Courses," "Social Activities," "Summer Vacation," and "Girls' Physical Education" in response to a request from Mrs. Linda Mumford in Beatrice, Nebraska. GIS girls also were asked to write to girls' clubs throughout the country via pen pal exchanges. One group with whom GIS girls corresponded was the King's Daughters in Boston. Although the letters that Genoa girls sent to their pen pals were not preserved, the letters that they received from the Boston girls were frequently published in the *Pipe of Peace,* along with exhortations for Genoa girls to write more frequently.[67]

GIS girls' extracurricular writing also consisted of letters and requests to school administrators. The school archives bulge with letters to school personnel written by GIS students. One frequent form of communication was the request to visit home. Because school funding was tied to the number of pupils enrolled, school administrators usually refused to allow students short visits home for fear that they would not return. When students' requests were denied, some wrote directly to the Indian commissioner for a second opinion. Iva Valliere wrote such a request for permission to go home for a week:

> Would you please let me go home on a visit as I have been gone for a year and want to go home for a while. I want to stay a week at home and then come back to school. All the rest of the girls got to go home and I didn't. Mr. Chandler, my agent said if you were willing for me to go home a week it was all right with him. I have been good and I have always minded the rules.[68]

In keeping with the in loco parentis role that GIS educators assumed for their pupils, Valliere's letter illustrates her use of literacy to gain agency. It is interesting that her rhetoric mirrors that of a typical teenager attempting to gain privileges—negotiating for rights on the premise that "All the rest of the girls" had them, reminding the reader that she has always played by the rules of the GIS, and referring to her reservation agent, Mr. Chandler, in an attempt to bolster her claim with another administrator's approval. The superintendent's reply to the commissioner—which was never sent to Valliere herself—shows his belief that the mother sought Valliere's inheritance from her dead father and that her request to return for a week "is simply a ruse to get home. She would not return."[69] Clearly Valliere could never have persuaded the superintendent about the validity of her request given the assumptions undergirding his decision, but her letter does show that GIS girls used literacy in ways that sought to improve their own lives.

Other GIS girls used writing to lodge complaints about their treatment. In 1909, several girls wrote Commissioner R. G. Valentine asking for the removal of their house matron.[70] Although the girls' original letter no longer exists, apparently their rhetoric was successful because the commissioner wrote to the superintendent:

> From the tone of the letter, I judge that these girls are sincere in their complaints, and did not write in a malicious or defiant spirit, and it seems to me that a kind-hearted, tactful employee with a knowledge of where the trouble lies should be able to win them over in a very short time. Much discontent and home-

sickness can often be overcome by giving thoughtful considera-
tion to such appeals as this.[71]

In addition to these forms of writing, GIS girls also participated
in the production of the *Indian News,* a monthly newspaper that was
distributed not only to students and their families but also to sub-
scribers nationwide, including school alumni, other government
boarding school employees, and community patrons. Although the
content of this newspaper was tightly regulated by school administra-
tors, it did offer GIS girls opportunities to represent their classroom
compositions and their extracurricular work, such as speeches writ-
ten for debate contests. In addition, the *Indian News* published letters
from school alumni, thus providing a site for exchanging information
about former students and for maintaining connections to Indian
communities beyond the school's boundaries. Thus, although GIS
girls' educational experiences are often read in primarily assimilation-
ist terms, they did use reading and writing to resist these constraints,
both inside and outside the classroom.

Conclusion

In 1934 the Genoa Indian School was closed after a change in federal
policy that aimed to educate Indian children more economically and
efficiently in public and reservation schools. Most students returned
to day schools on their reservations or entered public schools in their
home communities. Although the GIS girls' literacies were shaped by
the school's particular and local context, the artifacts they left behind
also reflect more generalizable patterns regarding girls' literacy expe-
riences in the Progressive Era. Although it is difficult to know the ex-
tent to which GIS girls were resisting school ideologies based on the
literacy artifacts they left behind, their texts offer insights into how
their reading and writing participated in, contributed to, and remade
their experiences of being female and American Indian within a fed-
eral government boarding school. And although GIS girls faced
unique constraints with respect to how the domestic science curricu-
lum was conceptualized or technologies of literacy were used to rep-
resent their identities, they faced similar pressures as mainstream
girls, particularly in terms of using their reading and writing to gain
access in increasingly public contexts. As Catherine Hobbs suggests,
literacy for women of the nineteenth century (and I would argue
twentieth as well) was both a social disciplining and liberating phe-
nomenon, creating women who were "empowered as subjects, sub-

jects who could not only resist restrictive socialization, but who could imagine alternatives and broader spheres of action."[72] As the GIS girls' literacy artifacts suggest, girls in the Progressive Era used reading and writing to construct and assert their identities in response to the varied pressures they faced in a rapidly changing society.

Amy Goodburn

Notes

1. Priscilla Ferguson Clement, *Growing Pains: Children in the Industrial Age, 1850–1890* (New York: Twayne Publishers, 1997), p. 83.

2. David I. Macleod, *The Age of the Child: Children in America, 1890–1920* (New York: Twayne Publishers, 1998), p. 76.

3. Catherine Hobbs, "Introduction: Cultures and Practices of U.S. Women's Literacy," pp. 1–33 in *Nineteenth-Century Women Learn to Write*, edited by Catherine Hobbs (Charlottesville: University Press of Virginia, 1995), p. 2.

4. John L. Rury, *Education and Women's Work: Female Schooling and the Division of Labor in Urban America, 1870–1930* (Albany: State University of New York Press, 1991), p. 11.

5. Marilyn Dell Brady, "The New Model Middle-Class Family (1815–1930)," pp. 83–123 in *American Families: A Research Guide and Historical Handbook*, edited by Joseph M. Hawes and Elizabeth I. Nybakken (New York: Greenwood Press, 1991), p. 104.

6. Nancy S. Dye, "Introduction," pp. 1–9 in *Gender, Class, Race, and Reform in the Progressive Era*, edited by Noralee Frankel and Nancy S. Dye (Lexington: University Press of Kentucky, 1991), p. 2.

7. Nancy Woloch, *Women and the American Experience*, 2d ed. (New York: McGraw-Hill, 1994), p. 337.

8. Brady 1991, p. 105.

9. Lawrence A. Cremin, *The Transformation of the School: Progressivism in American Education 1876–1957* (New York: Alfred A. Knopf, 1961), pp. viii–ix.

10. For general histories, see David Wallace Adams, *Education for Extinction: American Indians and the Boarding School Experience, 1875–1928* (Lawrence: University Press of Kansas, 1995); Michael C. Coleman, *American Indian Children at School, 1850–1930* (Jackson: University Press of Mississippi, 1993); Francis Paul Prucha, *The Churches and the Indian Schools 1888–1912* (Lincoln: University of Nebraska Press, 1979). For histories of particular schools, see K. Tsianina Lomawaima, *They Called It Prairie Light: The Story of Chilocco Indian School* (Lincoln: University of Nebraska Press, 1994); Robert A. Trennert, Jr., *The Phoenix Indian School: Forced Assimilation in Arizona, 1891–1935* (Norman: University of Oklahoma Press, 1988); Devon A. Mihesuah, *Cultivating the Rosebuds: The Education of Women at the Cherokee Female Seminary, 1851–1909* (Urbana: University of Illinois Press, 1993); Isabelle Knockwood, *Out of the Depths: The Experiences of Mi'Kmaw Children at the Indian Residential School at Shubenacadie, Nova Scotia* (Lockeport, N.S.: Roseway, 1992).

11. Wilma Daddario, "'They Get Milk Practically Every Day': The Genoa Indian Industrial School, 1884–1934," *Nebraska History* 73, no. 1 (Spring 1992): 2–11.

12. Macleod 1998, p. 84.

13. Daddario 1992, p. 4.

14. Selma Berrol, "Immigrant Children at School, 1880–1940," pp. 42–60 in *Small Worlds: Children and Adolescents in America, 1850–1950,* edited by Elliott West and Paula Petrik (Lawrence: University Press of Kansas, 1992), p. 45.

15. *Pipe of Peace* [Genoa, NE] May 29, 1891, pp. 1–2. Lincoln: Nebraska State Historical Society.

The *Pipe of Peace* was the Genoa Industrial Indian School's first newspaper, published weekly from 1886 to 1890. The *Indian News* was the second GIS newspaper, published monthly from 1897 to 1920 and 1930 to 1934 ([Genoa, NE] Nebraska State Historical Society, Lincoln, NE). For more about the role of American Indian school newspapers, see Daniel F. Littlefield, Jr., and James W. Parins, *American Indian and Alaska Native Newspapers and Periodicals, 1826–1924* (Westport, CT: Greenwood Press, 1984); and James E. Murphy and Sharon M. Murphy, *Let My People Know: American Indian Journalism, 1828–1978* (Norman: University of Oklahoma Press, 1981).

16. Horace R. Chase, "Reports of Indian Schools," *Annual Report of the Commissioner of Indian Affairs to the Secretary of the Interior, United States Bureau of Indian Affairs* (Washington, DC: Government Printing Office, 1888).

17. *Pipe of Peace,* April 17, 1891, p. 3.

18. *Pipe of Peace,* August 28, 1891, p. 1.

19. Bessie Johnston, "Reports of Indian Schools," *Annual Report of the Commissioner of Indian Affairs to the Secretary of the Interior, United States Bureau of Indian Affairs* (Washington, DC: Government Printing Office, 1886), p. 13.

20. Johnston 1886, p. 13.

21. Lynn Vallone, *Disciplines of Virtue: Girls' Culture in the Eighteenth and Nineteenth Centuries* (New Haven, CT: Yale University Press, 1995), p. 157.

22. Barbara Sicherman, "Reading *Little Women:* The Many Lives of a Text," pp. 245–266 in *U.S. History as Women's History: New Feminist Essays,* edited by Linda K. Kerber, Alice Kessler-Harris, and Kathryn Kish Sklar (Chapel Hill: University of North Carolina Press, 1995), p. 249.

23. Jane E. Rose, "Conduct Books for Women, 1830–1860," pp. 37–58 in *Nineteenth-Century Women Learn to Write,* edited by Catherine Hobbs (Charlottesville: University Press of Virginia, 1995), p. 39.

24. Ellen M. Plante, *Women at Home in Victorian America: A Social History* (New York: Facts on File, 1997), pp. 2–4.

25. Sicherman 1995, p. 250.

26. Lomawaima 1994, p. 204.

27. *Pipe of Peace,* May 22, 1891, p. 3.

28. *Pipe of Peace,* June 5, 1891, p. 3.

29. Samuel F. Tappan, "Reports of Indian Schools," *Annual Report of the Commissioner of Indian Affairs to the Secretary of the Interior, United States Bureau of Indian Affairs* (Washington, DC: Government Printing Office, 1885), p. 228.

30. Horace R. Chase, "Reports of Indian Schools," *Annual Report of the Commissioner of Indian Affairs to the Secretary of the Interior, United States Bureau of Indian Affairs* (Washington, DC: Government Printing Office, 1887), p. 246.

31. Mariana Burgess, 1891, *Stiya* (Cambridge: Riverside Press), p. 3.

32. Burgess 1891, p. 55.

33. Burgess 1891, p. 47.

34. Burgess 1891, p. 35.

35. Burgess 1891, p. 49.

36. Joan Jacobs Brumberg, *The Body Project: An Intimate History of American Girls* (New York: Random House, 1997), p. 70.

37. Lonna M. Malmsheimer, "Imitation White Man: Images of Transformation at the Carlisle Indian School," *Studies in Visual Communication* 11 (1985): 54.

38. "Clean Teeth Lend a Glow . . ." *Indian News* (June 1915).

39. Lucy Lasley, "The Dress of the Genoa Students," October 9, 1931, Genoa Indian School Archives.

40. One former student wrote a letter that was published in the September 4, 1891, edition of the *Pipe of Peace* espousing the value of *Stiya*: "Today I read the story of the Carlisle girl called 'Stiya.' All Indian children should read it and follow her example."

41. Lucille M. Schultz, *The Young Composers: Composition's Beginnings in Nineteenth-Century Schools* (Carbondale: Southern Illinois University Press, 1999), p. 114.

42. Zoe Lamson, *Indian News* (May 1908): 16.

43. Mary L. Rutledge, *Indian News* (May 1908): 17–18.

44. Clara A. Livermore, *Indian News* (May 1908): 20.

45. Ida McNamara, *Indian News* (May 1908): 17.

46. McNamara 1908, pp. 17–18.

47. Nettie Worth, "The Mouse," *Indian News* (March 1907): 23.

48. Sari Knopp Biklen, "The Progressive Education Movement and the Question of Women," *Teachers College Record* 80 (1978): 327–328.

49. Vallone 1995, p. 140.

50. Karen Graves, *Girls' Schooling during the Progressive Era: From Female Scholar to Domesticated Citizen* (New York: Garland, 1998), p. 279.

51. Knopp Biklen 1978, p. 327.

52. John L. Rury, "Vocationalism for Home and Work: Women's Education in the United States, 1880–1930," *History of Education Quarterly* (Spring 1984): 21–44, p. 24.

53. Macleod 1998, p. 84.

54. Lomawaima 1994, p. 201.

55. Annie Arrow Side, *Indian News* (June 1919): 7.

56. Eloise Rave, *Indian News* (June 1919): 7–8.

57. *Indian News* (September 1915): 20.

58. Alice Littlefield, "Learning to Labor: Native American Education in the United States, 1880–1930," pp. 43–59 in *The Political Economy of North American Indians,* edited by John Moore (Norman: University of Oklahoma Press, 1993), pp. 46–47.

59. Carolyn A. Haynes, *Divine Destiny: Gender and Race in Nineteenth-Century Protestantism* (Jackson: University Press of Mississippi, 1998), p. xi.

60. Mabel Davis, "Cotton," *Indian News* (September 1915): 5–6.

61. Mamie Stewart, "From Field to Kitchen," *Indian News* (September 1915): 6.

62. Rosalie Sherman, "Our Class History," *Indian News* (June 1907): 7–9.

63. Sherman 1907, p. 7.

64. Sherman 1907, pp. 7–9.

65. Anne Ruggles Gere, *Intimate Practices: Literacy and Cultural Work in U.S. Women's Clubs, 1880–1920* (Urbana: University of Illinois Press, 1997).

66. Schultz 1999, p. 129.

67. *Pipe of Peace,* May 15, 1891, pp. 2–4.

68. Iva Valliere, Letter to Federal Indian Commissioner C. H. Burke, September 4, 1922, Bureau of Indian Affairs Papers File 820 72150, National Archives, Washington, DC.

69. Sam B. Davis, September 18, 1922, Bureau of Indian Affairs Papers, National Archives, Washington, DC.

70. Lucy Dick and Lillian Wren, Letter to Federal Indian Commissioner R. G. Valentine, Bureau of Indian Affairs Papers File 154 20808, National Archives, Washington, DC.

71. R. G. Valentine, Letter to Sam B. Davis, March 24, 1909, Bureau of Indian Affairs Papers File 154 20808, National Archives, Washington, DC.

72. Hobbs 1995, p. 26.

5

"That Cosmopolitan Feeling":
Teenage Girls and Literacy, 1920–1970

Now don't get me wrong. . . . I get around. I read. I listen to the
radio. And I have two older sisters. So you see, I know what the score
is. I know it's smart to wear tweedish skirts and shaggy sweaters with
the sleeves pushed up and pearls and ankle-socks and saddle shoes
that look as if they've seen the world. . . . I'm not exactly too small-
town either. I read Winchell's column. You get to know what New
York boy is that way about some pineapple princess on the West
Coast . . . and why someone, eventually, will play Scarlett O'Hara. It
gives you that cosmopolitan feeling.

—Maureen Daly[1]

Maureen Daly won first prize when she entered her short story,
"Sixteen," in *Scholastic* magazine's national high school writing
contest. In the quote above, Daly includes reading twice among the
defining characteristics of teenage girls, amid radio, shaggy sweaters,
and saddle shoes. Reading represents both knowledge of her immedi-
ate teenage culture and access to the distant worlds of New York high
society and Hollywood gossip, allowing a small-town high school stu-
dent to feel "cosmopolitan." Daly's act of writing also demonstrates
her engagement with various media and her ability to weave national
messages into her story of teenage life. By the late 1930s, growing
awareness of teenage girls as a distinct group helped Daly's well-writ-
ten story of unrequited love and self-awareness resonate with adult
readers. Daly proved to be popular with teenage readers as well, pub-
lishing her first novel, *The Seventeenth Summer,* while in college in the
early 1940s. Over the next few years, she wrote a column for
teenagers in the *Chicago Tribune,* "The Sub-Deb" column for teenage
girls in the *Ladies' Home Journal,* and many more works of teen advice
and young love.

Daly's story demonstrated the importance of reading and writ-
ing in her life, but what did literacy mean for a broad range of teenage

girls in the twentieth century? How did girls negotiate reading and writing in an increasingly commercialized world, from material directed at them to the broader range of available materials, from formal writing in school to less formal expressions in diaries, stories, yearbooks, and letters? At the turn of the twenty-first century, terms such as "teenage" and "girl power" circulate widely. Catalogs, movies, television series, magazines, and websites designed for teenage girls abound. New websites and zines created by teenage girls appear regularly as girls adopt new technologies for expressing and negotiating reading and writing in public spaces. At the turn of the twentieth century, however, teenage girls received little attention from creators of consumer culture or commercial popular culture and wielded little power as a group—in fact, they were not yet defined as a distinct group.

As girls in the first half of the twentieth century outgrew books and magazines designed for children and found few media created specifically for their age group, they satisfied their reading interests in various ways, often integrating reading and writing into their lives in uniquely "teen" ways. In doing so, they strengthened their emerging group identity and played an active role in the development of teenage girls' culture and literacy. But the forces that shape markets and influence group identity are complex. Publishers cultivated girls' consumer desires and insecurities to sell products. Teenage girls navigated these consumer messages and challenged parents, schools, and even peers, over when and how to interact with these cultural symbols, yet they often accepted dominant social messages about femininity, heterosexuality, and beauty. High school girls defined themselves, in part, through the acts of reading and writing, and simultaneously, creators of reading and writing materials helped shape their identity and profit from it.

Education and Girls' Literacy

To understand what, how, and why girls read and wrote, we need to look at some larger changes in education and literacy leading up to and including this period. Elementary schooling spread nationally, though unevenly, in the nineteenth century. By 1900, 95 percent of Americans attended primary school. With this spread of public education, illiteracy fell. In 1900, 11 percent of the population was classified as illiterate; by 1930 the total illiteracy rate was 4.3. Illiteracy remained higher among African Americans. For example, the rate was 16.4 percent in 1930, but showed significant improvement over late-

nineteenth-century rates of 80 percent. High literacy rates, combined with inexpensive printing processes and a rapidly growing infrastructure of publishing, marketing, and advertising, led to a rise in publications targeted at specific audiences. By the late nineteenth century, some magazines and books were created for entire families, but materials were increasingly published specifically for men, women, or children. Recognition of a girls' market, separate from a boys' market, was apparent by the early twentieth century. But recognition of a distinct market for teenage girls that would both reflect and shape girls' reading and writing developed more slowly.[2]

The rise of high school was central to expanding female literacy and literature. In 1900, fewer than 7 percent of seventeen-year-olds graduated from high school. Although females slightly outnumbered males among graduates, high school remained an experience for the privileged few. By 1930, about 60 percent of all high school–age youth attended school, and almost 30 percent graduated. By 1940, close to 80 percent of fourteen- to seventeen-year-olds attended high school, and roughly 50 percent graduated. These numbers remained lower among African Americans and immigrants, but by 1960, 90.8 percent of whites and 86.8 percent of "nonwhites" aged fourteen to seventeen attended high school. High school had become a defining experience, and high school culture both a widespread reality and a market niche. The experience of high school would help shape girls' reading and writing, although not always in ways intended by teachers, administrators, or even publishers.[3]

As school curricula became increasingly standardized in the early twentieth century, girls' education focused on basic math and reading skills as well as "female" skills, such as bookkeeping, typing, and home economics. Even after World War II, when most classes were no longer restricted to girls or boys, girls were strongly encouraged to take gender-specific courses such as cooking, sewing, and home management. Schools also increasingly emphasized literacy for both girls and boys throughout the curriculum because reading and writing were understood as critical to full participation in society. In addition, schools supported expanded literacy in various ways outside the prescribed curriculum—sometimes unwittingly. Extracurricular activities such as school magazines and newspapers or clubs provided space and purpose for less supervised reading and writing activities. And by bringing together young people day after day, schools provided the essentials for peer culture that often led to shared literacy activities, such as notes passed in school, collective reading of magazines, and shared diary writing. Outside schools, although sometimes within

peer cultures fostered by school, girls used the tools of reading and writing to build a distinct teen culture, to interact with national popular culture and media, and to explore their emerging adult voices.

"I love books": Girls and Reading

Politicians, religious leaders, social scientists, and educators have long expressed concern over the influence of popular media on girls, from eighteenth-century novels to twentieth-century comics and movie magazines. In the 1920s, researchers found that first- and second-year high school girls still read children's magazines; by age fourteen or fifteen, they switched to women's magazines.[4] In the 1930s and 1940s, as material written specifically for teens increased, this concern resurfaced. A 1947 *Ladies' Home Journal* article, "What's Wrong with High School," blamed popular culture, including "comics, pictorial magazines, [and] monosyllabic pulps" for drawing "the youngster *away from good reading.*" The author further complained that youth "memorizes swing verses almost by osmosis, yet cannot quote a line of decent poetry."[5]

In the early 1940s, Alice Sterner investigated the influence of media on youth by studying the habits of high school students in Newark, New Jersey. Sterner found similar reading patterns across age, socioeconomic status, and intelligence. Gender proved the most significant factor in determining interest and reading habits—girls read more magazines than boys and were more likely to read romantic materials. *Life, Look, Reader's Digest,* the *Saturday Evening Post,* and *Liberty* shared the attention of boys and girls. Favorites exclusively among girls included women's magazines such as *Ladies' Home Journal* and *Good Housekeeping* and movie magazines, including *Movie Story* and *Silver Screen.* Sterner stated that girls found great joy in reading magazines.

In conclusion, Sterner wrote, "the power of any single [medium] has often been overemphasized," confirming Daly's contention that girls read and wrote in a dialogue with other media, especially during this period of growth and specialization of media.[6] When Sterner undertook her study, the publishing world had begun to recognize girls' interest in adult magazines and to address girls through special columns or booklets. By the time she published her work, after World War II, publications targeted specifically to teenage girls had emerged.

By the early twentieth century, girls' fiction had expanded from advice books to serials with active heroines such as Ruth Fielding. By the 1930s, this genre included Nancy Drew, a character whose hold on girls' imaginations remained powerful for decades.[7] June Corotto,

a high school girl in Ashland, Pennsylvania, in the mid-1940s, fondly remembered years later the Nancy Drew books she and her best friend read together: "every birthday [we] gave each other either a new book or a lapel pin." Corotto spent countless hours searching her grandparents' house for secret passages, "measuring walls and tapping for hollow areas (as I had read in my Nancy Drew mystery books). No part of the house was left unmeasured or untapped." Another diarist remembered scavenging library shelves and forty years later wrote, "I can still close my eyes and see exactly where different books were kept, Bobbsey Twins, Nancy Drew."[8] Girls read other books as well, including serials written for boys and books intended for adults, but the intense pleasure and powerful memories surrounding female heroines remained unsurpassed.

Why were these experiences so powerful? How did girls acquire, read, and analyze these books, both individually and collectively? Some girls recorded their reading habits in diaries and letters, providing clues to the meaning of reading. Yvonne Blue grew up near Chicago. She began writing her diaries at age eleven, and at age twelve, in the fall of 1923, she entered high school. Precocious, creative, and intelligent, she recorded her fantasies, friendships, and social life, as well as her rapid transition from a carefree child to a self-conscious high school student. She filled her diary with the books she read, blending plot summaries with analysis. In 1923, Blue wrote, "I bought 'Little Men.' . . . it sure is good. I think I like 'Little Women' better though." She frequently recorded various methods of attaining books—gifts from parents, books borrowed from friends or libraries, and books she purchased—as well as long lists of current favorites.[9]

In September 1923, Blue wrote, "I started the best book today. It is by Webster and is called 'Just Patty.' It is about boarding school. I love books about boarding school. Patty is full of mischief and very funny." She also imagined herself as characters in the books she read. After reading *The Beloved Vagabond* by William Locke, she wrote of her desire to be a vagabond, with the caveat, "I mean the neat, clean kind like Mifflin who philosophized." In 1925, after reading *Confessions of an Opium-Eater,* she flirted with danger, "I would like to take opium once. If I were sure I could stop at once." Another day, she wrote, "I read an article by Fans Messan, a French sculptor who won recognition by dressing as a boy. Oh how I would love it if Bobbie [a female friend] and I could dress like boys, steal rides on freight trains to New York . . . rent a studio as boys . . . and write and become famous."[10]

By 1926, however, at age fourteen, Blue and her best friend Bobbie added advice literature and women's magazines to their repertoire.

Blue's insecurity and anxiety about her appearance and relationships rose dramatically. In April 1926, she wrote, "Bobbie and I are planning to be *wonderful!* to improve ourselves. We want to be very thin and silent, but to say unusual things when we speak." The two girls formalized their pledge: "Our new passion is self-improvement. . . . we made up a wonderful set of rules." The rules centered on control of the body and the mind for the sake of attaining popularity, including "Keep polished," "Follow the Health chart," "Talk the right amount and clearly," "Go to extremes," and finally, "Have a way with people." A few days later, she requested "30 or 40 'Little Blue Books,'" while claiming "I know all about self-improvement."[11] Blue's reading choices remained eclectic, from Frances Hodgson Burnett to Jules Verne to Oscar Wilde. But her diary entries increasingly revolved around efforts to "improve" her body and behavior or to achieve "popularity."

Other girls recorded similar responses to advice columns and articles. Katherine Rosner lived in upstate New York and kept a diary during her sophomore year in high school in 1929. After reading an article in her school library, she wrote "a darling story that contained some awfully true things. It said that to be popular a girl must have *four* things: A. good looks. B. good clothes. C. nerve. D. practice." She then compared herself to these "truths": "Well, I know I'm not *terribly* homely, and I have fairly nice clothes, but the last two are conspicuous by their absence." A few months later, she wrote despondently, "I suppose the fault is partly my detestable self-consciousness, and partly my disgusting Inferiority Complex, and partly—the important, unknown part—a million other things. Oh, my life is all wrong, and I'm all wrong, and I haven't anything to live for." In contrast to Blue's strategy of entering her fantasy world, Rosner recorded anger at being excluded, "After reading the society section in the Sunday papers, I almost go mad. I'd give *anything* to be rich enough to go to boarding school. Sometimes I almost go wild wanting it."[12]

Just for Girls

When Rosner wrote these words, publishers were only beginning to recognize teenage girls as avid, faithful readers with disposable income. The first publications to address girls directly were *American Girl* and *Everygirl's,* the official magazines of the Girl Scouts and the Camp Fire Girls, respectively. These magazines catered specifically to organization members, though, and few outsiders subscribed. In the late 1920s, editors at the *Ladies' Home Journal* discovered that girls

read their mother's copies or even bought their own. They established a column entitled, "The Sub-Deb, a Page for Girls," and led the way for mass-circulation women's magazines to address younger readers. The first sub-deb editor wrote as though her readers were wealthy debutantes-to-be with an endless supply of friends and funds. The column advised girls on how to plan and host elaborate parties, grow out bobbed hair, dress elegantly, and develop skills such as decorating, cooking, and knitting.

When Elizabeth Woodward began writing the column in 1931, she addressed high school girls more directly, shifting the tone to that of a big sister and adding an emphasis on boys and relationships. Woodward strongly advised girls to *attract* dates by cultivating looks, listening skills, and a "fun" personality rather than *pursuing* them by calling boys on the phone or (gasp!) inviting a boy to a movie. The cardinal rule was to play games well, but not too well. These traits were also recommended for winning friends and teacher approval. Throughout the 1930s, advice on relationships expanded to include debates on going steady, petting, responsibility, and the dangers of peer pressure—issues that appealed to a high school audience.

As the column grew in popularity, articles and advertisements for girls appeared more frequently throughout the *Ladies' Home Journal*. Short stories praised virtuous teenage heroines who did not neck, drink, or smoke but always won the boy. Other characters flirted with career aspirations before meeting the "right" man and choosing marriage over career. The advice, party ideas, and fashions, though, were still designed to cultivate responsible, glamorous young adults.

The February 1938 sub-deb column "Shaggin' on Down," however, marked a new attempt to follow as well as lead. This column imitated teen slang in order to teach the "latest" dance steps—drawing upon dances already popular among many girls and spreading them further. The *Ladies' Home Journal* intensified these efforts in October 1942 with the introduction of a newspaper, "The Scoop"—related to the magazine but physically a distinct publication—with features, fiction, fashions, and club news produced just for girls.

The word about teens spread quickly. In February 1941, *Parents' Magazine* introduced the column "Tricks for Teens," based on a successful department store contest, inviting teenage girls and their mothers to submit descriptions and pictures of high school fads. The initial column addressed mothers and sympathized with their struggles to understand high school "fad-shions." Due to the enthusiastic response from teenage girls, however, the column soon addressed

girls directly, "TEEN-AGE high-schoolers, this is *your* feature. Urge mother to read it, too."[13] And *Parents' Magazine,* intended for adults, began to carry articles, fashion spreads, and advertising targeted specifically at teenage girls.

This interest led the Parents' Institute to introduce *Calling All Girls* in July 1941, the first general magazine designed exclusively for "girls and sub-debs." Filled with comics, *Calling All Girls* also contained short stories and advice on fashion, manners, and beauty. Advertisements for the new magazine assured mothers that its content would be entertaining and wholesome. In March 1944, "Tricks for Teens" moved to *Calling All Girls,* and *Parents' Magazine* returned to parents. Initially a quarterly magazine, *Calling All Girls* became monthly in response to high circulation and reader interest. It was not destined for long-term success, however, because the publishers never quite understood the audience or the advertising base. By 1945, circulation reached a respectable 500,000, but the emphasis on comics kept the average age of readers below thirteen. The age base and magazine format did not attract profitable fashion advertisers.

Seventeen magazine debuted in September 1944 with greater teen appeal. The first issue sold out quickly—400,000 copies in six days. Monthly circulation exceeded 1 million copies by February 1947 and two-and-a-half million by July 1949. *Seventeen* claimed to reach more than half of the six million teenage girls in the United States through copies shared with friends. Readers were mostly from white middle- and upper-middle-class families but reached across broader age and class boundaries than *Calling All Girls* and girls' columns.

Seventeen followed a recipe of teen fashion, beauty, movies, music, dating, boys, friendships, parents, careers, and education. Many girls liked it because it tried to make them better teenagers rather than good little girls or elegant adults. Helen Valentine, *Seventeen*'s first editor-in-chief, envisioned a magazine that would treat teenage girls seriously and respect their emotional and intellectual needs, in addition to helping them choose their first lipstick. To achieve this goal, the magazine included articles on war and inflation as well as regular book reviews. *Seventeen* also acquired substantial advertising revenue, translating its editorial message and teenagers' buying power to businesses and advertisers.

Although *Seventeen* drew from the experience of its predecessors, it quickly surpassed them. *Calling All Girls* attempted to mimic *Seventeen*'s success, deleting the comics and investing additional money in art, writers, and production. Parents' Institute also redi-

rected its efforts to attract preteens, aged nine to twelve, to a new publication, *Polly Pigtails*. Despite such changes and competition from glamour magazines such as *Junior Bazaar, Seventeen* firmly established the market for girls' magazines and remained the leading competitor until the 1980s.

In the 1950s, an explosion of magazines, such as *Modern Teen, Teen Time, Teen Parade,* and *Hep Cats,* sought the attention of working-class teens and offered teenagers an alternative to the middle-class messages of *Seventeen*. They frequently imitated movie, gossip, or pulp fiction magazines designed for adult audiences (but often read by adolescents before the advent of teen versions) and included many letters, advice columns, and fan news. Their popularity was sporadic, and they rarely stayed in print for long, but they did signify a further broadening of the teenage market. *Seventeen,* while retaining its hold on the middle-class market, changed in the 1950s as well. The original staff was replaced, and the magazine entered a period of transition toward closer ties with advertisers. The initial attention to responsible citizenship was almost entirely overshadowed by articles on fashion, dating, and early marriage.[14]

In the 1960s and 1970s, *Seventeen* and other girls' magazines responded to the feminist movement with a shift toward personal growth and independence. Articles on the Peace Corps, new careers in science, teen Democrats and Republicans, and racial prejudice joined the articles on clothes, looks, and domestic skills. *Seventeen*'s thirtieth anniversary edition in September 1974 heralded the new opportunities that had opened for teenage girls since the 1940s—girls could be anything they wanted to be and could successfully combine their careers with family life. These options appeared alongside articles and advertisements that continued to stress beauty, fashion, and male approval, though, offering mixed messages for readers to navigate.

In some ways, girls led the industry in the creation of teenage magazines. They demonstrated their passion for reading, especially about themselves, by appropriating parents' magazines or movie magazines. And when publishers finally took notice and begin catering to their interests, first through newspaper or magazine columns and eventually through dedicated publications, they became devoted fans. As competition increased, girls' magazines diversified and began to reflect more fully the range of adult publications available. *Seventeen* magazine remained the undisputed leader, though, for decades, offering a complicated array of messages, ideas, beauty, and fashion. Despite, or perhaps because of, these mixed messages, they appealed to a broad range of teenagers generation after generation.

"It is trashy, I supposed. But oh, so interesting!": Navigating Murky Waters

The existence of contradictions may in fact have helped teenage girls further develop their skills as critical readers, as they negotiated an array of messages and selected the messages that appealed most readily to their interests and beliefs. Between 1920 and 1970, reading options for girls changed significantly, but for the most part, reading remained a complex negotiation. Girls used their reading habits to establish themselves in relation to adults, children, and increasingly the world of teenagers. The writings and experiences of several teenage girls offer a glimpse into this complicated realm of interactive reading and growing teen identity.

Beth Twiggar, an aspiring writer, wrote frequently and passionately in a long series of diaries. Growing up in Ossining, New York, she entered high school in the mid-1920s and filled her diaries with rich, colorful descriptions of her friends, activities, and relationship to popular culture. Twiggar's writing often reflected the "jazzy" style of the 1920s culture that she deeply admired, and her wit, prescient analysis of the changing world around her, and knack for self-reflection make her diaries both entertaining and illustrative. She wrote on her birthday in 1928, "Yes by George. I'm coming on! Fifteen! Indeed I'm getting quite venerable. Acquiring new ways of maturity and not reading the Oz books." She separated herself from the books of her childhood, defining her maturity against them. The protagonist in a short story written by a high school girl in 1925 similarly placed herself "above" childhood, but in this instance by claiming what she *had* read: "She was above these trivial affairs. Had she not read [French philosopher, Henri] Bergson and understood it?" This author defined her maturity positively by identifying her reading ability and interest.[15]

More frequently, however, reading served to establish a girl's place among her peers. Reading together was a common activity. Yvonne Blue wrote casually in 1925, "After Ginny and I had looked at 'Life' for a while . . . [we] had some ice cream." Sharing magazines and books was equally common. "Save the movie classics please," Helen wrote repeatedly to her fifteen-year-old friend Frances. One high school senior donated her "precious leather-bound book of etiquette" in her yearbook "will" to save a younger girl "from further incriminations." As part of sharing, girls recommended books, often informing the recipient of the plot or anticipated emotional impact. "You surely have missed a book that would drive the blues away and make your sides ache with laughter," Adele shared in a 1929 letter.[16]

Escape from "the blues" is a recurring theme in girls' interactions with reading—it brought pleasure. Whether reading challenged girls to think or allowed them to escape into fantasy, strengthened teenage friendships or fostered notions of adulthood, pleasure remained central. One source of pleasure originated with materials deemed inappropriate by adults. Girls often wrote about the "guilty pleasure" they experienced while reading romance stories, movie magazines, or pulp fiction.

Yvonne Blue wrote in 1926, after reading the pulp fiction novel *Dope,* "it is trashy, I supposed. But oh, so interesting!" And these pleasures multiplied through sharing. Katherine Rosner wrote in 1929, "Saturday night when I slept at [a girlfriend's] house, she told me the story of a certain book, 'The Spaniard,' which sounded very thrilling, so today I bought it, and have already read it twice. It was *hot,* really, but the one [her friend] read, as a serial in the Sunday 'New York American' was much more satisfactory, and I was rather disappointed." A 1933 yearbook entry highlighted the pleasure of reading the "unapproved": "Well, well, is Miss S's face red? After all her lectures about good literature, see what the seniors read. First of all, Cosmopolitan, not so-o-o-o bad . . . but, oh look, at the literary value of the following: College Humor, Ballyhoo, Judge, and Peppy and Snappy stories. My! My!"[17]

Girls teased each other about such reading habits, as in this yearbook "will": "Helen leaves a volume of sentimental love stories. In case of napping, she recommends them as a keen soft pillow (that is, if the plot is especially mushy)." Similarly, in the yearbook photo accompanying this bequest, two girls posed for the camera, peering enthusiastically at a confessional magazine with the caption, "True confessions? Tisk!!!" Many other yearbooks played with this notion, presenting similar photos and drawings of girls daydreaming about movie magazines while pretending to read their schoolbooks or teasing girls who read them openly.[18]

This image of teenage girls reading magazines as a social activity became a stock characterization in portrayals of teenage girls by the early 1940s. A 1942 advertisement for Pepsi-Cola in *Scholastic* magazine depicted two teenage girls in one girl's bedroom, a symbol of middle-class space and values. One girl sits on the bed with an open book in her lap and a partially eaten apple in her hand, while the other looks into her dresser mirror, applying face powder. The second girl supposedly speaks in teen slang, ending not surprisingly with Pepsi's central role in teenage social life. The girl reading is part of the stock "teen" background, on equal par with applying makeup or drinking Pepsi.[19]

In this advertisement, the reading material is merely a prop, quickly thrown aside for a date and a Pepsi. But reading could also be thought provoking. June Calender had a much more complicated relationship to reading, as did most girls, than did these fictional Pepsi drinkers. Born on a farm in rural Indiana, Calender wrote a series of diaries during her high school years in the mid-1950s, and they record the strong influence of popular culture on high school girls outside urban centers. She read *Seventeen* magazine and regularly attended movies, adopting styles and attitudes while romantically envisioning herself a fashionable intellectual misplaced in a rural community. She commonly incorporated the rhetoric of advice literature for women and teenage girls into her writing, "I can be as witty as the next person; I dress as well as any of the 'top' girls; I'm as attractive as most; I can take responsibility better than many; and I have much more adult view-points than most; so what's wrong?" But she also reflected advice literature anxieties, writing at length about her own inadequacies and evaluating each piece of clothing or conversation to discover why she did not meet an idealized vision of popularity.[20]

Calender often wrote about what she read, alternately moving from quests for popularity to analyses of world crises. While reading a *Reader's Digest* version of *Tomorrow* by Philip Wylie, she paused to write, "[It] grips me, the Soviet A-bomb attack has such horrifying probabilities that I dislike thinking about it and yet I have previously thought about it and I realized that it is not in the realm of impossibility and I must think about it." She consciously reflected on the impact of science fiction as well: "It gives you something to think about. Most stories haven't much food for the brain but good (I don't mean 'men from mars,' etc.) science fiction has a meaning and message and are yours for the seeking. I love it." But Calender felt some conflict between her passion for reading and her desire to be "popular": "A 15 year old, as pretty, smart, and fun-loving as I shouldn't have to sit at home and read (although when else will I get my reading done and I must admit I love to read. It's just that 2 sides of me pulling against one another)."[21]

Calender's expression of this conflict exposes yet again the mixed messages magazines presented to girls. Reflecting middle-class values of education, teen publications encouraged girls to study yet warned that girls who studied too seriously might not have enough time to focus on looks and popularity. Elizabeth Woodward reminded girls in a 1936 Sub-Deb column, "I'm all for getting good marks in school! But smiling smugly over topping the class; obviously palling with your teachers; hiding yourself away in books—no!" Her advice,

"Make yourself the best all-round sport you can. Go in for clothes and subtle make-up, dramatics, sports, student activities, the yearbook." A 1946 student poem similarly reflected this sentiment, stating that the girl who "can write a theme on some dry topic / while sun and breeze and tennis lure you out" would earn good grades but would "be a 'drip,' my dear!"[22]

Calender used her relationship to reading and writing to fight prescriptions for her future, responding angrily to family predictions that at age twenty-two, she would be married and raising several children. "Boy that infuriates me!!! That is the most to say the least!!! Of all the nerve!!! When I'm 22 I'll have just started on my career after having finished 4 years of college and won't be too interested in marriage and certainly not children. Ohhh!!!!!" She conveyed slightly more ambivalence in an entry describing her mother's new Betty Crocker cookbook, however, writing, "it is wonderful!! Oh the lovely things I hope to make." Yet a few sentences later, she wrote, "I'm so terribly tired of cooking—I really can't see how any woman can stand to do the cooking every meal, every day, and all the other things a wife has to do." At times she rejected marriage completely, at other times only marriage that would require her to sacrifice a career outside the home for a life of cooking, cleaning, and raising children.[23]

As Calender's entries demonstrate, teenage girls did not always accept mass media representations of their current lives or of their futures. By the 1940s, media characterized high school girls almost exclusively by their fads, emphasizing conformity. A 1944 *Life* magazine article titled "Teen-Age Girls" began, "There is a time in the life of every American girl when the most important thing in the world is to be one of a crowd of other girls and to act and speak and dress exactly as they do." The article labeled high school fads "capricious," stating that girls lived in a separate world of bobby sox. Similarly, *The March of Time* 1945 newsreel "Teenage Girls" portrayed girls whose lives centered on clothing, soda shops, and telephones. But high school girls did not quietly accept this dismissal of their intelligence or their efforts to experiment with peer conformity and individual expression through fads. Many wrote to *Scholastic* magazine's "Jam Session" column in protest: "Certainly *my* life is far from the ecstasy of carefree existence which *Life Magazine* would have me believe." Another wrote that the depiction "of us as frivolous, flippant morons is not in the least accurate. . . . The average teen-ager discusses world affairs as well as the latest crooner." As these quotes demonstrate, writing—in diaries, yearbooks, letters to friends, or more publicly in letters to magazines and newspapers—proved a powerful and important tool,

offering girls a forum for disagreeing with negative characterizations and for defining themselves.[24]

"Strictly secret!": Girls and Diaries

High school girls expressed themselves through writing in many forms from the 1920s to the 1970s, including diaries, poems, stories, high school yearbooks and newspapers, and letters to friends or magazines. These personal records reflect the form and purpose of the writing, but they also provide rare insight into girls' daily lives, friendships, and relationships with consumer culture and popular culture—insight into how girls internalized, personalized, and used various messages to construct worldviews. Similar to girls' experiences with reading, writing provided pleasure, a way to communicate with themselves and their imagined future selves as well as with the world. Although girls read enthusiastically and often communally, writing signified a proactive, expressive act.

This act of expression could take many forms and undeniably varied according to the individual and the situation. Writing a story for a class assignment, for example, can be limiting. It is a response to an assigned topic, and one knows a teacher will read it. Yet reading school essays written by girls from this period can also be revealing. A high school student embodied the voice of many aspiring young writers in 1926 when she wrote a poem for her English class, "They tell me I am quite / Too young to try to write / The young, green sprouts / Of thought that struggle / In my half grown brain for life. / They are fools, / They are too old." A decade later, another student wrote of discrimination and pain in a class assignment, "I never knew / That being black / Punished me. / In my land / Black matched a tree / And the sky at night."[25]

In an autobiography written for a high school psychology class in 1938, a girl in northern California described her career goals, "a designer of women's clothes, as my ideas tend more toward clothes than art for art's sake. . . . As for the rest of my future, I have not thought further than my career. Possibly I shall marry someday, or perhaps I'm just being optimistic."[26] She also reflected a complex attitude toward women's place in society, expressing not only doubt about her ability to attract a mate but also, as with Calender's diary entries, ambivalence about a traditional path that would place marriage before a career. Formal school writings can be revealing and personal, sometimes unintentionally. Diaries, in contrast, are often written specifically to be revealing and personal. Although they must be read

carefully, as productions rather than unmediated reflections of life, diaries offer an outlet, a (sometimes) private space to explore, fantasize, vent, and record.

Girls often personified their diaries by writing "Dear Diary," as if communicating with a close friend, leaving the reader wondering about potential or imagined audiences. Within a very private genre, scholar Margo Culley writes, the imaginary reader "shapes the selection and arrangement of detail within the journal and determines more than anything else the self-construction the diarist presents." Beth Twiggar addressed this directly in various ways. Sometimes she addressed herself, "Well, Beth dear, speak truly," but she also acknowledged that even writing for herself was a self-conscious, constructed act, "It is a great relief to write in my dear diary where I won't lie to please anybody—not even myself!" Twiggar also demonstrated her desire for an audience, inventing the imaginary "Mr. Pry." Although she regularly admonished Mr. Pry for snooping in her diary, she also directed his reading of it, "(Mr. Pry, that last sentence is to be read with irony.)" She saved her diaries, conscious of potential future audiences, and eventually donated them to a library, making them available to scholars and students.[27]

Some teenage girls shared diaries with real-life friends. Yvonne Blue recorded several such events: "Bobbie was over today and I showed her parts of my diary." Another day she reflected, "Lucile showed me parts of her diary. It was a great deal like what I expected in a way, but in another way entirely different." The culture of diary writing included a mixture of free form and highly stylized responses to events and emotions. Girls compared their entries and sometimes evaluated each other's reflections, demonstrating trust in the friendship by sharing a diary. June Calender wrote in 1955 that a friend "read most of the diary preceding this one and got mad a couple of times but got over it pretty well." Despite differing interpretations of events, sharing served to cement the friendship. Calender reflected years later on the significance of her teenage diary writing: "gradually it became a place to write about the things I could not tell my mother (mostly crushes on boys). . . . The diaries became my emotional outlet; time and again, in them, I write how I didn't show my feelings to friends. I expressed them only in the diaries." In light of these real or imagined audiences, girls sometimes only hinted at delicate issues, filling diaries with important silences as well as words.[28]

Acquiring a diary could be a significant event by itself, although diaries held different meaning for various diarists. Frances wrote to a friend that she spent her "Christmas money on a diary, which I started

the first of the year, oh my! And it is going to be *strictly secret!*" Yvonne Blue "bought a *magnificent* diary" in 1925: "It is a huge volume with a red leather back and 'RECORD' stamped on it in gold. The front is stiff rough black stuff with rounded red leather covers. Its pages are lined and numbered, there are 500 of them! The book cost $4.00, but it was worth it." Every aspect of the book brought pleasure—from the physical details to the potential it represented. Blue wrote sadly at the end of one diary, even though she immediately began another, "I am really sorry to close this account. It has been a great pleasure to write my thoughts fun and adventures here. . . . It is with real regret that I lay down my pen, as I finish the record of one of the happiest years of all my thirteen."[29]

Diarists often reread passages written minutes, days, or years before, reliving, editing, and analyzing previous thoughts. Beth Twiggar wrote that her diary served as a "bridge between my inner self and outer self." Yvonne Blue, however, contemplated her teenage diaries several years later, and wrote, "What is it about diaries, I wonder? You can't be honest in them—these pages are one long succession of poses of one kind or another—and if you were honest I don't know whether it would be much better. It's a strange kind of conceit that makes a totally unimportant person want to record for posterity."[30]

Whether girls bought diaries or received them as gifts, the books played an important role for diarists and serve as a unique window into the daily lives of teenage girls. The diaries, letters, and stories quoted here tell individual stories, but they also tell important national stories. They record personal responses to national trends, as well as the individual experiences of different life stages. And they demonstrate the importance of writing and expression for teenage girls in the twentieth century.

Conclusion

In 1920, many girls read outside school and frequently wrote to each other and for themselves. By 1970, awareness of girls' reading and writing habits and the potential for profit had created intense market interest, resulting in a proliferation of mass-produced girls' magazines, fiction, and diaries. Girls continued to seek reading materials that gave them pleasure or challenged them to think. They continued to write in diaries, in high school yearbooks and magazines, and for themselves. Through reading and writing, girls defined themselves and shaped their group identity. Girls also explored adult worlds and negotiated messages of femininity, heterosexuality, and consumerism.

Since 1970, girls have appropriated new technologies and ideas to play a more active role in the public shaping of girls' reading and writing. This opens the door for new lines of inquiry into girls' increased options for creativity and self-definition, for the chance to create even more extended communities, and for the potential to blur, as well as sharpen, lines of age and gender.

Kelly Schrum

Notes

1. Maureen Daly, "Sixteen," *Saplings* (1938): 16. Daly's story won a *Scholastic* award and was reprinted in several popular women's magazines, such as *Redbook* and *Woman's Day,* as well as collections and anthologies.

2. U.S. Department of Commerce, *Historical Statistics of the United States: Colonial Times to 1970* (Washington, DC: GPO, 1976), pp. 368–382; Carl F. Kaestle et al., *Literacy in the United States: Readers and Reading since 1880* (New Haven, CT: Yale University Press, 1991), pp. 19–32; Aaron Benavot and Phyllis Riddle, "The Expansion of Primary Education, 1870–1940: Trends and Issues," *Sociology of Education* 61, no. 3 (July1988): 191–210; Cathy N. Davidson, ed., *Reading in America: Literature and Social History* (Baltimore: Johns Hopkins University Press, 1989); and Selma Berrol, "Immigrant Children at School, 1880–1940," pp. 42–60 in *Small Worlds: Children and Adolescents in America, 1850–1950,* edited by Elliott West and Paula Petrik (Lawrence: University Press of Kansas, 1992).

3. U.S. Department of Commerce 1976, pp. 368–382.

4. Davidson 1989; Frank D. Henderson, "Voluntary Reading of 2,083 Junior and Senior High School Pupils," unpublished master's thesis, University of Washington, Seattle, 1926.

5. George H. Henry, "What's Wrong With High School?" *Ladies' Home Journal* (January 1947): 77 (italics in original). See also James Gilbert, *A Cycle of Outrage: America's Reaction to the Juvenile Delinquent in the 1950s* (New York: Oxford University Press, 1986), especially chaps. 5 and 6.

6. Alice P. Sterner, *Radio, Motion Picture and Reading Interests: A Study of High School Pupils* (New York: Teachers College Press, 1947).

7. Claudia Nelson, "Girls' Fiction," pp. 327–333 in *Girlhood in America: An Encyclopedia,* edited by Miriam Forman-Brunell (Santa Barbara, CA: ABC-CLIO, 2001); Suzanne M. Ashworth, "Susan Warner's The Wide, Wide World, Conduct Literature, and Protocols of Female Reading in Mid-Nineteenth-Century America," *Legacy* 17, no. 2 (2000): 141–164.

8. June Goyne Corotto, "Typescript reminiscences," June 1984, Schlesinger Library, Radcliffe Institute, Harvard University, Goyne Corotto Papers, A/C822; June Calender, 1953–1956, "Diary," Schlesinger Library, Radcliffe Institute, Harvard University, June Calender Papers, 89-M55.

9. Yvonne Blue Skinner, "Diary," 1923, Schlesinger Library, Radcliffe Institute, Harvard University, Yvonne Blue Skinner Papers, 85-M195.

10. Skinner diary, 1923–1926.

11. Skinner diary, 1926. For a full exploration of the historical relationship

between girls, body image, and appearance, see Joan Jacobs Brumberg, *The Body Project: An Intimate History of American Girls* (New York: Random House, 1997).

12. Katherine Rosner (pseudonym), "Diary," 1929, Schlesinger Library, Radcliffe Institute, Harvard University, Katherine Rosner Papers, 92-M10.

13. *Parents' Magazine* (April 1941): 108.

14. Charles Brown, "Self-Portrait: The Teen-Type Magazine," *Annals of the American Academy of Political and Social Science,* Vol. 338, *Teenage Culture* (November 1961): 14–21.

15. Beth Twiggar Goff, "Diary," 1928, Schlesinger Library, Radcliffe Institute, Harvard University, Beth Twiggar Goff Papers, 90-M130; R. R., "Youth," *Bryn Mawrtyr* (1928), Bryn Mawr High School (Baltimore, MD): n.p.; Skinner diary, 1925.

16. Skinner diary, 1925; "Letters to Frances Turner," Bryn Mawr School [hereafter Letter to Frances Turner], September 5, 1919; *Dictum Est,* Red Bluff Union High School (Red Bluff, CA), 1928; Letter to Adele Siegel, 1929, Adele Siegel Rosenfeld letters, Schlesinger Library, Radcliffe Institute, Harvard University, Adele Siegel Rosenfeld Papers, 90-M109: December 10.

17. Skinner diary, 1926; the story mentioned is most likely by Arthur Sarsfield Ward, *Dope: A Story of Chinatown and the Drug Traffic* (New York: R. N. McBride, 1919); Cassell, 1919; Rosner diary, 1929; *The Forester,* 1933, Forest Park High School (Baltimore, MD), p. 56.

18. *The Forester* 1931, p. 70; *Westward Ho* 1935, Western High School (Baltimore, MD); *Westward Ho* 1935: 117.

19. Pepsi-Cola advertisement, *Scholastic* 41, no. 7 (October 1942): back cover.

20. Calender diary, 1953–1954.

21. Calender diary, 1953–1955.

22. Elizabeth Woodward, "The Sub-Deb," *Ladies' Home Journal* (November 1936): 129; Anonymous, *Bryn Mawrtyr* (1946): 90.

23. Calender diary, 1953–1954.

24. "Teen-Age Girls: They Live in a Wonderful World of Their Own," *Life* (December 11, 1944): 91–95; *The March of Time,* "Teenage Girls, 1945," 1945; *Senior Scholastic,* October 22, 1945, 42 (italics in original).

25. Grace Sibley, "Too Young," *Saplings* 23; Mary Anderson, "I Never Knew," *Young Voices: A Quarter Century of High School Student Writing Selected from the Scholastic Awards,* edited by Kenneth M. Gould and Joan Coyne (New York: Harper and Brothers, 1945), p. 227.

26. Oakland Growth Study, Institute of Human Development, Berkeley, California.

27. Margo Culley, "Introduction," pp. 11–23 in *A Day at a Time: The Diary Literature of American Women from 1764 to the Present,* edited by Margo Culley (New York: Feminist Press, 1985): 11–23; Goff diary, 1928, 1929.

28. Skinner diary, 1925.

29. Frances Turner letters, n.d., emphasis in original; Adele Siegel Rosenfeld diary, 1931, Schlesinger Library, Radcliffe Institute, Harvard University, Adele Siegel Rosenfeld Papers, 90-M109; Skinner diary, 1925.

30. Goff diary, 1928; Yvonne Blue Skinner Papers, essay for college psychology class, 1933; Babs Black, "My Diary," *Quid Nunc* (1935), Roland Park Country School (Baltimore, MD): 54.

6

Expanding Literacies at the End of the Twentieth Century: Girls, Writing, and Science Education

If you ask any girl in the late 1990s who is the most influential young woman in the United States, you're likely to get this answer: Mickey Mouse Club member turned pop star diva Britney Spears. Although Britney may have little direct connection to girls' scientific literacy, she stands as a powerful icon for young girls to emulate, repudiate, or simply admire. Like her female predecessors Madonna or Mariah Carey, Britney takes center stage as one of the few widely known, young, powerful females in American culture. In her interviews and music, Britney makes it clear that she is doing what she wants to do—not simply following "the rules" that others lay out for her.

What makes Britney so interesting is that, from an outsider's perspective (adult researchers, educators, parents), it is difficult to see how Britney Spears challenges "the rules" of what it means to be a young woman in the United States. She fits the physical stereotype of ideal beauty (young, blond, and thin). As a self-proclaimed teen virgin and former Mouseketeer, she fulfills the image of "the good girl." Her songs and videos graphically depict the image of a seductress who defers to the needs of her partner (i.e., the 2001 song titled "Slave 4 U"). Nevertheless, Britney stands out as a new kind of model for young women; she knows what she wants and enjoys the fame and fortune she has achieved. And, if commercials are indicative of public reaction, the Pepsi commercial that features former presidential nominee Bob Dole in awe of her greatness speaks volumes about how this teenage girl has captivated the attention of both youth and adults.

What we want to suggest is that this closer look at Britney reveals much about the position and literacy practices of young women in the United States at the end of the twentieth century. Simply put, girls want to position themselves as powerful agents in control of their lives. Yet by examining the kinds of choices that girls make in terms of their interests, attitudes, and career choices, we see that

young women position themselves in roles, ideologies, and practices that reinforce stereotypical images of "girls": "boy-crazy," "a girl's best friend," "future mother," "the teacher's pet," or even "Lolita."[1]

Girls' literacy practices reflect the kinds of contradictory messages and positions that are available for them to construct their identities. The message, "Be yourself. Take control of your life," is coupled with "Appearance matters. Thin is beautiful." How can girls be in control of their lives yet accept these roles so easily? Or do they? One of the goals of this chapter is to explore how girls make sense of their own identity and the role of science and writing in this process. More specifically, we hope to provide insight into the complicated relationship between girls and science by exploring the potential for connecting the study of science and writing to the prevailing concerns of girls themselves.

Girls' literacy practices at the end of the twentieth century are related to the kinds of texts that they are reading and writing, and when given the choice, they are reading and writing texts about matters of identity broached by people like Britney. To be sure, these texts have been influenced and even challenged by the literacy practices of decades past. Historian Joan Jacobs Brumberg argues that the diary, one of the oldest forms of literacy practices for young women, continues to have appeal for young women as a vehicle for self-expression and discovery. Although the form of the diary remains fairly stable, the content of the entries has shifted with each historical era. Reading contemporary girls' diaries, Brumberg concludes that now, more than any decade past, girls are "concerned with the shape and appearance of their bodies as a primary expression of their self-identity."[2] Young, white, middle-class girls, according to Brumberg, spend a great deal of time reading, writing, watching and talking about "the body problem," including scrutinizing themselves and others in terms of an imaginary perfect body.[3] "The body problem" not only is an issue for young girls but touches even their role models. In a January 2002 episode of MTV's "Total Request Live," Britney readily confessed that she "works hard" to keep in shape to the tune of 1,000 crunches a day. Discussions of Britney center on her body as much as on her music. Consider that in February 2002 there were 28,000 websites devoted to the debate over the natural or enhanced status of Britney's breasts.

In addition to "body issues," research in the area of girls and literacy reveals central themes and issues. Linda K. Christian-Smith notes that much of the literacy practice of young women revolves around themes of romance, desire, and fantasy.[4] Like Britney, though,

girls' interest in romance novels and magazines does not suggest passivity. Christian-Smith observes that these "texts of desire" provide girls an opportunity to think and talk about their desires, hopes, and dreams.[5] Indeed, much of the "literate underlife" for girls in junior high and high school involves reading and writing about love, friendship, and betrayal.[6]

Another key theme in research on girls and literacy involves social standing and the careful art of acquiring and maintaining popularity among classmates.[7] In her study of the hidden literacies of junior high, Margaret J. Finders found that literacies were developed and used for the purposes of establishing communities, competing for social status, staking a claim, and defying authority.[8] Objects like the "Yearbook" (both the club and its product) serve as space to confer status through writing. Literacy practices, according to Finders, severed along social (and class) lines. For the "tough cookies," reading and writing at home was seen as a refuge from the literacy practices at school where they felt excluded or marginalized.[9] This scholarship demonstrates that young women continue to struggle between "voice" and "silence" in constructing their identities.[10]

Although much of the literacy scholarship focuses on girls' reading and writing practices in the language arts classroom, there is a growing trend to use the terms "literacy" and "literacy studies" across the curriculum.[11] Moreover, a handful of studies combine research on reading and writing with ethnographic analysis to look at how issues like social standing, in addition to gender, class, and race, shape girls' performance in the classroom.[12] For example, researchers found that one of the factors that inhibits girls' participation in computer science classes and activities in school is the fear of being perceived as a "hacker"—someone who loves to use computers.[13]

Another such study is Alison Lee's *Gender, Literacy, Curriculum*, which explores girls' and boys' literate practices in the domain of geography. Lee argues that gender plays a critical role in how students encounter and engage with the school curriculum of geography.[14] Boys and girls position themselves differently within the classroom, and they reconstruct or rewrite the curriculum in different ways. Lee combines feminist theories of curriculum and critical pedagogy with a linguistic approach to literacy to trace the production of gender difference through classroom dynamics, as well as the representation of the formal curriculum. In addition, Lee provides a close textual analysis of two student essays (by Robert and Katherine) on "shifting cultivation," or ecosystem modification.[15] One of the differences is in the students' use of voice. Robert's essay "purports to speak for it-

self," according to Lee, whereas Katherine's essay operates as a more "interpersonal" form of writing.[16] Consistent with other research, Lee found that Katherine demonstrated a "greater investment in writing" and established a personal voice or position from which to talk about the topic.[17] For example, Katherine's essay uses the terms "we" and "you" to make connections between her and the reader, as well referring to "our land" (something personal and connected) rather than "the land."[18] Lee's study illustrates how gender as a form of literacy not only influences how students make sense of the curriculum but may actually compete with other forms of literacy, for example, geographic literacy. As in Furger's study regarding technology, some of the assumptions and practices of the geography curriculum are in competition with the assumptions and practices of being an adolescent girl, such as fitting in, connecting with others, and emphasizing the relationships between subject matter concepts.

In this chapter, we make use of this research on girls' literacy practices across the curriculum to explore how they understand and reconstruct the science curriculum toward a larger project of "becoming somebody."[19] Philip Wexler uses the term "becoming somebody" to characterize what he says is the central project for adolescents in secondary schooling—discovering who one is and who one wants to become.

About the Project

The four authors came together from disparate disciplinary backgrounds—Janet Russell in biochemistry, Paul Miller and Andrea Lunsford in composition and rhetoric, and Lisa Weems in cultural studies of education. As a group, we share the assumption that science and scientific literacy is informed by the identities, literacy practices, and social contexts that construct how science is defined, valued, and approached in the high school classroom.

Recent educational research shows mixed results in science scores among our nation's boys and girls.[20] Overall, both male and female students have slightly improved science scores since the 1970s and 1980s.[21] However, several reports document a "gender gap" in participation and achievement in science.[22] For example, in 1999, males outperformed females at ages thirteen and seventeen in average science scores. Although this study finds that the "gender gap" is not significant for students at age nine, the gap between boys' and girls' performance in high-stakes science tests increases steadily as students move from elementary to middle to high school.[23]

Like other educators, we sought not only to understand but also to *intervene* in the problem of girls' seeming disengagement with science. To this end, we engaged in collaborative action research to (1) identify what were some of the key issues and concerns articulated by girls regarding science instruction and (2) develop and implement a curricular project that took into account these issues with respect to both content and pedagogy. Before we discuss girls' literacy practices regarding science, we provide a brief description of the girls and the classroom and school contexts.

During the 1999–2000 school year, we collected ethnographic data from a sample of high school students at Midwestern Girls School (MGS) regarding students' scientific and technological literacies. We conducted in-depth interviews and a series of surveys with students regarding their attitudes and experiences toward science and the science curriculum. We augmented our analysis of the role of writing, technology, and culture in the science classroom with daily classroom observations. MGS is an independent single-sex school located in a Midwestern metropolitan area with a predominantly middle-class Anglo-American student population. We selected MGS because it has (1) a high number of girls enrolled in advanced science courses and (2) a relatively high degree of technological resources for classroom use, including a twenty-terminal computer lab equipped with Internet access, a database, and web-authoring computer applications. Moreover, the school exhibits characteristics of high-technology integration into the formal science curriculum. For example, in the ninth-grade science classroom, students employed digital and computing technologies in learning about the laws of motion in physics.

A total of fifty-seven students and three teachers participated in the study through classroom observation. A sample of twenty-seven juniors and seniors was selected from the following advanced science courses—Chemistry in the Community, Astronomy, Physics, Advanced Placement (AP) Biology, and BioEthics—for more in-depth analysis of literacy practices and attitudinal data. Students from this sample participated in face-to-face interviews and surveys, and they submitted their writing. In addition, thirty students in freshman Biology class completed a survey regarding their experiences and aspirations regarding scientific endeavors. Out of the fifty-eight students, eight were African American, one was Asian, two were South Asian, and forty-seven were Anglo American. In the next section, we discuss the literacy practices in the secondary science classroom. We begin with the voices of two young women regarding their interest and aspirations in science.

Literacy Practices in the
MGS Secondary Science Classroom

Physics last year wasn't much fun. I found that I couldn't do a lot of the problems, and I didn't see how it really related to life. And a lot of the concepts, I didn't truly understand because there weren't examples on how it [worked], how it related to life, that you could even understand where it was coming from. It was like, here's the formula, work with it.

—Hillary, age 18

[I like] biology. Not so much the plants and stuff, but like human stuff. In eighth grade we did genetics. I really liked that. Genetics is fun. . . . In sixth grade I wanted to be the surgeon general. But I don't think I ever want to do research. I like actually working with people. That's better I think. So I guess I'd be just another pediatrician that makes kids get better. Bubble-gum medicine.

—Zoe, age 14

The formal literacy practices and curriculum in science classrooms at MGS can be characterized as "traditional." They reflect a common practice in science education: textbooks and laboratory worksheets. The formal curriculum and pedagogy centered on lectures of information that students read the previous evening, followed by a question-and-answer session regarding homework and chapter exercises (such as completing definitions, doing computations, and balancing equations). Typically, during the next class period, the teacher assigned students to conduct a laboratory exercise in small groups. Students completed the laboratory worksheet questions, including several computational questions and a final "application question" (i.e., what happened and how and why did you come to this conclusion?). Students turned in laboratory worksheets, and the teacher handed them back individually with limited discussion. For assessments, students took a ten-question quiz to review sections from the textbook. After grading the quiz, the teacher handed them back to students and discussed only those questions that were answered incorrectly.

These literacy practices are traditional in three central ways. First, the pedagogy in the science classroom is based on lecture and recitation. Second, the science curriculum maintains a binary between the humanities and the sciences. Third, the science curriculum represents the most common form of literacy practice in modern U.S. schooling since the turn of the twentieth century.[24] Students are involved in various types of reading (textbooks, novels, poems, story and number problems, research reports and essays) and writing (note taking, expos-

itory writing, essays, and numeric problems). Yet the uses of these forms remained within traditional disciplinary boundaries. That is, students are exposed to and engage in narrative forms of writing primarily in English classes and to a lesser degree in history and language classes. In contrast, the literacy practices in secondary science classrooms primarily consist of students reading small sections from textbooks as "homework," teacher lectures, and student recitation of the formal curriculum. Only in limited situations, such as individual research projects, were students allowed or even encouraged to read primary research reports or essays. Furthermore, students were seldom required to make connections between the information learned in science and other forms of literacy, such as knowledge of the world and their role in it. This kind of pedagogy reflects the kind of "narrow" view of literacy, particularly scientific literacy, as the successful regurgitation of a predetermined set of information and skills.[25] Although all the teachers in the study expressed a more expansive philosophy of scientific literacy, students consistently held a narrow view of scientific literacy.[26] Students defined scientific literacy as memorizing and reciting scientific facts, concepts, and equations that were "correct" according to the teacher or "the right answer" according to the textbook.

With this vision of scientific literacy, students viewed writing as a peripheral activity in the science classroom. The most common form of reading and writing in science class was note taking from the textbook or teacher lectures. Moreover, students found it frustrating when the science curriculum did not follow this linear sequence. Students reported that doing well in science class meant reciting textbook information. Students gave various reasons for why this was necessary: (1) it is what the teacher wants, (2) it is what will be required of us to get an "A" in the class, (3) it is what will be required of us in college, and (4) "that's how science is." Regardless of the reasons, students consistently claimed that science is a fixed body of knowledge and that it was their task to simply memorize and report back that knowledge. Thus, writing, which students felt had an interpretive function, was seen as of little use in the science classroom.

Reading and taking notes on the textbook is helpful because it prepares students for test taking, but it does little toward developing a scientific literacy that encourages students to (1) think critically and (2) retain scientific information or knowledge about scientific processes. As several students commented, the difficulty of writing in science classrooms lay precisely in the way that it forces students to communicate their understanding of the material. Moreover, when viewed as the presentation of a particular position that must be sup-

ported with specific evidence that students must identify, organize, and select, writing facilitates a more student-centered sense of scientific literacy. In the next section, we discuss how writing fits within the larger agenda of science education reform. Then, drawing from the issues raised in both our local research and the national dialogue, we outline why and how we constructed an alternative curricular module called the "Xenical Project."

Science, Literacy, and Standards

The labs, to me, don't really help me to understand the concept. It just seems like busy work to me.

—Yvonne, age 18

The *National Science Education Standards* published by the National Research Council have much to say about where science education should go, but they also—more indirectly—have much to say about where secondary science education has been. The central recommendation of the *Standards* is a shift away from the study of science as a finished, static product and toward an emphasis on science as "inquiry," which requires more than simply "hands-on" activities and the processes of observing and experimenting. Inquiry, as defined in the *Standards,* requires that "students describe objects and events, ask questions, construct explanations, test those explanations against current scientific knowledge, and communicate their ideas to others. They identify their assumptions, use critical and logical thinking, and consider alternative explanations. In this way, students actively develop their understanding of science by combining scientific knowledge with reasoning and thinking skills."[27]

The *Standards* reflect a desire to move away from passive models. Consider the changed emphases in the standards for science content.[28] Table 6.1, outlining the new emphasis on inquiry in the science content standards, is highly compatible with student writing; indeed, one wonders if it could be implemented without significant amounts of student writing.

The precision and complexity involved in the science of pursuing an extended inquiry, developing an explanation, and communicating the explanation to others requires writing for several reasons. First, since memory cannot manage, recall, and order the various data and explanations generated by such inquiry, writing (in the broad sense that includes linguistic and visual forms) is the most expedient (perhaps the only) means of preserving and manipulating such infor-

Table 6.1

Less Emphasis On	More Emphasis On
Knowing scientific facts and information	Understanding scientific concepts and developing abilities of inquiry
Studying subject matter disciplines (physical, life, earth sciences) for their own sake	Learning subject matter disciplines in the context of inquiry, technology, science in personal and social perspectives, and history and nature of science
Separating science knowledge and science process	Integrating all aspects of science content
Covering many science topics	Studying a few fundamental science concepts
Implementing inquiry as a set of processes	Implementing inquiry as instructional strategies, abilities, and ideas to be learned

mation. Furthermore, although media such as oral exchange and internal cogitation are useful as tools for critical thinking, writing is a crucial tool for capturing such thinking so that it can be reviewed, developed, and revised (by oneself and others) over extended periods with the precision required by science.

Unlike writing, reading has always been an integral part of science education. However, student reading has usually taken the form of perusing science textbooks, which usually present an ahistorical, distilled version of the content of scientific knowledge. It is fitting that perhaps the most famous critique of ahistorical, foundationalist approaches to science, Thomas Kuhn's *The Structure of Scientific Revolutions,* was occasioned by his study of science textbooks. In the first chapter of that book, "Introduction: A Role for History," Kuhn notes that science is perpetuated from one generation to another through textbooks that typically expunge history and present science as a permanent, universal, timeless truth that may well have been discovered incrementally over time but was always true independent of that historical discovery. By de-emphasizing history, truth and discovery are pried loose from the rough-and-tumble changeable world and moved to a timeless realm of permanent truth.

Here we see a crucial example of how pedagogy in science and theoretical, paradigmatic assumptions of science are inextricably tied. The very process of distilling the history of science out of the knowledge of science to facilitate pedagogic presentation has reified science—such distillations are no longer merely viewed as means of practically and efficiently teaching science but as the very nature of science. Learning science in this ahistorical way leads to metaphysical and epistemological assumptions about science that move science education away from active, inquiry-driven models to passive models of reception of static knowledge.

When scientific knowledge is viewed as a finished product, it becomes static, separate, distinct subject-matter disciplines that should be known "for their own sake" rather than as the products of practical inquiry. The understanding of process and context called for by the new model requires a sacrifice of breadth for depth, in that true inquiry can be a long and winding road that does not lend itself to rapid coverage of content.[29] In the new model, because subject matter disciplines are no longer studied for their own sake, they must be integrated with and related to "inquiry, technology, science in personal and social perspectives, and [the] history and nature of science."[30]

Unfortunately, the *Standards* do not address directly the issues of most concern in the context of this article: how do the *Standards'* recommendations for changes in the pedagogy of scientific literacy affect girls? More specifically, how might writing facilitate a broader definition of scientific literacy and what counts as science? These two questions are not unrelated, in that girls have historically underperformed in science compared to boys, and girls have historically performed well in fields that incorporate writing. Writing might well provide many girls with a tool for learning science that is more amenable to their learning style.[31] Although that was our hunch, we wanted to know from their perspective what kinds of science education and curriculum would be interesting and useful in developing scientific literacy.

Understanding Girls' Scientific Literacy Practices

Question: "What do you think is important for MGS students to know about science when they graduate from high school?"

—Lisa

Answer: "I mean, most of the information that I've used I won't remember. Some of this stuff I'm like, 'when am I ever going to use this again?' . . . You just memorize for the test and then you forget about it. There are certain things to know, you know, in biology: how your

body works, photosynthesis, and those kinds of thing. The kind of things that are common knowledge to everyone. Chemistry, I don't really see the point of it. And you know physics, there's more a point, like with speed and velocity and things that relate to our lives in general are the things that I like to learn."

<div align="right">—Lindsay</div>

This passage comes from an interview with Lindsay, a senior at Midwestern Girls School, during the final months of the school year. In this passage Lindsey expresses a sentiment that reverberated across the entire sample consistently throughout the year: students view much of the science curriculum and science in general as a meaningless set of information. According to the students at MGS, science is difficult, boring information that bears little relevance to their interests and experiences. Thus, the science curriculum is something to be resisted, struggled with, or memorized, but merely for purposes of getting a good grade. As Lindsey notes, the science curriculum is acquired through memorization. Yet memorization is not synonymous with fluency, competency, or interest in the material. Lindsey's narrative is particularly insightful because it highlights the thematic areas that inform our understanding of girls' scientific literacy.

Girls' Experiences with and Interest in Science

Interest in the science curriculum is important among females because feeling positive about their science classes is the best predictor of the pursuit of a scientific career.[32] In our ethnographic interviews and surveys, students identified various levels of interest in science. At one end, three students expressed a high interest in science, saying that the world of science is "fascinating," "fun," and "interesting." Students attributed this interest to a certain level of ease with the content in general and specifically with the ability to do what they considered "sciency" things such as memorization, problem solving, and balancing equations. However, some students talked about science being fun when they participated in "hands-on" projects that reflected their own personal interests. At the other end of the interest spectrum, five students said that they find science boring, citing the same activities (working in the lab, inventing things, and making tedious measurements) as typical "scientist" activities that held no interest for them. The remainder of the students (eight interviewees) reported moderate interest in science. Almost all of the students associated science with mathematical computation (a skill many found difficult and impersonal) and thus of no interest to them currently or in the (perceived) future.[33]

The girls in our study reported both positive and negative attitudes toward science, the science curriculum, and science classes. Positive factors associated with an interest in science included positive prior experiences with science, both inside and outside the classroom, teachers who demonstrated a strong interest in using science to understand everyday problems, and performing well on science tests. Negative factors that inhibited interest in science included a science curriculum that omitted the "real-life" connection, the actual science textbooks, teachers who "teach from the textbook," and doing "story problems that are 'long and dull.'"

These responses demonstrate the congruity between the kinds of changes called for in the *Standards* for science education and the attitudes and experiences of the girls. Both reject a science curriculum that is decontextualized from its real-life purposes and applications. Many students described science as a difficult subject because of the emphasis on memorization, problem solving, and balancing equations. Despite "difficulty" as a barrier, students' disinterest in science stemmed from its association with math. Furthermore, this association determined their interest and perceived ability to do well in science:

> Well, math is hard for me to get the right answer. Science is like that. I'm not interested in it. It just confuses me. I guess I kind of liked Biology last year because it had to do more with us and stuff. But the equation balancing and chemistry and stuff, I can't really get into it.
>
> —Jill

Jill's sentiment, "I can't really get into it," reflects a theme heard continuously from the girls—"science is for scientists," not the average person. Girls repeatedly talked about science as an activity that only scientists as a special group of researchers do. Remember Zoe's narrative from earlier:

> [I like] biology. Not so much the plants and stuff, but like human stuff. In eighth grade we did genetics. I really liked that. Genetics is fun. . . . In sixth grade I wanted to be the surgeon general. But I don't think I ever want to do research. I like actually working with people. That's better I think. So I guess I'd be just another pediatrician that makes kids get better. Bubble-gum medicine.
>
> —Zoe

For Zoe, the study of genetics is an example of science—that could be fun—but something that researchers do in isolation. In con-

trast, doctors work with people, and pediatricians work with kids. Here, Zoe separates the three categories into scientists, medical doctors, and pediatricians and delineates her own ranking in terms of interest and social value. Although she seems to diminish the work of the pediatrician ("I'd be just another pediatrician"), she infers that this less-special form of science (relative to the study of genetics or being the surgeon general) has its value: "That's better . . . [to be someone that] makes kids get better." At age fourteen, Zoe has already learned that there are various groups within the scientific community and has a sense of where she might want to participate.

When asked to discuss positive experiences in science class, students most commonly described inquiry-based projects. Several students vividly recalled science fair activities in which students were able to select their own problems to investigate and were given the tools to discover the answers. For example, one student enthusiastically recounted a project in which she decided to investigate whether sponges or washcloths held more bacteria. Working with a science teacher, the student conducted an experiment to determine bacteria levels, analyzed the results, and presented the findings to classmates. This type of project is an example of the kind of "authentic learning" called for in the *Standards*. The *Standards* propose that science classrooms become more like mini-laboratories in which the curriculum is student-centered, constructivist, and collaborative. The role of the teacher in such a classroom is to act as a facilitator and resource in the learning process, but the inquiry is driven and designed by students' particular interests and "real-life" problems and questions.[34]

To Girls, Relevance Matters in Science Curriculum

One area in which students found agreement is in their desire for curricular materials, concepts, and activities that relate to their everyday lives. We asked them to comment on the extent to which what they perceive what they are learning in school is relevant—that it builds upon and expands their previous knowledge and experience about "the real world." In general, students felt that some classes, such as biology and literature, provide them with the content and space to equip them to make educated decisions about the problems and situations they encounter as persons and citizens in contemporary society. In the following passage, Gail, a senior with self-expressed "little interest in science," noted the importance of having a "big picture" or foundational knowledge of science for all students regardless of interest or career aspirations:

Question: "Can you think about specific topics across your courses, what are some of the topics or concepts that may be important for students like yourself to know when you leave [high school]?"

—Lisa

Answer: "Um, probably, um, the cycle, the life cycle, how every part of our world fits into that, from precipitation to plants, to people, the environment around us. I think that's probably the most important part. How we all fit into the big theme of life. And then from there, I'd say human development and the body, but the big cycle."

—Gail

Gail's perspective, that students should leave high school with the "big picture" knowledge of scientific information, is exactly the type of "scientific literacy" called for in science education reform. Rodger Bybee, one of the visible proponents of such reform, advocates that science education focus more on the larger, yet basic, processes of science, and less on rote memorization of the intricacies of scientific disciplines such as chemistry and physics. Such an approach does not advocate that the fine details of scientific content inherent in chemistry and physics be overlooked. Instead, this approach argues that teachers should foreground the basic concepts and processes of scientific knowledge in delivering and assessing a science curriculum.

Students noted that classes that intentionally emphasize the context, relevance, and applications of science are particularly helpful in facilitating their interest in scientific content and learning about science in general. However, students made a distinction between simply reading about social issues related to science and the types of activities that afforded them the opportunity to make meaning of the material. Specifically, several students commented that "working from the textbook" or "going through the textbook" was not only tedious but also did not facilitate either short-term or long-term retention of even the most basic concepts encountered. Students claimed that hands-on experience and discussion are the most productive means for comprehending the material. This finding involves two separate yet related points: students indicated that (1) they are interested in (and even enjoy) hands-on experiences in science and that (2) this interest leads to a better comprehension of the material. The combination of the hands-on activity with a *discussion* of its purpose, consequences, and significance led students to a better understanding of the

content, as well as the relevance of that content to their everyday lives. Again, students recounted several project-based activities in which they generated research questions and conducted research. This approach was viewed as an organic method of gaining substantive understanding and "the big picture," as opposed to the narrower method of working from the textbook and conducting experiments to illustrate concepts seen as "external" to their knowledge, experience, and interests. The significance of this finding cannot be underscored sufficiently: student comments elaborated their belief that science had little to do with their everyday lives, unless the information was put into a broader context that included their own real-life experiences, knowledge, and interests. In other words, students expressed interest in science when their own knowledge and experience was placed in the center of the learning process and *science* was employed to expand that preexisting knowledge and experience. Let us return to Gail's comment that learning biology—specifically, the life cycle—is essential to scientific literacy. When asked to rate the most important science course at the high school level, she states:

> Well, I think biology, if I had to rate them, would be the most important one. Just cause *we are the study of biology.* I almost wish I had more of an interest in biology, because it is so important. So I would say that's the most important one, because it directly relates to us. I think that's more beneficial than ECP [Explorations in Chemistry and Physics], which gives an overview, because you can really focus on something.

Here, Gail contrasts biology class with an overview course (ECP) designed to be a precursor to chemistry and physics classes. ECP introduces students to basic concepts and processes of chemistry and physics and is required for every freshman prior to biology. According to Gail, the scientific content involved in biology forms the foundation of what students should know about science because students can immediately identify with the material. What Gail and most of the other students said is that the foundation for learning science is the ability to understand how the curriculum relates to them and the world around them. In other words, "relevance" matters in science education. Science classes that present scientific information within the context of "everyday experience" are essential for building and refining scientific literacy. Furthermore, students indicated that project-based learning was an important medium for creating and sustaining interest in scientific curriculum and learning. Allowing girls to select and investigate scientific problems facilitated ownership of the learning process.

The Xenical Project:
An Alternative Curriculum as an Intervention

In thinking about the relations among gender, science, and literacy, we view girls as active, competent meaning makers. In other words, we are not just concerned with making girls more comfortable with traditional notions of science; we are also interested in how girls challenge traditional ideas and practices related to science. Given the promise of writing in science education and our desire to move away from passive, ahistorical textbooks, we began exploring software that might make reading and writing more interactive and inquiry-driven. We selected a software package titled Web Integrated Science Environment (WISE) because it offers tools for the early stages of the writing process that make the reading and pre-writing processes visible to both the student and others. One feature of the application is that it allows students to create, revise, and save notes as they read through preselected evidence (see Figure 6.1). Another feature of the WISE software package, Sense-Maker, allows the student to easily sort the pieces of evidence into pre-existing or self-defined categories (see Figure 6.2).

Working with this software, we created a project that asked students to imagine themselves in the role of a doctor as they analyzed evidence for and against the use of Xenical, one of the leading pharmaceutical drugs on the market for losing weight.[35] As a drug, Xenical works to block absorption of a portion of fat that has been ingested. The goal of the project was to enable students to engage in inquiry-based science that incorporated multiple layers of reading and writing to evaluate scientific evidence. We asked students to imagine themselves as doctors who have just received a request from a patient regarding the use of Xenical. The final product of the project was a recommendation (in the form of a letter to this imagined patient) on the use of Xenical for dieting and weight management (see "Recommendation to a Patient" in Part 2 of this volume). In the Xenical project, we presented students with fourteen pieces of evidence to evaluate and categorize. Students were encouraged to evaluate the evidence in terms of its scientific, social, or ethical merits and relevance to their recommendation. If the student felt the evidence supported the use of Xenical, she would drag and drop the evidence piece into a self-selected category (such as "good things about Xenical") and write a brief note explaining the selection. If the evidence did not support the use of Xenical, the student would drag the evidence piece into a different category. After sorting all the evidence, students ranked the importance of the evidence using the color-coding feature in the software.

Figure 6.1 The note-taking feature in the WISE environment.

Figure 6.2 SenseMaker allows students to drag and drop evidence into separate boxes

Students then used their notes and ranking of the evidence to construct an overall recommendation on whether or not to use Xenical.[36]

One of the advantages of this approach is that it managed to be simultaneously innovative and familiar. We have already seen that the standards call for new emphases in assessment that are largely met through the use of writing. The use of a fairly conventional essay as the capstone of the Xenical project allows teachers to employ a somewhat familiar form in an atypical context—a science class. And as we have seen above, the use of a conventional essay meets the new emphases called for by the *Standards,* especially in assessment. But the Xenical project also introduces a more radical innovation in the form of SenseMaker. It works in the margin between reading and writing—an area sometimes referred to as prewriting—where conventions are less constrained than they are in finished essays. However, SenseMaker complements the more conventional finished product of the final essay, allowing students to employ their categorizations and rankings to organize their essays.

As we developed and implemented the project, we noticed that the notion of writing collapsed into the notion of reading, so that both were continually active, inquiry-driven processes. Both reading and writing, then, became activities consonant with the new emphases called for by the *Standards.* Students more thoroughly analyzed the evidence and their thinking by writing justifications for their categorizations and by ranking the relative importance of categorized evidence by color coding. Consider, for example, two written notes by Laura regarding previously read articles. Each note includes two prompts. The first prompt asks the student to identify information relevant for their final recommendation. The second prompt asks students to evaluate the article in terms of its credibility, accuracy, reasonableness, and support (CARS). On the first article concerning heart complications caused by the drug Fen-Phen, Laura writes:

> 1. The info from this site that I want my client to know: [onscreen prompt] that there is hope after being on the drug, but once they are off the drug they might go and gain all the weight back and want to get back on the drug, therefore giving them problems. I can't exactly say much right now since I am still not all clear on what bad side effects Xenical gives you "This finding is good news for patients," [the online article] says. "However, we strongly recommend that any patient exposed to fenfluramine or dexfenfluramine (another diet drug that was withdrawn at the same time) receive a complete physical exam and an echocardio-

gram if there are signs or symptoms of cardiovascular disease or if a physical examination is inconclusive."

2. Regarding CARS, this is/isn't/can't tell a good site because: [on-screen prompt] I believe that this is a good artical. They are asking the experts opinion and getting both the good and bad sides of the medicine. However, like I said above I am not sure if Fen Phen and Xenical act in the same way so I am not sure that this really has anything to do with Xenical, other than that it could scare a patient who is actually going to take a drug similar to Fen Phen.

In this note, Laura uses the CARS criteria to conclude that the article is credible because it draws from expert opinion on the effects of Fen-Phen, but she is unsure about the application of this information to the present study of Xenical. In other words, this note allows Laura to flesh out the logic of the argument and its usefulness for her recommendation in terms of scientific credibility. Now consider Laura's note regarding an article that defines obesity:

1. The info from this site that I want my client to know: [on-screen prompt] I think this is a bad site for someone overweight bc it is pointing out all the wrong things my client has done to get fat. It seems as though this article is blaming my client and I do not think any obese person wants to hear this. They need confidence and good things not comments like it is your fault you didn't exercise.

2. Regarding CARS, this is/isn't/can't tell a good site because: [on-screen prompt] this is a good article in the sense of CARS but I would rather my overweight client not see this.

In assessing the overall credibility of the article (criteria with the acronym CARS), Laura concludes that the information is helpful. However, Laura's evaluation of the article also takes into account other dimensions of the article—such as tone, audience, and potential outcomes for the reader. Laura's concern about this article is less about its "truth" and more about its potential reception by her client. This second note captures Laura's ambivalence about the usefulness of the article. Both notes reflect the student's thinking as it occurs between the practices of reading and writing and allows the student to express her evaluation of scientific issues in the context of issues like confidence and stigma.

Our selection of the topic (the use of drugs in diet and weight

management) was equally important. The task was to create a module that met the interests and needs of both the teacher and students. We selected this topic after multiple consultations with the participating classroom teacher and students in the course Chemistry in the Community. Through regular classroom observations and discussions with the students, we learned that students were extremely interested in issues of nutrition. We knew the students were studying pharmaceuticals, energy, and the chemistry of diet, so we were able to construct a module that was both rigorous and meaningful—integrating new information with what the girls already knew.

Girls had this to say about the Xenical project:

I thought it was a good project because it is something that most young girls can relate to. It was interesting because it was a "real-life" situation that took into account many different aspects—science, advertisement, social, and political things. It was kinda fun, which brought my interest level up. I also liked how it was so interactive, and you could log on at home and stuff. . . . that was pretty cool.

—Tracy

It was a good way to present information, through advice. True, you can just write a paper about your opinion, but your tone changes considerably when your audience isn't your teacher.

—Beth

I liked combining everything I learned and writing my recommendation to the client.

—Nicki

The Xenical project was a success from multiple angles.[37] First, girls responded with immediate interest in learning about and discussing issues of drugs and dieting. Second, the emphasis on writing and writing from a different identity (the status of a "doctor") permitted girls not only to express their own voices but also to experiment with the voice of an authoritative scientist. Finally, because of the emphasis on collecting evidence, taking notes, and writing a final recommendation, the students were allowed to change their views as they collected and analyzed the information. In the interviews, students viewed science as a "right or wrong" "product-oriented" discipline. The "process" nature of the Xenical project highlighted the inquiry and interpretive aspects of scientific research and evaluation, which

was something the girls said they valued throughout their curriculum. Finally, in a postproject survey, girls reported that they enjoyed the project and would recommend using it with other students.

Perhaps most interesting is that although girls reported in the interviews that they did not think that writing had a useful place in the science curriculum, the written and oral responses after the Xenical project indicated that writing did make a difference. The writing emphasis of the project allowed girls to sort through the evidence, determine an audience, and express their own voices. Thus, it appears that the changes called for in the *Standards* not only work toward developing scientific literacy but might also further the use of science to expand girls' literacy practices regarding what it means to be a girl (i.e., body image, dieting, appearance, etc.).

Conclusion

Scientific literacy involves gaining a certain competence in scientific concepts and information. Like the science education standards, we propose a broader definition of scientific literacy. Broadening definitions of scientific literacy involves moving away from a passive model of memorization and regurgitation of facts toward a more inquiry-based practice that foregrounds the social context, application, and relevance of science. Our research suggests that the latter definition of scientific literacy may be useful for all students, but is particularly important for female students in high school science education.

As Sue V. Rosser notes, the level of interest and participation in science and technology has both opened up *to* and been opened up *by* girls and women over the past thirty years.[38] For example, girls "outperform" boys in terms of grades they receive in science classes.[39] In addition, more young women are choosing to enroll in AP science classes than they were in the early 1990s.[40] However, as educational researchers, scientists, science teachers, and others conclude, the struggle for "gender equity" in the science classroom and science careers is far from over. As the girls' accounts above illustrate, interest and participation in science and technology are not just a matter of access to courses or careers. Access is not synonymous with interest. Statistics regarding the number of postsecondary degrees across the sciences indicate that scientific careers have become more *accessible* but not necessarily *desirable* for young women to pursue. Girls' interest, participation, and success in the field of science are related both to issues of identity and to their conceptions of science, reading, and writing. Informed by our research, we believe that much work re-

mains in terms of thinking about the relationship between gender, science, and literacy. This work may begin by developing science curricula and pedagogical strategies that are co-constructed by and with girls regarding their current scientific literacy practices.

In our research, girls articulated the need for science education that allows them to explore problems and topics that are relevant to their everyday lives. In addition, the use of writing as both a process and product allowed girls to feel ownership over the inquiry and evaluation process. As an interpretive endeavor, writing allowed girls to use their own voices to articulate both their own definitions of science and the importance of specific information in solving problems.[41]

Scientific literacy, moreover, involves the negotiation of knowledge and experience. For girls, science education typically demands that they adopt a universal model of neutrality and objectivity when evaluating information. Feeling that there is no place for their own voices and interpretations, many girls show disinterest in science and adopt a "tune-out" attitude. In contrast, we found that if the science curriculum (such as the Xenical project) not simply encourages but *requires* students to take an active role in collecting and analyzing information, then female students see that scientific inquiry is not inherently incompatible with the identities and practices of their gender literacy.

Lisa Weems, Paul Miller, Janet Russell,
and Andrea A. Lunsford

Notes

1. Deborah Appleman, "Alice, *Lolita,* and Me: Learning to Read 'Feminist' with a Tenth-Grade Urban Adolescent," pp. 71–88 in *Breaking the Cycle: Gender, Literacy and Learning,* edited by Lynne B. Alvine and Linda E. Cullum (Portsmouth, NH: Boynton/Cook, 1999).

2. Joan Jacobs Brumberg, *The Body Project: An Intimate History of American Girls* (New York: Random House, 1997), p. xxi.

3. Brumberg 1997, p. 197.

4. Linda K. Christian-Smith, *Becoming a Woman through Romance* (New York: Routledge, 1990).

5. Linda K. Christian-Smith, ed., *Texts of Desire: Essays on Femininity and Schooling* (London: Falmer Press, 1993).

6. Margaret J. Finders, *Just Girls: Hidden Literacies and Life in Junior High* (New York: Teachers College Press, 1997).

7. Finders 1997; Deborah R. Dillon and Elizabeth B. Moje, "Listening to the Talk of Adolescent Girls: Lessons about Literacy, School, and Life," pp. 193–224 in *Reconceptualizing the Literacies in Adolescents' Lives,* edited by Donna E. Alverman et al. (Mahweh, NJ: Lawrence Erlbaum Associates, 1998).

8. Finders 1997, p. 54.

9. Finders 1997.

10. Carol Gilligan, *In a Different Voice: Psychological Theory and Women's Development* (Cambridge, MA: Harvard University Press, 1982); Jill M. Taylor, Carol Gilligan, and Amy M. Sullivan, *Between Voice and Silence: Women and Girls, Race and Relationship* (Cambridge, MA: Harvard University Press, 1995).

11. Finders 1997; Christian-Smith, 1993; Linda K. Christian-Smith, "Young Women and Their Dream Lovers: Sexuality in Adolescent Fiction," pp. 100–111 in *Women's Bodies: Sexuality, Appearance, and Behavior,* edited by Rose Weitz (New York: Oxford University Press, 1998).

12. Alison Lee, *Gender, Literacy, Curriculum: Re-writing School Geography* (London: Taylor and Francis, 1996); Dillon and Moje 1998; Roberta Furger, *Does Jane Compute? Preserving Our Daughters' Place in the Cyber Revolution* (New York: Warner Books, 1998).

13. Reported in Furger 1998, p. 23.

14. Lee 1996, p. 4.

15. Lee 1996, p. 104.

16. Lee 1996, p. 173.

17. Lee 1996, p. 172.

18. Lee 1996, p. 132.

19. Philip Wexler, *Becoming Somebody: Toward a Social Psychology of School* (London: Falmer Press, 1992).

20. Arlene McLaren and John Gaskell, "Now You See It, Now You Don't: Gender as an Issue in School Science," pp. 136–156 in *Gender In/forms Curriculum: From Enrichment to Transformation,* edited by Jane Gaskell and John Willinsky (Ontario and New York: OISE Press/Teachers College Press, 1995).

21. Peggy Orenstein, *Schoolgirls: Young Women, Self-Esteem and the Confidence Gap* (New York: Anchor/Doubleday, 1994).

22. American Association of University Women, *Gender Gaps: Where Schools Still Fail Our Children* (New York: Marlowe and Company, 1999); McLaren and Gaskell 1995.

23. American Association of University Women 1999, p. 54.

24. William Pinar, "The Reconceptualization of Curriculum Studies," *Journal of Curriculum Studies* 10 (1978): 205–214.

25. Rodger W. Bybee, *Achieving Scientific Literacy: From Purposes to Practices* (Portsmouth, NH: Heinemann, 1997).

26. Although it is beyond the scope of this article to sufficiently analyze the complex relations between science education and science literacy, we can assume that student literacy is related to the science instruction they receive. Science instruction includes both what (content) is taught and how (pedagogy) it is received. Literacy and curriculum, however, involve meaning-making and thus cannot be simply reduced to the content itself. Furthermore, we must also remember the distinction between a teacher's philosophy and practices in the classroom, school, and larger social context.

27. National Research Council, *National Science Education Standards* (Washington: National Academy Press, 1996), p. 2.

28. National Research Council, p. 113.

29. This change in emphasis became a significant issue when we attempted

to integrate inquiry with high school curricula, which required that designated material be covered within an allotted time.

30. However, John Dewey, who advances experience and inquiry in education, warns against wholly dismissing the organization of knowledge into subjects and disciplines. Organizing knowledge in this way provides a complement to individual experience by providing a tool (as opposed to an independent end) to guide inquiry, and it maintains and develops the discipline across generations.

31. American Association of University Women 1999.

32. Marsha Lakes Matyas and Linda Skidmore Dix, eds., *Science and Engineering Programs: On Target for Women?* (Washington, DC: National Academy Press, 1992); and Marsha Lakes Matyas, "Science Career Interests, Attitudes, Abilities and Anxiety among Secondary School Students: The Effects of Gender, Race/Ethnicity, and School Type/Location," paper presented at the Annual Meeting of the National Association for Research in Science Teaching. New Orleans, April 28, 1984.

33. One exception was Lindsay, who described an almost euphoric pleasure in mathematical problem solving, thus keeping her interest in science high: "finding out how everything fits together like a puzzle."

34. Michelle K. McGinn and Wolff-Michael Roth, "Preparing Students for Competent Science Practice: Implications of Recent Research in Science and Technology Studies," *Educational Researcher* 28, no. 3 (1999): 14–24.

35. To read the overview and mechanics of the project, go to http://wise.berkeley.edu/WISE/demos/fat/.

36. Using the web-based environment (WISE) described above, we developed, implemented, and researched several projects: Darwin's Revolutionary Evolutionary Theory, The Chemistry of Acne, Tabloid Trash vs. Serious Science, Xenical, and so on.

37. See Janet Russell, Lisa Weems, Sarah K. Brem, and Mary Ann Leonard, "Fact or Fiction? Female Students Learn to Critically Evaluate Science on the Internet," *Science Teacher* 68, no. 3 (2001): 44–47.

38. Sue V. Rosser, *Women, Science and Society: The Crucial Union* (New York: Teachers College Press, 2000).

39. American Association of University Women 1999, p. 35. This point underscores the complicated relationship between girls, science, and literacy. Although girls receive better grades than boys in science class, they receive lower scores on standardized science tests.

40. American Association of University Women 1999, p. 47.

41. Gilligan 1982; Brown and Gilligan 1992.

Part 2: Primary Documents

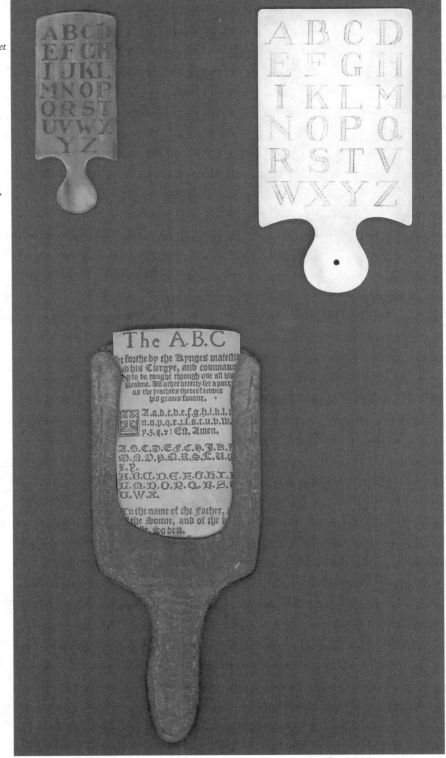

An alphabet on horn, ca. 17th century; an alphabet on ivory, ca. 18th century; a leather-covered hornbook containing a paper alphabet from the late 16th century (Department of Special Collections, Kenneth Spencer Research Library, University of Kansas.)

Instructional Materials

Hornbooks (ca. Sixteenth, Seventeenth, and Eighteenth Centuries)

Through the centuries, girls have confronted a wide array of school texts, conduct books, magazines, and other instructional materials that provide explicit lessons in reading and writing. Such instructional materials also embody the cultural, political, and religious values of the time period in which they were produced.

During the colonial period, hornbooks often served as a child's first instructional text. Not a book, but rather a single sheet of paper pasted onto wood or other durable material, hornbooks typically featured the alphabet, a religious invocation, the Lord's prayer, and perhaps a short syllabary, thus linking literacy with religious devotion. The three hornbooks on the facing page are from the sixteenth, seventeenth, and eighteenth centuries. They appear courtesy of the Department of Special Collections at the Kenneth Spencer Research Library, University of Kansas.

The New-England Primer (1727)

The New-England Primer has long been recognized as a central text in the literacy education of girls and boys in colonial New England. The earliest surviving edition of the Primer is from 1727, though scholars like Paul Leicester Ford and Charles F. Heartman have documented advertisements for an "enlarged edition" of The New-England Primer in the final decades of the seventeenth century. New editions of the book continued to appear throughout the nineteenth century. Contents of the Primer typically included alphabet lessons, the Lord's Prayer, the Apostles' Creed, the Ten Commandments, Now I lay me down to sleep, the advice of British martyr John Rogers to his children, and other prayers and religious texts. With its catechistical lessons, The New-England Primer links the acquisition of literacy skills with deference to parental, civil, and religious authorities. For more on the The New-England Primer and its role in communicating shared social values to children, see the work of David H. Watters.

Included here is The New-England Primer's beginning alphabet with illustrated woodcuts. This alphabet lesson draws upon biblical lessons and emphasizes religious devotion. These images from The New-England Primer appear courtesy of the Department of Special Collections at the Kenneth Spencer Research Library, University of Kansas.

THE
NEW-ENGLAND
PRIMER

IMPROVED

For the more eafy attaining the true reading of Englifh.

TO WHICH IS ADDED

The Affembly of Divines, and Mr. COTTON's *Catechifm.*

BOSTON:

Printed by EDWARD DRAPER, *at* his Printing-Office, in *Newbury-*Street, and *Sold* by JOHN BOYLE in *Marlborough-Street.* 1777.

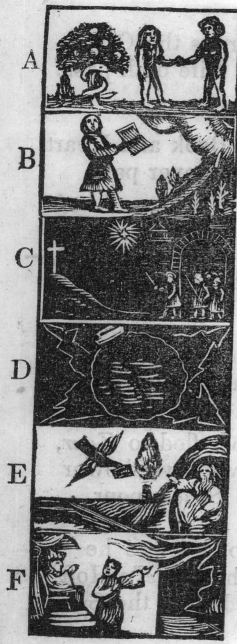

A — In A D A M's Fall
We finned all.

B — Heaven to find,
The Bible Mind.

C — Chrift crucify'd
For finners dy'd.

D — The Deluge drown'd
The Earth around.

E — E L I J A H hid
By Ravens fed.

F — The judgment made
F E L I X afraid.

The beginning alphabet with illustrated woodcuts from The New-England Primer *(Charles and E. Jennifer Monaghan Collection of Books on the History of Reading in the United States. Department of Special Collections, Kenneth Spencer Research Library, University of Kansas).*

G — As runs the Glass,
Our Life doth pass.

H — My Book and Heart
Must never part.

I — Job feels the Rod,—
Yet blesses GOD.

K — Proud Korah's troop
Was swallowed up

L — Lot fled to *Zoar*,
Saw fiery Shower
On *Sodom* pour.

M — Moses was he
Who *Israel's* Host
Led thro' the Sea.

N — Noah did view
The old world & new

O — Young Obadias,
David, Josias
All were pious.

P — Peter deny'd
His Lord and cry'd.

Q — Queen Esther sues
And saves the *Jews*.

R — Young pious Ruth,
Left all for Truth.

S — Young Sam'l dear
The Lord did fear.

T — Young Timothy
Learnt sin to fly.

U — Vasthi for Pride,
Was set aside.

W — Whales in the Sea,
GOD's Voice obey.

X — Xerxes did die,
And so must I.

Y — While youth do chear
Death may be near.

Z — Zaccheus he
Did climb the Tree
Our Lord to see.

WHO was the first man ? — Adam.
Who was the first woman ? — Eve.
Who was the first Murderer ? — Cain.
Who was the first Martyr ? — Abel.
Who was the first Translated ? — Enoch.
Who was the oldest Man ? — Methuselah.
Who built the Ark ? — Noah.
Who was the Patientest Man ? — Job.
Who was the Meekest Man ? — Moses.
Who led *Israel* into *Canaan* ? — Joshua.
Who was the strongest Man ? — Sampson.
Who killed *Goliah* ? — David.
Who was the wisest Man ? — Solomon.
Who was in the Whale's Belly ? — Jonah.
Who saves lost Men ? — Jesus Christ.
Who is *Jesus Christ* ? — The Son of God.
Who was the Mother of *Christ* ? — Mary.
Who betrayed his Master ? — Judas.
Who denied his Master ? — Peter.
Who was the first Christian Martyr ? — Stephen.
Who was chief Apostle of the *Gentiles*? — Paul.

The Infant's Grace before and after Meat.

BLESS me, O Lord, and let my food strengthen me to serve thee, for Jesus Christ's sake. Amen.

I Desire to thank God who gives me food to eat every day of my life. Amen.

The beginning alphabet with illustrated woodcuts from The New-England Primer *(Charles and E. Jennifer Monaghan Collection of Books on the History of Reading in the United States. Department of Special Collections, Kenneth Spencer Research Library, University of Kansas.)*

The Teacher's Assistant in English Composition, John Walker (1801)

In documenting the history of writing instruction, Robert Connors has suggested that John Walker's The Teacher's Assistant in English Composition was a definitive text in the early nineteenth century. The book was first published in England in 1801 and was, according to Connors, reprinted at least eleven times before 1853 (Connors 1997, 304).

In the early nineteenth century, students were expected to respond to either single-word topics or short maxims (e.g., Travelling; Books; Well begun is half-done) as they learned to write. These topics and maxims called for students to demonstrate their awareness of and commitment to communal values, not to express their personal experiences or insights. Students would turn to commonplace books and their knowledge of classical literature and history to generate their compositions.

Walker divided such traditional writing assignments into two sorts: themes, which were argumentative, and subjects, which he suggested should be treated in five parts (Definition; Cause; Antiquity or Novelty; Universality and Locality; and Effects). To help students memorize the rules for developing and organizing their themes and subjects, Walker presented the rules in both prose and verse forms. Aware, though, that students' capacities varied widely, he also included "easy essays" and lessons in narrative in The Teacher's Assistant.

Excerpts that follow include Walker's instructions to parents and teachers; his discussion of narrative as a stepping stone toward more advanced writing assignments; and "Courage and conjugal Affection in a Female," a narrative writing assignment. Though Walker's book is intended for "the Improvement of Youth of Both Sexes," the violent story of Arria's bravery and devotion to her husband is one of the few places where members of the female sex make an appearance in The Teacher's Assistant.

INTRODUCTION.
Directions to Parents and Preceptors, in the Use of the following Work.

In the first place, the rules in prose must be written out by the pupil, and explained more fully by the teacher. The rules versified must also be copied and explained, by comparing them with the prose; after which the pupil must get them by heart.

In the next place, the teacher must read over the Theme distinctly to the pupil, observing the correspondence of each part with the rules. When this is done, the teacher should talk over the Theme to the pupil, by making use of his own words in as familiar a manner as possible; after which he should read the Theme over a second time

to the pupil, and then leave him to put it down from memory as well as he is able.

It will be necessary for the pupil to have a book in quarto, like a copy-book, and to write his exercise on the left hand page: if he should write more than one page will hold, he should turn over the leaf and continue to write on the left hand page, and so on till the Theme is finished.

The teacher should then inspect what is written, and correct what is improper, rather by giving the pupil's thought a proper turn, than changing it for one more accurate; for it is the pupil's idea which ought to be *"taught how to shoot,"* as an idea thus humoured will thrive much better in the human mind than one that is not a native of the soil. Care should therefore be taken that the teacher do not affect too elegant a style in his corrections, but, as much as possible, to make them of a piece with the pupil's own production.*

When the Theme is thus corrected, the pupil should be ordered to copy it out fair, with all the improvements, upon the right-hand opposite page, that the original and the corrected copy may face each other; and this going over the Theme a second time will imprint the corrections in the pupil's mind, and insensibly make them his own.

After the Theme is first read over and explained, it would be advisable to set the pupil upon writing it as soon as possible, that it may not slip out of his memory.

Perhaps it would not be without its use to desire the pupil to write his first sketch upon a bit of loose paper, and to leave it till the next morning, when he may try to make improvements of his own, and recollect something more of the Theme that was given him: he may do the same another morning, and then he should copy what he has done upon the left-hand page of his book of exercises for the inspection of the teacher. This method, if I am not mistaken, will in some measure take away the difficulty which arises from the thoughts of doing his best at first, and make him enter on his exercise with more ease and alacrity than if he were to begin it in a more formal manner in his book.— "These little things," as Dr. Goldsmith observes on another occasion, "are great to little man;" and some of the best practical moral philosophers have laid the greatest stress upon the doctrine of associations.

*Quintilian excellently observes, "that luxuriance in juvenile composition is an infinitely better sign than sterility. Teachers should not aim at too great correctness, which may possibly cramp the genius too much, by rendering the pupil timid and diffident; or perhaps discourage him altogether, by producing absolute despair of arriving at any degree of perfection."

As the capacities of pupils are very different, a very different method should be adopted in teaching them; but scarcely, in any part of education, can instruction be given in classes with so little convenience as in writing Themes. Particular care, therefore, should be taken to let the classes be small, and to form them of such pupils as have nearly the same capacity. If a whole Theme should be too difficult either for a single pupil or a class, let them only have the three first parts given them for the first exercise, and the four last for a second: if this should be found too hard, it may be advisable to give them but two parts at a time. Nay, for those who have almost an invincible repugnance to this sort of exercise (which is often the case), a single part at a time may be enough to begin with. "Divide and conquer," as Dr. Johnson observes, "is a maxim true in letters as well as "in politics;" and we should always keep in view a rule of the greatest importance in teaching, that the advances in a difficult art cannot be too easy and gradual.

The attentive teacher will observe, that every Theme, Subject, and Essay, has an instructive and moral tendency; and if he is at first displeased with the want of ease and elegance in the language and style, he will easily recollect that such a style would have been unsuitable to the capacities of young people just beginning to put their thoughts upon paper, and that the first aim of their teacher ought to be, to enable them to express some of the most obvious ideas in the most obvious words. The very elegant style of Mr. Addison would in this case be too delicate to meet their apprehension: his most ingenious turns of thought would be lost upon them; and some of the finest passages in his Spectators might be read to them, without their being able to carry away with them a single idea.

The first object, therefore, in the following Work was, to convey clear and prominent ideas; to arrange these ideas in such a manner as to make one thought suggest another; to give as much imagery to the thought as possible, that a picture might remain in the mind of the pupil which would enable him to clothe it in words, when the more refined and sentimental part of the subject might escape him. In short, it is the business of the teacher, in this case, to embody thought and sentiment as much as possible, and, as Shakespeare finely says,

—*"to give to airy nothing*
A local habitation and a name."
. . .

It need scarcely be observed, that it is of the utmost importance that pupils should not have this book in their possession. So difficult and irksome at first is the task of writing their thoughts, that young

people will risk every thing to ease themselves of the burden. This book, therefore, should be carefully kept from them; as even one of them in a school, if the teacher's eye be not upon them while they write, will be sufficient to frustrate his expectations. The rules, therefore, should be written out by the teacher, and given to the pupil to copy, without permitting him to see the book; and even if the teacher were to copy out the Theme or Subject, and read it in manuscript to the pupil, it might probably have a good effect on his mind; as it might lead him to suppose there was no such book in being, and give him the idea of rarity and worth which manuscript generally carries with it above what is in print.

. . .

SKETCHES AND OUTLINES IN NARRATIVE.

In teaching to write Exercises, I have often observed that the most difficult part of the composition is the connectives. If a pupil, therefore, of the lower class, seems remarkable backward in writing, perhaps it might not be improper to direct him to make his sentences as sort as possible, and, instead of tacking one member to another in a long chain by relatives and conjunctions, to relate his subject by short detached members. When he has done this, the teacher may shew him how these connectives may be supplied, and, by copying over the exercise thus connected and perfected, he may be led to a use of the connectives by himself.——This may be called giving a *sketch* of a subject.

But as some pupils have an almost invincible repugnance to putting down their thoughts upon paper, every method, and even every stratagem should be made use of to induce them to try at it: for which purpose, I have often thought that if a short simple story were read to them, and then a paper given them with the leading words of the story written at certain distances, and left for them to fill up, it would be an easy means of bringing them on to undertake that terrible task of writing their own thoughts. This may be called drawing the *outline* of a subject, in the same manner as a drawing-master traces the outlines of a picture which he leaves for the pupil to fill up; and there seems to be no reason why one method should not be as conductive to improvement in writing, as the other in drawing. Both these modes of writing will be exemplified in the following pages.

. . .

Courage and conjugal Affection in a Female.
ARRIA, the wife of Paetus, understanding that her husband was

condemned to die, and permitted to choose what death he liked best, she went and exhorted him to quit life courageously; and bidding him farewell, gave herself a stab in the breast with a dagger she had hid under her garment; then drawing it out of the wound, and presenting it to Paetus, she said, "The wound I have given myself is not at all painful; I only feel for that which you must give yourself in following my example."

> The Outline.
> ARRIA,
> Paetus,
> condemned to die,
> death he liked best,
> to die courageously;
> farewell,
> breast
> dagger
> presenting
> Paetus,
> not at all painful;
> feel
> you must give yourself
> example.

The Young Lady's Friend, Eliza W. R. Farrar (1836)

Many girls in the early nineteenth century did not enjoy an extended period of formal education in the numerous female academies that burgeoned in the first half of the century. Acquiring their literacy skills largely within their own homes, they turned to conduct books as crucial instructional texts. These gender-specific texts presented an ideal vision of female behavior. Eliza Farrar's The Young Lady's Friend *serves as a useful representative of this popular genre. Like other conduct books, Farrar's text covers such topics as the rules for pouring tea and coffee, guidelines for nursing the sick, and advice on dealing with servants.*

In the chapter reprinted here, Farrar turns her attention to Mental Culture. A dialogue unfolds between two young women about how reading, writing, and education are useful skills, rather than just ornamental accomplishments. Farrar then offers advice about "a course of reading," and she counsels her readers to begin with texts like Mrs. Barbauld's "Female Studies" and Miss Martineau's "Philosophical Essays on the Art of Thinking." According to Farrar,

such treatises could give young women a clear idea of the "true uses of knowledge," and they could then move on to a systematic study of history, biography, and philosophy. She also advises young women to produce written abstracts of their reading, as the "frequent exercise of the mind in composition" is "one of the most important means of mental culture."

CHAPTER XX.

Mental Culture.

A Conversation on Usefulness.—Display.—Reading without Thinking.—Applications for Aid.—Periodical Literature unfit for the Young.—Reading with an Object desirable.—Study of History.—Exercises in Composition.—A Course of Reading on History.—Biography.—British Poets.—Travels.—Grammar and Rhetoric.—Sentiment and Morality.

So much time is ordinarily wasted in the life of a young lady, that few are aware how much might be accomplished by a scrupulous economy of minutes and a methodical appropriation of hours. But, believing as I do, that there is time enough for the performance of every domestic duty, and for the cultivation of the mind also, I would warn my young friends against sacrificing one to the other. Some persons make an arbitrary division of things into useful and ornamental, and class mental culture under the latter head. This mistake was so well combated by a friend of mine, aged twenty, in conversation with a girl of eighteen, that I will relate what passed. Sarah, the elder one, had been talking to Anna about reading and studying, when the latter said with a sigh, "Well I cannot expect to be like you; Nature meant me to be only useful."

Sarah. "I should be very sorry, if I thought she had not made me for the same purpose."

Anna. "O, you are above being useful. You were meant to be ornamental; everybody is willing you should be so; few can be like you, for few can make such attainments, and those who can are not expected to be useful."

Sarah. "What do you mean by being useful?"

Anna. "O, you know, fulfilling one's duty in the common relations of life."

Sarah. "Do I neglect that?"

Anna. "No, I would not say that, but you do not put your whole mind into it."

Sarah. "Why should I, if I have mind enough for that and other things too?"

Anna. "Well, you are more ornamental than useful at any rate."

Sarah. "It seems to me that you strangely limit the term useful. I suppose you mean that we are useful, only when we are making raiment for the body, or setting the house in order, or tending the sick."

Anna. "O, and visiting the poor, and keeping Sunday school."

Sarah. "Well, do you propose doing this last without cultivation? Shall the blind lead the blind?"

Anna. "That requires no knowledge beyond Christian morality."

Sarah. "The highest knowledge of all, and to which all other attainments are subsidiary!"

Anna. "Well, but granting that, of what other use, Sarah, are all your accomplishments? They make you very independent, I know, and much admired by certain persons; but then they render insipid other society, in which they are not appreciated, and from which you can gain nothing; and what good do they do anybody but yourself?"

Sarah. "I think they do some good, when they make my father and brothers like to be at home and talk with me. You have often complained, that you could not make home attractive to your father and brothers, and lamented the ennui of the one, and the idle amusements of the other. As to its making the sort of society, of which you speak, insipid to me, I know that although you spend so much time in it, it is as disagreeable to you, as it is wearisome to me. You are always bringing me stories of the calumnies which are afloat about you and your friends. Now I say, that much of this wicked gossiping arises from idleness, and that if these people's minds were better furnished, their tongues would be less venomous."

Anna. "But if we can do nothing for this society, ought we to withdraw ourselves wholly from it?"

Sarah. "If we cannot raise its tone, I think it may be of some use to bear a quiet testimony, that we can find some better way of passing our time, than in tasteless, childish amusements, the monotony of which is only relieved by the most malicious backbiting."

Anna. "I wish I could think as you do, but I have always been afraid, that if I were very cultivated, I should not be so useful."

Sarah. "If you enlarge your views of utility, you will perhaps see that we promote it no less by ministering to the spiritual than the temporal wants of others. I cannot consider the person who gives me a beautiful thought, enriches me with a valuable truth, or leads me to take more liberal views of the capacity of the soul or the value of time, is less *useful* to me than that other kind of beings who make jellies for me and watch with me in illness, or take me to ride, and entertain me with their best cheer, when I am well. Let none of us neglect the common duties of our spheres; but if any hours be left,

can we devote them better than to acquiring a knowledge of the laws of God's world, or the minds and history of his creatures? Are we not thus fitting ourselves to perform the highest kind of duty towards each other? And I do believe, that if we judiciously manage our time on earth, short though it be, there will be sufficient to enable us to be useful in the highest sense of that term, as well as in the sense in which you use it."

A great many very good people limit the sense of the word *useful,* as Anna did; but as well might we query what the use is to the body of each portion of food it receives, as to doubt that knowledge, properly taken into the mind, conduces to its strength and enlargement.

There is another class, who value intellectual attainments very highly, but not on the true ground; not because they increase our usefulness and happiness; not because we have immortal souls, that crave knowledge as the body does food; but merely as the means of succeeding in society, for the poor purpose of *display;* and the leading thought of such girls is, "What shall I do with this that I am learning?" She who reads merely for the sake of talking about a book, with which others are acquainted, or that she may embellish her conversation with quotations, or because it is expected that she should know certain facts and names in history, will miss the true end of all study, and will be unable effectually to reproduce any of the ideas so taken in.

"The knowledge which is gained by reading, is of little worth, when the mind is unprepared to receive and assimilate it. If we passively adopt the opinions we meet with in books, or remember the facts they relate without any endeavour to reflect upon them, or to judge of their relation to other facts, we might almost as well not read at all. We may gain knowledge, such as it is; but, at the same time, that knowledge will impede instead of strengthening the operations of our intellects, and the load of facts will lie like a heavy weight, under which the motions of the reasoning power will become more and more feeble, till at length they stop. If, on the contrary, we meditate, compare, choose, and reject, where opinions are in question; arrange and apply, where facts are the subject of inquiry, we cannot read too much for our intellectual improvement. The mind will hold all the knowledge that can ever be put into it, if it be well chosen and properly introduced."*

*See Miss Martineau's *Miscellanies,* 2 vols. published by Hilliard, Gray & Co., Boston.

Let those who are seriously desirous of improving their minds, read first such books as will throw light upon the proper treatment of them. Read the letters of Mrs. Barbauld, on "Female Studies," and on "The Uses of History;" also, Miss Martineau's "Philosophical Essays on the Art of Thinking;" these will show you what is the necessary preparation of the mind for deriving improvement from reading, and give you clear ideas of the true uses of knowledge.

Very young ladies should not aim at being acquainted with the periodical literature of the day, nor with the various new books which they hear their elder friends conversing about. Their leisure should be chiefly given to standard works in their own language, or the study of classic authors in foreign tongues. Life is too short, and time too precious, and books too numerous, to allow of your reading a work in order to ascertain whether it be worth the perusal. It is wise to profit by the experience of others in this respect, and to read only such books as are well recommended.

A course of reading, undertaken for the purpose of ascertaining some particular points in history, or by way of testing some theory in morals, or for any specific object, will fructify the mind more than years of aimless reading. If you consult the works alluded to by the authors you are studying, and acquire all the collateral information which belongs to any subject that engages your attention, you will find your interest to increase as you trace the connexion, and that ideas, thus followed out, become a part of your own mind, and suggest new thoughts and feelings.

It should be a rule with you never to pass over a word you do not know, or a thing you do not understand, without either looking for its explanation in dictionaries, encyclopædias, &c., or making a note of it in a little book, kept for the purpose, that you may inquire its meaning of the first person you meet with, who is competent to give it.

Many persons take a dislike to history, from having studied it only in the abridgments used in schools; whereas the voluminous accounts given of the same events, and which are shunned as a heavy task, would prove far more entertaining. The more you read about some things, the more interested you become, and this is the case with history. When you are familiar with certain scenes and characters, you will wish to know additional particulars concerning them. When you have read Goldsmith's and Littleton's accounts of the parent country, you will like to know how Hume describes the same events; and having read what two Protestants and one infidel say of them, it will be doubly interesting to know what Lingard, the Roman Catholic, will write on the same subject; and after all these, the

sketch given by a philosopher, such as the late Sir James Mackintosh was, will impart a new interest to England's story.

There are so many entertaining biographies and memoirs which may be read in connexion with English history, that it must prove a high treat, an intellectual feast, to any mind prepared to enjoy it. After reading two or three short histories, so as to have a general idea of the progress of events, it is well to take a full account, like Hume's, and read the biographies of great characters, in connexion with the times in which they flourished. The various memoirs, too, should be read in the same way. The history should be considered as a skeleton, which is to be filled out by all the collateral information you can procure. Shakespeare's historical plays, and Scott's historical novels, may be read to great advantage in connexion with the history of the period to which they belong.

Written abstracts of what you read will not only assist your memory in recollecting dates and facts, but will aid you in arranging, comparing, and reflecting upon what you have acquired. They should be frequently referred to, and occasionally studied very thoroughly, if you would reap the full benefit of them.

Whenever you are reading or studying, take care to have within reach, gazetteers, maps, biographical charts, dictionaries, encyclopædias, &c., and never grudge the time that you spend in consulting them.

However irksome may have been the writing of themes at school, you cannot relinquish the frequent exercise of the mind in composition, without neglecting one of the most important means of mental culture. Nothing is a greater help to accuracy of statement, and accuracy of thought. Those who are unaccustomed to this exercise, may begin by writing down the thoughts of others from memory; a sermon or a lecture, a conversation or a passage from a book, will furnish a topic. In the last case, the novice can compare her composition with the original, and so correct it. The more varied the subjects you treat of, the more useful will be the exercise; and if the labor of composition be irksome to you, there can be no stronger proof that your mind requires the discipline. It should be remembered, that, however valuable these compositions are, as exercises of the young mind, they seldom have any intrinsic merit, and should, therefore, be kept to yourself, and destroyed when they have answered their purpose.

Having been frequently applied to for a list of the books which I should recommend a young lady with plenty of leisure to read, I presume that such a guide will be sought for in this work, and shall there-

fore endeavor to furnish it.** No course of reading can be pointed out, which will suit the minds of all equally well, or be accessible to the generality of readers. Many must be satisfied to cull from it, what the scanty libraries around them will supply; but such may comfort themselves with the reflection, that a few books, thoroughly studied and well assimilated to the mind, do us more good than a hasty, careless perusal of many volumes.

Every well educated person, whose mother tongue is English, must be acquainted with the great poets who have adorned and enriched the literature of England. Many of them it is sufficient to read; but you must study Milton, and Shakspeare, become intimately acquainted with Young, Goldsmith, Thomson, Gray, Parnel, Cowper, Campbell, Burns, Wordsworth, and Southey; also the ethical parts of Pope's poetry.

Always read the life of an author in connexion with his works, if you would fully understand and appreciate them; but beware of surrendering your mind passively to what the biographer may think of his subject. Johnson's "Lives of the Poets" is a celebrated work, and one worthy of an attentive perusal in connexion with the British Poets; but it contains many of that great author's prejudices, and some examples of flagrant injustice, against which the reader should be on his guard.

In judging of the character of the English poets, from Chaucer to Cowper, you will find no better guides than Campbell in his "Specimens of the British Poets," and Dr. Aikin in his "Letters to a Young Lady, on a Course of English Poetry." Indeed, in a majority of the poets mentioned by Campbell, the specimens which he has given, together with "Aikin's Select Works of British Poets," are sufficient for a young reader. Campbell's "Biographical and Critical Notices of the British Poets," his "Essay on English Poetry," and his Lectures on Poetry, in the "New Monthly Magazine," will assist you in forming a correct taste and in appreciating the various merits of the different poets.

Study Shakspeare with Schlegel's Lectures and Mrs. Jameson's "Characteristics of Women."

Your course of reading should be partly determined by the interest excited in your mind by accidental circumstances and conversations. When you have heard an animated discussion of the merits of certain standard works, with which you are unacquainted, that is the time

**See Note A, at the end of this volume. [Farrar included at the end of her conduct book some sixty historical and biographical texts as a course of reading.]

to read them, whilst your mind is all alive to the subject. If you are introduced to a foreigner, who discourses of his own country till he awakens an interest in scenes and manners that are new to you, follow up the impression, by reading all you can find that relates to those subjects.***

If anything leads your mind to consider the philosophy of language and grammar, and you become interested in examining the instrument that you are constantly using, you will be greatly assisted in doing so, by reading "Harris's Hermes," and "The Diversions of Purley."

Rhetoric may next claim your attention; and if your mind is properly awakened to the subject, you find great entertainment, as well as instruction, in the following works; "Blair's Lectures on Rhetoric," "Kames's Elements of Criticism," and "Campbell's Philosophy of Rhetoric."

Of the Tattler, Spectator, Rambler, and numerous other periodical papers which had such a vogue in the last century, it is now necessary to read only a selection; and this has been wisely made by Mrs. Barbauld, and published for the benefit of young persons, with an admirable critical essay prefixed to it.

Works of sentiment and morality are so numerous, and of so mixed a character, that, whilst great care is necessary in making a wise selection, the number of good ones is too large for me to attempt a list of them.

First Lessons in Composition, G. P. Quackenbos (1851)

G. P. Quackenbos's First Lessons in Composition perpetuates traditions inherited from previous generations of writing teachers and textbook authors, like John Walker, and also looks forward to new trends in literacy education. Quackenbos's list of writing assignments, which is reprinted here, includes abstract topics (e.g., the fickleness of fortune; the progress of civilization) that would require students to draw upon their knowledge of classic literature and community truisms. But Quackenbos begins his list with letter writing and epistolary situations that would mirror students' personal experiences, and among the descriptive topics are things and places (a market, a church, a fire engine) that students would likely have encountered in their own lives. By the second half of the nineteenth century, writing teachers could no longer presume their students would be well read, particularly in the classics (Connors 1997, 308), and as Lucille M. Schultz has documented, Swiss educator

***See Note B, at the end of this volume. [Farrar's recommended list of books on travel included roughly a dozen texts.]

Johann Heinrich Pestalozzi's theories of childhood development, which privileged concrete experience over abstractions, gained purchase among educators in the United States.

LETTERS.

1. Write a letter to your teacher, giving an account of the manner in which you spent your last vacation.

2. Write to a friend, describing your sister's wedding, and the festivities on that occasion.

3. Write to a cousin in the country, giving an account of a concert, the Museum, or any place of public amusement which you may have recently visited.

4. Write to a parent, or other relative, travelling in Europe, about domestic matters.

5. Write an answer to the preceding letter, in which the parent would naturally give some account of his travels in Europe.

6. Announce in a letter to a friend that his brother whom you knew, and who resided in the same place that you do, is dead. Give an account of his sickness. Offer such consolation as is in your power.

7. Write a note to a friend, requesting the loan of a volume.

Write a note, inviting a friend to spend the holidays at your father's house.

Write a note, regretting that prior engagements will compel you to decline a friend's invitation.

8. Write a letter to a merchant, applying for a situation as clerk, and stating your qualifications.

Write an answer from the merchant.

DESCRIPTIONS.

9. An Elephant.
10. A Market.
11. A Farm.
12. A Canal.
13. A Hotel.
14. A Garden.
15. A Manufactory.
16. A Church.
17. A Fire-engine.
18. A Dry-goods Store.
19. Describe "A Steamboat" and "A Ship"; tell wherein they differ, and wherein they are alike.

20. Treat in like manner, "A Clock and a Watch."
21. A Bird and a Beast.
22. A Man and a Monkey.
23. A Snake and an Eel.
24. A Horse and a Cow.
25. A Sleigh and a Carriage.
26. Describe the place in which you live.
27. A Thunder-storm.
28. A Lake Scene.
29. A Storm at Sea.
30. The Country in Spring.
31. Scenes of Peace.
32. Scenes of War.
33. Contrast between a Morning and an Evening Scene.
34. A Scene in an Auction Room.
35. The Good Scholar.
36. The Idle Boy.
37. The Intemperate Man.
38. An Indian.
39. Thanksgiving Day.

NARRATIONS.

*Fiction.**

40. Adventures in California.
41. An Encounter with Pirates.
42. A Lion Hunt in Southern Africa.
43. The Indian's Revenge.
44. The History of a Pin.
45. The History of a Bible.
46. The History of a Cent.
47. The History of a Shoe.
48. The Story of an old Soldier.
49. Robinson Crusoe.

*Historical Narrations.***

50. The Discovery of America.
51. The American Revolution.

*For the Exercises in Fiction it will be necessary to draw on the imagination; in some cases it may be well for the teacher to assist the pupil with remarks on the subject. In the case of "the History of a Pin," it is necessary only to imagine some of the scenes that a pin would be likely to pass through, and to relate them as if the pin itself were speaking; thus, "The first recollections that *I* have," &c.

**In the Historical Narrations and Biographical Sketches, the pupil must

52. The Reign of the Emperor Nero.
53. The Invasion of Russia by Napoleon.
54. The Crusades.
55. The Reformation.
56. The Crossing of the Red Sea. (Exodus, chap. xiv.)
57. David and Goliath. (I. Samuel, chap. xvii.)
58. Jephthah's Daughter. (Judges, chap. xi., verse 29.)
59. Naaman, the Leper. (II. Kings, chap. v.)
60. The History of Jonah.

Biographical Sketches.

61. Washington.
62. Franklin.
63. Charlemagne.
64. Alfred the Great.
65. Shakspeare.
66. Queen Elizabeth.
67. Columbus.
68. Julius Caesar.
69. Alexander the Great.
70. Homer.
71. Moses.
72. Ruth.
73. Solomon.
74. Daniel.

ESSAYS.

75. Spring.
76. The Beauties of Nature.
77. The Mariner's Compass.
78. The Advantages of Education.
79. Evening.
80. The Fickleness of Fortune.
81. Disease.
82. Chivalry.
83. Honesty.
84. The Ruins of Time.
85. Gambling.
86. The Study of History.
87. Youth.

obtain his facts from some history. He must clothe them, however, in his own language.

88. Winter.
89. The Starry Heavens.
90. Government.
91. Old Age.
92. Anger.
93. Ambition.
94. Contentment.
95. The Sun.
96. City Life.
97. Life in the Country.
98. The Life of the Merchant.
99. The Life of the Sailor.
100. The Life of the Soldier.
101. Manufactures.
102. The Spirit of Discovery.
103. Newspapers.
104. Freedom.
105. The Art of Printing.
106. The Influence of Woman.
107. The Ocean.
108. The Pleasures of Traveling.
109. The Wrongs of the Indian.
110. Summer.
111. Night.
112. Death.
113. Revenge.
114. The Study of Geography.
115. Music.
116. The Moon.
117. The Stars.
118. Comets.
119. The Earth.
120. Day.
121. Autumn.
122. The Pleasures of Memory.
123. The Sabbath.
124. The Fifth Commandment.
125. Virtue.
126. Egypt.
127. Snow.
128. Mountains.
129. Forests.

130. Character of the Ancient Romans.
131. Our Country.
132. The Miser.
133. Oriental Countries.
134. Hope.
135. Life.
136. Rivers.
137. Astronomy.
138. Rain.
139. Vice.
140. Riches and Poverty.
141. The Fourth of July.
142. The Bible.
143. Morning.
144. The Art of Painting.
145. The Mahometan Religion.
146. The Applications of Steam.
147. The Great West.
148. Idleness.
149. Gratitude.
150. The Inquisition.
151. The Advantage of Studying the Classics.
152. The Hermit.
153. Courage.
154. Early Rising.
155. Perseverance.
156. Flowers.
157. Modesty.
158. Intemperance.
159. Genius.
160. The Orator.
161. Peace.
162. War.
163. Patriotism.
164. The Jews.
165. The English Noble.
166. Peasant Life.
167. The Sources of a Nation's Wealth.
168. Truth.
169. A Republican Government.
170. Dissipation.
171. Envy.

172. The Attraction of Gravitation.

173. Love.

174. Nature and Art.

175. The Progress of Civilization.

176. Poetry.

177. The Feudal System.

178. Silent Influence.

179. The Drama.

180. The Mind.

181. "Whatever is, is right."

182. "Beware of desperate steps; the darkest day—/ Live till to-morrow—will have passed away."

183. "There's a Divinity that shapes our ends, / Rough hew them how we may."

184. "Health is the vital principle of bliss."

185. "Heaven from all creatures hides the book of fate."

186. "Be it ever so homely, there's no place like home."

187. "Hypocrisy, the only evil that walks / Invisible except to God alone."

188. "Kings are earth's gods; in vice their law's their will; / And if Jove stray, who dares say, Jove doth ill."

189. "Sweet is the image of the brooding dove! / Holy as Heaven a mother's tender love!"

190. "The bolt that strikes the towering cedar dead, / Oft passes harmless o'er the hazel's head."

191. "Who by repentance is not satisfied, / Is nor of heaven, nor earth."

192. "Honor and shame from no condition rise; / Act well your part; there all the honor lies."

193. "Suspicion is a heavy armor, and / With its own weight impedes more than it protects."

194. "Treason does never prosper."

195. "I love thee, twilight! for thy gleams impart / Their dear, their dying influence to my heart."

196. "True charity's a plant divinely nursed."

197. "Good name in man and woman / Is the immediate jewel of their souls."

198. "Sweet are the uses of adversity."

199. "Man yields to custom as he bows to fate, / In all things ruled—mind, body, and estate."

200. "Experience is the school / Where man learns wisdom."

201. Honesty is the best policy.

202. All is not gold that glitters.

203. One to-day is worth two to-morrows.

204. Birds of a feather / Flock together.

205. Great talkers, little doers.

206. Keep thy shop, and thy shop will keep thee.

ARGUMENTATIVE DISCOURSES.

When the subject is given in the form of a question, the pupil may take either side.

1. Is conscience in all cases a correct moral guide?

2. Do public amusements exercise a beneficial influence on society?

3. Does the study of classics, or of mathematics, afford the better discipline to the mind?

4. Is a monarchy the strongest and most stable form of government?

5. Did the Crusades have a beneficial influence on Europe?

6. Do the learned professions offer as promising an opening to a young man as mercantile life?

7. Is a nation justified in rising against its rulers?

8. Is a lawyer justified in defending a bad cause?

9. Is it an advantage for a young man who intends to become a merchant to go through college?

10. Do parents or teachers exercise the greater influence in forming the character of the young?

11. Is it best for judges to be elected by the people?

12. Does the Pulpit or the Bar afford a better field for eloquence?

13. Does the reading of novels have a good or bad effect on the community?

14. Do inventions have a tendency to improve the condition of the laboring classes?

The Lady's Guide to Perfect Gentility, Emily Thornwell (1856)

Guides for letter writing and collections of model letters have been a part of Western literacy education since at least the Middle Ages. By the nineteenth century, girls typically turned to etiquette manuals for advice on proper epistolary conduct. As Jean Ferguson Carr notes in her essay in this volume, girls' increased access to educational opportunities in the nineteenth century helped to solidify literacy's position as crucial evidence of a girl's class standing, upbringing, and her cheerfully obedient nature. Along with the content of girls' writings, the

physical appearance of their texts was also scrutinized. By not blotting her paper and neatly folding her letters, a girl could indicate her potential as a tidy, future housekeeper and mother.

In her 1856 guide to "perfect gentility," Emily Thornwell devotes a chapter to letter-writing, proscribing appropriate types of stationery, colors of sealing wax, and salutations. Thornwell also includes seventeen model letters, covering situations that range from extending invitations to a picnic to responding to an unfaithful suitor. Included below are Thornwell's model letter from a girl at boarding school to her mother; a letter from an aunt warning her young niece about being seen with rakish young men; and the niece's grateful reply.

CHAPTER V.

The Whole Art of Correct and Elegant Letter-Writing.

Useful Hints and Rules for Letter-Writers—Selecting Materials for Writing—Due Arrangement of What Is to Be Written—Models or Plans for Various Letters and Notes Pertaining to Domestic Matters, Love, Marriage, Entertainments, Etc., Etc.

Useful hints and rules for letter-writers.—In answering a letter, always attend to any questions or inquiries for information which may have been addressed to you by your correspondent before you proceed with your own thoughts and information.

Avoid the introduction of too many quotations from other authors, particularly those in a foreign language; it is ridiculous affectation to write a Latin or French phrase, when an English one would do just as well; it is as bad as talking in a technical language to a person who knows nothing about it.

Never use hard words unnecessarily; nor particular words or phrases too often; use as few parentheses as possible; it is a clumsy way of disposing of a sentence, and often embarrasses the reader.

Correct spelling and good grammar are so essential to fine writing that the absence of them destroys the force of the best sentiments.

THE REQUISITE WRITING MATERIALS.

Kind of paper.—The choice of materials for writing, without being very essential, is yet necessary; to write on very coarse paper is allowable only for the most indigent; to use gilt-edged, and perfumed paper for business would be ridiculous.

The selection of paper ought always to be in keeping with the person, age, sex, and circumstances of the correspondents. Ornamented paper, of which we have just spoken; paper bordered with colored vignettes, and embossed with ornaments in relief upon the

edges, or slightly colored with delicate shades, is designed for young ladies, and those whose condition, taste, and dignity presuppose habits of luxury and elegance.

Distinguished persons, however, reasonably prefer simplicity in this thing, and make use of very beautiful paper, but yet without ornament.

A whole and clear sheet of paper necessary.—It is extremely impolite to write upon a single leaf of paper, even if it is a billet; it should always be double, even though we write only two or three lines. It is still more improper to use for an envelope paper on which there are a few words foreign to the letter itself, whether they be written or printed.

Size of sheet, spaces, margin, etc.—Letters of petition or request should be in folio, that is to say, upon a sheet of paper in its full size; the margin should be very broad, say, two or three inches.

If we are writing to a superior, we should leave large spaces between the lines. Also, commence the letter quite low down upon the sheet, and be particular not to crowd the writing, as it is considered disrespectful, especially if our correspondent be elderly. In writing a familiar letter, it is as well to begin near the top of the sheet, and write compactly, but legibly, leaving a small margin, or none if preferred.

Dating.—The date of a letter may be put at the beginning when we write to an equal; but in writing to a superior it should be at the end, in order that the title at the head of the letter may be entirely alone.

In letters of business, it is necessary to date legibly and correctly at the top, on the first line, so that it may be quite perspicuous. In a simple billet, we put the day of the week, and the hour of the day, if we please, in small hand, at the bottom of the note.

Folding and sealing.—Every letter to a superior ought to be folded in an envelope. It shows a want of respect to seal with a wafer; we must use sealing-wax. Men usually select red; but young ladies use gilt, rose, and other colors. Both use black wax when they are in mourning. Except in this case, the color of the seal is immaterial, but not the size, for very large ones are in bad taste. The smaller and more glossy, the better, and more tasteful the appearance. Although sealing-wax is preferable, still we must sometimes avoid using it; it is when we are afraid the letter may be opened.

When the letter is closed with or without an envelope, we put only a single seal upon it; but if the letter is large we use two. If it contains important papers it should have three seals or more, according to the size of the envelope.

If a friend takes charge of a letter as a favor, it would be quite im-

polite to put more than one seal upon it. If the letter should be folded in such a manner that, by opening it at the end, its contents may be read, it would be equally regardless of delicate propriety to put a little wax upon the edges. This precaution is only to be used when the letter is sent by post, or an untried domestic.

When we use no envelope, and the third page of the letter is all written upon, we should leave a small blank space where the seal is to be put; as, without this precaution, many very important words may be lost, especially if it is a business letter.

Style of addressing different persons.—If a person has many titles, we select the highest and omit the others.

The use of the pronouns *he* and *she* should be avoided in billets of invitations, regrets, acceptances, etc., on account of their liability to confuse the mind as to whom precisely such pronouns refer.

Unceremonious billets may commence in this way; "Mr. and Mrs. N. present their respects to Mr. and Mrs. Such-a-one, and request," etc.

We do not pretend to regulate, by any ceremonial, the sentiments of the heart, but it is in good taste to abstain from too frequent use of endearing epithets, especially when they are not truthful; such as "*Your tender, sincere, constant and faithful friend.*"

Manner of commencing and closing.—The manner of addressing a lady should always be tinged with a degree of respect, especially if the communication proceed from a gentleman. A trifling style when addressed to superior persons is quite intolerable. In closing a note, always use some of the established forms of politeness, such as "*I am, dear madam, with sincere regard, yours, etc.,*" or "*Believe me, my dear sir, with much respect,*" etc.

Proper arrangement of what is to be written.—When you write upon any subject, consider it fully before putting it upon paper, and treat of each topic in order, that you may not be obliged to recur to any one again, after having spoken of another thing, as it confuses the mind.

If you have many subjects to treat of in the same letter, commence with the most important; for if the person to whom you write is interrupted while reading it, he will be the more impatient to resume the reading, however little interesting he may find it.

It is useful and convenient to begin a new paragraph at every change of the subject.

Letters of introduction.—A letter which is to be shown, as a letter of introduction, or recommendation, should never be sealed, since the bearer ought necessarily to know the contents. And to seal it, without first having allowed the bearer to read it, would be extremely

impolite. You should prove to the person recommended that you have spared no pains to render him a service.

A young lady to her mother, on entering a boarding-school.

TROY, *Jan.* 1*st,* 1855.

MY DEAR MOTHER:

As you are, no doubt, desirous to hear whether I am both well and happy in the new scene of life to which I have been introduced, I avail myself of the first opportunity to ease your anxiety upon this subject. My health has been uniformly good since we last parted; indeed, I may say that it is rather improved, owing, probably, to the change of air, and the regulations made in regard to our diet, duties and exercise.

On missing your company, and that of my father, sisters, and brothers, and meeting with a number of new associates in the persons of my school-fellows, I felt myself at first in rather low spirits, and it was some time before I could reconcile myself to the loss of the comforts and indulgences of home. But I have now surmounted all unpleasant feelings in these particulars, and can truly say that I am as contented and happy, almost, as I used to be at home; I will not say quite, since I am separated from the presence of my dear parents.

You may gather, therefore, from what I have said, that I have no cause to find fault with any one of those in whose charge I have been placed, or with any of my school-fellows; indeed, I am confident that in a short time I shall have formed some delightful friendships. I feel assured that this favorable intelligence will give you delight; and may I hope soon to be cheered by news equally satisfactory from my much loved home? Believe me, my dear mother,

Your affectionate daughter,
ANNIE WHARTON.

From an aged lady in the country to her niece in New York, cautioning her against keeping company with gentlemen of bad reputation.

DEAR NIECE:

The sincere affection which I now have for your indulgent father, and ever had for your virtuous mother when she was alive, together with a tender regard for your future happiness and welfare, have prevailed on me to write you what I have heard concerning your too unguarded conduct, and the too great freedom you manifest when in the

company of a certain Mr. Buxby. You have been seen with him at the theatre, at Niblo's, at the Museum, as well as promenading Broadway!

Do not imagine, niece, that I write this from a principle of ill-humor; it is on purpose to save you from ruin; for let me tell you, your familiarity with him gives me no small concern, as his character is extremely bad, and as he has acted in the most ungenerous manner to two or three estimable young ladies of my acquaintance, who entertained too favorable an opinion of his honor.

It is possible, my dear girl, as you have no great fortune to expect, and as he has an uncle from whom he expects a considerable estate, that you may be tempted to imagine his addresses an offer to your advantage; but that is a matter beyond question; for I have heard that he is deeply in debt, as also that he is privately engaged to a rich old widow in the Jerseys. In short, he is a perfect libertine, and is ever boasting of the frailty of our sex, and adducing proofs to sustain himself.

Let me prevail on you, my dear niece, to avoid his company as you would that of a madman; for, notwithstanding, I still hope you are strictly virtuous, yet your good name may be irreparably lost by such open acts of imprudence. I have no other motive but an unaffected zeal for your interest; and I flatter myself you will not be offended with the liberty taken, by

<div align="right">Your sincere friend, and affectionate aunt
MRS. CLARA UPTON.</div>

The young lady's answer.

HONORED MADAM:

I received your letter, and when I consider your reasons for writing, I thankfully acknowledge you my friend. It is true, I have been at those public places you mention, along with Mr. Buxby, but was ignorant of his real character. He did make me proposals of marriage, but I told him I would do nothing without my father's consent. He came to visit me this morning, when I told him that a regard for my reputation obliged me never to see him any more, nor even to correspond with him by letter, and you may depend on my adhering to my resolution.

In the mean time, I return you a thousand thanks for your friendly advice. I am sensible every young woman should be careful of her reputation, and constantly avoid the company of unprincipled flatterers.

To convince you of my sincerity, I shall leave New York in about six weeks, and will call and see you after I have been at my father's.

<div align="right">I am, honored madam, your obliged niece,
FANNIE HALL.</div>

McGuffey's Fifth Eclectic Reader, William McGuffey (1879)

As girls gained greater access to formal education over the course of the nine-teenth century, the figure of the girl as a reader and writer became common-place in elementary textbooks, like William McGuffey's popular series of read-ers. Though such textbooks were often intended for a mixed audience of both boys and girls, these textbooks generally sent young women slightly different messages about their skills as readers and writers than the lessons their male counterparts might have derived from the textbooks. As Jean Ferguson Carr sug-gests in her essay in this volume, this lesson from McGuffey's Fifth Eclectic Reader *portrays a young girl, Ernestine, competing with two boys for the title of Best Reader, but Ernestine's abilities to read, write, and speak are linked to domestic values and her role as a caretaker of others.*

I. THE GOOD READER.

1. It is told of Frederick the Great, King of Prussia, that, as he was seated one day in his private room, a written petition was brought to him with the request that it should be immediately read. The King had just returned from hunting, and the glare of the sun, or some other cause, had so dazzled his eyes that he found it difficult to make out a single word of the writing.

2. His private secretary happened to be absent; and the soldier who brought the petition could not read. There was a page, or favorite boy-servant, waiting in the hall, and upon him the King called. The page was a son of one of the noblemen of the court, but proved to be a very poor reader.

3. In the first place, he did not articulate distinctly. He huddled his words together in the utterance, as if they were syllables of one long word, which he must get through with as speedily as possible. His pronunciation was bad, and he did not modulate his voice so as to bring out the meaning of what he read. Every sentence was uttered with a dismal monotony of voice, as if it did not differ in any respect from that which preceded it.

4. "Stop!" said the King, impatiently. "Is it an auctioneer's list of goods to be sold that you are hurrying over? Send your companion to me." Another page who stood at the door now entered, and to him the King gave the petition. The second page began by hemming and clearing his throat in such an affected manner that the King jokingly asked him if he had not slept in the public garden, with the gate open, the night before.

5. The second page had a good share of self-conceit, however, and so was not greatly confused by the King's jest. He determined

that he would avoid the mistake which his comrade had made. So he commenced reading the petition slowly and with great formality, emphasizing every word, and prolonging the articulation of every syllable. But his manner was so tedious that the King cried out, "Stop! are you reciting a lesson in the elementary sounds? Out of the room! But no: stay! Send me that little girl who is setting there by the fountain."

6. The girl thus pointed out by the King was a daughter of one of the laborers employed by the royal gardener; and she had come to help her father weed the flower-beds. It chanced that, like many of the poor people in Prussia, she had received a good education. She was somewhat alarmed when she found herself in the King's presence, but took courage when the King told her that he only wanted her to read for him, as his eyes were weak.

7. Now, Ernestine (for this was the name of the little girl) was fond of reading aloud, and often many of the neighbors would assemble at her father's house to hear her; those who could not read themselves would come to her, also, with their letters from distant friends or children, and she thus formed the habit of reading various sorts of hand-writing promptly and well.

8. The King gave her the petition, and she rapidly glanced through the opening lines to get some idea of what it was about. As she read, her eyes began to glisten, and her breast to heave. "What is the matter?" asked the King; "don't you know how to read?" "Oh, yes! sire," she replied, addressing him with the title usually applied to him: "I will now read it, if you please."

9. The two pages were about to leave the room. "Remain," said the King. The little girl began to read the petition. It was from a poor widow, whose only son had been drafted to serve in the army, although his health was delicate and his pursuits had been such as to unfit him for military life. His father had been killed in battle, and the son had a strong desire to become a portrait-painter.

10. The writer told her story in a simple, concise manner, that carried to the heart a belief of its truth; and Ernestine read it with so much feeling, and with an articulation so just, in tones so pure and distinct, that when she had finished, the King, into whose eyes the tears had started, exclaimed, "Oh! Now I understand what it is all about; but I might never have known, certainly I never should have felt, its meaning had I trusted to these young gentlemen, whom I now dismiss from my service for one year, advising them to occupy the time in learning to read."

11. "As for you, my young lady," continued the King, "I know you will ask no better reward for your trouble than the pleasure of carry-

ing to this poor widow my order for her son's immediate discharge. Let me see if you can write as well as you can read. Take this pen, and write as I dictate." He then dictated an order, which Ernestine wrote, and he signed. Calling one of his guards, he bade him go with the girl and see that the order was obeyed.

12. How much happiness was Ernestine the means of bestowing through her good elocution, united to the happy circumstance that brought it to the knowledge of the King! First, there were her poor neighbors, to whom she could give instruction and entertainment. Then, there was the poor widow who sent the petition, and who not only regained her son, but received through Ernestine an order for him to paint the King's likeness; so that the poor boy rose to great distinction, and had more orders than he could attend to. Words could not express his gratitude, and that of his mother, to the little girl.

13. And Ernestine, had, moreover, the satisfaction of aiding her father to rise in the world, so that he became the King's chief gardener. The King did not forget her, but had her well educated at his own expense. As for the two pages, she was indirectly the means of doing them good, also; for, ashamed of their bad reading, they commenced studying in earnest, till they overcame the faults that had offended the King. Both finally rose to distinction, one as a lawyer, and the other as a statesman; and they owed their advancement in life chiefly to their good elocution.

DEFINITIONS.—1. Pe-tĭ′tion, *a formal request.* 3. Ar-tĭc′ū-lāte, *to utter the elementary sounds.* Mŏd′ū-lāte, *to vary or inflect.* Mo-nŏt′o-ny, *lack of variety.* 4. Af-fĕct′ed, *unnatural and silly.* 9. Drȧft′ed, *selected by lot.* 10. Con-cīse′, *brief and full of meaning.* 11. Dis-charġe′, *release.* Dĭc′tāte, *to utter so that another may write down.* 12. Dis-tĭnc′tion, *honorable and notable position.* Ex-prĕss′, *to make known the feelings of.*

NOTES.—Frederick II. of Prussia (*b.* 1712, *d.* 1786), or Frederick the Great, as he was called, was one of the greatest of German rulers. He was distinguished for his military exploits, for his wise and just government, and for his literary attainments. He wrote many able works in the French language. Many pleasant anecdotes are told of this king, of which the one given in the lesson is a fair sample.

"How to Keep a Journal," W. S. Jerome,
St. Nicholas (1878) and
"Keeping the Cream of One's Reading,"
Margaret Meredith, *St. Nicholas* (1886)

During the nineteenth century, magazines designed specifically for children began to emerge. As Gillian Avery (1994) has documented, close to 250 juvenile periodicals were launched between 1840 and 1900. One of the most popular of these was St. Nicholas, *published by Scribner's as a juvenile version of its family literary magazine.* St. Nicholas, *like other children's magazines, offered children important, extracurricular instruction in writing and reading.*

In this 1878 article on keeping a journal, W. S. Jerome covers everything from choosing an appropriate notebook to selecting topics that are worthy of recording in a diary. Jerome explicitly calls his young readers' attention to the ways in which the habit of journal-keeping offers far more pleasurable opportunities to improve one's powers of observation, penmanship, spelling, and punctuation than can be found in merely copying printed letters and sentences in writing textbooks. Not a means of self-exploration or experimentation, journal-keeping, according to Jerome, is a way to establish orderly habits and self-discipline.

St. Nicholas *also schooled its young audience in appropriate reading habits. In 1886, Margaret Meredith offered advice on how to keep the "cream of one's reading." She describes her own "snipper book," or scrapbook, and encourages boys and girls to follow her example. By doing so, young readers could create new texts suited to their own individual needs and interests out of the overwhelming array of mass-distributed books and magazines that became available in the nineteenth century.*

HOW TO KEEP A JOURNAL.

By W. S. Jerome.

Autumn is as good a time as any for a boy or girl to begin to keep a journal. Too many have the idea that it is a hard and unprofitable task to keep a journal, and especially is this the case with those who have begun, but soon gave up the experiment. They think it is a waste of time, and that no good results from it. But that depends upon the kind of journal that you keep. Everybody has heard of the boy who thought he would try to keep a diary. He bought a book, and wrote in it, for the first day, "Decided to keep a journal." The next day he wrote, "Got up, washed, and went to bed." The day after, he wrote the same thing, and no wonder that at the end of a week he wrote, "Decided not to keep a journal," and gave up the experiment. It is such attempts as this, by persons who have no idea of what a journal

is, or how to keep it, that discourage others from beginning. But it is not hard to keep a journal if you begin in the right way, and will use a little perseverance and patience. The time spent in writing in a journal is not wasted, by any means. It may be the best employed hour of any in the day, and a well-kept journal is a source of pleasure and advantage which more than repays the writer for the time and trouble spent upon it.

The first thing to do in beginning a journal, is to resolve to stick to it. Don't begin, and let the poor journal die in a week. A journal, or diary, should be written in *every day,* if possible. Now, don't be frightened at this, for you do a great many things every day, and this isn't a very awful condition. The time spent may be longer or shorter, according to the matter to be written up; but try and write, at least a little, every day. "*Nulla dies sine linea*"—no day without a line—is a good motto. It is a great deal easier to write a little every day, than to write up several days in one.

Do not get for a journal a book with the dates already printed in it. That kind will do very well for a merchant's note-book, but not for the young man or woman who wants to keep a live, cheerful account of a happy and pleasant life. Sometimes you will have a picnic or excursion to write about, and will want to fill more space than the printed page allows. Buy a substantially bound blank-book, made of good paper; write your name and address plainly on the fly-leaf, and, if you choose, paste a calendar inside the cover. Set down the date at the head of the first page, thus: "Tuesday, October 1, 1878." Then begin the record of the day, endeavoring as far as possible to mention the events in the correct order of time,—morning, afternoon and evening. When this is done, write in the middle of the page, "Wednesday, October 2," and you are ready for the record of the next day. It is well to set down the year at the top of each page.

But what are you to write about? First, the weather. Don't forget this. Write, "Cold and windy," or "Warm and bright," as the case may be. It takes but a moment, and in a few years you will have a complete record of the weather, which will be found not only curious, but useful.

Then put down the letters you have received or written, and, if you wish, any money paid or received. The day of beginning or leaving school; the studies you pursue; visits from or to your friends; picnics or sleigh-rides; the books you have read; and all such items of interest should be noted. Write anything that you want to remember. After trying this plan a short time, you will be surprised at the many things constantly occurring which you used to overlook, but which now form pleasant paragraphs in your book. But don't try to write

something when there is nothing to write. If there is only a line to be written, write that, and begin again next day.

Do not set down about people anything which you would not wish them to see. It is not likely that any one will ever see your writing, but it is possible, so, always be careful about what you write. The Chinese say of a spoken word, that once let fall, it cannot be brought back by a chariot and six horses. Much more is this true of written words, and once out of your possession, there is no telling where they will go, or who will see them.

The best time to write in a journal is in the evening. Keep the book in your table-drawer, or on your desk, and, after supper, when the lamps are lighted, sit down and write your plain account of the day. Don't try to write an able and eloquent article, but simply give a statement of what you have seen or done during the day. For the first week or two after beginning a journal, the novelty of the thing will keep up your interest, and you will be anxious for the time to come when you can write your journal. But, after a while, it becomes tedious. Then is the time when you must persevere. Write something every day, and before long you will find that you are becoming so accustomed to it, that you would not willingly forego it. After that, the way is plain, and the longer you live the more valuable and indispensable your journal will become.

But some practical young person asks: What is the good of a journal? There is very much. In the first place, it teaches habits of order and regularity. The boy or girl who every evening arranges the proceedings of the day in systematic order, and regularly writes them out, is not likely to be careless in other matters. It helps the memory. A person who keeps a journal naturally tries during the day to remember things he sees, until he can write them down. Then the act of writing helps to still further fix the facts in his memory. The journal is a first-class teacher of penmanship. All boys and girls should take pride in having the pages of their journals as neat and handsome as possible. Compare one day's writing with that of the one before, and try to improve every day. Keeping a journal cultivates habits of observation, correct and concise expression, and gives capital practice in composition, spelling, punctuation, and all the little things which go to make up a good letter-writer. So, one who keeps a journal is all the while learning to be a better penman, and a better composer, with the advantage of writing original, historical, and descriptive articles, instead of copying the printed letters and sentences of a writing-book.

But, best of all, a well-kept journal furnishes a continuous and

complete family history, which is always interesting, and often very useful. It is sometimes very convenient to have a daily record of the year, and the young journalist will often have occasion to refer to his account of things gone by. Perhaps, some evening, when the family are sitting and talking together, some one will ask, "What kind of weather did we have last winter?" or, "When was the picnic you were speaking of?" and the journal is referred to. But the pleasure of keeping a journal is itself no small reward. It is pleasant to exercise the faculty of writing history, and to think that you are taking the first step toward writing newspapers and books. The writer can practice on different kinds of style, and can make his journal a record, not only of events, but of his own progress as a thinker and writer.

KEEPING THE CREAM OF ONE'S READING.
By Margaret Meredith.

My plan dates from a few delightful weeks which I spent with a girl friend, long ago. We were devoted to poetry and to reading aloud; and in that occupation we had the aid of a brilliant, accomplished young woman. She selected for us from Coleridge, Shelley, and several other authors, whose entire works she knew we would not care to read, all the specially fine poems or passages, and these we read and discussed with her over our fancy-work. It was charming. At last, she suggested that, as I was soon to go away and leave the books and clippings with which I had been growing familiar, it would be helpful for me to write down the choicest bits, and try in that way to keep in some degree what I had gained. This I did, putting the extracts in a school copy-book which our friend dubbed "Snippers,"— from an odd seamstress word which she had picked up by chance.

Other "snipper" books followed when that one, years after, had been filled.

My system is an orderly one. All my books are broad-paged and wide-lined, thus preventing the cramped and crowded writing which often makes such books unreadable. When I find anything which strikes me as worth keeping, I note on a slip of paper, somewhat longer than the book I am reading, the number of the page and make a perpendicular line beneath it, with a cross line indicating the relative position of the sentence which I wish to keep, thus:

23
†

If the page is in columns, I make, instead of the single line, a rough parallelogram, and note within it by square dots the relative positions of the sentences chosen for preservation, thus:

187

This slip of paper I use as a bookmark until it is filled or the book is finished, noting upon it, as indicated, the choicest passages and their positions on the pages. When I have finished the book I go carefully over these selected sentences. Many are discarded; the rest go into my "snippers." Below the first entry and to the right, I place the name of the book and its author, both heavily underscored; below the others, the word "Ibid" or "ditto," underscored. At the top of each page I note the year, and at the head of each batch of extracts the month or day.

Paragraphs cut from newspapers, which are worth saving, are pasted as a fly-leaf to the inner edge of the page, or even slipped under the binding thread.

In carrying out my plan I am always content with hasty work,—but I write plainly, and if possible with ink, as much fingering destroys pencil-marks. I once tried classifying the extracts, but this scarcely paid for the trouble.

I used sometimes to wonder whether these books of selections were of any real value. But I have grown now to prize them greatly. Many a time I go to them for a dimly remembered phrase or passage. Sometimes, too, I read them over, for of course they give me the essence of what I most like and admire in my reading. A short time since I lent one to a literary friend, and was surprised to find she enjoyed it so greatly that she was almost unwilling to give it back.

I am very glad that I began this practice in my young days. It gives very little trouble, and that little is a pleasure.

There is a familiar expression about an "embarrassment of riches." This is the greatest disappointment I experience with my "snippers." For, occasionally, a book has too many good things in it to be easily copied, and then my only relief is to own it and, marking it vol. *X,* add it to my row of extract-books.

"Books for Varying Tastes," Sophie L. Goldsmith, *American Girl* (1932)

A publication of the Girl Scouts, The American Girl *was one of the first periodicals in the early decades of the twentieth century that specifically targeted girls. The magazine's book reviews were one means of directing girls to reading material deemed appropriate by adults. Consistent, though, with the mission of*

the Girl Scouts, The American Girl *strove not merely to address girls but to involve them more actively in the magazine's publication.*

The book review column reprinted here reveals how the magazine's professional editors and writers worked to establish an interactive relationship with young readers. In her May 1932 column, Sophie L. Goldsmith poses a direct question to the girls about the relationship between style and substance in literature. She encourages girls involved in literary societies to debate whether "new and interesting material has enough pep in itself to make good writing desirable, but not essential."

It is also of interest that Goldsmith's column features novels about "mountaineer girls" in Kentucky and their lack of educational opportunities. By the 1930s, Appalachia had emerged as a distinct region in the United States, characterized in part by a seeming lack of literacy skills among its inhabitants. The use of reading, writing, and language practices to mark a region as "Other" within the landscape of the United States suggests much about the cultural weight that literacy carries in American society. In this volume, see also Dorothy Allen Brown Thompson's diary (1911–1914) for a discussion of "missionary" work in Kentucky as well as the nineteenth-century essays written by students at Julia Tevis's Science Hill Academy in Shelbyville, Kentucky, which disrupt stereotypes about educational levels in Kentucky.

Excerpts from The American Girl *are reprinted with the permission of the Girl Scouts of the USA.*

BOOKS FOR VARYING TASTES

By Sophie L. Goldsmith

To dwellers in the all-absorbing world of books, it is sometimes curious to note how one idea, or one country, or one special kind of character seems occasionally to predominate in books which come tumbling in from publishers all over the country. There can be no deep-laid plot to give us chiefly mystery books, or books about how we pulled ourselves out of financial holes, or books about Mexico or China; and yet, as each month the books accumulate, there seems to be one note which is struck again and again. When, last month, we read the story of Sairy Ann of Kentucky in *Mountain Girl* by Genevieve Fox, we had then no idea that the state of "Kaintuck" was to figure so largely in this month's crop of books. It is, indeed, one of the most interesting sections of our country, with its courageous mountaineers, its feuds which have been the subjects of so many tales and dramas, and its ballads.

Nowhere, we feel, has it been better handled than in *The Here-To-Yonder Girl* by Esther Greenacre Hall (Macmillan). Miss Hall, you will remember, has written several short stories for THE AMERICAN GIRL. Although Tassie Tyler's position is something like that of

Dickens' famous character, poor Jo of *Bleak House,* because she, too, is always "a-movin' on from here-to-yonder," her splendid vitality and courage prevent her from becoming at all blue or downcast. She carries that red head of hers, flaming as "vividly as the sumac bushes along the creek bank," dauntlessly high, despite the fact that she scarcely knows where it is going to rest from one day to the next. When a visiting sister and her family take up space in the Adams' household grudgingly accorded to Tassie, she makes eagerly for the Singing Branch School, about which Cindy Wilson has told such wonders. But although its marvels are even greater than she had been led to believe, there is no room for her. And, in her misunderstanding and fierce mountain pride, she rushes away before she really understands the situation, and tumbles into the midst of the orphaned Wiley family. They need her badly, and she is soon mothering them all. In addition to the cares of her adopted family, she sees to it that her friend Dillard Nolan has a chance to develop his musical talent, and finally, by timely warning and heroic efforts, she rescues Singing Branch School itself from a forest fire. Forest fires are always thrilling—we meet with another in California this month—but the description of this one and of Tassie's part in it is particularly fine. Throughout the book, we listen to language so musical and so picturesque, that it proves a fitting introduction for another book whose scenes are laid in the mountains of Kentucky, which older people are reading and which some of you will surely enjoy. It is *The Weather Tree* by Maristan Chapman (Viking). If you love Kentucky and its quaintly original turns of speech, if you can revel in the beauty of style which is always a feature of Maristan Chapman's writing, you can find no more poetic companion than this book.

Clever Country by Caroline Gardner (Fleming H. Revell) proves by its very title how many surprises are in store for people who care to study Kentucky, because the word "clever" as used by the mountaineers means "generous." Mrs. Gardner is the Executive Secretary of Chicago's Frontier Nursing Service, and her book is an account of her experiences as a nurse, trying to bring comfort, cleanliness and modern standards of healthy living to the mountaineers so utterly lacking in them. After our excursions in the field of fiction, by means of Sairy Ann, of Tassie Tyler, and perhaps of Maristan Chapman's vivid people, it is interesting to get a straight, first-hand account of conditions as a genuine trained nurse, a trained nurse with a permanent twinkle in her eye, met them.

Besides the Kentucky tendency noted in this month's selections, there is another not so attractive and one which I would be a trifle dubious about mentioning at all did it not bring up a very interesting question which I hope some of you will answer in your letters to me.

It is this: Would you rather read books well written about timeworn subjects, or books which deal with fresh and interesting material in an inferior manner? There is, for instance, *Great American Girls* by Kate Dickinson Sweetser (Dodd, Mead). We well remember *Famous Girls of the White House,* which combined fine material with good writing. Certainly there is no finer material, nor any less hackneyed, than the lives of Maude Adams, Geraldine Farrar, Nancy Astor, and Emily Dickinson, who, with many others of equal interest and importance, form the subjects of her new book, *Great American Girls.* Yet their absorbing stories are here told in a sentimental and a stilted way which is so irritating that we lose sight of what the author is trying to tell us. Or do we? I wish you would let me know your opinions on this matter.

Barbara Benton, Editor by Helen Diehl Olds (Appleton) is another book about which I am just a little doubtful because its subject is so good and so undeniably interesting, and yet it would seem as though an author evidently familiar with the duties of editors should herself have submitted to considerably more editing. The story is a good one, and especially girls for whom the lure of the newspaper world is as irresistible as it was for Barbara will breathlessly follow the recital of her trials and tribulations when the editor, engaged by Mrs. Benton to run the paper during her absence, deserts and leaves the job on the hands of sixteen-year-old Barbara. There is plenty of amusing incident, yet the manner of its telling is not worthy of its material.

What a good subject for a Literary or Debating Club this might be: "Resolved: That new and interesting material has enough pep in itself to make good writing desirable, but not essential." If any of you ever debate it, please send me an invitation!

There are, to be sure, many books which fulfill both requirements. *Swallowdale* by Arthur Ransome (J.B. Lippincott and Junior Literary Guild) is an outstanding one. We have met the characters before in Mr. Ransome's first book, *Swallows and Amazons.* They are a most engaging lot of boys and girls, and their knowledge of camping is truly staggering. Mate Susan, for example, is worth her weight in gold. A girl, as Captain Flint observes, who, after a real shipwreck goes right to work starting a fire and drying the crew's clothes without any hand-wringing or head-shaking, is a treasure indeed. Evidently there is nothing like camping for developing the stiff upper lip. Even after the beloved *Swallow* has met with the shipwrecking accident which proved so nearly fatal, the crew grits its teeth and manages to have a landlubber's summer full of adventure.

Circus Day is by Courtney Ryley Cooper (Farrar and Rinehart) who, as he tells us, ran away from home twenty-eight years ago to

become "the world's unfunniest clown." Every aspect of the circus is dear to him, and he makes it absorbingly interesting to us. We who have met elephants in Mukerji's or Kipling's or Kurt Wiese's stories, have a new experience awaiting us when we are introduced to Old Mom, that sagacious leader, to Alice and Myrtle and Topsy and other members of a race the handling of which is bound to be, as Mr. Cooper observes, "a big subject!" We hobnob with the famous trainer, Dutch Ricardo, and listen in fascinated horror as he tells the story of the treacherous leopard. It is not so long ago that the world felt a universal pang at the news of Lillian Leitzel's death, and it is with utter absorption that we read of her life as a trapeze artist. Written in breezy colloquial language, the book in this respect as in others is an interesting contrast with *Circus* by Paul Eipper (Viking and Junior Literary Guild). This book is not so exciting as *Circus Day,* but in its quiet scholarly way and with the advantage of a superior literary approach, it is equally interesting. The photographs by Hedda Walther with which it is illustrated are most striking and artistic. We are taken behind the scenes of the actual circus, and shown an "artist's wagon" which is calmly invaded by a tigress and her trainer who wish to bid their historian welcome. Mr. Eipper is made in every possible way to feel at home with that miscellaneous hodgepodge of men, women and animals he so fervently adores.

"Books for the Older Girls," Sallie W. Stewart, *Girls' Guide* (1933)

In addition to magazines, organizations for girls typically published handbooks that included recommended reading lists. Like the "five-foot shelf of books" that Harvard president Charles W. Eliot proposed as the basis of a liberal education available to all citizens, the 1933 edition of the National Association of Colored Girls' (NACG) Girls' Guide *offered its members the following list of books and called special attention to "Current Books On and By Negroes." Though many of the chapters of the National Association of Colored Women (NACW) had informally fostered junior clubs, President Sallie W. Stewart was authorized in 1930 to create an official, affiliated organization for African American girls between the ages of six and twenty-five. The NACG's mission was to initiate the "moral, mental, and material" development of its members and to "install ideas of finer womanhood at a tender age"* (Girls' Guide).

As Joan Shelley Rubin has documented in her work on the rise of middlebrow culture, recommended reading lists, like the one included in the Girls' Guide, *stand as an important attempt to manage the reading lives of individuals and to help them make appropriate choices from among an increasingly diverse number of texts. Some girls, no doubt, found such lists useful in the*

early decades of the twentieth century as the rise of consumerism strengthened the link between the acquisition of particular products with one's social status and personal character. This excerpt from the Girls' Guide is reprinted with the permission of the National Association of Colored Women.

BOOKS FOR THE OLDER GIRLS

"Dreams, books, are each a world; and books, we know, are a substantial world, both pure and good."

Barrie—"Margaret Ogilvy." Scribner, 1919; $1.35. Story of a good, shrewd, intensely humorous Scotch mother.

Bible, O.T.—"Esther." (In Biblical idyls. Modern reader's Bible.) Macmillan. 1913; 35c. A young Jewess risks ambition, love and even life to be true to the ideals of her people.

Bonstelle—"Little Women Letters from the House of Alcott." Little, 1914; $1.25. Letters, extracts from journals, etc., which reveal the beautiful home life of the Alcotts. Should follow "Little Women."

Cooper—"The Spy" (Mohawk ed.), Putnam, n.d.; $1.50. Story of the American revolution and of a hero employed by Washington in secret service of great danger.

Deland—"Old Chester Tales." Harper, n.d.; $1.75. Grosset; $1.00. Tales so real and so human that we have a feeling of acquaintance and affection for the people who live in them.

Dickens—"Great Expectations." (Gadshill ed.) Scribner, n.d.; $2.50. Story of an unusual boy told by himself.

Grahame—"Wind in the Willows." Scribner, 1916; $1.35. Illustrated by Paul Branson. Scribner n.d.; $2.50. Tale of animal adventures, fascinating to older readers.

Harte—"Luck of Roaring Camp." (Popular ed.) Houghton, 1919; 90c. (Overland ed.) Houghton, 1903; $2.50. Stirring tales of the West.

James—"Daisy Miller." Harper, 1901; $1.50. Tells of an unconventional American girl, and her adventures abroad.

Jewett—"The Queen's Twin." Houghton, n.d.; $1.25. Stories which bring the charm and individuality and bracing air of the real New England.

Kipling—"The Day's Work." Doubleday, 1919; $1.50. Two very interesting and very different stories in this volume are: .007 and The Brushwood Boy.

Lagerlof—"Further Adventures of Nils." Doubleday, 1911; $1.50, Grosset; $1.00. More than twenty vivid stories which reflect love of country and Swedish life and customs.

Leamy—"Golden Spears and Other Fairy Tales." Fitzgerald, 1911; $1.25. Lovely, Irish folk tales.

Locke—"The Rough Road." Lane, 1918; $1.50. Story of the remaking of James Marmaduke Trevor, otherwise "Doggie" from a mollycoddle to a fine specimen of a man and a soldier.

McDougall—"Little Royalties." Revell, 1904; $1.25. Biographical stories of Edward VI, Napoleon's little son and other royal children.

Maeterlinck—"Our Friend the Dog." Dodd, 1913; $1.25.

Meigs—"Master Simon's Garden." Macmillan, 1919; $1.60. A story of a garden which blooms its way through several generations, and has a deep influence on the lives and loves of the pioneer New Englanders.

Muir—"Stickeen." Houghton, 1909; $1.25. Story of a dog's adventure on a glacier.

Muir—"Travels in Alaska." Houghton, 1915; $2.50. A book which will give great pleasure to lovers of high adventure.

Noyes—"Collected Poems." Stokes, 1913; $3.00. Stories of old England, told in poetry full of color and music.

Paine—"Boy's Life of Mark Twain." Harper, 1916; $1.50. The story of a man who made the world laugh and love him.

Palmer—"Life of Alice Freeman Palmer." Houghton, n.d.; $1.50. Very interesting story of the struggles and final success of a charming girl.

Parker—"An American Idyll." Atlantic Monthly Press, 1919; $1.75. This book is the record of a life of great promise, as well as a beautiful love story.

Richards—"Joan of Arc." Appleton, 1919; $1.75. An intimate story of the maid of France which will be particularly interesting to girls.

Rittenhouse—"Little Book of Modern Verse." Houghton, 1913; $1.00. (Flexible Leather); $2.50. A delightful collection of short poems.

Sanchez—"Life of Mrs. Robert Louis Stevenson." Scribner, 1920; $2.25. Full of good stories and interesting illustrations which show the Stevensons in some of their most romantic adventures.

Scott—"Rob Roy." (Dryburgh ed.) MacMillan, n.d.; $1.25, Estes, 1893, 2 vols.; $3.00. Rob Roy, the chieftain of the MacGregor, was a follower of Prince Charles in the exciting rebellion of 1715.

Stern—"My Mother and I." Macmillan, 1917; $1.00. The daughter of a Polish rabbi comes to America and finally breaks away from her traditions. Her mother is a splendid companion throughout the struggle.

Stevenson—"Home Book of Verse for Young Folks." Holt, 1915; $2.25. Delightful collection which includes old favorites and new poems for children of all ages.

Thackeray—"The Virginians." Houghton, n.d., 2 vols.; $3.00. (Biographical ed.) Harper, 1899; $2.00. A sequel to Henry Esmond.

Verne—"Mysterious Island." Burt, n.d.; $1.00. Scribner, 1918; $2.50. Sequel to Twenty Thousand Leagues Under the Sea.

Walpole—"Jeremy." Doran, 1919; $1.75. Story of a boy and his dog, Hamlet.

White—"African Camp Fires." Doubleday, 1913; $1.50. Spirited, humorous sketches of hunting and adventure in British East Africa.

Zwilgemeyer—"What Happened to Inger Johann." Lothrop, 1919; $1.50. We follow Inger Johann, with a smile, through the difficulties into which her impetuous disposition is always entangling her.

CURRENT BOOKS ON AND BY NEGROES
FICTION

"The Walls of Jericho," by Rudolph Fisher—One of the best novels of Harlem yet written. Its language, its humor, its psychology, are true to the type it depicts.

"Dark Princess," by W.E. Du Bois—The mingling of an allegory on world union of the darker races and certain realistic pictures of the economic and political problems of the Negro in the United States.

"Quicksand," by Nella Larsen Imes—The story of a sensitive cultivated mulatto beset by hereditary, social and racial forces over which she has little control and into which she cannot fit and her subsequent defeat.

"The Magic Island," by W.B. Seabrook—Above everything a book of voodoo in Haiti, the author describes this phenomena in minute detail and with an open point of view.

"Home to Harlem," by Claude McKay—With amazing vividness and zest, McKay pictures life in Harlem. Here there is drama, tragedy, comedy, romance pathos and most of the other elements one asks for in literature.

"Plum Bun," by Jessie Fauset; "The White Girl," by Vera Caspary—Both novels deal with the problems of Negro girls who cross the color line.

"Black Majesty," by John Vandercook—The biography of Henry Christophe, dominating figure in the Haitian revolt, the most romantic figure in the history of the world. He freed Haiti, successfully defied Napoleon Bonaparte and ruled his kingdom with an iron hand.

"Black April"; "Scarlet Sister Mary," by Julia Peterkin—The doings and superstitions of the Gullah folk on the Blue Brook plantation in the lowlands of South Carolina, told with sympathy and beauty by a southern white woman.

"This Side of Jordan," by Roark Bradford—An unflinching novel of life among the Negroes of Louisiana. Unlike Mrs. Peterkin, Mr. Bradford refused to compromise or retreat before the unpleasant.

"Rainbow Round My Shoulder," by Howard W. Odum—The story of the life, the wanderings, and the loves of a Negro type-character—a black Ulysses, who works, sings, lies, loafs his way about in this American scene.

"Porgy"; "Mamba's Daughters," by Du Bose Heyward—Painstaking delineation of the picturesque elements in Negro life in Charleston.

"The Conjure Woman," by Charles W. Chestnut—A new edition of Negro folklore set down some twenty-five years ago by the first Negro novelist.

"Nigger to Nigger," by E.C.L. Adams—In bits of sermons, brief episodes related in dialogue, verse and short sketches, often less than a page, the very soul of the Negro is revealed—his philosophy of life appreciated.

"Blacker the Berry," by Wallace Thurman—A novel of Harlem and the problem of color distinctions within the Negro world written by a Negro.

"Black Sadie," by T. Bowyer Campbell—The cinematic sage of an ordinary Southern girl exposed to extraordinary circumstances.

"The Pedro Gorino," by Captain Harry Doan and Sterling North—The adventures of a Negro sea-captain in Africa and on the seven seas in his attempts to found an Ethiopian Empire.

NON-FICTION

"Negro Labor in the United States," by Charles H. Wesley—Beginning with slave labor in colonial times, Mr. Wesley reviews chronologically the story of Negro labor.

"Black America," by Scott Nearing—Dealing with the Negro not as a social problem but as an oppressed race, this well known radical has brought together an immense amount of material, collected and classified statistics, facts, statements, descriptions.

"American Negro," Annals of the American Academy of Social Science, November, 1928—Contains 39 articles on all phases of the Negro problems written by these familiar with the subject: Race Relations, The Negro as An Element in the population of the U.S., the legal status of the Negro, the Economic Achievement, the Mental Ability, Organizations for social betterment, Race Relations are the titles of the seven divisions.

"Bibliography of the Negro," by Monroe N. Work—Lists thousands of sources for information about all phases of Negro life. For

the student, research worker, artist, writer and everyone interested in Negro life.

"The Negro in Contemporary American Literature," by Elizabeth Lay Green—A study outlined on the general theme.

"Maggie L. Walker: Her Life and Deeds," by Wendell P. Dabney—The chronology of the life of a remarkable woman—the first woman in America to become the president of a bank—the story of the growth, under her leadership, of the Order of St. Luke with resources of over half a million dollars.

"Rope and Faggot," by Walter White—A biography of Judge Lynch—the authoritative book on lynching.

"The American Negro," by Melville Herskovits—An anthropometric study in racial crossings—resulting in the emergence of a biological new Negro.

"Portraits in Color," by Mary White Ovington—Twenty portraits of representative Negroes—veritable success stories. Here is the president of a great university, a consul, a biologist, a would be founder of an African republic, a dark Luther Burbank, a singer of spirituals, an investigator of lynchings, and the leader of a great social organization.

"In Spite of Handicaps," by Ralph W. Bullock—Biographical sketches of eighteen contemporary American Negroes who have succeeded in business, professional and artistic pursuits. Includes individuals omitted by Miss Ovington.

"What the Negro Thinks," by Robert Russa Moton—Pointing to cooperation between whites and blacks for the good of both and for America, and yet not bowing before the pretensions of the white mind, Dr. Moton invites the white man to speculate still further over the Negro's condition and to help speed the day when abuses must go.

"Health and Wealth," by Louis I. Dublin—An Authoritative discussion of the Negro health problem by one of America's foremost investigators. A masterly analysis of the problems facing the Negro—death rates, susceptibility to disease and the industrialization of the Negro are treated with helpful suggestions for bettering conditions.

"Race Attitudes in Children," by Bruno Lasker—A study of the origins of social disharmony. An analysis of the ways in which children acquire attitudes toward persons of other races.

"Negro Problems in Cities," by T.J. Woofter—A study based upon the movement of Negroes to the larger cities—neighborhoods, housing, schools and recreation.

"Plays of Negro Life," selected and edited by Alain Locke and Montgomery Gregory—Twenty plays of the contemporary Negro theatre including the more important work of both Negro and white authors. Includes a chronology and bibliography of Negro drama.

"The Weary Blues": "Fine Clothes to the Jew," by Langston Hughes—The collected verse by the poet of the people.

"Caroling Dusk"; "Color"; Copper Sun," by Countee Cullen—Adding new glory to his reputation as the most vivid of the younger poets, "Copper Sun" has both gaiety of youth and the sophistication of the modern intellectual.

"Dear Diary" (1935) and "How to be Popular Tho' Teacher's Pet" (1936) Elizabeth Woodward, *Ladies' Home Journal*

While organizations for girls targeted their membership with periodicals and handbooks, mainstream magazines helped to establish a national audience of girls in the early decades of the twentieth century. When editors at Ladies' Home Journal *began to realize that teenage girls were often avid readers with disposable incomes, they instituted "The Sub-Deb Column, A Page for Girls" in the late 1920s.*

As in other periodicals, the articles in women's magazines that directly targeted girls often fulfilled a didactic function, offering them lessons in how to define themselves through their own reading and writing practices. In the two Sub-Deb columns included here, editor Elizabeth Woodward provides guidance on diary-keeping and on how to balance academic success with popularity among one's peers. Woodward's advice on diary-keeping differs sharply from W. S. Jerome's nineteenth-century admonishments, which appear earlier in this volume. By the middle of the twentieth century, diaries had become more private texts where girls could record events and emotions they would wish to shield from the eyes of parents, teachers, and other authority figures.

For more on the Sub-Deb columns and the role of magazines in girls' lives, see Kelly Schrum's essay in this volume. These Sub-Deb columns appear with the permission of Ladies' Home Journal.

Dear Diary. Even kid brothers know that diaries are extra-special private! So why not cut loose and say what you think in yours? If you're going to take time out from a terrific day to write down somewhere what happened—why not write down what did happen? An engagement calendar would do just as well as some of the diaries I've

been hearing about. "School all day; piano lesson; movies with Malc; marvy time." Two or three or sixteen weeks later, what have you?

Well, there's one Sub-Deb I know who trusts me with her diary. In fact, she said I could show you how it went. How a diary should go! Here's a page from it:

"This has been one of those days when I was just in the pink! It didn't get off to such a good start, what with stepping through the lace on the bottom of my pet slip, and squeezing out an extra couple of minutes waiting for the postman—and then not getting any-thing—and missing the car so I had to fly like a fly.

"I knew I'd live through the day when Lou, the jane that sits in front of me in math and has ears like handles on a loving cup, called me 'teacher's pet,' and I managed to eke out 'Don't be jealous; I hear the janitor is mighty fond of you.' Well, her mouth opened and snapped shut like a rubber band. I always knew some day I'd get the last word.

"All through the day the teachers kept asking me the right ques-tions. In history, I knew the Presidents in order and that was all. But I couldn't forget them because the initials of their names also stood for 'Will Al Jones Meet Me At the Junction?' Which was something I had on my mind.

"I thought I had reached the top when I found a SPECIAL!!! from George waiting for me when I got home from school. With a bid for the Spring Prom. (An exclamation point wouldn't do it, so I'll just let the period stand.) Considering that I was sure, it was surprising to realize how relieved I felt. Now I know I'll wear my white dress with the cherry velvet—or maybe I won't, because it's a few too many months too soon to make up my mind for the last time.

"But the nicest part of the day was when Bill called to take me to the movies. I suspect I looked pretty nice in my blue, that I shall proba-bly take from the tissue paper some day to show my two daughters how I dressed when I was young. Well, Bill just looked at me and said, 'Hon-est, when you glow like that, I'm in your hands to make or break.' Well I can't write Bill down. So I'll just curl up and think about him."

. . .

How to be Popular Tho' Teacher's Pet. "I get good marks in school. Is that the reason why I'm not popular?"

No, no, a thousand times no! But if your only claim to fame is that you know all the answers in biology class, you won't dance very far or be shown the moon very often!

People who know everything are terrible bores. They're so far ahead of the rest of us that we get out of breath trying to catch up

with them. And we entertain a slight loathing for them for setting us such a pace.

I'm all for getting good marks in school! But smiling smugly over topping the class; obviously palling with your teachers; hiding yourself away in books—no! If you want to have people think you're a dried-up fossil that's dusty to touch—go right on being teacher's pet.

Here are five things to do to live down good marks:

Take them for granted. You try to do your best in your school work; and if your best happens to be a little better than the rest—that's that. But don't forget that the others are maybe not doing their best. If they were, you wouldn't be so far out ahead.

Avoid knowing the answers to everything. Establish a reputation for knowing absolutely nothing about playing a saxophone, or broad jumping, or sewing—and wanting to know, and failing every time you try, and laughing about it. That puts you on the level with the rest of the crowd.

Don't be the big help every time. People who sponge seldom love the spongee. If you help someone with Latin, ask her help in something else. Put yourself on the receiving end of favors that other people will like to do for you.

Leave your school work behind you. When you're out with people, forget it. If you do—they will.

Make yourself the best all-round sport you can. Go in for clothes and subtle make-up, dramatics, sports, student activities, the yearbook. Let people see the other sides to you. They'll like them.

These five things do not cloud the issue that you still get the best marks. They just take the sting out of it. If you get good marks and are the best forward on the basketball team, a screaming success in the class play, and the clumsiest sewer of an apron, and a slick dancer—everyone will think you're a good egg. And it's quite all right for a good egg to get good marks.

"Write a Better Book Review this Semester," Helen G. First, *Seventeen* (1960)

First published in 1944, Seventeen *magazine broke new ground as a commercially successful, national magazine for teenage girls, and it remains a dominant player among periodicals that target young women in the twenty-first century.* Seventeen *has over the years forged close ties with advertisers, and articles on beauty, fashion, and romance now seem to dominate the magazine's pages. Throughout its history, though, the magazine has provided young women with explicit instruction in reading and writing. For more on* Seven-

teen *magazine and its complex role in the literacy education of girls, see Kelly Schrum's essay in this volume.*

In the book review column below, Helen G. First offers advice about writing book reports. She candidly positions herself in opposition to classroom teachers of English and instead encourages girls to think of school book reports as "love letters." In doing so, First highlights the intensely pleasurable experience that reading can be while also reminding girls that their primary concerns should be dating and romance.

WRITE A BETTER BOOK REVIEW THIS SEMESTER

Reading a book is like falling in love. It's a very private matter, and your feeling is more genuine if hugged to yourself. Reviewing a book is like writing a meaningful love letter of discovery to your beloved, a letter which shows what you have learned about yourself in reaction to your loved one, what secret charms and wonders you have discovered in him that you didn't know existed before. It reveals the happiness you share, the joy of loving.

But, alas, this is not the sort of book review all teachers of English want from their students. Perhaps it is a fear of honest human emotion that makes some teachers turn book reviewing from love-letter writing into "bragging." The "kiss-and-tell" approach generally used in the classroom runs like this: Summarize the story line; name and describe all the characters; analyze the style. To me this mechanistic approach is as inappropriate as telling the crowd in the lunchroom everything *he* said or did on last night's date instead of becoming aware of the human feeling that was stirred by a gentle smile, a touch of the hand. Can one ever reconcile the wish to write a love letter to a book with the requirement to brag, "I read a book"?

Most of the world's transactions do follow basic rules, rules established by good sense, experience and expedience. Teachers, therefore, have required certain forms to be met, even if these forms serve merely to show that you have satisfied only the basic requirement of having done the reading. The more mature the person, the better he is able to reconcile both what he is required to do and what he wishes to do. So this is *your* project.

Put away your teacher's review outline while you proceed to the more important business of reading, for reading in a very special way is the core of reviewing. Read as though you and the people in your book are the only inhabitants on a tiny desert island. When you part company to return to the world of reality to write your review, you will feel as emotionally attached to them as you do to the bunkmates you left behind after last summer's camping experience. When you

are thus closely bound up with them, you are ready to argue with and against them on all levels. What reaction do you have to the integrity and morality, or lack of it, of the various fictional and biographical characters, to their techniques for getting along with people, to their capacity for genuine love? What people in your real life do they resemble and help you understand better? Which one would you most like to be, to know, to love? Why, why, *why* do you feel that way?

At this point your teacher's review outline is ready to be draped like a clothes tree with your own reactions, for an outline is only a skeleton until laboriously filled in bit by bit with the flesh of feeling and the intellect of ideas. How you review your book, the meaning, enthusiasm, or significance you give your book depends not so much upon your native writing ability as upon the *way* you have read your book. If you read with passion and drive, your review will follow almost automatically. It will not reflect automatism or slickness. It will reflect that quickened alertness and responsiveness to the experiences of life and literature. It will be your own love letter to literature.

A few for you to review: **The Green Years and Shannon's Way** by A. J. Cronin (reissue), Little, Brown, $4.95. . . . **The Night They Burned the Mountain** by Thomas A. Dooley, M.D., Farrar, Straus & Cudahy, $3.95. . . . **The Fear Makers** by Wilfred Schilling, Doubleday, $3.95. . . . **Through Streets Broad and Narrow** by Gabriel Fielding, Morrow, $4.50. . . . **Imperial Caesar** by Rex Warner, Little, Brown, $5. . . . **The Landscape and the Looking Glass** by John H. Randall III, Houghton, Mifflin, $5.75. . . . **Nightshade** by Helen Topping Miller, Bobbs-Merrill, $3.75. . . . **Ring the Night Bell** by Paul B. Magnuson, Little, Brown, $5.

School Assignments

"Imperfections of Female Education," Albana C. Carson (1851), "Mystery," Eugenia Stout (1853), and "My Will," Ellen Riley (1856)

Turning to the writing done by girls in their school classrooms usefully complicates the construction of any straightforward narrative of progress in the history of literacy and education. School essays, compositions, and other writing assignments suggest that girls found ways to interject their personal interests when faced with the abstract writing assignments associated with the early nineteenth century; that girls have mastered a range of academic discourses, even when an official curriculum might have sought to restrict their intellectual horizons; and that educators have long worked to construct innovative assignments that tap the energy and imagination of girls as they develop their powers as users of the written word.

In the nineteenth-century compositions included here from students at Julia Tevis's Science Hill Female Academy in Shelbyville, Kentucky, three young women point to the importance of education in their lives and challenge those who would deny girls access to serious scholarly pursuits. (See Jean Ferguson Carr's essay in this volume for a discussion of the ways in which girls' increased access to education did not silence a lively and long-standing public debate about the appropriateness of feminine trespasses into the male domain of letters.)

In the first essay, Albana ("Binnie") Carson regrets that girls typically spend but a few years in school and then return home to idleness; she also challenges the notion that boarding schools can combine serious academic subjects, like grammar and mathematics, with the acquisition of feminine accomplishments, like dancing and drawing. Ellen Riley's "My Will" pursues a more personal approach as she bequeaths her affection and esteem to her teachers and encourages her fellow students to appreciate the intellectual opportunities available to them at Science Hill. Eugenia Stout's essay does not deal explicitly with female education. Instead, she looks more broadly at the fascination with science and progress that was becoming a prominent feature in the intellectual landscape of the nineteenth century. Though intrigued by the possibilities of the steam engine and the discovery of the calorie as a unit of energy, she warns against the chicanery of mediums and the pseudo-science of mesmerism. By pointing out the need for careful consideration of all that is offered as scientific knowledge, Stout constructs a powerful, if subtle, argument for the importance of formal education in the lives of girls and women. See Janet Carey Eldred and Peter Mortensen's essay in this volume as well as their Imagining Rhetoric: Composing Women of the Early

United States *for more information on Science Hill Female Academy and its students.*

These three essays by students at the Science Hill Academy appear courtesy of the Filson Historical Society, Louisville, Kentucky.

IMPERFECTIONS OF FEMALE EDUCATION

[By Albana C. Carson]

It is frequently said, and by many really believed, that the intellect of woman is inferior to that of the other sex. And pray whence arises this inferiority, this deficiency? Perhaps from the organization of the medium of mind. It may be, that the brain of woman, would present to the anatomist some woful want in its weaving and structure. And yet I do presume to think, there is no such difference. No! God has endowed woman with a mind not inferior to that of man; for when her mind is sufficiently cultivated, she is quite as capable of digesting abstruse subjects as man. When the wise Creator placed our first Father in Paradise, He proposed to make a help-meet, or suitable for him, and surely there could have been little suitability in an inferior intellect. O, proud lords of creation—but indeed some of our own sex, poor things, believe we are man's inferiors in the scale of intellect. Fathers have arrived at the erroneous conclusion, that a daughter receives the whole of her literary education in five or six years. Girls are first sent to school, generally, at the age of five (too early by the way). They are sent a year or two, to a school, said to be very superior. But at the expiration of that term, it is thought better for the daughter to remain at home the next session, as she is very young, and was very closely confined during the past attendance at school. The time at home is spent in idleness, and she forgets all she had learned. Her parents conclude, perhaps a country-school would be better, as she would have better opportunity for exercise. She then must recommence her studies, which is very discouraging, for she thinks if she is always beginning, she can never make an ending. The session closes, and parents express surprise that their daughter has made so little progress in her studies, but attribute it to the teacher's neglect, as their daughter has a very superior mind for a child of her age. The next step is, to send to another school. In this manner are spent many months, nay years of her precious time, and still she finds herself not much nearer the summit of the <u>Hill</u> of <u>Science</u> she has been essaying to climb than at first. Having arrived at an age when she can feel the importance of education, and being conscious of her deficiencies, she reproaches herself that she has misspent so many golden moments each of which might now be a diamond in her crown, but

she and her parents willingly conclude that her slow progress arises from incompetency in teachers. A boarding-school must then be sought, as it is fashionable to send daughters to a boarding-school. This is truly an era in her life. She will enjoy so many advantages, that it will not require an effort on her part, as boarding schools have a wonderful power of opening one's eyes, and removing all impediments from the path of learning. Indeed, the <u>being</u> at a boarding school, is to our young lady the "Open Sesame," to all the wealth of education. She will have no more difficulty with Grammar, and Mathematics will be divested of all intricacy. The Father thinks his daughter is very well advanced, considering the disadvantages, which have surrounded her, and as she is a very sprightly girl, she can go quite through a course of studies in two years. Then, in two years must be condensed the study of all those important branches which would require at least <u>five</u> of intense application. To these must be added, Music, French, Drawing and all those accomplishments which are so desirable. Of course, she must take Dancing lessons too, as she is very awkward and this is the only means of making her graceful. But I should say, this would rather tend to make her <u>graceless</u>. The time devoted to this unnecessary acquirement, might be much more profitably spent in cultivating the kind and charitable affections of the heart. After the daughter has been taken through by this <u>pushing process</u>, she returns home with a smattering of several studies, and a thorough knowledge of none. But she has been to a boarding-school, and of course, is styled, "the accomplished Miss. Such a one." She has gone <u>through</u>, as she says, with a number of books, but perhaps it would be better, if she never had seen some of them. She has laid a foundation of sand, upon which, to erect an edifice of gold and precious stones. Her mind is prepared to enjoy nothing but the chit-chat of the gay and frivolous, and to make <u>novels</u> her companions. This is passed off under the assumed title of "<u>thorough education</u>." Then under all this false and improper treatment, we must be upbraided with want of capacity. I wonder indeed that we acquire so much as we do, in the way of education. I mean the education of the whole spiritual being—the education of the mind and of the heart. From infancy, our passions are allowed to control the better feelings of our nature, and we are encouraged by parents generally, to participate in all those unnecessary indulgences so averse to knowledge. Knowledge is exacting. She requires all your time and talents. Then, how can one be thoroughly educated, who attempts to grasp, knowledge with one hand, and pleasure with the other. It seems as though young ladies of the present age, are educated without an aim or with a very senseless

one, for they are taught to appreciate dress, display, and amusements, more highly than any thing else. What advantages can be derived from these things in after life? and what <u>good</u> has <u>ever</u> been accomplished by such pursuits? When the world shall awake on this all important subject, and when a proper length of time shall be devoted to the education of woman's mind, and thorough training in all the solid and useful sciences be bestowed, when she shall be encouraged to read books of Travel and History, books of Natural Science, books of <u>true</u> Poetry, instead of <u>trashy</u> Novels, we shall hear less said of her defects, and frivolities, and more of her intellectual capacity, and her companionship with high and noble minds.

<div style="text-align: right">Binnie Carson.</div>

MYSTERY.

[By Eugenia Stout]

It is a well known fact that the mind of man is ever in search of something new and strange. And, Mystery in all ages, has been the magic wand, by which the cupidity, and ambition of the <u>few</u>, have established and maintained an influence over the <u>many</u>; and thus made them tools or slaves. There is an innate principle within us, which bids us to seek, to learn, and to know—and, many are not satisfied to remain within the bounds to which the Almighty has limited our knowledge, but are ever striving to cast aside the impenetrable veil of the future, and read the hidden mysteries, not yet unfolded to our view by time. The ancients being without the light of divine revelation, were consequently ignorant of their own destiny, and destitute of one glimmering ray to cheer the present or point out their future; and were ever struggling in the dark mist, which surrounded them; endeavouring vainly to learn something of their destinies. But <u>we</u> the people of the nineteenth century, pride ourselves in our knowledge of both ancient and modern science, and regard nothing as too mysterious for us to understand; no problem too difficult to solve, no depth in science, beyond our skill to fathom. As for constructing a rail-road to one of the planets, that is nothing to what we expect to do—We have made such rapid advances that we now even talk slightingly of the aid of that mighty Giant Steam, the invention and potency of which, has hitherto been the pride and boast of our immediate forefathers—And, our modern chemists have discovered a yet more powerful and serviceable agent, by which to propel our many, varied, and mighty engines; in Caloric, or rather <u>air</u> expanded by caloric; this unseen agent we have pressed into service. Talk of the ancients—they were mere earthworms compared to us—they did not so much as

know the world was round—it seems very strange to us, that its roundness and revolutions were not earlier discovered; but, as has been remarked, a pigmy on the shoulders of a giant, can see farther than the Giant—And yet poor mortals! <u>we</u> are still surrounded by mysteries—We know the great Oak grows from the tiny acorn—but do we know how?—We force the invisible air to move our mighty engines, but do we know "whence it cometh or whither it goeth"— The tree produces the bud, the bud the blossom, the blossom, the fruit; and yet though this miracle is performed year, after year under our eye, do we understand how this beautiful process is effected and carried on? No verily—"we see and yet we perceive not"—strange it is that with these wonders daily unfolding before us, which no mortal can explain, many affect to believe only what they understand—but on the other hand if some believe too little, there are many, who believe too much—Witches, Spiritual rappers, nothing is too monstrous for their vast credulity; Spirits of the departed knock at their doors, overturn furniture, and raise tables from the floors; and we have among us, wise mortals, who profess to interpret this very singular language for Spirits; and still, notwithstanding, their dignified offices, they modestly term themselves <u>mediums</u>—Medium, has two significations; it may mean a <u>good</u> or a <u>bad</u> person—Moses was a medium—a medium between God and his people—The witch of Endor was a medium between the living and the dead. Some of us may have formed a wrong conception of a witch—it has been the general opinion that witches are old, odious, deformed and wrinkled: Ancient soothsayers were generally persons of superior knowledge; they were acquainted with the laws of Nature, and possessed sufficient ingenuity to turn this knowledge to account, in accomplishing their deceptious purposes—they were denominated the wise ones— so the witch of Endor, may have been as young, beautiful and accomplished as any of the graceful mediums of the present day—nevertheless, in divine revelation she is called a witch—Wicked people are not always ugly; Jezebel was probably handsome in her early youth, and she tried to retain the semblance of beauty, in more advanced age, as many do in our day, with paint, lilly white, and jewelry. Well, if our modern mediums follow the same trade that she of Endor did, what are they? As revolting as it may be, we must answer—witches—Saul said, call me up him, whom I shall name—and the woman said whom shall I bring up to thee? and he said—Samuel—The mediums of the present day, have read at least this part of the <u>Holy Book</u>—they are asked bring me up, whom I shall name they answer—whom shall I bring up to thee?—Wesley, Clay, Webster, &c. We have as great reason

to believe, that the witch of Endor was as much frightened at the appearance of the spirit, God permitted her to evoke, as was poor Saul himself—and, so would be the blaspheming witches and wizards of our time, were God to permit spirits to answer to their impious calls—but on this subject, we are not left in doubt—The spirits of the dead come not back, (at least not those of the righteous) to rap on tables, and maliciously toss furniture, hither and thither—even were such a belief, not too absurd for ordinary credulity—divine revelation sets the matter forever at rest. "Him that overcometh will I make a pillar in the temple of my God, and he shall go no more out"—David says, of his son, whom God had taken, "I shall go to him, but he shall not return to me"—The belief that Saints should leave their glorious realms on high, and come at the call of any strolling mountebank to answer silly questions, is certainly very preposterous—In the dark ages, before the universal dissemination of God's word through all ranks and classes, it was not so unnatural that even the churches should share the darkness, and Mystery that veiled the truth from mankind in general; but now, the cloud is withdrawn from Zion and is settling on the brains and proud hearts of some of our unsanctified literati—It is not to be wondered at, that many who bring their minds to believe these wicked falsehoods, coming as they do from Satan "the Father of lies" become subjects for the Lunatic Asylum. It is said that the stream of Idolatry flowed over the nations, from Egypt, I ask whence originated the absurdities, of Biology, Craniology, Spiritology, and a thousand other fooleries equally ridiculous, leading to results as deplorable! If the memory of these follies be not lost in merited oblivion, a hundred years hence, we, so <u>very</u> wise in our own conceit, of the nineteenth century, will be regarded as the supremest of world-wide ignoramuses—Easily may these wicked follies, also be traced back to Egyptian darkness—and this corrupt source will continue to send forth its foul streams, until those twin sisters, of Heaven; Christianity and Knowledge, walk hand in hand throughout all the labyrinths of humanity, lighting up their dark paths, and scattering every where peace and happiness; when the veil of ignorance shall be removed from the bright face of Science, and Philosophy untrammeled, will travel abroad from cottage, to cottage, as well as from castle to palace—Nature then instead of presenting a sealed volume of mysteries, will open her pages to the view of man—his mind no longer shaded by sin and sorrow, will find the sublime, yet simple explanation of all in the <u>Bible</u>—then will he be taught to acknowledge that mystery of mysteries, one immutable, omnipotent, omnipresent Creator.

MY WILL.

[By Ellen Riley]

I pause to think, how soon the moment will arrive, when I am to leave these Classic Halls, in which so many joyous days, have been spent, where I have reviewed my <u>last lessons</u>, and where has been woven, a chord of love, which binds my heart so closely <u>here</u>. Where hence-forward will be those sunny dreams which so long have warmed my fancies and my heart. Alas! soon this body is to be consigned to that destroying monster (Society.) But ere I leave this Harvest-home, fain would I bequeath to friends much loved, the wealth which has been for years accumulating in the casket of my heart. Therein are more treasures than I imagined could be mine. First, to her whose life has been devoted to moulding, and refining young hearts, and preparing them for their future destiny, who has been my guardian for several years past, whose eye has watched with eager interest my unsteady progress in ascending the steep and rugged "Hill of Science," who has cheered me on and given me a helping hand, when an occasional wearisomeness has caused my foot-steps to falter, or when allured by the flowers of Indolence, I have lingered by the wayside inhaling their stupifying fragrance, has encouraged me onward with redoubled speed in search of pearls of <u>wisdom</u>, inscribed with lessons of <u>truth</u>, never to be effaced by the busy finger of time. To my dear Teacher and Mother, what can I give, what have I, worth bequeathing? I can find nothing among all my treasures which would be so appropriate for you, Mrs. Tevis, as the largest portion of my Gratitude and Love, and though these may appear insignificant when compared with more costly gifts, presented by others, yet, I only ask that they may be accepted for my sake, while at the same time, I place upon my own heart the little "Forget-me-not" and utter a sincere prayer that God will ever bless you as now. What can I give thee, my teacher of Mathematics which will be more acceptable than the recollection of those Algebra sums, and the demonstration of those difficult propositions together with a tribute of heart-felt affection. Cast them not away as trifles but preserve them as coming from a grateful heart. I also bequeath to you my thanks for the trouble you have taken in impressing those principles upon my mind which will doubt-less ever remain. Mr. Kappes with you I leave a bouquet of happy remembrances whose sweet odor will remind you of the many songs we have often sung together. Gathered by the hand of one so undeserving it will I fear too soon seem withered and bereft of interest among the many flowers presented by more beloved pupils, but I would ask that you treasure them for the givers sake and let not the chord of love by

which they are bound together be broken asunder by forgetfulness, and thus one by one fall and disappear for ever—but rather cherish them as all that remains of a loving friend. To all remaining teachers I <u>will</u> blessings for their past kindness, with a hope that I may be remembered. To each and every one I give a heart full of love and memories brightest flowers to be regarded as a memento of June 1856.

And now, to you, my dear Classmates, to you who have participated in my every joy and sorrow, who when a tear has dimmed my eye yours also have been filled; when a smile has wreathed my lips it has been returned by a similar expression from you; to my cherished friends I willingly give and bequeath a large share of friendships richest gems. 'Tis sad to leave you thus—yet take the gift—'Tis all I have. Friendship is not a name. It's something more. 'Tis set with rarest jewels. Take and wear them near your heart. May time only serve to brighten their lustre. Such sentiments possess the indestructible elements of immortal life, and now that I am to be separated from you, who have been to me like spirits of inspiration, I would ask that I may not be forgotten—for I would not that my poor name should fade from pleasant remembrances of your youth. Nothing can deprive us of the placid enjoyment that springs from the memory of early days. To all remaining school-mates do I give a hope that no adverse circumstances may occur to disturb this possession of joy during the remainder of your stay here. Endeavor to realize that you are now preparing for the realities of life—that you are not always to spend your time thus, with nought to disturb the flowing tide of pleasure and happiness; hence you should be more diligent in the search for those things which fade not, and which are as immortal as the soul of man.

Has unkindness towards you or any one marred my stay here?

Does any one remember unpleasant words that I have spoken? Then let them be forgotten—Yes, I am sure that they will be—and that I shall receive as I have given—A place, a <u>warm</u> place, in the hearts of those, I love and leave here.

> And now, farewell ye scenes, so loved, so fair,
> Midst which, pure generous pleasures dwell,
> Pleasures, which others oft may share
> But I must leave—Farewell! Farewell!
>
> But most of all ye loved ones here,
> My heart so ardent, loves so well
> Though I leave you, still how dear,
> Are cherished friends—Farewell! Farewell!

"Cotton," Mabel Davis (1915) and
"From Field to Kitchen," Mamie Stewart (1915)

*Written in 1915 at the Genoa Indian School in Nebraska, Mabel Davis's "Cotton"
and Mamie Stewart's "From Field to Kitchen" reflect the domestic science curricu-
lum that was first introduced into schools during the Progressive Era. As educa-
tional reformers worked to build relationships between the classroom and students'
lives beyond school, female students found themselves learning nutrition, hygiene,
household budgeting, and other subjects that would make them efficient managers
of their homes.*

*Karen Graves has noted that one of the consequences of the domestic science
curriculum was to sidetrack white, middle-class girls out of college preparatory
courses as it professionalized the vocation of homemaking. For girls of other so-
cial and racial backgrounds, the consequences were more dire as the domestic sci-
ence lessons minorities received often prepared them to be obedient household
servants.*

*In her essay in this volume, Amy Goodburn offers a close reading of Davis's
and Stewart's essays. She analyzes how these girls move among various registers: the
language of the traditional research paper; the conventions of the domestic science
demonstration; and myths of manifest destiny.*

COTTON.

Mabel Davis.

We are told that cotton was unknown in the most ancienttimes and
not until about 450 years before Christ. It was for the first time men-
tioned by Herodotus theancienthistorian. This is the first record of the
use of cotton, but undoubtedly it was used many years before he wrote.

We donot know where this plant was first used but since the word is
derived from an Arabian word it is most likely that they, the Arabians
knew its use and value.

Cotton was introduced into Rome 63 years B.C. and was then used
for awnings. The famous Caesar used cotton cloths to cover the forum
and the way leading from his house, it was a great novelty and for a time
was considered one of the greatest wonders of the city.

The people in India made cotton in ancient times which they prized
very highly. These people attained such skill in spinning that a single
pound of thread measured 115 miles in length.

The finest cotton goods of ancient times were made by them. Some
qualities were so fine that they could scarcely be felt by the hand, and when
spread on the grass and covered with dew, became invisible.

It is certain that the plant was cultivated in China long before the
Christian Era, but as late as the seventh century it was planted for its

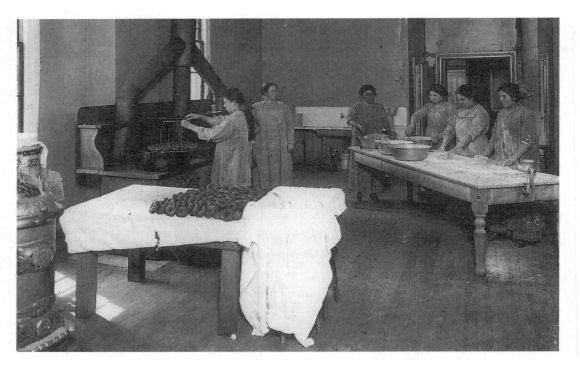

Native American girls making doughnuts (National Archives)

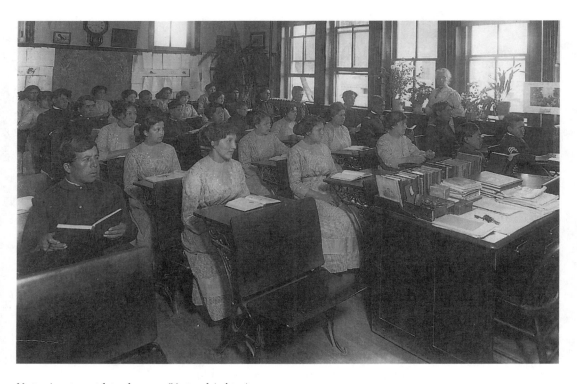

Native American girls in classroom (National Archives)

value. About the thirteenth century the Chinese discovered the value of its fiber for cloth.

When Columbus was on one of his voyages he found the cotton plant growing wild in this country.

Later explorers found it as for north as the lands bordering on the banks of the Mississippi. When Cortez started from Cuba he also found the plant in use in Mexico. From this we see that cotton has just recently been growing in our country. The early settlers of Georgia and Carolina at first grew cotton in their gardens for ornament, and it was not until after the Revolutionary war that any considerable attention was given to its cultivation for practical purposes. It was then the American planters began to give serious attention to its culture, and from that time its progress has reached a high degree.

The seed in this country, is planted in March and April and blooms in June, bearing very pretty blossoms which change their hue three times a day. The seeds begin to ripen the first of September, and when the flower falls off the bolls which contain the cotton grow very rapidly and soon burst open and set the imprisoned cotton free. All the bolls donot ripen at once so the plant continues its growth until the frost comes.

The picking now begins until late in autumn, it must be very interesting to watch these earnest workers. Let us take an imaginary trip down to South Carolina, and visit one of these beautiful fields, as we enter, the first point which is impressed upon our observation is the vast stretch of land containing this plant. We can imagine how pretty these fields look. The snow white cotton mingling with the bright green leaves. As we go on further we discover that nearly all the work on the plantatian is hand labor and is performed by the negroes. We notice them with bags tied about their necks or waists in which they put the cotton, and then empty it into a large basket, when filled they place the baskets on their heads and carry it to the place where it is ginned; the next process is drying, then the ginning; which is running the wool through the gin to separate it from the seed it is ready then to be packed into bales for shipping. The bales are pressed with a powerful press, wrapped in burlap and banded with iron. They are then sent to factories.

The uses of cotton enter so completely into our life that we could not now do without it. We find it in our sleeping rooms, in our wearing apparel in the awnings for our houses.

Cotton fabrics are more extensively used than any other material, there is not a place open to commerce phere it is not carried. We find it in palaces of kings in the huts of the Barbarians and in the

homes of the rich and the poor. There are many varities of cloth made from cotton, we can only notice one, and here is a piece of the finished material which I will use to demonstrate in cutting of an apron.

FROM FIELD TO KITCHEN.

Mamie Stewart.

Long ago when a Frenchman was visiting this country, he overheard an old Indian telling his men that they ought to consider how the white people were living on seeds and how they sowed them. He said that the white men lived longer because they did not have as many hardships which the Indian did in pursuing his game. He said his game had four legs while the Indian only had two to chase it. And he also told them that it took at least two years for the game to be fit for food while it took a very short time for the seed to ripen fit for food.

When the inhabitants of a country sow wheat we know that civilization is there, for it makes the people stay and build their homes.

The "Home" of the first Civilization was in Asia Minor between the Tigres and Euphrates Rivers and that is where wheat is supposed to have first flourished. About three or four thousand years ago a monument was erected by the Egyptians and that showed Egyptian king with an ear of wheat in his hands offering it to his God.

We read of wheat in the scriptures as being made into leavened and unleavened bread and offered to the Lord as a Thank-offering.

Wheat bread is the only white bread. Wheat flour made into a loaf of bread is the highest type of human food. Many people prefer the third grade flour because it has more of the food properties in it. Many house wives perfer the blend of spring and winter wheat.

Starch, gluten and bran make up the wheat kernel. We need the starch, and gluten in the flour so we count the bran as being useless to mankind so we give it to the beasts of burden.

It is not only the grain that is valuable but the wheat straw is used for various purposes. It serves as a building material made into bales and piled side by side and on top of each other, forming walls for granary and the loose straw is supported on a frame for the roof. It is also used for a fuel to feed the Thresher.

A slender kind of wheat growing in Italy is made into fine hats called "Leghorn." Very few kinds of plants will answer as many purposes as the common wheat will.

A little girl who lived in some Western state went to the Eastern shore to visit. Her friends asked her if she thought that the ocean was

beautiful. "Yes, she replied, but I do not think it is as beautiful as the waving ocean of grain at home." Now you who have seen the beautiful fields of waving grain can readily see what a beautiful sight it is.

Now we are going to show you one of the many good things we have learned in the Domestic Science Kitchen. We will make some drop-cakes. We wish we could give each one of you a sample but there are too many of you to even give a taste to each.

"The Circulation of the Blood" and "Surf Bathing," Frances Royster Williams (1915)

As an aspiring artist, Frances Royster filled her 1915 high school notebook not only with school essays and assignments but also with complex drawings and illustrations, particularly in connection with her study of human physiology. Her essay on the circulation of blood, reprinted below, is accompanied by her drawings of the heart, its muscle fibers, and the circulatory system.

In an essay for her English class, which she drafted three times, Royster uses words to create mental images for her readers. She describes the waves as mountains and makes the "milkwhite foam" come alive in its "churning, bubbling, . . . [and] laughing."

After graduating from high school and attending the Kansas City Art Institute, Frances Royster Williams became a successful commercial artist and the writer/illustrator of "Cuddles and Tuckie," a syndicated series featuring two children that appeared in more than fifty newspapers during the 1940s.

Materials from the Frances Royster Williams Collection appear here courtesy of the Western Historical Manuscript Collection, Kansas City.

THE CIRCULATION OF THE BLOOD

The inferior & superior venicava are busily filling the right auricle with dark venous blood, collected from all parts of the body. When the auricle contracts the blood can not get back into the great veins because it is flushed forward by the great volume of blood behind it. The door into the right ventricle lies open & the blood flows through it until it is full.

The ventricle now begins to contract; the tricuspid valve at once closes & thus prevents the backward flow of the blood & the blood is driven into the pulmonary artery past the semilunar valves.

The pulmonary artery carries the blood to the lungs. The dark, impure blood is driven along smaller & smaller vessels until it reaches the capillaries of the lungs. Here it is, at it were, spread out to be purified. Exposed to the oxygen of the air, the blood gives up its impurities & loses its purple color. It takes up a great deal of oxygen of the

Anterior View of the Heart

Muscular Fibers of the Auricles

Diagram of the Circulation of blood

In her study of human physiology, high-schooler Frances Royster Williams drew the heart, its muscle fibers, and the circulatory system. (Frances Royster Williams Collection, Western Historical Manuscript Collection, Kansas City.)

air in exchange, & in a purified state & of a bright scarlet color, it comes back to the heart by the four pulmonary veins which pour it into the left auricle.

From the left auricle the blood is forced past the mitral valve into the left ventricle. As soon as the left ventricle is full it begins to contract. The mitral valve at once closes & blocks the passage into the left auricle, & the blood has no other way open but past the semilunar valves into the aorta.

The aorta & its branches, as we already know, distribute the blood through every tissue of the body. From the tissues it is again returned by the veins to the right auricle of the heart, & thus the round of circulation is continually kept up.

<div align="right">
FR

Jan. 1915.
</div>

SURF BATHING

The sun was yet high in the heavens as I splashed out into the breakers. No sooner had I recovered from being knocked down by a white-capped, foaming, dashing billow, than another wave rose in its stead, swelling into a mountain, then breaking into a curved wall sending forth sprays from its top, one mountain tumbling over the other, each hurrying and scurrying and trying to reach the shore first. But I was prepared for this one; giving one great spring, I shot through the wall of water and came out on the other side, just in time to see the last fragments of this water mountain swish upon the shore. Urged by the undertow I moved out farther where the giant waves did not break. As each mountain welled up before me, I rode easily over it, ascending high, then descending into a valley as the surf broke furiously into a mass of churning, bubbling, spraying, laughing, milk-white foam behind me.

<div align="right">
Period 1

Frances C. Royster

Surf Bathing.

Dec 13, 1915

written three times.
</div>

"All About Me," "Dear Ellen," and "What America Means to Me," Mary R. (c. 1960s)

Written by a fifth-grade girl in Iowa during the 1960s, these three essays further reveal the range of writing tasks students confront in their classrooms as well as the creativity of educators who attempt to design assignments that make literacy the foundation of the entire curriculum. Nellie J. Hall Williams, Mary's teacher, used innovative writing assignments to become more familiar with students' lives both in and out of the classroom; to reinforce lessons in history and other subject areas; and to inculcate mainstream cultural values.

In the first essay, Mary R. describes herself, responding to a series of questions provided by her teacher. What kinds of books do you like? If you could have two wishes, what would they be? How many people are in your family?

In the second assignment, Mary R. adopts an epistolary format to demon-

strate her mastery of concepts learned in social studies about the settlement of the Appalachian mountains during the eighteenth century. She assumes the persona of a girl who has moved with her family to Boonesborough, Kentucky, and she writes to her friend, describing methods of travel, the textile work she and her mother accomplish, and the dangers of life on the frontier.

The final text included here, "What America Means to Me," provides Mary with an opportunity to demonstrate her patriotism and understanding of the principles upon which the United States was founded. She cites the importance of religious freedom, the right to public assembly, and the importance of an unfettered press.

These essays appear courtesy of the Western Historical Manuscript Collection, Kansas City.

ALL ABOUT ME

My family calls me Francie. Everybody else calls me Mary. I think swimming is a good sport. I like to watch and play tennis. I like to make pictures of animals especially horses. My favorite books are Laura Ingalls Wilder books, and the Bobbsey Twins books. My favorite radio program is WHB. My favorite kind of music are the Beatles movies. I don't go to the movies very often. But when I do go I enjoy it very much. On my vacation we went to Saint Louis and saw the Monkey show at the zoo. Then we rode the train free. I have been to many interesting places.

I would like to go to the Hawaiian Islands, Europe, and Liverpool, England. My two wishes would be to have a horse of my own, and to see the Beatles in person. I have ridden some, but I would like to have my own horse.

After school I usually go and do my homework and practice piano. I go out to play sometimes. At home I do dishes and clean house on Sat. I help my Mom a lot. My mother teaches piano lessons after school on Tuesdays and Wednesdays. I take piano lessons from my own mother.

There are four people in our family, there is: my sister, Margaret Lyn—14, my mother and father. My sister goes to Maple Park Junior High. My dad is a school teacher. My mom stays at home and does work.

When I grow up I would like to be a housewife. I am going to get a teachers degree and so if I want to teach. This was my story about me. I have my carreer all figured out.

Mary R.

Boonesborough
Kentucky
Dec. 23, 1756

Dear Ellen,

The trip to Kentucky wasn't too rough. We went part of the way by flatboat and the rest of the way by wagon.

How is it back in North Carolina? The weather is fine here. The land and game is wonderful, too.

Pa went to the store to get meal for Ma to make bread. He went to Boonesborough. I hope he brings back some candy for George, Hannah, and me.

Our cabin is nice and roomy. While George was helping Pa build the cabin, a log fell on his leg. It's not broken. He's getting better.

If you come here could you, bring my brown chest? How's my dog coming along? Have you gotten your cat?

The crops are growing very well. Have you had snow? We haven't.

For Christmas Pa, George, Hannah, and I are going to get Ma a spinning wheel.

I have gotten my sampler finished. It wasn't too hard to do.

Our schoolhouse is red brick. The boy behind me doesn't bother me much. The one beside me makes faces at me. The school is 5 miles away.

I reckon you miss me. I miss you very much.

Tommorrow we are going to have a house raising.

About time for supper. I hear Ma calling me to help make supper. Bye.

Your friend,
Mary R.

P.S. Have a nice Christmas.

WHAT AMERICA MEANS TO ME

America means many things to me. The one thing that stands out in my mind is freedom. I am going to name some of these freedoms.

One of these freedoms in our country is education. In our schools we learn languages. In grade school we learn Spanish. In Junior High we have some to pick from. We also learn about other countries such as South America, Mexico, etc. I enjoy history because of the interesting things the people did then. The thing I like is when Paul Revere rode that night. Sometimes we learn different kinds of religions. The Pilgrims came here because they couldn't worship as they pleased.

Another of these freedoms in our country is religion. In the U.S. We may worship as we please. Here you may pick your own church. If you pick one church and go there all the time you shouldn't support other churches. You should go to church every Sunday if possible. You don't have to go if you don't have a church to go to.

Another freedom in our country is freedom of speech. In the constitution it says you may say what you want about the government as long as you don't tell lies.

You may assemble together in a group peacefully. Some groups get together but they plan to do some criminal or bad things.

Another freedom in our country is printing. You may print anything you want in newspapers or magazines as long as it is the truth.

In our government we have a choice between 2 people. We can get laws changed by voting for 1 or more people who think the same as we do.

America is a land of opportunity. We are allowed to travel. Some of the places in the United States are Disneyland, World's Fair, State Parks, etc. Something interesting would be to go to other countries. It would be fun I think to go to Canada, Brazil, etc. Going to other continents like Africa, South America, Australia, Asia. If you went to Africa or South America you might be a missionary. I would think it fun to be a missionary and go to South America and Africa.

Improvement is a another freedom. We are able to get jobs. We could try hard and get a better job. Sometimes homes don't look too good. We are free to get the materials to make a house look better. I think if the father gets a fairly good salary he might be able to move to a better house.

The End
Mary R.

"Recommendation to Patient," Laura Griffith (pseudonym) (c. 1999–2000)

Recognizing that standard curricula in many fields of study traditionally dominated by men (e.g., science, math) may actually compete with the assumptions, priorities, and practices of being an adolescent girl, educators at the dawn of the twenty-first century have sought to revise classroom practices to engage more fully female students, often including various types of reading and writing assignments as part of their revisionary efforts. Researchers Lisa Weems, Paul Miller, Janet Russell, and Andrea Lunsford report on their work in this area in "Expanding Literacies at the End of the Twentieth Century." With teachers at Midwestern Girls School, they designed a science assignment that fore-

*grounded the application and relevance of science to girls' lives. The girls re-
searched a popular weight loss drug, and assuming the role of a physician,
each one wrote a recommendation to a patient about the drug's use. The girls
were given access to a web-based software that allowed them to find informa-
tion about the drug, evaluate that information, and synthesize their findings.*

*The recommendation included here reflects the student's understanding of
crucial scientific concepts (e.g., Body Mass Index; the digestive process), yet she is
able to write about them within the context of a meaningful personal relation-
ship, rather than to compose an objective, detached scientific report issued to an
unidentified audience. For a contrasting essay that deals with scientific concepts,
see Frances Royster's 1915 essay on the circulation of blood in this volume.*

RECOMMENDATION TO PATIENT

Dear Client,

I have learned that you are interested in taking the ever so popu-
lar diet wonder Xenical! Well, I think you would be happy to know
that I have done much research for you and would like you to read it
thoroughly. There are many good outcomes from Xenical, however,
there are also some bad ones. I hope you read this carefully and think
very hard about taking Xenical, because good health is what you need
to keep in mind. I have read many interesting articles on Xenical. Like
I said some are good and some are bad, and some explain the differ-
ences between Xenical and other drugs. Sure, the information given to
me about the other drugs could scare you from taking those other
drugs. First, you need to figure out your BMI (Body Mass Index). To
do so you may visit the web address having to do with BMI, or simply
take your weight in Kilograms and divide it by your height in meters
squared. I am assuming that your BMI is above 30. If not, I would rec-
ommend that you do NOT take Xenical. There are many other things
that you could do if your BMI was lower than 30. However, if you are
an athlete with a lot of muscle or a pregnant women your BMI will not
be exactly precise. I am assuming that your BMI is above 30, because
otherwise you would not have been recommended to such an excel-
lent Doctor as myself. Alright, let's move on. Let me tell you what
Xenical does to your body. [It] acts locally in the gastrointestinal (GI)
tract, inhibiting the action of GI lipase and preventing absorption of up
to 30% of ingested dietary fat. Xenical has a unique molecular struc-
ture which allows it to bind to the active site of GI lipase and blocks its
activity. The enzyme is thus unable to break triglycerides down into
their component parts. A significant proportion of dietary fat therefore
remains undigested and unabsorbed, passing through the GI tract, un-
changed. 70% of ingested fat is however absorbed in the normal fash-

ion, ensuring sufficient absorption of fat soluble vitamins. (text quoted from project page). If you decide that this is the diet wonder for you, you will need to dig deep in to your pockets, and search the cracks in the couch, because each individual pill can cost you over a dollar! That is right, over a buck for one pill, and not to mention you need to take them three times a day. That gives you a monthly bill of around $140.00. Now you will not be taking Xenical for a lifetime, but if you get off of it and notice that you are gaining your weight back and decide to get back on it, it could take a couple of years for your body to adjust. You must also take into consideration that most healthcare providers will not cover Xenical. Xenical works by going through your digestive track. It prevents 30 % of the fat that you consume from ever being digested. Now, this sounds great, right? You can eat as much fat as you want, or so you think. If you are an obese person you should get in the habit of eating healthy. If you are on Xenical it would definitely help to eat healthy, therefore, when you get off the pill, you will have a good diet already started and all you have to do it continue. However, because you are not getting all the fat-soluble vitamins you would normally get, you should take some more, but not to many more, just the amount that you are not getting. Now, back to what happens to you physically. Your body may have something called "Anal leakage." I do believe that this is self explanatory, however, if you find you are not understanding this please feel free to contact me. The difference between this drug and Fen-Phen, the other diet pill, is that one, Fen-Phen has had some very horrible side effects, and well you can't get it because it has been recalled. It also affects the central nervous system. There is another drug by the name of Metabolife. The maker of Metabolife was in trouble and arrested for possession of methamphetamine. Would you really want to be taking a drug from someone who works with illegal drugs also. I feel that a lot of the creators of diet drugs make a drug with the priority being, which can bring in the most money, not the healthiest pill. However, in the case of the Xenical creators, I know that they took into much consideration in creating their drug, because it shows in their patients and work. If there is a diet drug for you, well I think we may have found it. If you, my client, is able to work out and has not tried an excellent diet, working out, and just overall tried to be a healthy person, I would not suggest Xenical—yet. Once they have tried everything and have realized that there is no hope, I would suggest Xenical. Xenical will not make you lose huge amounts of fat. Xenical helps patients lose between 10–16 percent of their body weight, or an average of about 600 calories a day. Xenical is a great medicine, It's like the advent of the Pill. That separated sex from re-

production; well, this separates food from nourishment. Xenical will not alter your brains chemistry. Therefore, if you lose weight and then get off the drug, you may not necessarily stay the weight you are. That is why I strongly recommend you eat right, and stay healthy and work and cooperated in the most superlative manner possible, to comply with Xenical. Your brain will not automatically think that you are skinnier than you where, you must treat your body like it is skinnier, so you get used to it and then, your brain will. I have a read a few articles on the amount of time you need to be on Xenical. I have read that some people are planning on taking Xenical for the rest of their lives. Others, are just planning on taking Xenical for a few months to a few years. Mostly, those that are taking it for a short period of time, are the clients that are not very obese, but are trying to get set in the right direction. They will take it for a certain amount of time and soon set into a good eating habit and good exercise plan. In chemical terms this is Xenical, what it does and everything about it: Xenical is a non-systemic anti-obesity drug called lipase inhibitors which act in the gastrointestinal tract to prevent the absorption of fat by about 30 percent. Drugs in this class do not achieve their effect through brain chemistry. In other words, Xenical is not an appetite suppressant. Dietary fats are large molecules which need to be broken down by enzymes called lipases before they can be absorbed into the body. When taken with a meal, Xenical interferes with the activity of these enzymes. This allows about 30% of the fat eaten in a meal to pass through the gut undigested. Your body cannot convert these excess calories to fatty tissue or use them as a source of energy. This will therefore help you to reduce your weight, maintain your lower weight and minimize any weight regain. Basically, what I am telling you is that I think Xenical is a safe drug . . . according to all the information we have. You must, and I emphasize must, consider that Xenical, like many diet drugs, has not been around long enough for anyone to know for sure the long term effects. However, if this is a risk you are willing to take, and I believe it is a smart risk, I will be happy to support your decision. It can help reduce your risk of many horrible diseases such as diabetes, hypertension, type 2 diabetes, coronary artery disease, stroke, gallbladder disease, osteoarthritis, sleep apnea and some cancers related to being obese. That is a huge laundry list of health problems, and that is why, as of right now, I believe your best bet would be to take Xenical. It can help you become the slimmer, healthier you that I am assuming you want. If you need any more guidance on Xenical or my information, I would suggest you give me a call. Hope to see you and talk to you soon, Dr. Laura Griffith, M.D., Ph.D. (904)555–1212

School Newspapers and Literary Societies

"Editorials," Prudence Withers, *The School Paper* (1898)

School newspapers, literary magazines, and societies have served as significant sites where girls develop their literacy skills. Though typically organized, sponsored by, or affiliated with formal educational institutions, these extracurricular literacy activities have often provided girls with more flexible learning opportunities that emphasize peer interaction, rather than the typically hierarchical relationship between teacher and student. Becoming involved with school publications or joining a literary society allows girls to connect with fellow students who are similarly interested in writing and literature, and as Katherine H. Adams has documented in her study of well-known American women writers, such supportive relationships with other young writers have often been crucial to the development of professional women journalists, novelists, and poets, like Zona Gale, Pearl Buck, and Zora Neale Hurston. While not every girl who writes for her school newspaper or joins the debating team will choose to earn a living by her pen, such activities do allow girls to further refine their skills as readers and writers.

Serving as editor of The School Paper *provided Prudence Withers with a significant apprenticeship in the challenges of periodical publication. In her editorial, she encourages her fellow students to submit their work and attempts to dispel the pain any young writers might feel at not seeing their work in print by mentioning that all the work received by the newspaper had been "creditable." She must also correct errors from previous issues and fend off humorous attempts by her staff to engineer her own demise in hopes of having a truly shocking topic for the next issue.*

This excerpt from The School Paper *appears courtesy of the Western Historical Manuscript Collection, Kansas City.*

Editorials.

Several of the articles appearing in this month's paper are contributions from the very youngest members of the school. The contribution box has been well filled, and we hope there will be no falling off in the sketches and stories placed there, because no more have been printed in this issue. The articles we did not have space in our paper to print, as well as those printed, are creditable. It gives us great pleasure to see the young members take such an interest in the work, not only because we need their help now, but because in a few years, when the present members of the staff will have been graduated, these younger pupils will have entire control of the paper, and we feel very sure of success both now and in the future. Such strong school spirit as ours can not fail to carry through any project that may be undertaken.

It is our wish to correct a mistake made in our last number, in the article on foot ball. The statement was made that last year and the year before Yale held the championship. We ask the pardon of our Princeton friends for giving Yale more credit than she deserves. The young man who wrote the article has aspirations toward Yale. Perhaps this accounts for the mistake.

One of the first difficulties of an editor is the choice of topics for the editorial page. In discussing this with the staff, some one suggested, a little too enthusiastically, that the editor-in-chief should commit suicide to give a thrilling topic for a leader. This would not help matters at all, for who would write the editorial? It is necessary that she should live for this, and then we hope that the next few months will furnish events sufficiently interesting to supply matter for editorials.

The latest event of interest to the whole school is the organization of a dramatic club. The upper grade of the grammar department is included with the academic in this enterprise. Soon after the decision was made in favor of the association, a meeting was called and as only one candidate was proposed for each office the elections were most flatteringly unanimous. The officers of the club are: Theo Mastin, as president; Laura Nelson, as property woman, and Serena Smith, as secretary and treasurer. In the carrying out of this plan we hope to afford profit, pleasure and amusement to the members of the school, and some day when we show great improvement, we shall invite outsiders to witness our histrionic talent.

"The History of the Lygaeum," Priscilla Washington, *Lincoln High School Annual* (1904)

In this short essay, Priscilla Washington offers an institutional history of the Lygaeum, a literary society for girls which had operated for over eight years at Lincoln High School, a segregated institution for African Americans. Members prepared and gave speeches, debated educational issues, and researched the lives of prominent African American women. For more information on literary societies and clubs, see the bibliographic entries for Anne Ruggles Gere and Elizabeth McHenry in the reference chapter of this volume. This excerpt appears courtesy of the Black Archives of Mid-America.

THE HISTORY OF THE LYGAEUM.

On the 25th of October, 1898, a progressive set of young ladies of the Lincoln High school assembled themselves together and organized a club and named it the Lygaeum, from Lygea, the heroine of Quo Vadis.

These young ladies are now out in life engaged in various occupations, but the result of their work still lives. They elected as their first president Mrs. Sarah Bailey, vice president Birchie Pierce; secretary, Miss Julia Fields; assistant secretary, Miss Jennie Watts, and Miss Anna Jones critic and treasurer.

At this same meeting five members were appointed to draw up a constitution, which at the next meeting was read and received. This constitution set forth the main objects of the club, which were: "For their mutual improvement; for the entertainment of their friends; for the cultivation of the amenities of social life, and for the promotion of literary culture." They also made it a part of their constitution that the critic should always be a lady teacher of the High school, who would give advice to the members and criticise their conduct.

On November 22, 1898, Mrs. Yates made an excellent address to the club on "Physical Culture." On January 17, 1890, the club discussed the subject "Resolved, That the education of girls should differ from that of boys." On February 14, 1898, the members were favored with a St. Valentine program which contained quotations and the history of St. Valentine, by Miss Colbert.

On April 3, 1900, Miss Letha Drake was elected president of the club. On May 29, 1900, the young men of the G.O.C. presented to each young lady of the Lygaeum a complimentary ticket to the anniversary of the G.O.C.

On January 22, 1901, the club had a general discussion of the "Ideal Woman of Today." Many talked on the subject and named several of the leading negro women whom they had selected as their ideals. The program of February 13, 1901, was made an interesting one by an excellent address made by Mrs. Leurlean Wilson, entitled "A Trip to Texas." It was more interesting because Mrs. Wilson is an alumnus of the High school.

At this age of the club the membership increased and many planned ways to make the club more interesting to the young ladies of the school. On March 5, 1901, Miss Anna Jones addressed the club on "Mental Culture," and Miss Cross favored them with a mandolin solo.

On October 1, 1902, Miss Minnie Wortham was elected president of the club and during her administration the G.O.C. and the Lygaeum together gave a party at the residence of Miss Estella Benton's, but after this the later parties were held at the Vendome, as the membership was too large to be entertaied in any private home.

On February 29, 1903, the club rendered a program in memory of Fred Douglas. The program was given during the administration of Miss Lade Nelson.

The program of March 17, 1903, was an excellent talk on "Thinking One's Own Best," by Miss Anna Jones. The talk was enjoyed by all who heard it.

Easter was approaching and for the sake of some of the young ladies who were expecting to get new suits for the occasion, Mrs. H. O. Cook on March 24, 1903, made an address to the club entitled "Consider Your Purse Before You Purchase." This address was of a great benefit to each member.

During the six years of its history the club has enrolled 476 members and been of great benefit to the members and the High school.

<div align="right">PRISCILLA WASHINGTON.</div>

"The Mouse," Nettie Worth, *Indian News* (1907)

Native American Nettie Worth shared this story at the Victoria Society literary club while attending the Genoa Indian School. In her essay, on girls' literacy in the Progressive Era, Amy Goodburn suggests that "The Mouse" can be read as an ironic commentary by Worth on her own boarding school experiences. See Goodburn's essay in this volume for more information on Worth and her classmates at the Genoa Indian School.

<div align="center">THE MOUSE.</div>

<div align="center">By Nettie Worth.</div>

<div align="center">An Original Story Read at the Victoria Society.</div>

I was born out in the field among the thick green grass away from all kinds of disturbances. We were five in the family including my mother and father and had a very nice home. While we were yet quite young our mother was very kind to us and took good care of us.

Our home was located near a garden and so it was an easy matter for our mother to bring us good things to eat. As we grew a little older and able to play out we were always playing and running about and had no fear of anything although our mother often warned us to always be on the look-out lest those great big giants they call people may happen to run across us and then there would be no hope for us. Yet days passed by very happily at our home. Till one day our mother told us that we were old enough to take care of ourselves and that we must get out into the world and make our own living of course we didn't like to leave our folks but it was for our own good so, as I had a brother and a sister, my sister and I decided to set out together. The days were beginning to get cold so we started out hoping to find a warm place and finally we came to a large building which we afterwards found was the

school building; and we wandered and wandered all through this building hunting for a place to make our home. We found a room on the first floor which suited us very well so we looked and walked around and noticed that there was some corn hanging up in the corner and that pleased us very much so we decided to make our home right there under the radiator where it was warm and quiet. After we were all fixed, we both climbed up to where the corn was and were just enjoying our meal when we heard a noise and the door opened, and imagine how scared we were when we saw several of those great big giants that our mother often warned us of walking in, we jumped to the floor and ran into our hole I didn't think they had time to see us as we fairly flew for refuge. In a short time while all was quite and so thought these giants were gone, but when I peeped out they were all sitting at the desks so I kept very still waiting to see what would happen next. One of the giants who was seated in front of all the others got up, and when I saw her rising I went out of sight in a second for I thought she had seen me and was coming for me but found out I was mistaken so I placed myself where I was before and listened. This giant was speaking in a language that I could not understand then I noticed that different ones got up and spoke in the same language, then I knew that the giant who was in front of all the others must be the teacher and the others pupils that she was teaching.

By and by I noticed that this procession went on twice a day and so I was obliged to keep out of sight these certain times of the day, yet I was chased around the room by these giants several times, but some how or other I was always able to escape unharmed. One day I was way up among the corn eating same as usual and didn't notice that some of these giants had come in and I suppose I must have been making quite a loud noise among the dried corn husks that attracted their attention as I know I couldn't have been seen, for before I knew what was up I saw these giants with their hands which were about three or four times as large as I was reaching out toward me, why, I never was so frightened before in all my life. I made one great big leap, although I didnot land on my fore feet. I passed out of sight in a hurry and I have never made another attempt at that corn since.

"Are You Building a House or Shack?"
Doris Mae Wells, *The Lincolnian* (1916)

With its focus on a recent school assembly at Lincoln High School, Doris Mae Wells's "Are You Building a House or Shack?" functions like a more traditional news article. Wells mentions the speaker's credentials and summarizes his key

points. She clearly imagines, though, a more intimate relationship with her audience than would be expected of an objective news reporter. Phrased as an interrogatory, Wells's headline speaks directly to her classmates, and she closes the article by praising the principal for arranging such a worthwhile assembly. The excerpt reprinted here appears courtesy of the Black Archives of Mid-America.

ARE YOU BUILDING A HOUSE OR SHACK?

On Friday, October 7, the pupils of Lincoln High School listened to an address on this subject by Lawyer William Harrison of Oklahoma, who so diligently fought the "Jim Crow" question through the courts of his state, and who even went to Washington and fought it there.

He talked mostly along the lines of building strong foundations. He told of a beautiful building in Birmingham, Ala., that is condemned regardless of its fine architecture on account of not having a strong and solid foundation. Every time any boy or girl misses his or her lesson they have slipped a cog and are that much farther behind in their education. A building that is condemned will have to be torn down, a boy or girl who fails to make the foundations substantial will in the future be passed over, just when they are trying to be someone.

I think, the most important thought of his address was that a child should strive to be intellectually taller than his parents, and if with his superior advantages he does not make a superior man, he is defective and the race needs no one who is in that condition. He also spoke of two classes of individuals; those who think and those who are thought for. Since this is an age of rapid progression, if you are going to be thought for you will be in the defective class. The thinking man rules the world. The girl who has the ambition and willingness to work is going to be great. To be great does not mean wealth, fine clothing, and popularity, for a thief can be wealthy and dress up to date for a while at least. But in order to be great you must accomplish something.

Mr. Harrison told of the pleasure of visiting the Woolworth Building in New York City. At first he was a little reluctant about entering but finding out that it was as deep as it was tall all fear passed away. So it is with us as students and especially this is true of the Seniors; if we expect to gain an honorable ascendency we must first go down which will require hard work. For the higher up you expect to be the deeper down you must go. His last thought was, dig deep, lay well your foundation; greater foundation can no man lay than that which is laid in Christ Jesus.

I think all the Senior students as well as others will readily join me in saying that this talk was one of the most interesting and inspir-

ing that has been given from the platform, and our honorable Principal Prof. J. R. E. Lee needs to be commended on bringing such a worthy character to us.

DORIS MAE WELLS.

"Irresistable Charm," Alma Green, *Coles Pilot* (1937)

The Coles Pilot *was a joint project of the printing program and English department at R. T. Coles Vocational School and Junior High School, a segregated institution for African Americans. English classes served as a laboratory where students wrote and edited articles for the paper, and students who were training for careers as typesetters and pressmen oversaw the physical production of this paper. Alma Green's article on skin care may reflect her own vocational interests—the school offered a program in beauty culture for students interested in careers as hair stylists and makeup artists. For more information on how vocational education impacted girls from a variety of racial and ethnic minorities, see Amy Goodburn's essay in this volume on girls' literacies in the Progressive Era. This excerpt appears courtesy of the Black Archives of Mid-America.*

IRRESISTABLE CHARM

(By Alma Green)
The Skin and Its Care

Some days when we are riding or walking we get a glimpse of some individual with clear, fresh, delicately colored skin with a magnetic charm that makes you take a second look. You know instinctively that it is the sort of skin which will be just as lovely to touch as it is to look at. This isn't a gift bestowed upon some people and denied others. Every single one of us had it when we were at the "toddling age." Some us lose that fine texture and clear freshness much sooner than others. Then it is certainly worth while to give a lovely skin the beauty care that will keep it that way; and a not-so-good skin, treatment to repair its faults and make it as attractive as possible.

Skin care is really very simple. First of all keep your skin clean. Just removing the dirt that shows isn't enough. Every type of skin needs soap and water. Just any soap won't do. Use one of the mild beauty soaps that is made especially for the skin. Just rubbing your face with a soapy wash cloth isn't doing a thorough cleansing job. Cleanse it with cleansing cream first. Then dip your wash cloth in hot water and hold it over your face so that the warmth sinks in. The heat opens up the pores and loosens the imbedded dirt. Rinse the lather off with your wash cloth and warm water. Finish by dousing your face in cold water. Cold water is one of the best beauty aids you can find

anywhere. It brings up the healthy circulation that cleans and nourishes the skin from within. It is also a grand astringent which closes up the pores and keeps the skin fine textured.

Fingernails should not touch the skin. Always use cleansing tissues in removing blackheads.

When you're beautifying your skin don't stop at your neckline! Cleanse your neck with cream the same way you do your face. In Europe men judge a woman's age by her neck more than they do her face, so be sure you include your neck in the treatment to make your skin a beauty asset.

The face should be creamed before motoring in order to protect it from the heat and winds.

Well so long, friends, have a lovely summer vacation and for beauty's sake take care of your skin.

The Girls' League Gazette (1944)

In February 1942 President Roosevelt signed Executive Order 9066, which paved the way for more than one hundred thousand individuals of Japanese ancestry living in the United States to be removed from their homes and resettled in internment camps scattered throughout the West for the duration of World War II. Education in the camps emphasized the importance of patriotism and "American" values, and this was often reflected in the school-sponsored writing done by girls in the camps.

Young women who participated in the Girls' League at Butte High School in the Gila Relocation Center produced their own club newspaper. In the first two pages of the April 15, 1944, issue, articles include humorous treatments of blind dates and the color code of hair ribbons. These light-hearted articles abut more serious items that discuss the racism faced by internees and attempts to forge relationships with peers in other area high schools through a convention of all area members of the Girls' League. For more on Asian American girls and the Japanese Internment Camps, see the poetry of Mary Matsuzawa and June Moriwaki and the Sr. High School Girl Diary in this volume. These pages from The Girls' League Gazette *appear courtesy of the Bancroft Library, University of California, Berkeley.*

Girls' League Gazette

Vol. II—No. 1 BUTTE HIGH SCHOOL April 15, 1944

GIRLS' LEAGUES CONVENE TODAY

ADVISORS MESSAGE—

To all girls at the convention:

We are proud to have you here today. It is a pleasure to talk with you and to think, play and associate with the girls and advisors from the various parts of Arizona.

It has been fun planning activities for you—it is fun playing and discussing with you, but I think the most precious aspect of the day will be our memories of you, and the new understanding that will come about us as we make new friends, and see life from another point of view.

Many of us in camp were active members of the Girls' League Federation of California and perhaps, had it not been for the evacuation we would have been unable to convene with you here.

I, as advisor, welcome you. We are at your service at all times, whether it be during this history making convention or after it is over. We are sincerely glad you came. I hope you will take back to your school our best wishes.

Jane Eckenstein
(Sponsor)

BUTTE LOSES 43 GIRLS

Approximately 43 girls have left Butte High since the beginning of the school year. The Juniors rank highest with 77 girls against the Seniors, who have 74 girls enrolled. The smallest number enrolled is in the Freshman class with 54.

MISS JANE ECKENSTEIN

FORMER MEMBERS SPEAK TO CLUB

Two guest speakers, Mary Yamauchi and Ayako Muraoka, have recently addressed the members of the Dash 'n Circle, a club composed of girls aspiring to become secretaries.

Mary, secretary to Mr. W. C. Sawyer, spoke about her experiences in this position. Ayako is a secretary in the medical department.

The calendar of future activities includes an initiation of new members, and a school wide social.

The newly elected officers of the club are as follows: President, Frances Yanaginuma; Vice-President, Teru Yamauchi; Secretary, Yoshiko Hozaki; Treasurer, Grace Sato, and Publicity Chairman, Mary Saika.

FORMER BUTTE HIGH GIRL VISITS GILA

Smiling, and beaming with the thought of being home again, Mary Eto, former active Senior Girls' League member, returned to Gila on March 30.

"Everybody is just swell," she declared. Upon being asked about racial prejudice, she replied, "Although in some of the nicer districts of Salt Like City no one holds a grudge against you, some of the former Japanese of that city seem to resent your being in that city. This is partly due to the behavior of some of the Japanese evacuees who came there in the beginning and let their bitterness get the best of them, and began to start fights in the clubs and restaurants. For this reason, many of the nicer parts of the city are closed to the Japanese.

"Although I was lonesome in the beginning, I soon began to make new friends, most of them being Caucasian. I really advise everyone to relocate as soon as they can for they really treat you wonderfully," she concluded.

Mary is working at the home of Mr. and Mrs. Harmon, and she declares that she is treated like their daughter. To further prove that the barrier of prejudice is slowly but surely going down, she was asked to sing the solo part at the Caucasian church which she attends regularly.

HIGH SCHOOLS OF ARIZONA TO PARTICIPATE IN EVENTS

After weeks of elaborate preparation, girls from various parts of Arizona will meet today at the first Girls' League Convention at Butte High to promote better understanding among themselves and to discuss the vital problems facing them today.

Included in the day's program will be a general assembly with addresses by Michi Nishiura, president of the Girls' League; Miss Jane Eckenstein, advisor; F. W. Miller, principal; and Yoshio Migaki, president of the A.S.B. At the same time a talent exchange representing talent from the various schools will be presented. Following the assembly will be a field meet at which the girls may compete in several sports. After lunch a comprehensive tour of the camp will be taken and a conference to discuss the problems of youth today and in the future will take place. A closing assembly and a social will conclude the events of the day.

We hope by means of this convention, to establish a firmer bond among the girls who attend in understanding and facing our problems together and in aiding each other in solving them, declared Michi Nishiura.

The girls in attendance will represent the High Schools of Gilbert, North Phoenix, Phoenix, Tempe, Scottsdale, Tolleson, Tucson, Mesa, and Canal. The discussions, which are divided into five topics, are: The Basis of Popularity in High School, My Parents and I, Making a Future in America, How We Can Help in the War Effort, and Preparing for Marriages. The girls upon registration will be divided into their respective groups and will be led in discussion by a representative of their own choosing. Kimii Nagata, former president

(Continued on Page 4)

Butte Girl-Boy Scouts Have Joint Meeting

Butte Senior Girl Scouts participated in a joint campfire meeting with the Boy Scouts on the second Butte on Wednesday, April 5.

Highlighting the meeting were the weenie roast and a short program of skits and songs. The guests were Mrs. Alleen Sawyer, Mr. Hugo Wolters, and Mr. Verling Marshall.

Sixteen girls are needed for drum practice on Tuesdays and on Saturday morning at recreation hall 39, stated Mrs. Alleen Sawyer.

BUTTE REPRESENTED BY FOUR DELEGATES

Michi Nishiura, president of the Girls' League, Miss Jane Eckenstein, advisor, Yanie Watanabe, and Alice Noguchi represented Butte High School at the Official Girls' League Spring Convention at Peoria High School on Wednesday, April 12.

The purpose of the convention was to promote democratic ideals among the girls of Arizona. Yanie and Alice were chosen by the girls of Butte High as delegates.

G.A.A. Barn Dance Features Novelties

A conglomeration of zoot suiters, cowboys, and jitterbugs crowded the floor midst yells, shrieks and feminine giggles.

No, not a riot, but it was the G.A.A. barn dance with girls dressed like boys bringing their favorite gal.

Voted the best among the zoot suiters were Yanie Watanabe and her "babe," Mary Matsuzawa. Aki Yamamoto and Sachi Ishii took top honors dressed in farmers' apparel. Miyuki Inai and Midge Hozaki were the best jitterbug dancers, while Tats Matsushita and Chieko Arima waltzed to their fame.

LUNCHEON HELD BY JUNIOR LEAGUE

The Junior Girls' League Council held a luncheon party Wednesday, April 5, at the Home Economics Building, stated Miss Velma Bowen, advisor.

The Junior Girls' League will be the sponsors of the talent assembly to be held this coming week, although the exact date is still unknown.

Some of the other plans for the remainder of the term are as follows: Jam Session in the latter part of April, Spring Fashion Show in May, and a social honoring the freshmen who will graduate into the senior league, added Miss Bowen.

★ ★ ★ F E A T U R E S ★ ★ ★

[EDITORIAL]

AMERICA CHALLENGES YOU

Nisei, America challenges you! Your native land, the United States of America, challenges you to take the oath of allegiance to the United States . . . Those words you've repeated since you were a youngster in grade school, without a care in the world, as the Stars and Stripes gently kissed the soft breeze. Those words, "I pledge allegiance to the flag of the United States, and to the republic for which it stands, one nation, indivisible, with liberty and justice for all."

Yes, America is definitely on the alert, wondering if those yellow-skinned, black-headed people, who were deprived of constitutional rights, homes, occupations, and friends will look to another future, or will they fail to carry on the work of their issei parents, who once braved the Pacific to nurture the black soil of our country.

America is wondering if you have become so narrow-minded and so full of self-pity, that you are afraid to try again, or has this evacuation built up your ambitions, strength, and courage, through the realization, and experiencing of such an incident.

America is wondering with hostile eyes, if you will denounce your native land for that of your parents, merely because you are bitter and full of heart-ache. They are wondering if you still have the fight to venture outside the snug gates, and win more people on your side through showing them that you are just as loyal and just as capable of bearing the name, American.

The decision is what they think. Will they deny their posterity the right to enjoy the bountiful privileges of the American home, an education far superior to those of other nations . . . will they? That is the question which voices the challenge.

Does this second generation have the initiative and power to guarantee that the future generation, too, may say, "I pledge allegiance to the United States . . ."?

—By Sachi Wada.

ON BLIND DATES

Blind dates may be fun, but when all our fondest dreams are crushed on his appearance they turn into ghastly nightmares. Here's an example of a blind date.

What we expect of our escorts:
1. Tall, dark, and handsome.
2. Clean cut, clean shaven.
3. Smooth and graceful dancer.
4. Somewhere between 18 and 25.
5. Wide shoulders, small hips.
6. Wavy black hair, shiny white teeth, lively gait.
7. Cold cup of coke at the Soda fountain.
8. A movie in the loges, with cushion on the chair.
9. A drive into the open country in a Ford V-8.

What We Get:
1. Short, black, but passable.
2. Stubby faced, hard on the school girl complexion.
3. Heavy bulldozer that keeps yapping at the toes.
4. Anywhere from 12 on up to 18. Then from 27 to 65.
5. Wide shoulders, wider hips, widest midsection.
6. Silver in the hair, gold in the teeth, lead in the pants.
7. A guzzle of water from the rain barrel.
8. A silent picture with a pile of rocks in a chair.
9. A walk up the hills with cactus in your seat.

A FRIEND

a sonnet

By YANIE WATANABE

Slowly, inevitably, the tides of
 your love
Sigh gently onto my starved
 shore,
And softly fluttering as a dove
Closer they come to my in-
 nermost core.

I breathe it all in, it means so
 much;
The joy, unexplored beauty
 of it all.
And I thank God that there is
 such
A one like you who would
 never pall.

Then I realize so foolishly—
I stand alone and watch
 those tides recede;
You're leaving that shore, that
 hungry me,
Who upon your generous
 store did feed;
With never a backward glance
 do you give
To one that needed those
 tides to live.

You don't have to live in a
tree to be a sap.

Hickory dickory dock, two
mice ran up the clock; the clock
struck one, the other got away.
Hickory dickory dock.

PROPHECY — 1964

As the mist clears, we see life as it is in the year 1964.

(Victor) Herbert A. Sturges is placed first on the hit-parade with his new song, which is sung not by crooning, not swooning, but ruining Frank Yamanaka, Sinatra.

Masako Yamasaki is leading her troupe of old-aged chorus girls, composed of Lily Katayama, Yuki Takahara, Taxie Kojima, Mary Saika and Frances Ogasawara, as we see through the television.

At the age of 36, youthful Shiz Hotta makes her grand debut as the glamorous Hetty Lamour.

Outside the peace is disturbed by Irene Hara, who leads her construction gang on a W.P.A. project. She finally realized her life ambition.

Ruth Yamamoto has every man at her beck and call; for she can mold any man into any form she desires—she's a sculptress.

Martha Koda and Jessie Omura are diligently at work in scrubbing the floors of the great hotel, The Eckenstein. As they work they sing the old folk-song, now forgotten—Mairzy Doats.

Since women are coming into the world, since the retiration of Bob Hope Yuri Fukushima is doing a grand job with her hash. Where there's Fukushima, there's Yuri.

Teacher was trying to explain philanthropy.

Teacher: If I saw a man beating a donkey and I stopped the man, what would I be displaying?

Little Boy: Brotherly love.

GAZETTE STAFF

Editor Sachi Wada
Associate Editors Fumi Anraku, Mitsie Koyama
Business Manager Frances Ogasawara
News Editor Fumi Kuratani
Fashion Editor Beverly Yoshimoto
Art Editor Ila Sato
Sports Editor Shizeko Nakamura
Advisor Miss Jane Eckenstein

Fashion Parade

Just like the appearance of the first robin or wild flower on the hillsides, the coming of Spring is heralded by the appearance of a motley of pastel shades, new sheer blouses, skirts and dresses.

Yuki Hozaki's white rayon blouse, which is gathered cleverly with a black ribbon, is drawing much attention on the campus, while Hannah Yamamoto's darling white gaily embroidered cotton blouse with dainty eyelets around the neckline has caught more than one envious glance. Better watch out, Hannah, we might be tempted!

Jumpers like those of Esther Eto, Frances Suzuki, and Yo Tanaka, with pert daisy trimmings, have also climbed high on the popularity poll.

Sumi Kojima's form fitting, collarless white suit is certainly easy on the eyes, with its box-pleats and its three-quarter length sleeves. The white trimmed buttonless dark green suit that Tats Matsushita has been sporting seems enough to fulfill anyone's fondest dreams.

Sweaters, which are a "must" in any girl's wardrobe, are being shed as the hot weather sets in, but we can't forget Mary Shinmoto's eye-catching pink pullover, Hideko Inouye's white cardigan, and Penny Ishimoto's luscious lavender pull-over.

New spring colors coming into precedence are watermelon red and lavender. Novel multicolored flowers nestled in the hair are fast taking the place of the usual ribbons.

SAY IT WITH RIBBONS

Have you ever stopped to consider what color ribbon you have been wearing in your hair? Well, watch it from now on for here they are. Heed it and like it, or take the consequences.

Red—Danger. Highly explosive in wrong company.

Orange — Mellow, pleasant, agreeable.

Yellow—Open for dates—always.

Blue—I'm particular. Watch your manners.

Green—Once. I grab I keep. Watch it.

Purple—I'm fickle and hard to ascertain.

Brown—Lay off, see! I'm gonna be a career woman.

White—Never dated, but hope to be.

Gray—I'm wise, I'm mature. Young squirts haven't got a chance.

Kissing is a bad habit to get into, but a worse one to fall out of.

reel 272
frame 315

Second page of the April 15, 1944, issue of The Girls' League Gazette. *(Butte High Schoool, Gila Relocation Center, Arizona, 2, no. 1 [April 15]: 1–2. Japanese American Evacuation and Resettlement Records, 1930–1974. BANC MSSS 67/14c. Reel 272, frames 315–316. Bancroft Library, University of California, Berkeley).*

Friendship Albums and Yearbooks

Friendship Album, Mary Virginia (Early) Brown (1840)

Both informal albums and official school yearbooks have offered girls signifi-
cant opportunities to use their literacy skills to create a textual record of their
lives as well as to cement peer relationships in the present moment.

While attending the Female Collegiate Institute in Virginia in the
1840s, Mary Early kept a friendship album, asking fellow students to sign its
blank pages. It may seem surprising that mortality is a common theme in
these two entries written by teenage girls, but for young women of earlier cen-
turies, death was not necessarily a distant prospect to be faced in one's old
age. See Phillis Wheatley's poem, "On the Death of a Young Lady of Five Years
of Age," and note that Eliza Southgate Bowne, Jane Turell, and Elizabeth Coo-
ley McClure, whose writings appear in this volume, all died before reaching
the age of thirty. This material from the Early Family Papers appears courtesy
of the Virginia Historical Society.

The Album is one of Friendships dearest minions. It is the de-
clared enemy of Oblivion. Its owner may well regard it as of ines-
timable value. In future years, when the scenes of youth shall have
been reckoned among those that "were, but are not" this book per-
chance will be considered a most valuable memento of other days.
Those friends whose names are here inscribed will doubtless be far
removed from you. Some will have fallen victims to iron-hearted
Death. Others, whose rosy cheeks and sparkling eyes now tell of
buoyant spirits and high hopes may have become pale and melancholy
from Disease or Sorrow. Where then shall we be? Futurity's unrolled
manuscript alone can reveal out Fate. May your life be a happy one,
and your death triumphant.

Your true friend. S.
Female Collegiate Institute.
Feb. 1st, 1840.

To Mary Virginia
Shall I wish thee fame? Its circlet scathes the fairest brow, and its
crown is fatal to woman's peace.
Shall I wish thee wealth? Perchance 'twould cause thee to forget
thy Maker, and place thy Affections where moth and rust corrupt; and
of themselves they ne'r can satisfy the longings of the immortal soul
for Happiness.

Shall I wish thy days may be unclouded—and thy Life calm as summer evenings be? Alas! Change is stamped on all things earthly, and bliss is not of earth, its home is Heaven.

But I would wish thee endowed with all the dignity, and moral courage of those, "Who were last at the cross and earliest at the grave." I would thy mind should be richly stored with knowledge— that knowledge which will remain though all else fail; and secure Happiness to its possessor in every situation, united with sufficient Intellectual energy to guard you from Fashion's trammels, and Pleasure's seductive charms. I would thy influence should be,

"Like a glorious pile of diamonds bright,
 Built on a steadfast cliff"
but yet as gentle, and as mild,
 "As the soft wave [?] the wrapt in slumber lies,
 Beneath the forest shade"

In fine [?] that Him whom thou hast chosen in thy youth for thy Guide, may thus be ever in after years thy Heavenly Father; and then should misfortune lay its iron hand upon thy spirit, or peaceful and happy the sun of thy Life go down, thy name will be written in the "Lamb's book," and an eternal Home in the pure, blessed, world above be thine, where "Parting is never Known; Never! No! Never!"
F.C. Institute
Feb. 4th, 1840

Yours very sincerely
Mary Cole Wilber
Buckingham Co. VA

"Our Class History '07," Rosalie Sherman, *Indian News* (1907) and "Class History," Thelma M. Brinson, *The Lincolnian* (1925)

Student-authored class histories have been a common feature of school yearbooks throughout the decades. They provide students with an opportunity to create a permanent record of their collective experiences and to celebrate their common bonds.

In the first class history featured here, Rosalie Sherman documents the struggles and triumphs of her classmates at the Genoa Indian School (GIS). As Amy Goodburn notes in her reading of Sherman's text in this volume, the traditional tropes of progress are used to describe both the history of the United States (a history in which Sherman does not include Native Americans) and the personal histories of GIS students. Goodburn also notes that this class his-

tory does include moments of critique and rebellion. Sherman remarks that only six of the previous year's eleven junior class students had stayed as seniors and were graduating.

The second class history included here comes from Lincoln High School in Kansas City, Missouri. It was written by graduating senior Thelma M. Brinson in 1925 when L.H.S. was a segregated school for African Americans. Writing for a much larger class (400 students entered L.H.S. as freshmen in 1921), Thelma composes a history that is far less specific about particular course material or school events. Instead, she taps into allegorical traditions and English literature, casting her class history as a retelling of Bunyan's Pilgrim's Progress. *This excerpt appears courtesy of the Black Archives of Mid-America.*

OUR CLASS HISTORY '07.

Rosalie Sherman.

We all like to know the history of Noted Authors and writers, and to find out all that we can about prominent people. So I will bring before you tonight the history of our class of 1907, consisting of six members. Among us we have one who represents Montana, one from Minnesota, three from Nebraska and one from Wisconsin.

We have worked together as a class for three years, under our present teacher Miss Fisher, whom we all respect and thank for her kindness and helpful patience to us all during the time we have been in her class.

But we are now preparing to go out into the world for ourselves and to make use of the education we have gotten here at Genoa.

We struggled through fractions and percentage, both of which we thought must be very hard indeed. We heard people talking about fractions and wondered what the word "fraction" meant, but before we knew it we were surrounded by them and saw that we had to work out of them someway, so we just put our minds into action and after a few weeks of hard work saw light again before us. Then came the mysteries of percentage and interest these we have solved but there were still other obstructions in our way to encounter and over come.

We have studied the history of our country, from the beginning to the present time. How Columbus discovered America and when the first settlers came and planted a colony at Plymouth Rock in 1620; how the Puritans suffered through that cold winter and of the lives that were lost. And we understand why Jamestown is holding their Exposition.

We have traced the history of the English people from their earliest barbarous days to the present, where we find them a mighty nation, having all that civilization can give. Taking the subject of our

manual training, I think we have accomplished enough to work our way through life. We girls can all make our own dresses and cook a nice meal, and also have learned to take care of our own homes. We would be glad to have you come and make us a visit some day in our own little homes, and then you can see for yourselves what we have accomplished in school.

We don't say that we have learned all that there is to learn, because we know none of us have gotten to the point where we can say we know it all. We do not think that because we have gotten over the little obstacles that have come in our way, we can now go on smoothly. No, there are larger obstacles to over come and conquer yet. But we all can at least try and if we don't at first succeed we can try try again.

Boys and girls you never can expect to travel through life without work, and so we should all prepare ourselves for the work that is put before us and each may then take his choice as to what he would like to fit himself for in life.

We should all strive to have enough gumption and ambition about us to stand on our own feet and work side by side with our white brothers and sisters in the world.

As a class we have struggled to keep together. A year ago there were eleven of us but as you all can see some have dropped out, and now there are only six of us that have worked our way through so far, and we hope that we all are standing on such a solid foundation that we shall be able to make our way well through the world.

I will now give you a little sketch of our future life which is before us.

My two classmates, the young men, have decided to make painting their profession, and we most sincerely hope for and wish for their success.

One of our girls will go to her own home after many years of absence—to British Columbia.

Three of us feel that we have not accomplished all there is in store for us, and so have decided to attend school again.

We shall look back with pleasure on our happy School days, our many companions and advisors.

We extend our gratitude to our Superintendent and all employees under him, who have guided and helped us along in our preparation for our life work.

CLASS HISTORY

Early in the autumn of 1921 a group of 400 Pilgrims, realizing their fate if they remained in the Land of Ignorance, banded them-

selves together to set out to find the Celestial City of Wisdom. In their anxiety to make this journey they little dreamed of the terrors which they would meet and the difficulties which they would encounter before they reached their destination. But they had been told that this was a rich land and all who journeyed to it would be well rewarded for their effort, and in the end be better prepared to embark upon the great sea of Life.

After their plans and purposes were laid out and their ideals and standards set up, this band of knowledge-seekers set out and all pledged their loyalty and support until they should sojourn four years later with many of their aims and purposes well accomplished.

During the first stages of their journey (Freshman year), the Pilgrims' progress was very slow, for the path was infested with many dangerous bogs. In the midst of a great plain, they came to many miry sloughs (mathematics, science, and civics) and some heedless of all warning fell in, and because of their lack of courage began to sink deeper into the mire and would have perished had it not been for the kindness of a passing stranger (Inspiration). Others fell into the bogs of English, General Science and Latin, and would also have perished had not Inspiration lent them her aid. And after being set upon solid ground again, they awakened to the fact of their lost conditions, and there arose in their minds many fears and doubts and discouraging apprehensions. Then, looking back upon these places with disgust, they hurried to join others whom they saw ahead.

Now as the Pilgrims traveled on they came to a high steep hill (Sophomore year) and they began to quake with fear lest they should fail in their attempts to scale its sides. They were just on the point of turning around when Hard Study appeared and greatly aided them and told them to beware of Low Grade, because he was a person of no good influence.

Now, as they progressed, the weaker Pilgrims in the rear were attacked on all sides by demons. Temptation, Discontent, and Self-Satisfaction, caused some of them to give up the journey. Employment, by his flattering remarks, lured many into his clutches. Laziness robbed some of their aims and resolutions and left them so destitute that they wished with all their hearts that they had never started and that they might die.

But soon they came to a quiet harbor, where they rested for the night. After a refreshing slumber the Pilgrims came to another hill (Junior year), and when they reached the top, they saw men running towards them. The name of one was Mistrust, and the other, Discouragement, who told them that they had started on the wrong road.

Then, said Mistrust, "Just over on yonder hill there lies two fierce lions, and if you come within their reach they will tear you to pieces." At this many of the Pilgrims trembled with fear, but the more courageous ones said, "Sirs, to go back and be a slave to Ignorance is foolish, no matter what lies over in yonder regions we will yet go forward." Mistrust and his companion then ran down the hill and the Pilgrims went on their way. Now they entered a dark narrow passage and, looking before them, they espied two huge lions. Then they became sore afraid, for they saw nothing but destruction before them. But venturing nearer, the keeper of the gate, whose name was Ambition, perceiving that they were afraid, came to their rescue and they learned that the beasts were harmless, and that they were chained there for a trial of faith, and the discovery of those that have none. He cautioned them to keep in the middle of the path and no danger would befall them.

Now, as the Pilgrims traveled on they were met by a foul fiend, whose name was Despair. At this sight of his hideous face they became troubled and began to cast about in their minds whether to go back or stand their ground. Realizing that they had no armor for their backs, so if they fled they would give him greater advantage with ease to pierce them with his darts, they resolved to venture on and stand their ground. Valiantly giving battle, they quickly overcame him and put the monster to flight and never saw him again.

At the end of this valley there was another called the Valley of the Shadow of Death (Senior year) and the Pilgrims had to pass through it because the way to the Celestial City (graduation) lay through the midst of it. Many of them failed to make this last lap of the journey, for they visited the Castle of Indolence (summer vacation), and while there they became acquainted with an evil dweller (Temptation), who, by his bad influence, persuaded them to give up the journey.

The Pilgrims perceived that as far as this valley reached a deep ditch (English Lit.) was on the left, and on the right was a dangerous bog (Chemistry), which even if a good soul fell in, he found no bottom for his feet to stand on. The pathway here was very narrow and being inhabited by wild animals they were greatly frightened. After they had traveled in this disconsolate condition for some time they gathered more courage and soon came to the end of the valley. In the light of the clearing they saw the blood, bones and mangled bodies of those who had failed in their attempt to pass through.

And now at the end of the valley they were, to their surprise, near the end of their journey for the spires and steeples of the City of

Graduation were in view. They saw directly before them a deep wide river (Final Exams) and some of them became very afraid for fear they could not cross. But the courageous ones resolved that nothing should stand before them now, for they had traveled too far to turn around. On the bank of the other side they saw their old friends (Class Advisors) waiting to aid them. A few of the Pilgrims at first did not attempt to cross over with the rest for fear they would be caught in the Rapids of Low Grades and be swept away, but after much persuasion and aid they crossed in safety. When they reached the gates of the city, they were saluted by trumpeters, who, with their melodious music, made even the heavens echo with sound. They noticed that the city shone like the sun, the streets were paved with gold, which men walked upon with golden harps and sang praises to them, and they thought they heard all the bells therein to ring, to welcome them thereto. Oh, by what tongue or pen can their joy be expressed! Thus they came to a gate and there was written over it in golden letters, "Enter ye into the Kingdom of Wisdom, for riches and success shall be thine."

Thus with their journey ended, the Pilgrims looked back with tear-dimmed eyes over the many paths which they had traveled during their journey. But as they look again at the inscription on the gate joy reigns in their hearts supreme, for after all their trials and troubles they are a smaller but wiser band.

THELMA M. BRINSON, '25.

"Class Prophecy," Carrie Gipson and Hermena Clay, *The Lincolnian* (1922)

While friendship albums, scrapbooks, annuals, and yearbooks provide important opportunities for girls to use their reading and writing skills to construct their past, they also can provide a means of looking forward. Class prophecies allow girls to document their hopes and dreams for the future.

The class prophecy included here comes from the 1922 Lincolnian, the yearbook of Lincoln High School in Kansas City, Missouri. Coauthored by two young women, Carrie Gipson and Hermena Clay, the prophecy reveals that these girls predict bright futures for themselves and their classmates. Gipson and Clay envision their classmates as successful educators, doctors, ministers, business owners, union organizers, opera singers, film stars, social workers, and office managers. They also predict happy home lives as members of the class of '22 become wives, husbands, and parents.

It is, of course, impossible to know what inside jokes might lurk in these paragraphs. Would students have chuckled over the improbable marriage of Mr. X to Miss Z? Or is student Y ironically described as a renowned chef because she

failed a cooking class at L.H.S.? Like all texts, class prophecies are written in a specific context for a particular audience. As literacy scholars revisit decades old texts, we can only speculate about the meanings we might be missing.

CLASS PROPHECY

Look at that calendar!! Can you beat it!! Today is June 9, 1932. And to think I had forgotten the class of '22 has been out ten years. Silly of me, isn't it? Oh! I've got it! Tomorrow when I start on my tour over the continent in my latest model aeroplane, I will look up as many of my classmates as possible.

I am now located at the Millinery Association's Headquarters in Boston. I have been elected Chief Organizer of Colored Millinery Shops in the various districts of the country. This position gives me the opportunity to make a tour of this kind every year. Since I have made it a custom never to travel alone, I have invited one of my closest friends and former chums in school to accompany me. Miss Hermena Clay who is here also has attained the honor of being supervisor over the "Conservatory of Music."

We left Boston at 5:30 a.m., and after riding about eight hours we reached the city of New York and landed on top of the Grand Hotel St. Regis, which is owned by Clarence Toko Wright, and were greeted by thousands of spectators who cheered our arrival. We were escorted from the roof to the magnificent lobby by the assistant manager, Dexter Miller. Whom do you think we saw at the registration desk, none other than Miss Lucille Bauknight, the registering clerk. She told us that we would surely enjoy our dinner for Mr. James Murphy was the chef assisted by Miss Edith Tandy, pastry cook.

After a most appetizing meal we dressed for the evening banquet given in our honor. No wonder we enjoyed the music so intensely for it was rendered by the North Eastern Syncopated Orchestra of which Mr. Harry Cooper is sole manager and chief cornetist. He is assisted by our famous Violin and Saxophone player, Mr. Eli Logan. Others of this orchestra are Miss Edith Greenlee, pianist; Calvin Young, clarinetist; (and what do you think? Calvin is still carrying out his chief delight, meddling with the ladies,) Leroy Maxey, drummer and xylophonist and many other experienced musicians. After the orchestra had ceased playing one of its excellent numbers our attention was attracted by some new comers. We were astonished to see Luther Hatcher and his recent bride, Mrs. Hatcher, our former Helen Taylor. Mr. Hatcher is one of New York's noted contractors. We learned from him that Kenneth Campbell was football and basketball coach at Howard University and the most astonishing thing was that he had

given his hand to Miss Marie Wison about two weeks previous. Before her marriage she was the office clerk at Howard. The banquet soon ended and after Hermena and I had conversed over the news we had heard, we piled into bed.

I was awakened early the next morning by the ringing of the telephone. I picked up the receiver and gave a lazy, "Hello." At once I recognized the shrill voice of one of our dear friend, Mabel Crisp. She regretted very much that she was unable to attend the banquet and invited us to visit the "May-Bird" Shop owned by her and her sister Birdie. I immediately awoke Hermena and told her the news. After breakfast we were driven to the said shop. On our way back we became very interested in a classy sign which read, "Armstrong and Co., Clothing Manufacturers." Thinking this might give us an opening for a Millinery Shop we entered and to our great amazement; whom do you think we saw but our frivolous little Miss Harriet Armstrong. She greeted us very cordially and showed us through the building. Among the many workers, we found as supervisors of the different departments, Misses Wilhelmenia Greene, L. E. LeFlore, Mattie Davidson, Alberta Stubbs, and Teressa Moore.

Realizing that time was rapidly passing we left New York for Cleveland, Ohio. On our way we saw many aeroplanes, one of which passed us so rapidly that it nearly frightened us. After seeing they must have been racing with us, we sped up and as we were about to overtake them, we had reached Cleveland. By chance we landed at the same field. Whom do you suppose the occupants of our rival aeroplane were? None other than John Bell and Hazel Harpole just returning from a happy honeymoon. Mr. Bell told us of his prosperous career and took us to see his magnificent bank. On entering and glancing up we saw Miss Althelia Hayden as cashier. Some of the other clerks were Misses Elma Tomlinson, Betty, and Oma Taylor. In the printing office we found Miss Faye Steele, private secretary; and Mr. Lawrence McCormick, assistant manager.

Our main purpose in coming to this city was to visit Cirlee Miller's Millinery Shop. Although she has recently become Mrs. Bass, she refuses to give up her business. While conversing with Cirlee, in walked Ruby Simons as we thought, but were readily informed that she is now Mrs. Larke. When we asked her how she was using her trade, she replied, "Oh I think the best way is making hats for my little twins, Harry and Harriet." While lunching with Cirlee, we were told that one of the finest cafeterias in the city was owned by Bertha Griggs and Christine Lovell. We were also told that James Knighton and Victor Reef owned a large drug store in another section of the city.

As our time was limited we were unable to stay more than one day in Cleveland, therefore we rushed back to our aeroplane and started on our journey to Detroit, Michigan, where we arrived late that evening. Feeling the need of a facial massage and a shampoo, we at once looked up a first class beauty parlor. On entering the "La Frae" Beauty Parlor, we were confronted by a very neat and attractive young lady whom we recognized at once as Miss Mary Spencer. We were treated with great hospitality and were told that Miss Mary Payne, her assistant, was out at the time on business. We next visited the Austin and Murray Aeroplane Builders. To prove their great success, it is well to know that the aeroplane that we are now touring in, is one of their latest models. Earle told us that Miss Callie C. Murphy was principal of one of the largest schools in the city. Miss Willene Gooch being girls' directress in the same school. He said that Miss Josephine Mills was doing Y.W.C.A. work, while Miss Zelma Taylor was doing similar work to that of Miss Gooch's in the Community Center. While we were chatting of school days, our conversation was interrupted by a shrill voice coming from behind a large aeroplane, crying, "Daddy! Daddy!" We looked around and behold we saw a cute little fellow pursued by a young lady whom we did not recognize at first, but after a moment's observation, we saw not a soul other than Mrs. Araminta Hicks Austin. No wonder the baby's name was Earle, Jr., for it was every inch like its dad. We learned that Mr. Clyde Murray was also married to Miss Byrdella Selectman. We spent the night in Detroit, and left early the next morning for Chicago.

On arriving in Chicago our first stop was at the beautiful home of Miss Priscilla Oates, who is a leading coloraturist in the "Chicago Grand Opera Co." The morning was spent very pleasantly and while lounging around, our attention was attracted to the streets by the sweet strains of music. We rushed to the front windows and saw a large band led by Mr. Earle Jefferson. Mr. Lamar Harrison was also one of the chief players. From the banners we knew that the band was giving a concert in the auditorium the same night.

To our surprise Priscilla had invited all of the Lincolnites in the city to a dance in our honor. Among the guests were Lawyer Charles Carr and his wife, Mrs. Whelmer Moore Carr, who with Miss Charlyne Fields are managers of the swellest dancing academy in the city. Dr. Hackett Hardison, his recent bride, Mrs. Pauleta Smith Hardison, and Miss Bonnie McClain, who are two of Chicago's leading film stars, were also there. Messrs. Emmett Wyatt and Harold Johnson, noted film producers were guests also. Dr. William Woods who is an eye, ear, nose, and throat specialist took advantage of the party and

announced his engagement to Miss Glodene Wilson, a former nurse in his employ. We were forced to say goodbye to our many friends and start the next day for Kansas City, the home of our dear old L.H.S.

Arriving in Kansas City near the closing hour of school, we found the teachers and students very busy. After going into the office, we visited the Domestic Art Department which is now located in the new building. Here we found to our great surprise Miss Hattie Jones in complete charge of the Sewing Department. Next we saw Miss Connie Crisp who is head of the Millinery Department. We then visited the magnificent library. As supervisors of the different departments we found Misses Julia Arnold, Ollie O'Neal, Virtle Barnes and Mayme Payne. We found Mr. Zeora Hercy in charge of the Mechanical Engineering department. From him we heard that Mr. Clarence Bacote had walked in his father's footsteps and had become an excellent minister. Being nearly out of business cards we visited the now famous printing department and were delighted to see Mr. Lloyd Williams and Theodore Brown as instructors. The department is so large that clerks had to be employed. Some of these were Misses Bertha Logan, Vernice Dudley, and Twintinia Brown. We were told that Mr. Louis Payne, the advertising manager, was out at the time. After leaving the school we visited a very attractive little Madame Walker Shop on the corner of 19th and Vine Streets. This shop was owned by Misses Myrtle Winston, Genevieve Taylor, and Lillian Jackson.

. . .

Realizing that we had been on a three weeks tour, we found the need of foot wear, therefore we looked up a shoe shop. We found displayed in a very attractive window some very "snappy" shoes. We entered and a clerk approached us whom we recognized as Mr. Troy Bell. He told us that the manager, Mr. Theodore Briggs, had been called out of the city. We were also informed that Messrs. Louis Turner and William Kimsey were doing splendid work in a Military Academy here.

We left the following day for Philadelphia. This being our last stop, before returning home, we decided to make it a point of interest. Mr. George Johnson, who is running one of the largest garages in the city, drove us around to see the sights. We saw the building where Miss Verna Strong was doing splendid work in domestic arts. Afterwards we were driven to the beautiful home of Miss Frances Smith, who is a great social worker. We were just in time, for a tea party which was being given on her beautiful lawn. We were very cordially greeted by Miss Smith. Here we saw another one of our classmates, Miss Donis Arnold, a very efficient stenographer of the city.

Having spent a very delightful time, our next stop finds us back in Boston, lounging around our own home, conversing over our wonderful tour. How refreshed we are! It seems as though we have gone through dear old Lincoln High all over again. This trip has been as profitable as it has been pleasant, for we have been successful enough in establishing shops in nearly every city in which we have stopped. With a word of inspiration from our friends and experience which we have gained, we are now ready to continue our work with renewed interest.

Carrie Gipson, '22.
Hermena Clay, '22.

Signatures, Lucille Booth, *The Tiger* (1954) and Signatures, LouAnn Phelps, *Clarion* (1971)

Lucille Booth's senior high school picture. (Courtesy of Lucille Jane Booth)

As Margaret Finders found in her study of girls in junior high school in the 1990s, the signing of yearbooks can be one of the most important school-sanctioned literacy events in students' lives. Subtle, unspoken rules about who is invited to sign, about whose signature is not welcome, and about what constitutes an appropriate message can all be indicative of the various social hierarchies that govern school life.

The first set of signatures below come from a 1954 yearbook from Elkins High School, which had a student population of approximately 750 in grades 9–12. Lucille Booth's classmates typically wrote messages focusing on academics, calling for Lucille to remember both good times and bad in English IV, chemistry, Latin II, and civics. There seem to be few messages that deal with issues teenage girls would want to shield from the eyes of parents, teachers, or other authority figures.

The second set of yearbook messages and signatures come from a 1971 yearbook from University High School in Normal, Illinois. The students who signed LouAnn Phelps's yearbook seem far more self-conscious about the ritual aspects and expectations of yearbook signing. Mocking the conventions that seem to govern messages and signatures in earlier decades, students at U.H.S. jokingly write "This sounds like what I wrote in 9 other [yearbooks]"; they write upside down in order to make their messages stand out; and they test the limits of irony by writing "I really hate you!" instead of inscribing conventional

expressions of friendship and admiration. The messages in this 1971 yearbook also focus much more on life outside the classroom for teenage girls. Messages about "jungle juice," speeding tickets, and LouAnn's role as a Prairie Belle (P.B.), or pom-pom girl, suggest that these students feel the yearbook is a safe site for communication amongst peers.

<div align="center">

THE TIGER

ELKINS HIGH SCHOOL

ELKINS, WEST VIRGINIA

</div>

Dear Lucille:

Our dear old days at E.H.S. are about over. Remember all the fun we had in English IV and Problems of Democracy and all the other classes we had together in our previous years. Don't forget the fun we had at and after the ball games. Remember the time we fell down on our way home. Remember the night you filled my milk shake full of pepper. ha Remember the way we slaved over English IV. But I wouldn't change it if I could, would you?

I want to keep in contact with you through letters this summer and when you go to St. Mary's I still want you to write me. If you can I want you to come to see me this summer. You have been a wonderful friend, one I will always remember. Best of luck forever. I sure had a good time when I stayed with you. Remember the pin sticking. I'll bet that milk was delicious.

<div align="right">

Always,
Elizabeth

</div>

Dear Lucille:

Best of luck in your future years. Remember all the fun we had in English IV. I know you'll never forget.

<div align="right">

Love
Valjean

</div>

Best of Luck to a real sweet kid. Thank for the help in civics class.

<div align="right">

A pal
Nellie

</div>

Lucille,

Best wishes to you in the future and remember "ole" English IV.

<div align="right">

Love,
Linda

</div>

Lucille,

It's time for us to leave E.H.S. but I'll never forget English IV. Best wishes to a swell friend.

<div align="right">

Love,
Fay McGee

</div>

Dear Lucille,

Its been fun struggling through Latin II together. Lots of luck in the big wide world.

<div align="right">Dorothy D.</div>

Best of luck to a swell girl who really knew her chemistry.

<div align="right">Lewis Ray</div>

Many Thanks for your Tutoring in Chemistry. Good Luck Lucille.

<div align="right">Bill Gamier</div>

Lots of luck to a swell gal. Keep up the good work in college.

<div align="right">Tom McLaughlin</div>

Lucille,

It has been nice being in chemistry class with you this year. I know you have enjoyed the foul odors we encountered as well as I did. Best of luck for the future.

<div align="right">Pres. Iky</div>

Lucille,

Don't forget all the good times in Civics. Loads of success to a wonderful friend. I know you'll make good in whatever you do.

<div align="right">Love & luck,
Dixie</div>

Lucille,

I think you are a real nice girl. Don't forget Study Hall at 2:15 and Miss Barry.

<div align="right">Lots of Luck,
Ann Corby</div>

Dear Lucy,

Don't ever forget the wonderful times we have had together in Home Room, Civics, and Study Hall. Best of luck in any thing that you go to do.

<div align="right">Loads of Luck
your pal
Frances</div>

Dear Lucille,

It's going to seem funny not going to school anymore isn't it. I have had a lot of fun walking to school with you and going to Sunday school with you also. Lots of love to one of the sweetest girls I have ever met.

<div align="right">Glen Potts</div>

Best of luck in the future to a swell girl. Don't forget all the fun (?) we had in Latin I and II

<div align="right">Always a friend,
Judy Martin</div>

Dear Lucille,

It has been great knowing you. We have had the best times at noon and in English IV.

Now I guess it is time for us to go our own way. It is the time to say so long to the good old days in E.H.S. But even though we may not see each other for a long time we can still think of our high school days.

Stay just as nice as you are now and I know that you will be a success at whatever you may go to do.

Best luck always
Love Gail, '54

May 11, 1954
Dearest Lucy,

Well, here we are Seniors and about to graduate. Its hard for me to believe that we are Seniors. I remember when I was in about the third or fourth grade and would wonder if I would ever get to E.H. I guess you thought the same too.

Remember all the good and not the bad times we had while we were going to school. Thanks a lot also for helping me with most of my lessons. I've learned almost as much from you as from the teachers.

I wish you the best of luck in your nurses training. I know you will make a wonderful nurse and a cute little wife for some lucky guy. I mean it too. I know you will be a success in what ever you do no matter what you do.

Thanks a lot for being my most wonderful friend during our four years at E.H.S. Its not easy to find a sweet girl as you in a school of this size.

I guess we will write once in a while, while we both are in training. We will keep in touch every time we have time to write.

Again thanks a lot for being my most wonderful friend.

Love always
Kitty

Dear Lucille,

You are a wonderful friend. I hope you will have many good fortunes in the future and see you next year I hope.

Love
Jean Willis

Dear Lucille:

Here's wishing you all the luck and happiness in your nursing career. Your a swell girl. I have enjoyed having my classes with you. Be good! Have fun and don't forget me.

Always
Rebecca

Dear Lucille,

It sure has been fun being in chem. with you and I hope our friendship can grow even tho' you are leaving us this year.

<div align="right">Best of Luck Always.
Jean Mearns</div>

Dear Lucille,

I wish you lots of luck as you begin your career upon leaving high school.

It has been wonderful knowing you and having classes together. Remember Chemistry and Mr. Stalnaker's dreaded demand "Write out and hand in." Oh well, we tried.

Best of luck to a wonderful girl.

<div align="right">A friend,
Janet Underwood</div>

THE CLARION

UNIVERSITY HIGH SCHOOL

NORMAL, ILLINOIS

LouAnn,

I don't really know what to write because it will sound dumb. That's easy for me to say. You are the best prairie belle I've ever known; or any other girl either. That didn't sound right. But what I'm trying to say in a round about way is that you are the best, my favorite, I've had so many good times with you I would need more than two pages to tell you. I have to say you really know how to make me blush (wink, wink) I don't think I better write to much more neat stuff because any body who sees it will say he's a neat guy. I am and I know it, I am, I really am don't you think so. Definitely after reading this far. I couldn't possibly tell you how much fun you are to be with so I won't. Actually I don't mean any of this; I Hate you, you are a jerk! But come to think of it so am I, so I guess we fit together pretty well. I hope we always stay friends. Good Luck in any thing you ever do, of course with me around you couldn't go wrong. Sorry you're ankle! Runnin out of space and things to say so I'll just say See ya a lot in the future (and I mean that)

<div align="right">Dave M.</div>

Lou,

You freak! Keep up the spirit! You look great marching in the rain! Have fun in the future and stay as crazy as you are.

<div align="right">Patty Poe</div>

Lou,

Praire Belles was really fun last year! I love being one with you. Good luck this year.

Love,
Kris

Lou,

P.B.'s is really fun and I'm glad we're both in it. You're really fun to be with and being friends has really been great. (This sounds like what I wrote in 9 others (not really)). Good luck!

Marthy (Marti?)

Lou,

It's really been great being at U-High with you! I'll never forget our Drivers Ed class! It was so much fun! You make a good driving partner—1 accident prone one is enough! Good luck in the future.

Luv,
Janice

LouAnn,

To a girl with cow eyes the like of which I've never seen before. Stay good.

Jay

LouAnn, Peace

I couldn't stand to write it just plain so I chose upside down. It really doesn't make it more interesting though. I'm really glad that I'm still your friend. It's really great having you to talk to. Senior year is proving to be difficult for everyone, but we can still make it through as friends. If we ever did have bad times, I don't remember them. That's nice that the good far exceed the bad. You're really a sweet girl and a good choice of the people. Don't get too seniorish because I'm still trying to be Saintly. Well—I know that you've got success in your future but I wish you the best anyway. Be good, ya hear?

A friend always,
Nola Rae Mentzer
'72

LouAnn,

How's school and prairie bells. I hope all is going well. Go nuts this year and have a lot of fun. Glad I got to go to school with you. I hope to see you a few times this year. Good luck.

Tim

LouAnn,

I never knew you were so shy. I'm just taking up space now. I know what you mean and I really appreciate everything you said about how stupid, idiotic, dumb etc. about me. I want you to quit

making fun of me. I'd like to say in closing I really hate you! I know you hate me and so I hope we can get along. If you know what I mean, if not, you'll find out soon!!

<div align="right">Guess Who? D.M.</div>

LouAnn,

Bean with Boobs it's just not fair! You're B.Q of the world and you're really a lot of fun. I hope P.B.'s is fun this year! Be good and eat. I mean eat food! alot cause you are a bean,

<div align="right">Cow of the World</div>

Hey Goldie Locks,

A lot of us girls have been talking behind your back and we have noticed a big change in you. You are not as goofy as usual and are becoming very studious. What do you think you are, mature or somethin? You better straighten out or we're gonna straighten ya out.

<div align="right">Love
Peggy</div>

LouAnn,

This is stupid cause I really don't know what to say. We've had some cool times. Home Ec. I & II, jungle juice etc. Always remember, we're the cool class of '72!

<div align="right">Suzie Q. Knight</div>

Lou,

You're a great camper, and a really wild gal. I'll never forget the rowdy time we had in Danvers, especially in town. What else can I say that nobody else has?

<div align="right">Good Luck,
Jan</div>

Louie,

To the only girl painter I know (& only speeder—at least one who gets caught). You are a really tuff P.B. (Tuff—in that you won't relinquish your stand in issues i.e. work vs. P.B.) Oh well, you are really sweet. Lots-of-luck! I don't know why I write all this (I think the devil made me do it!)

<div align="right">Love ya,
Kathy</div>

Lou,

How can I tell you what I think of you, when you already know? You're one of the neatest girls in our class but you have a personality to match it. I really wish I had some classes with you. I really miss the fun we've had as Home Ec. Buffs.

<div align="right">Connie
'72</div>

Lou—

You are a real great girl. Don't forget all the stuff we've done. Now that we're seniors (tried and true, sorry Jungle juice W & 7-up) (Sorry I got mad that time!) we'll have to tear this school up.

Good luck,
Vicki

Lou

Your a great girl and a good friend. Math class isn't quite the same without you this year. I also want to thank you for being so nice to my car. I must repay you sometime for it. Good luck always.

Mary Reirstheimer

Lou,

You're a really beautiful gal and besides that you're the pride of Mrs. Brimsburg's class. (Just kidding.) You're really funny! Good Luck and I know you'll have fun!

Always,
Dave

Poetry and Short Stories

Reliquiae Turellae, et Lachrymae Paternae, Jane Turell (Benjamin Colman) (1735)

The functions of creative writing in girls' lives vary as widely as the texts they produce. Composing poetry can be a means of earning parental approval; establishing membership in educational, cultural, or spiritual communities; or protesting social injustices. Writing short stories and submitting them to contests can also be a prudent career move for an aspiring young writer; for other girls, more private fictional compositions allow them to explore possible worlds as they create and manipulate characters whose lives might be different than their own.

Born in 1708, Jane Colman Turell was the daughter of a prominent Boston minister, and her efforts as a writer cemented her relationship with her father as he oversaw her education. As E. Jennifer Monaghan notes, Jane's father's interest in his daughter's intellectual life led her to reach advanced levels of literacy by age eleven. As a girl, she composed both poetry and prose, paraphrased religious texts, kept a diary, and produced "some pieces of wit and humour."

The examples of Jane Colman Turell's literary efforts included here come from the printed versions of two sermons preached by Benjamin Colman after his daughter's death at the age of twenty-seven and the memoirs of her life authored by her husband of nine years, the Reverend Ebenezer Turell. The sampler of Jane's poetic production included here features a hymn, a paraphrase of Psalm 137, a response to fellow poet Mrs. Singer (presumably Elizabeth Singer Rowe), and an invocation of the poetic muse. Benjamin Colman's responses to his daughter are also included. By engaging with his young daughter through shared acts of reading and writing, Colman strengthened their familial bond while monitoring Jane's understanding of and commitment to the religious and cultural values of the community. For more on Jane Colman Turell, see E. Jennifer Monaghan's essay in this volume. The title page of Reliquiae Turellae *appears with the permission of the American Antiquarian Society.*

In this her Eleventh Year I find an *Hymn* fairly written by her, dated *January* 4. 1718. Which I give you Verbatim.

> I Fear the Great *Eternal One* above,
> The God of Grace the God of Love:
> He to whom *Seraphims* Hallelujah's *fing*,
> And Angels do their songs and Prai*f*es bring.
> Happy the Soul that does in heaven re*f*t,
> Where with his Saviour he is ever ble*f*t;
> With heavenly Joys and Rapture po*ff*e*f*t,
> No Tho'ts but of his God in*f*pire his Brea*f*t.

Reliquiæ Turellæ, et Lachrymæ Paternæ.
The Father's Tears over his Daughter's Remains.

Two SERMONS

Preach'd at *Medford,*

April 6. 1735.

By *Benjamin Colman*, D. D.

The *Lord's Day* after the 𝔉𝔲𝔫𝔢𝔯𝔞𝔩

Of His beloved *Daughter*

Mrs. *Jane Turell.*

To which are added,

Some large MEMOIRS of her

Life *and* Death,

By her *Consort*, the Reverend

Mr. 𝔈𝔟𝔢𝔫𝔢𝔷𝔢𝔯 𝔗𝔲𝔯𝔢𝔩𝔩, M. A.

Pastor of the Church in *Medford.*

Proverbs xxxi 26. *She openeth her Mouth with Wisdom,*
and in her Tongue is the Law of Kindness. Ver. 31. *Give*
her of the Fruit of her Hands, and let her own Works
praise Her in the Gates.

BOSTON: Printed by S. KNEELAND & T. GREEN,
for J. EDWARDS and H. FOSTER in Cornhill. 1735.

Happy are they that walk in Wisdom Ways,
That tread her Paths, and shine in all her Rays.

Her *Father* was pleas'd to encourage her in this feeble *Essay* she made at Verse: He condescended to return her *Rhymes* like her own, level to her present Capacity, with a special Aim to keep and fix her Mind on God and *heavenly Things,* with which she had begun. He therefore wrote and gave her the following Lines, which he permits me to insert.

Joy of my Life! is this thy lovely Voice?
Sing on, and a fond *Father's* Heart rejoyce.
'Twas nobly dar'd, my charming Child! a Song
From a *Babes* Mouth of right to *Heaven* belong.
Pleasant thy *Wit,* but more the sacred *Theme,*
Such as thy *Name* and all my *Cares* beseem.
Already you repay the Pains I took
To form you for your *Maker* and your *Book.*
Sing on my *Bird!* and let thy early Days,
Be Sacred to thy God and to his Praise:
Thy Infant Wit devote to things Divine,
And like some beauteous Infant *Angel* shine.
 But dost thou truly fear the *Eternal One* ?
Be sure you do, for he is God alone.
And would you join with *Angels* in their Songs ?
Thy earliest and thy best to Him belongs.
And dost thou count them *blest* that rest above,
In *Jesus* Presence, Image and his Love ?
Now seek a Name among his Saints, and let
Thy Heart on heavy Things be early set.
Then happy thou, *my Child,* in Wisdom's Ways
Shining in thy *transfigur'd Saviour's* Rays.

These Condescentions of her *Father* were no doubt of great Use to her, and had in some measure the Effect propos'd, to put her on thinking and writing more and better, and to gain more of his Esteem for Ingenuity and Piety, which she was wisely ambitious of; but above all to approve her Heart before God, *her Heavenly Father who sees in secret.*

And accordingly she early began a sort of *Diary* without the knowledge of any one, wherein in her *fourteenth* Year I find enter'd solemn and pertinent *Prayers* to God to deliver her and the Town from the *Small Pox* then threatning it; or to prepare her and his People for the Visitation: Also a Meditation and Prayers occasioned by the Death of a *Friend,* her Companion and Acquaintance,* a few Months after of that *Distemper*; fill'd with such Sentences as these—

*Mrs. Kilby

"Gracious and merciful *God* and *Father,* pardon my Sins for *Chrift's* fake. Let my Soul be precious in thy *fight.* I fly to thee for Protection. Give me an entire Refignation to thy Will and Preparation for Death; and let me be found among thy Children at the Great Day.

"I this Day follow'd to the Grave a true and faithful *Friend.* Lord fanctify her Death to me: Awaken in me proper tho'ts of my own Frailty and Mortality. I might have been taken away and fhe fpar'd.— Lord let me fee thy great Mercy in fparing me, and be fitted to live to Thee and to die to Thee. Spare and heal thofe that are vifited in the *Town,* and blefs it, and thy Churches in it, and all the Rulers of it ; and forgive mine Enemies for Chrift's fake. . . .

Pfalm cxxxvii. Paraphras'd, *Auguft* 5th.
1725. AEtat. 17.

As on the Margin of Euphrates Flood
We wail'd our Sins, and mourn'd an angry God;
For God provok'd to ftrangers gave our Land
And by a righteous Judge, condemn'd we ftand;
Deep were our Groans, our Griefs without compare,
With ardent Cries we rent the yielding Air.
Born down with Woes no Friend at hand was found,
No Helper in the wafte and barren Ground;
Only a mournful *Willow* wither'd there,
Its aged Arms by Winter Storms made bare,
On this our *Lyres,* now ufelefs grown we hung,
Our *Lyres* by us forfaken and unftrung!
We figh'd in Chains, and funk beneath our Woe,
Whilft more infulting our proud *Tyrants* grow.
From Hearts oppreft with Grief they did require
A facred *Anthem* on the founding Lyre:
Come, now, they Cry, regale us with a Song,
Mufick and Myrth the fleeting Hours prolong.
Shall *Babels Daughter* hear that bleffed Sound?
Shall Songs Divine be fung in heathen Ground?
No, Heaven forbid that we fhould tune our Voice,
Or touch the Lyre! whilft Slaves we can't rejoyce.
O *Paleftina!* our once dear Abode,
Thou once wert bleft with Peace, and lov'd by God
But now art defolate, a barren wafte,
Thy fruitful Fields by Thorns and Weeds defac'd.
I forget *Judea's* mournful Land,
May nothing profper that I take in Hand!
Or if I ftring the Lyre, or tune my Voice,
Till thy Deliverance caufe me to rejoyce;
O may my *Tongue* forget her Art to move,

And may I never more my Speech improve!
Return O Lord! avenge us of our Foes,
Deſtroy the Men that up againſt us roſe:
Let *Edoms* Sons thy juſt Diſpleaſure know,
And like us ſerve ſome foreign conquering Foe,
In diſtant Realms; far from their native Home,
To which dear Seat O let them never come!

 Thou *Babel's* Daughter! Author of our Woe,
Shalt feel the Stroke of ſome revenging Blow:
Thy Walls and Towers be level'd with the Ground,
Sorrow and Grief ſhall in each Soul be found:
Thrice bleſt the *Man,* who that auſpicious Night
Shall ſeize thy trembling Infants in thy ſight;
Regardleſs of thy flowing Tears and Moans,
And daſh the tender *Babes* againſt the Stones.

The forgoing Poem ſhe ſent to her *Father* from *Reading.* And it gain'd her the following *Letter* from him,

<div align="right">

Boſton, Auguſt 10th. 1725.

</div>

My Dear Child,
 Your's of the fifth Inſtant was exceeding pleaſant to me, both your Paraphraſe on the 137 *Pſalm,* & the *Letter* that incloſ'd it. In the Letter you wiſh you might inherit ſomething of your Father's Soul and therein his Gifts. If that be worthy of your Deſire God has in a great Meaſure given it to you; only you muſt go on by Reading and Study to improve the Powers which God has given you. My poor Gift is in thinking and writing with a little Eloquence, and a poetical turn of Thought. This, in proportion to the Advantages you have had, under the neceſſary and uſeful Reſtraints of your Sex, you enjoy to the full of what I have done before you. With the Advantages of my liberal Education at School & College, I have no reaſon to think but that your Genius in Writing would have excell'd mine. But there is no great Progreſs or Improvement ever made in any thing but by Uſe and Induſtry and Time. If you diligently improve your ſtated and ſome vacant Hours every Day or Week to read your *Bible,* and other uſeful Books, you will inſenſibly grow in Knowlege and Wiſdom, fine Tho'ts and good Judgment, from Year to Year, to the Pleaſure of your Friends, the Profit of your Children, if God give you any, and to your own ſpiritual and everlaſting Advantage; if you direct all unto, and govern it by the Glory of God. But as to a Poetical Flight now and then, let it be with you only a thing by the by. At your leiſure and ſpare Hours you may indulge your Inclinations this way. But let them not break in either

upon the daily Hours of *secret* Reading or Devotion.— So you *shall* confecrate your Heart & Life, your Mu*se* and your daily Works, to the Honour of *Chrift* in the Way of your own Salvation.

You ask me to forgive the flow of your Affections, which run with *fo fwift* a Current of filial Duty as may carry you beyond your *felf fometimes,* and make you wanting in that Re*fpect* which you aim at expre*ffing."* It is true, my *Dear,* that a young fond and mu*fical* Genius is ea*fily* carry'd away thus; and never more than when it runs into the Prai*fes* of what it loves; and I would have you therefore careful again*ft* this Error, even when you *fay* your Tho'ts of Reverence and E*fteem* to your *Father,* or to a *Spoufe* if ever you *fhould* live to have one. It is ea*fy* to be lavi*fh* and run into fooli*fh* Flatteries. I think you have done well to correct your Self for *fome* of your Excur*fions* of this kind toward me. Your *Father* is pleas'd with your love; and *you* are but a poor partial Judge of his Gifts or Virtues.—But if you *fee* any thing of Chri*ft* in any, and whatever things are *juft,* whatever things are *lovely,* think of the*fe* things and imitate them.

You de*fire* me to correct the faults in your Ver*fes.* I have always done that freely, both as to your Pro*fe* and Ver*fe.* Nor be di*fcourag'd* hereby, but in*ftructed.* It is your learning time, and I am not a*fham'd* of my *Pupil.*— But you have taken the la*ft* Paper of Ver*fes* with you, which prevents my *fending* you any Emendations of them. Commendation of them in the general I do however *fend.* The *ferious* melancholy *Pfalm* is well turn'd in the mo*ft* parts of it, con*fidering* your Years and Advantages for *fuch* a Performance. You *fpeak* of a *fingle* wither'dWillow which they hung their Harps on; but *Euphrates* was cover'd with Willows along the Banks of it, *fo* that it has been call'd *the River of Willows.* I hope, my Dear, your Lyre will not be hung on *fuch* a *forrowful Shrub.* Go on in *facred* Songs, and we'll hang it on the *ftately Cedars of Lebanon.* Or let the plea*fant Elm* before the Door where you are *fuffice* for you.—Give my love to Mr. *P*—and Madam, who receive you with *fuch* Courte*fie* and Love. We wi*fh* their plea*fant* Air and Conver*fation* may *ferve* your Health both of Body and Mind; and that your Company may be of *fome* Plea*fure* and U*fe* to them.

I am, your affectionate Father. . .

On reading the Warning by Mrs. *Singer.*

Surpriz'd I view, wrote by a *Female* Pen,
Such a grave Warning to the Sons of Men.
Bold was the attempt and worthy of your Lays,
To *ftrike* at Vice, and *finking* Virtue rai*fe.*
Each noble Line a plea*fing* Terror gives,

A ſecret Force in every Sentence lives.
Inſpir'd by Virtue you could ſafely ſtand
The *fair Reprover* of a guilty Land.
You vie with the fam'd** *Propheteſs* of old,
Burn with her Fire, in the ſame Cauſe grow bold.
Dauntleſs you undertake th' unequal ſtrife,
And raiſe dead Virtue by your Verſe to life.
A *Woman's* Pen ſtrikes the curs'd *Serpents* Head,
And lays the Monſter gaſping, if not dead.

. . .

<div style="text-align:center">

To my *Muſe, December* 29. 1725.

</div>

Come Gentle *Muſe,* and once more lend thine aid,
O bring thy Succour to a humble Maid!
How often doſt thou liberally diſpenſe
To our dull Breaſt thy quick'ning Influence!
By thee inſpir'd, I'll chearful tune my Voice,
And Love and ſacred Friendſhip make my Choice.
In my pleas'd Boſom you can freely pour,
A greater Treaſure than *Joves Golden Shower.*
Come now, *fair Muſe,* and fill my empty Mind,
With rich Idea's, great and unconfin'd.
Inſtruct me in thoſe ſecret Arts that lie
Unſeen to all but to a *Poet's* Eye.
O let me burn with *Sappho's* noble Fire,
But not like her for faithleſs Man expire.
And let me rival great *Orinda's* Fame,
Or like ſweet *Philomela's* be my Name.
Go lead the way, my *Muſe,* nor muſt you ſtop,
'Till we have gain'd *Parnaſſus* ſhady Top:
'Till I have view'd thoſe fragrant ſoft Retreats,
Thoſe Fields of Bliſs, the *Muſes* ſacred Seats.
I'll then devote thee to fair *Virtues* Fame,
And ſo be worthy of a *Poet's* Name.

Theſe were the early *Eſſays* of her Youth at *Poetry,* in which it muſt
be freely own'd that as there are many things *good* and *ingenious, ſo* there
is a great deal low and juvenile; which the candid underſtanding Reader
will be ready to excuſe from that common Rule of *a Child's ſpeaking and
writing as a Child.* At the ſame time, the Turn of the Mind here evident to
God and Religion, is what the Pious will eſteem and praiſe, and it is to

**Huldah

be wifh'd that Children may be taken herewith and drawn to imitate.——
It is eno' (as her honour'd Father elegantly exprefs'd it to me) if they
may be accepted as a *green offering of Firft-fruits bro't to the Door of the
Sanctuary,* the promifing *Earneft* of a future Harveft: at leaft, as the firft
lifping of the Tongue at Words is a pleafing *Mufic* to the Ear of the *Mother,*
and the firft Efforts of the *Mind* at Reafoning delightful to a *Father,* fo are
the firft Rifings of a natural *Genius* unto a wife Obferver.

"On Virtue" (1766), "To the University of Cambridge, in New-England" (1767), "On Being Brought from Africa to America" (1768), and "On the Death of a Young Lady of Five Years of Age" (1770), Phillis Wheatley

*At the age of eight, Phillis Wheatley, an enslaved African, was purchased on the
Boston docks by John Wheatley to serve his wife, Susanna. As part of the Wheat-
leys' efforts to introduce their young slave to Christianity, they taught Phillis
to read and soon found out that she was highly gifted. Phillis went on to learn
Latin as well as to familiarize herself with classical verse and the work of con-
temporary English poets. By the age of 14, she was writing poetry herself. As
E. Jennifer Monaghan notes, "literacy to Phillis was her key to self-definition. It
was her personal voice proclaiming her identity in a culture that defined her as
chattel, a thing to be bought and sold with no voice of its own."*

*As can be seen in the poems included here, much of Phillis Wheatley's po-
etry reflects her commitment to evangelical Christianity, and she sought
through her writing to convert others. For more on Phillis Wheatley, see E. Jen-
nifer Monaghan's essay in this volume.*

ON VIRTUE.

O Thou bright jewel in my aim I strive
To comprehend thee. Thine own words declare
Wisdom is higher than a fool can reach.
I cease to wonder, and no more attempt
Thine height t'explore, or fathom thy profound.
But, O my soul, sink not into despair,
Virtue is near thee, and with gentle hand
Would now embrace thee, hovers o'er thine head.
Fain would the heav'n-born soul with her converse,
Then seek, then court her for her promis'd bliss.

Auspicious queen, thine heav'nly pinions spread,
And lead celestial *Chastity* along;
Lo! now her sacred retinue descends,

Array'd in glory from the orbs above.
Attend me, *Virtue,* thro' my youthful years!
O leave me not to the false joys of time!
But guide my steps to endless life and bliss.
Greatness, or *Goodness,* say what I shall call thee,
To give an higher appellation still,
Teach me a better strain, a nobler lay,
O Thou, enthron'd with Cherubs in the realms of day!

TO THE UNIVERSITY OF CAMBRIDGE, IN NEW-ENGLAND.

While an intrinsic ardor prompts to write,
The muses promise to assist my pen;
'Twas not long since I left my native shore
The land of errors, and *Egyptian* gloom:
Father of mercy, 'twas thy gracious hand
Brought me in safety from those dark abodes.

Students, to you 'tis giv'n to scan the heights
Above, to traverse the ethereal space,
And mark the systems of revolving worlds.
Still more, ye sons of science ye receive
The blissful news by messengers from heav'n,
How *Jesus'* blood for your redemption flows.
See him with hands out-stretcht upon the cross;
Immense compassion in his bosom glows;
He hears revilers, nor resents their scorn:
What matchless mercy in the Son of God!
When the whole human race by sin had fall'n,
He deign'd to die that they might rise again,
And share with him in the sublimest skies,
Life without death, and glory without end.

Improve your privileges while they stay,
Ye pupils, and each hour redeem, that bears
Or good or bad report of you to heav'n.
Let sin, that baneful evil to the soul,
By you be shunn'd, nor once remit your guard;
Suppress the deadly serpent in its egg.
Ye blooming plants of human race devine,
An *Ethiop* tells you 'tis your greatest foe;
Its transient sweetness turns to endless pain,
And in immense perdition sinks the soul.

ON BEING BROUGHT FROM AFRICA TO AMERICA.

'Twas mercy brought me from my *Pagan* land,
Taught my benighted soul to understand
That there's a God, that there's a *Saviour* too:
Once I redemption neither sought nor knew:
Some view our sable race with scornful eye,
"Their colour is a diabolic die."
Remember, *Christians, Negroes,* black as *Cain,*
May be refin'd, and join th' angelic train.

ON THE DEATH OF A YOUNG LADY OF FIVE YEARS OF AGE.

From dark abodes to fair etherial light
Th' enraptur'd innocent has wing'd her flight;
On the kind bosom of eternal love
She finds unknown beatitude above.
This know, ye parents, nor her loss deplore,
She feels the iron hand of pain no more;
The dispensations of unerring grace,
Should turn your sorrows into grateful praise;
Let then no tears for her henceforward flow,
No more distress'd in our dark vale below.

Her morning sun, which rose divinely bright,
Was quickly mantled with the gloom of night;
But hear in heav'n's blest bow'rs your *Nancy* fair,
And learn to imitate her language there.
"Thou, Lord, whom I behold with glory crown'd,
"By what sweet name, and in what tuneful sound
"Wilt thou be prais'd? Seraphic pow'rs are faint
"Infinite love and majesty to paint.
"To thee let their grateful voices raise,
"And saints and angels join their songs of "praise."

Perfect in bliss she from her heav'nly home
Looks down, and smiling beckons you to come;
Why then, fond parents, why these fruitless groans?
Restrain your tears, and cease your plaintive moans.
Freed from a world of sin, and snares, and pain,
Why would you wish your daughter back again?
No—bow resign'd. Let hope your grief control,
And check the rising tumult of the soul.
Calm in the prosperous, and adverse day,
Adore the God who gives and takes away;
Eye him in all, his holy name revere,
Upright your actions, and your hearts sincere,

Till having sail'd through life's tempestuous sea,
And from its rocks, and boist'rous billows free,
Yourselves, safe landed on the blissful shore,
Shall join your happy babe to part no more.

"Some Verses," Dora Read Goodale (1877) and "The Young Hunter," Florence E. Tyng, *St. Nicholas* (1879)

As Jean Ferguson Carr notes in her essay in this volume, the rise of eminent women writers in the nineteenth century inspired many girls to imagine literary careers for themselves and to submit their own early work to publishers. As can be seen in the poem and short story included here, which appeared in the children's periodical St. Nicholas, *girls were most likely to be successful with publishers if their texts affirmed the constructions of girlhood that circulated in the wider culture.*

Ten-year-old Dora Read Goodale composed poetry that combined pastoral scenes with domestic concerns. Her poem describes a hummingbird's nest as a happy home built by an industrious avian pair. Florence Tyng submitted her short story, "The Young Hunter," in response to a contest sponsored by St. Nicholas. *The magazine published an illustration of a boy with a bow and arrow and invited readers to compose a story to accompany the picture. (As Lucille M. Schultz has noted, the use of illustrations and pictures as heuristics for composing became a feature of popular composition textbooks in the nineteenth century; see* The Young Composers.) *Tyng's winning contest entry is notable for the ways in which she invokes a boy's adventuresome spirit while also allowing her main character, Karl, to demonstrate more nurturing qualities as he cares for a lost bird.*

SOME VERSES, WRITTEN BY DORA,
ON A HUMMING-BIRD'S NEST, WHICH SHE FOUND
OVER HER STOCKING ON CHRISTMAS MORNING.

When June was bright with roses fair,
And leafy trees about her stood,
When summer sunshine filled the air
And flickered through the quiet wood,
There, in its shade and silent rest,
A tiny pair had built their nest.

And when July, with scorching heat,
Had dried the meadow grass to hay,
And piled in stacks about the field

Or fragrant in the barn it lay,
Within the nest so softly made
Two tiny, snowy eggs were laid.

But when October's ripened fruit
Had bent the very tree-tops down,
And dainty flowers faded, drooped,
And stately forests lost their crown,
Their brood was hatched and reared and flown—
The mossy nest was left alone.

And now the hills are cold and white,
'Tis sever'd from its native bough;
We gaze upon it with delight;
Where are its cunning builders now?
Far in the sunny south they roam,
And leave to us their northern home.

THE YOUNG HUNTER.

Karl lived in the far West near the mountains. One November day, he sat by the fire, watching his grandmother mix the bread, when a rap came at the door of the little cabin.

"Those tramps!" said the old lady. "Karl, you go."

Karl obeyed; and, as he opened the door, started back much surprised, for there stood the tall figure of an old Indian.

He wore a dark leathern jacket, with trousers to the knees, ornamented with beads and feathers; moccasins on his feet and rings in his ears. Although his arms were filled with bows and arrows, he had not come for war, for he held one out, saying pleasantly,

"Wantee shoot? Wantee buy?"

"Oh, Grandmother," said Karl, "look at these!"

"But you have no money, Karl," said the grandmother.—"How much are they?"

Karl's face fell as the Indian answered:

"One dolla', bow and arrow."

"I have no money," said Karl.

"Is there nothing else you would take for one?" asked the old lady.

The Indian replied: "Me hungry, me want dinnee."

The old Indian went in and sat down by the log fire and warmed himself, while the grandmother placed upon the table some bread, milk and venison. When he had finished, he gave Karl a fine bow of ash, and three arrows, and then left.

Karl's eyes sparkled as he asked his grandmother to let him go out to shoot.

"I'll bring home a deer," said he.

He then left the house, and called to his dog Snyder.

He shot at several birds, but they all escaped him; and it became evident that it would take a great deal of practice for him to become a skillful archer. He was tired of shooting with such poor success, and so decided to go home, when he heard Snyder barking loudly.

On turning, he saw him burying his nose in the ground near an old stump. He ran hastily to it, looking eagerly to see what the dog was barking at. It was a poor little bird which had not flown south early enough, and seemed frozen. He took it up and carried it carefully home, wrapped it in cotton and put it beside the fire, to see if it would revive. He then sat down to watch it, but soon, getting tired, he fell asleep.

He had not slept long when he heard a chirp, and looking up he saw the bird hopping about the floor. Karl spent the rest of the afternoon in keeping Snyder away from the bird, for the dog was very anxious for it.

That night, Karl told his father the whole story, and he was very much pleased. Karl then took the bird and opened a window so that it might be free again. It flew out in the moonlight, over those cold bleak mountains toward the sunny south.

So, good came of the young hunter's first trial after all.

FLORENCE E. TYNG (Age, 13 years.)

"Lines to My Classmates," Edna L. Turner, *The Lincolnian* (1920)

Edna L. Turner offered this poem to her fellow graduates in the class of 1920 at Lincoln High School, a segregated institution for African Americans in Kansas City, Missouri. Turner's focus on hard work, social responsibility, emulation, and progress reflects the position of leading African American educator and pragmatist Booker T. Washington, who argued that educational and economic achievement would allow African Americans to prove they were entitled to the civil rights that were automatically accorded to white citizens. This poem appears here courtesy of the Black Archives of Mid-America.

LINES TO MY CLASSMATES.

Seniors of nineteen-twenty,
The work we've attempted is nearly done;

Strive onward, get the best
Which is not gained by rest;
By labors hard and many pains
Can only come your gains.

In this great world of ours
Utilize each day's hours,
For life is brief and insecure,
So let us, then, the best procure.

We, the people of the colored race,
Emulate others, 'tis no disgrace;
Think of the progress now made,
Shall we stop, or allow it to fade?

Such act of imprudence is wrong;
Labor on, venture out, be strong;
Surrend'ring now means delay
In the future there's a brighter day.

Classmates, I wish you all good luck
Which lies embosomed in progress;
Plunge into it, do your best,
And He we trust will do the rest.

"Too Young," Grace Sibley, *Saplings* (1926)

*A student at the High School of Commerce in Portland, Oregon, Grace Sibley
penned this 1926 award-winning poem. Though Sibley, in the 1920s, had far
more educational opportunities than girls of earlier eras, her poetry still points
to ways in which girls felt that they had to struggle to claim a public voice.
"Too Young" appears here with the permission of Scholastic, Inc.*

TOO YOUNG

They tell me I am quite
Too young to try to write
The young, green sprouts
Of thought that struggle
In my half grown brain for life.
They are fools,
They are too old.

Who feels a rush of beautiful, breathless feeling
For that tree there—

Full grown—
Not too young—
Nor too old?

It is the wondering, questioning, timid sapling
That draws the tears of too much beauty—
From the eyes that see.

"Sixteen," Maureen Daly, *Saplings* (1938)

As Kelly Schrum notes in her essay on girls and literacy in the middle of the twentieth century in this volume, Maureen Daly's short story, "Sixteen," demonstrates the importance of reading in a teenager's life. Daly's narrator mentions reading twice in the first paragraph of her story. Through reading, the narrator never need leave her Wisconsin home to assure herself that she is dressing fashionably and that she is current on Hollywood gossip and New York society news. Daly's short story appears here with the permission of Scholastic, Inc.

SIXTEEN

By Maureen Daly, 16
St. Mary's Springs Academy, Fond du Lac, Wisconsin
Teacher, Sister M. Rosita
First Prize, Short Story

Now don't get me wrong. I mean, I want you to understand from the beginning that I'm not really so dumb. I know what a girl should do and what she shouldn't. I get around. I read. I listen to the radio. And I have two older sisters. So you see, I know what the score is. I know it's smart to wear tweedish skirts and shaggy sweaters with the sleeves pushed up and pearls and ankle-socks and saddle shoes that look as if they've seen the world. And I know that your hair should be long, almost to your shoulders, and sleek as a wet seal, just a little fluffed on the ends and you should wear a campus hat or a dink or else a peasant hankie if you've that sort of face. Properly, a peasant hankie should make you think of edelweiss, mist and sunny mountains, yodeling and Swiss cheese. You know, that kind of peasant. Now, me, I never wear a hankie. It makes my face seem wide and Slavic and I look like a picture always in one of those magazines articles that run—"And Stalin says the future of Russia lies in its women. In its women who have tilled its soil, raised its children—." Well, anyway. I'm not exactly too small-town either. I read Winchell's column. You get to know what New York boy is that way about some pineapple

princess on the West Coast and what Paradise pretty is currently the prettiest and why someone, eventually, will play Scarlett O'Hara. It gives you that cosmopolitan feeling. And I know that anyone who orders a strawberry sundae in a drugstore instead of a lemon coke would probably be dumb enough to wear colored ankle-socks with high-heeled pumps or use Evening in Paris with a tweed suit. But I'm sort of drifting. This isn't what I wanted to tell you. I just wanted to give you the general idea of how I'm not so dumb. It's important that you understand that.

You see, it was funny how I met him. It was a winter night like any other winter night. And I didn't have my Latin done either. But the way the moon tinseled the twigs and silver-plated the snow drifts, I just couldn't stay inside. The skating rink isn't far from our house—you can make it in five minutes if the sidewalks aren't slippery, so I went skating. I remember it took me a long time to get ready that night because I had to darn my skating socks first. I don't know why they always wear out so fast—just in the toes, too. Maybe it's because I have metal protectors on the toes of my skates. That probably *is* why. And then I brushed my hair—hard, so hard it clung to my hand and stood up around my head in a hazy hallow.

My skates were hanging by the back door all nice and shiny for I'd just gotten them for Christmas and they smelled so queer—just like fresh smoked ham. My dog walked with me as far as the corner. She's a red Chow, very polite and well-mannered, and she kept pretending it was me she liked when all the time I knew it was the ham smell. She panted along beside me and her hot breath made a frosty little balloon balancing on the end of her nose. My skates thumped me good-naturedly on my back as I walked and the night was breathlessly quiet and the stars winked down like a million flirting eyes. It was all so lovely.

It was all so lovely I ran most of the way and it was lucky the sidewalks had ashes on them or I'd have slipped surely. The ashes crunched like cracker-jack and I could feel their cindery shape through the thinness of my shoes. I always wear old shoes when I go skating.

I had to cut across someone's back garden to get to the rink and last summer's grass stuck through the thin ice, brown and discouraged. Not many people came through this way and the crusted snow broke through the little hollows between corn stubbles frozen hard in the ground. I was out of breath when I got to the shanty—out of breath with running and with the loveliness of the night. Shanties are always such friendly places. The floor all hacked to wet splinters from skate

runners and the wooden wall frescoed with symbols of dead romance. There was a smell of singed wool as someone got too near the glowing isingless grin of the iron stove. Girls burst through the door laughing with snow on their hair and tripped over shoes scattered on the floor. A pimply-faced boy grabbed the hat from the frizzled head of an eighth grade blonde and stuffed it into an empty galosh to prove his love and then hastily bent to examine his skate strap with innocent unconcern.

It didn't take me long to get my own skates on and I stuck my shoes under the bench—far back where they wouldn't get knocked around and would be easy to find when I wanted to go home. I walked out on my toes and the shiny runners of my new skates dug deep into the sodden floor.

It was snowing a little outside—quick, eager little Lux-like flakes that melted as soon as they touched your hand. I don't know where the snow came from for there were stars out. Or maybe the stars were in my eyes and I just kept seeing them every time I looked up into the darkness. I waited a moment. You know, to start to skate at a crowded rink is like jumping on a moving merry-go-round. The skaters go skimming round in a colored blur like gaudy painted horses and the shrill musical jabber reechoes in the night from a hundred human calliopes. Once in, I went all right. At least after I found out exactly where that rough ice was. It was "round, round, jump the rut, round, round, round, jump the rut, round, round——."

And then he came. All of sudden his arm was around my waist so warm and tight and he said very casually, "Mind if I skate with you?" and then he took my other hand. That's all there was to it. Just that and then we were skating. It wasn't that I'd never skated with a boy before. Don't be silly. I told you before I get around. But this was different. He was a smoothie! He was a big shot up at school and he went to all the big dances and he was the best dancer in town except Harold Wright who didn't count because he'd been to college in New York for two years! Don't you see? This was different.

At first I can't remember what we talked about, I can't even remember if we talked at all. We just skated and skated and laughed every time we came to that rough spot and pretty soon we were laughing all the time at nothing at all. It was all so lovely.

Then we sat on the big snow bank at the edge of the rink and just watched. It was cold at first even with my skating pants on, sitting on that hard heap of snow, but pretty soon I got warm all over. He threw a handful of snow at me and it fell in a little white shower on my hair and he leaned over to brush it off. I held my breath. The night stood still.

The moon hung just over the warming shanty like a big quarter slice of muskmelon and the smoke from the pipe chimney floated up in a sooty fog. One by one the houses around the rink twinkled out their lights and somebody's hound wailed a mournful apology to a star as he curled up for the night. It was all so lovely.

Then he sat up straight and said, "We'd better start home." Not "Shall I take you home?" or "Do you live far?" but "We'd better start home." See, that's how I know he wanted to take me home. Not because he *had* to but because he *wanted* to. He went to the shanty to get my shoes. "Black ones," I told him. "Same size as Garbo's." And he laughed again. He was still smiling when he came back and took off my skates and tied the wet skate strings in a soggy knot and put them over his shoulder. Then he held out his hand and I slid off the snow bank and brushed off the seat of my pants and we were ready.

It was snowing harder now. Big, quiet flakes that clung to twiggy bushes and snuggled in little drifts against the tree trunks. The night was an etching in black and white. It was all so lovely I was sorry I lived only a few blocks away. He talked softly as we walked as if every little word were a secret. "Did I like Wayne King, and did I plan to go to college next year and had I a cousin who lived in Appleton and knew his brother?" A very respectable Emily Post sort of conversation and then finally—"how nice I looked with snow in my hair and had I ever seen the moon so—close?" For the moon was following us as we walked and ducking playfully behind a chimney every time I turned to look at it. And then we were home.

The porch light was on. My mother always puts the porch light on when I go away at night. And we stood there a moment by the front steps and the snow turned pinkish in the glow of the colored light and a few feathery flakes settled on his hair. Then he took my skates and put them over my shoulder and said, "Good night now. I'll call you." "I'll call you," he said.

I went inside then and in a moment he was gone. I watched him from my window as he went down the street. He was whistling softly and I waited until the sound faded away so I couldn't tell if it was he or my heart whistling out there in the night. And then he was gone, completely gone.

I shivered. Somehow the darkness seemed changed. The stars were little hard chips of light far up in the sky and the moon stared down with a sullen yellow glare. The air was tense with sudden cold and a gust of wind swirled his footprints into white oblivion. Everything was quiet.

But he said, "I'll call you." That's what he said "I'll call you." I couldn't sleep all night.

And that was last Thursday. Tonight is Tuesday. Tonight is Tuesday and my homework's done, and I darned some stockings that didn't really need it, and I worked a cross-word puzzle, and I listened to the radio and now I'm just sitting. I'm just sitting because I can't think of anything else to do. I can't think of anything, anything but snowflakes and ice skates and yellow moons and Thursday night. The telephone is sitting on the corner table with its old black face turned to the wall so I can't see its leer. I don't even jump when it rings anymore. My heart still prays but my mind just laughs. Outside the night is still, so still I think I'll go crazy and the white snow's all dirtied and smoked into grayness and the wind is blowing the arc light so it throws weird, waving shadows from the trees onto the lawn—like thin, starved arms begging for I don't know what. And so I'm just sitting here and I'm not feeling anything. I'm not even sad because all of a sudden I know. All of a sudden I know. I can sit here now forever and laugh and laugh and laugh while the tears run salty in the corners of my mouth. For all of a sudden I know, I know what the stars knew all the time—he'll never, never call—never.

"I Never Knew," Mary Betty Anderson, *Young Voices* (c. 1930s)

Written in the years between 1936 and 1940, Mary Betty Anderson's poem "I Never Knew" offers a different vision of racial politics than Edna L. Turner's "Lines to My Classmates" in 1920. Anderson uses poetry as a medium for expressing a sense of racial pride and calls attention to the intrinsic equality of all people that is not dependent on education or accomplishment. Anderson's poem appears here with the permission of Scholastic, Inc.

I NEVER KNEW

I never knew
That being black
Punished me.
In my land
Black matched a tree,
And the sky at night,
And ebon was the
Color of the fight.
Black was the color
Of the jungle ground

And black was the beating
Of the tom-tom sound.
Black was as good
As anything we knew—
And, except in people,
Is for white men, too.

"My Plea," Mary Matsuzawa and "The Bend in the Road," June Moriwaki, *Cactus Blossoms* (1945)

Written by two girls of Japanese ancestry who were moved with their families to the Gila Relocation Center in Arizona during World War II, these poems reflect both hopefulness and despair. They express the conflicts some girls experienced as they negotiated their loyalties to their families' Japanese heritage and to the American culture that surrounded them. These poems appear here courtesy of the Bancroft Library, University of California, Berkeley.

MY PLEA

By Mary Matsuzawa

Oh God, I pray that I may bear a cross
To set my people free,
That I may help to take good-will across
An understanding sea.

Oh God, I pray that someday every race
May stand on equal plane
And prejudice will find no dwelling place
In a peace that all may gain.

THE BEND IN THE ROAD

By June Moriwaki

I walked along without changing my pace,
For this road was familiar to me,
With friends beside me, I knew each kind face,
I thought my goal easy to see.

It was a good road and very well laid,
Rocks and debris all removed;
At each bridge I found the toll had been paid,
By some one I cherished and loved.
But there was a bend not far away,
Beyond which conflict would start,

Dad staunch for the land in which he was born
And me for the one in my heart.

Now the road I had known sank out of sight
In the depths of a great ravine;
I groped and stumbled, for there was no light,
Or path as there always had been.
 So I discovered the road unlaid,
The road that I had to clear,
Toll for the bridges by me to be paid
As I looked to the coming year.

"Awakening," Beth Hinds, *Seventeen* (1961)

In this award-winning short story, Beth Hinds of Odessa, Texas, comments upon the composition assignments and writing advice that girls often encounter in school. Hinds's protagonist, Leslie, must write a short story for English class, and her teacher has advised that students write about their own experiences. Leslie's bemused and then annoyed mother reminds her daughter of a recent family vacation, but the family then learns that one of Leslie's classmates has been killed in a car accident. Though dealing with the death of a fellow student causes Leslie to reconsider old friendships and her experience would clearly make an excellent story, she concludes that "I just can't think of anything that's happened to me lately."

AWAKENING

The first snow of the year was falling quietly as Leslie came home from school. It was fine and powdery, like confectioner's sugar, she noticed, and it melted before it touched the ground. She stood watching the wind make swirly patterns of it in the air before she entered the house. The snow was pretty, she thought; maybe she could put it in her story some way.

As usual, her mother had a soft drink and something to eat waiting for her. This time it was a cold slice of cherry pie; she ate it a little guiltily, thinking of her new dress and how snugly it fit now—but it was a long time till supper, and fruit was good for you, and by the time she had justified herself, she had finished it.

She went into the living room where her mother was rereading *David Copperfield*. They always saved this part of the afternoon to get caught up on conversation. *David Copperfield*—she meant to read it one day when she had the time. But there were always too many places to go, or homework to do—like this story.

"Honestly, Mother," she exclaimed, sinking into a chair, "Mr. Richman must be trying to make authors out of us or something. Last week it was a poem and two essays, and now it's a short story."

"It's good exercise for you," her mother replied, smiling. "On what subject?"

"Anything," Leslie moaned. "That's just it. He said it would be better if we could base it on one of our own experiences—but I can't think of a thing that's happened to me that would make a good story."

Mrs. Neumann thought a minute. "We took that trip to Arizona," she suggested. "Maybe that might—"

"It might make an exciting background," Leslie interrupted, "but we just *saw* things. No one fell into the Grand Canyon or fell in love with a dashing stranger or anything."

Her mother laughed as she rose. "Thank goodness! Well, work on it while I get supper and then we'll see if we can't think of something that's dramatic later."

From the window of her room Leslie noticed that the snow was still coming down, but not sticking. She shivered a little in her warm room, looking at the cold, gray sky. She hurriedly drew the curtain and flung herself on the bed. Then she studied each of the stuffed animals on the bed intently, and next she turned to the pictures and souvenirs pinned on the walls, as if by sorcery one of them might lift itself up and present a plot. But they remained silent and cold, like the world outside.

All through supper her mind wandered, and she was scarcely aware of what she ate or of her family around her.

"A new boy in town?" Her father's eyes twinkled.

Her smile was a bit wan. "I'm afraid it's only a short story this time. From me. I mean, I have to write one and I can't think up a plot."

"Why don't you write a science fiction one?" Joel, of course—he lived in a ten-year-old world of his own but emerged briefly now and then to talk about it to others.

They laughed. "I'm afraid it wouldn't qualify; you see, it has to be a true experience or something like that," Leslie explained.

"And Leslie's sure she's never had an experience worth writing about," her mother added dryly.

"A failure at sixteen, huh?" Her father pushed his chair back while he handed out parts of the evening paper.

This was another nice part of the day, Leslie thought vaguely . . . nothing special, really, but the four of them gathered around the table, enjoying a silent companionship as they read about people and places and things happening in towns and countries they would never see. Sometimes they would comment to each other, as her mother

was doing now—with a little start, she realized her mother was speaking to her.

"Leslie, do you know a boy named Stephen Landers?" Her tone was the one she used to speak of things like Hurt or Sorrow or Trouble or Death.

"He's in my history class—no, algebra, I think. He just moved here a little while ago. Why? Did you meet his mother today or something?" She was curious and a little apprehensive at her mother's tone.

"He was killed in a car wreck this afternoon." Her mother studied the article. "He was nice-looking; poor boy. Here's his picture."

Leslie looked. She saw a rather unrecognizable, handsome, smiling face. Only the eyes were familiar, and the small dimple she had once absent-mindedly noticed.

"He never looked like that at school. I mean, he didn't smile like that. Of course, I only saw him sitting in the back of the room. And talked to him a couple of times, just about algebra and weather and things like that. His eyes were blue," she added for her mother, who was always interested in details. "Real light blue, and he had black hair." She felt a funny, sinking sensation in the pit of her stomach, the kind you got when made aware that something bad had happened, but it wasn't going to hurt you.

"How did it happen?" Her father was interested in details, too.

"It says he left school today to take some kind of college entrance exam. He ran into the blizzard coming home and just couldn't see well enough, I guess."

Her father took the paper. "Worst part of the storm at Farnhurst, it says, where the accident occurred; guess we must be on the fringe." They went on discussing the weather and the accident impersonally while she went back to her room.

Her head whirled a little and she tried to remember him: about four inches taller than she, rather slender, she finally decided. Dark hair. She remembered thinking once that his eyes were nice, shadowed by long, dark lashes. He had seemed shy and reserved, moving to a new town and all, and—well, average. Average. How many people were stuck together under that label, she wondered. They were individuals, really. As Stephen must be. "Was," she corrected herself, with a shiver.

The phone's harsh ring interrupted; she grabbed at it, glad to divert her mind from this morbidity. It scared her a little; it threatened to upset her everyday life and thought.

It was Charlotte, who plopped into the conversation with her customary gush and vigor. "Guess what? Vernon walked me to chemistry and he told me not to blow anything up. Wasn't that cute?"

Oh real cute, thought Leslie, real cornball. "Oh, sure. How'd you manage it?" she answered, though.

"Well, it just sort of happened. I was walking out of English and there he was at his locker and I just sort of stopped to talk to him, and then we walked on. I hope I can time it right tomorrow. Anyway, I thought of this real neat way to get him to ask me for a date. Want to hear it?"

"Sure," said Leslie automatically. Their conversations always ran like this. Charlotte was full of boring, trivial gossip that no one really cared to hear, and then, when she was finished, she would demand to know everything that had happened to Leslie during the day, whether she thought so-and-so was cute, whether he really liked whomever he was dating, and finally she'd ask for the answers to the history homework. They had run around together for ages; Leslie wondered if they were really friends. (She seemed to be seeing several things in a clear, new light tonight.)

She tried to shake off the uncomfortable perception. "Fire away," she added guiltily.

"Well," Charlotte paused emphatically, "next time I see him I'll say that my club is having a party in a few weeks, but I don't think it's right to ask anyone you've never dated. Because I really don't, you know, and then maybe he'll get the message. What d'ya think about that?"

"Fine," answered Leslie, "if you only want to be obvious and chase him." She felt a little irked that anyone could be so intense about silly chatter, especially now.

Charlotte was surprised. "Well, really, I don't think that there's anything so wrong with it, and anyway," she returned backhand, "I don't see that *you've* got any exciting prospects lined up. If—"

"I'm really not bothered by it now. It's weeks away, and anyway, if I have to I can always ask Roger." She could almost hear Charlotte starting to say, "Dear old Roger, it's always good to have someone like that, isn't it, though of course you'd almost rather not go 'cause you won't have much fun with him. That's how I feel with Charles . . ." and on and on.

Leslie rushed at a change of subject and almost unwittingly she asked, "Did you see the paper tonight?" Immediately she was sorry because in her new perspective she could not imagine Charlotte being sympathetic about anything not related to her.

But the sympathy came gushing over the wire. "About Stephen Landers? Oh, wasn't that *horrible?* I felt so strange when I read it, almost sick. I really can't believe it, can you? That's one of the things I called you about. Did you know he wanted a date with you?"

Leslie had to clutch the receiver tight to keep from dropping it.

"Are you sure?" she heard herself say and her voice startled her, sounding hollow and shaky.

"Sure, I'm sure. One day last week I heard him tell Charles he thought you were kind of cute and you had been friendly to him some, and he might ask you to go with him somewhere sometime. Only he didn't know if you'd go with him. You know how shy he was, being new and all. He told Vernon after two months here he still didn't feel as if he belonged."

"Oh, Charlotte," she breathed, "why didn't you tell me? We should have been friendlier to him and tried harder; gosh, I only talked to him twice, about school and stuff, not real conversation. It's terrible the things you never realize till it's too late."

"Yeah. I must have forgotten about it before I saw you again. Oh, well, I guess it really doesn't matter now, does it?" Her laugh resounded gruesomely. "Anyway, I've got to go—my father's giving me the signal. They're having the funeral tomorrow . . . Oh—this is what I really wanted to tell you. Vernon called me a while ago to get the English assignment—pretty good, huh?—and he told me he was going to the funeral."

Surprised, Leslie said, "I didn't know Vernon and Stephen were friends."

Charlotte laughed again. "Well, they aren't—weren't really. Vernon didn't know him too well. But he's got trig seventh period and a test he hasn't studied for, and all those who go get excused. So . . ."

"I think that's horrible!" Leslie was shouting. "I think it's the most cold-blooded thing I ever heard of."

"Well . . ."

"Of course, I realize that anything Vernon does is fine with you, but I did give you a little more credit than that, and you didn't have to laugh about it." Her voice was turning to a whine.

"Well, you don't have to cry about it either," returned Charlotte. "I think you must be sick or something; I've never heard you so touchy and all. This is the first time we've ever even come close to having a fight. Listen—Dad's getting frantic and I've got to hang up, but we'll straighten everything out tomorrow. You're probably just tired. Okay?"

"All right," Leslie said dully, "good-by." Her sudden fury was spent. She replaced the receiver and sat down on her bed.

She wasn't crying, but she had a strange, painful feeling in her heart. It wasn't only uncomfortable; it made her feel sad all over.

"At least he thought I was friendly." Leslie stretched out on the bed. With one hand she pulled back the curtain, staring out into the darkness. The snow was still falling, and beginning to stick. She switched

off the light and watched the moon make weird yellow shadows on the whiteness. Tomorrow the neighborhood kids would build snowmen and have snowball fights and eat snow ice-cream for dessert, but tonight the world seemed preserved in this smooth, icy loveliness. It seemed impossible that anything so beautiful could be the cause of grief—ugly, really.

Charlotte said Stephen had wanted to date her. She wondered if it were really true and decided it must have been. She lay staring at nothing in the dark, thinking vague, idle thoughts.

"What if he had asked me? Would I have gone? Yes, I think so . . . Where would we have gone? To the movies, probably, and afterward to get a Coke." She could see them, talking with the other kids and maybe dancing at the Teen Center. She would be wearing the new blue dress of course, and they would make some kind of joke about how it matched his eyes. Maybe after that they would go more places together. She saw them moving to a variety of places in quick succession—basketball games, bowling, more movies, drives on Sunday afternoons, a picnic in the park when it got warm enough, spending more and more of their free time together. She was leaving for a trip of some kind now, all dressed up in a new outfit, something smart in beige, perhaps, with heels to match, and he was saying goodbye. He was there to meet the bus, too, when she came back. Or a plane— that looked more sophisticated. Maybe eventually they might even go steady; she thought of her friends' astonished faces and squeals. She tried to imagine herself liking him that much, and it was easy enough, because after all, she hadn't really known him very long, and in her imagination he could be whatever she wanted.

She broke from her reverie with a start and a little feeling of guilt. It seemed wrong and selfish to be thinking like that.

Still, it might have happened—it nearly had. Suppose they had met several months ago and all this had happened. How would she be feeling now, right this very moment? Terribly sad and grieved, of course. And probably stunned and empty feeling inside. Would people come over and try to comfort her as they probably were doing at the Landers? Or would they realize she'd rather be alone with her sorrow, struggling with it heroically.

The romantic picture grew and grew. She was entering the church, dressed in a smart, simple black suit and the black picture hat she loved so well. Lots of flowers in the church, of course. She had been to a couple of funerals, aunts and distant relatives . . . they were, she recalled vaguely, rather like a dream, a ceremony one went through for custom's sake and then forgot. The realization never set

in until maybe months later, when you started to plan a trip, or failed to receive a birthday card or a letter.

Anyway, there would be beautifully sad organ music playing. The flowers would be pinned to screens, forming a massive background, and hers would be placed on top of the casket—ugh!—the word sent a shiver through her body and hit the pit of her stomach with a cold thud. She forced herself back to the flowers. They would be white—or perhaps red, for love? Which way was it? Maybe both. And people would know and comment; they would look for her and see a—a dignified grief. That was it. Beautiful, sincere, and moving. Would she cry? It seemed improper and unfeeling not to do so. But the sound of loud, hideous sobbing always made her shudder. And she hated to show her emotions in public; it made her feel undressed. Probably she would cry very silently, but so that anyone noticing would be touched by it. The sermon would be brief but eloquent, full of beautiful phrases of sorrow and consolation. Irrelevantly she remembered a poem they had studied in English by A. E. Housman, *To an Athlete Dying Young*. It went:

> Smart lad to slip betimes away
> From fields where glory does not stay,
> And early though the laurel grows
> It withers quicker than the rose.

She wondered if that could apply to Stephen. She thought she remembered he had been known for something in the town he had left, all-state baseball or track or something. Again she was startled—how little she really knew of him!

She turned over on her side and looked out the window again. The snow had stopped falling; the streets were thickly covered. The stars glittered with a cold, brittle light and the wind had muffled its noise. The stripped limbs of the trees were shaking from the frost; they set shadows dancing on the yellow pall cast by the moon.

She dropped the curtains with a start. Her mother had come into the room and turned on the light.

"Why, Leslie, whatever are you doing in the dark? It's after nine. Have you finished your story yet?"

"No, I—I've been trying to think of something to write about, and my mind is just—blank." She felt a little embarrassed at having to fib to her mother.

"And you couldn't think of anything you'd done or heard or seen lately? Surely we haven't given you a girlhood as dull as all that." (Mrs. Neumann was beginning to be a little exasperated. After all, they had

spent money and time to see that their children had the little extras and luxuries to supplement their public school education. And they had always taken them on nice, well-planned vacations to see things and learn, as well.)

"It's my fault," Leslie exclaimed, "I just can't think of *anything* that's happened to me lately."

"Busy Betty," Morgan Childs (2000)

Eleven-year-old Morgan Childs of Houston, Texas, composed this poem during a summer writing camp for girls. Like many girls at the dawn of the twenty-first century, Morgan's busy Betty has the opportunity to participate in numerous skill-enhancing activities: music lessons, dance class, tutorial sessions in math. In an Atlantic Monthly *article, David Brooks dubs such an over-achiever as an "organization kid," one who is successful, hardworking, deferential to authority, and optimistic. Raised by baby boomer parents, who approached child rearing as "the most important extra-credit art project" of their lives, organization kids experience endless opportunities for physical and intellectual growth. Like Busy Betty, though, some young women find themselves overwhelmed by the frenetic pace of continual enrichment.*

BUSY BETTY

Busy Betty had so much to do
 she played the piano and the violin, too.
After school she played in the band
 the tuba, the flute, the saxophone and
After that she went to a tutor,
 because math and science just didn't suit her.
Then she went off to dance—ballet and jazz
 and as if her schedule hadn't enough pizzazz,
 she still had to eat dinner, and then she was sent
 to acting class, where hours were spent.
At the end of the day, when Betty was tired,
 she cleaned the house since the maid was fired.
When Betty went to sleep she slept 'til eight,
 which wasn't enough 'cause she stayed up late.
Her schedule made school quick and easy,
 but later is what made Betty queasy.
After school she played in the band,
 the tuba, the flute, the saxophone and
 then after that she went to a tutor,
 because math and science just didn't suit her.
Busy Betty has so much to do
Does Busy Betty sound like you?

"I Am," Lauren Cannell (2002)

A high school student from the suburbs of Kansas City, Missouri, Lauren Cannell challenges the popular conception of girlhood offered by the teen magazines that target her as a potential reader. Clipping words and phrases from popular periodicals, Lauren creates her own expression of her identity as a girl: a strong, beautiful, spiritual, and confident young woman.

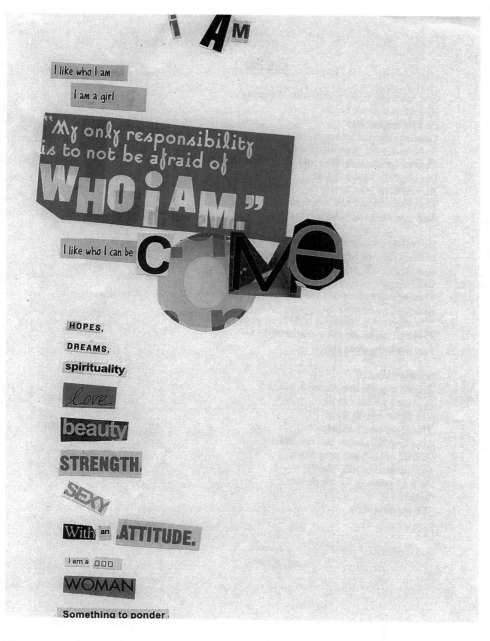

Clipping words from popular periodicals allowed Lauren Cannell to create a "found" poem that expresses her sense of identity. (Courtesy of Lauren Cannell)

Susanna Haswell Rowe
Courtesy University of
Virginia Library

Letters and Notes

A Girl's Life Eighty Years Ago, Eliza Southgate Bowne (1797–1802)

Epistolary writing has always been an important feature in the landscape of girls' reading and writing lives. From informal notes passed among friends in class to casual epistles addressed to distant family members, girls' letter writing has rightly been seen as an important means of sustaining relationships and building community. Letters can also, though, serve as a means by which girls further their education and exert their agency in the world as they make formal requests in writing to those who exercise authority over their lives.

Close study of the letters of Eliza Southgate Bowne reveal the many purposes epistolary writing fulfilled in her life. Born in 1783, Eliza Southgate was the third of Robert and Mary Southgate's twelve children. Young Eliza first attended school in her hometown of Scarborough, Maine. At the age of 14, she was sent to be "finished" at boarding schools near Boston. She eventually settled in the school at Medford run by Susanna Rowson, author of the best-selling novel, Charlotte Temple, *as well as other instructional texts for girls.*

The letters included here are addressed to Eliza's family members and friends: her father; mother; brother Horatio; sister Octavia, who also attended Mrs. Rowson's academy; and cousin Moses Porter. Eliza's epistolary efforts provide a glimpse into the unsystematic educational opportunities available to young women during the early national period. Though she often writes of social gatherings, fashion, and family news, Eliza's letters reveal how much she relished the formal studies she was able to pursue at boarding school. She reminds Octavia to treasure her own brief period of instruction and that upon leaving school, young women must rely on their own powers of observation for further education. In letters to Moses Porter, Eliza regrets that she had "learned to flutter about with a thoughtless gaiety . . . and left school with a head full of something, tumbled in without order or connection." She then announces to a seemingly skeptical Porter her own plans for systematic study and self-improvement. For more on Eliza Southgate Bowne's letters and girls' literacy in the early national period, see Janet Carey Eldred and Peter Mortensen's essay in this volume.

The Bowne house in which Elizabeth grew up. Scribner's Magazine 2, no. 1 (July 1894): 79. *Courtesy of Cornell University Library, Making of America Digital Collection.*

[to her brother, Horatio Southgate]

Medford, Oct. 17, 1797.

Dear Brother:

Yours of the 11th of Sept. was gratefully received by your affectionate Sister; and your excuse at first I thought not very good, but now I think it very good, for I have been plagued very much myself. William Boyd came from Portland about a fortnight since and by him I was informed that Sister Isabella's child was very sick and he was in doubt whether it would ever get over it. I feel for Isabella much more than I can tell you who is but just entered the bonds of Matrimony should so soon have sickness, and perhaps Death, be one of the guests of her family. I was also informed that the children had all got over the hooping cough and that Octavia was much healthier than she was before she had the small-pox. By my last letter from home Papa informed me that I might tarry all Winter and I have concluded to. I suppose you would like to know how I spend my time here. I shall answer, very well; my going abroad is chiefly in Boston, for I don't go out much in Medford. It was vacation about a week since and I spent it in Boston very agreeably.

I keep at Mr. Boyd's when I am there, and Mrs. Little's. I go to Boston every public day as Mr. B. is so good as to send for me. I am very fond of that family and likewise Mrs. Little's. You speak of my writing and you think that I have improved. I am glad of it. I hope I shall make as great progress in my other studies and be an "Accomplished Miss."

Horatio do write very soon; will you?

Adieu! your affectionate Sister
ELIZA SOUTHGATE.

[to her father, Robert Southgate]

Medford, Jan'y 9th, 1798.

My Good Father:

The contents of your letter surprised me at first; it may sometimes be of service to me, for while I have such a monitor, I can never act contrary to such advice. No, my Father, I hope by the help of Heaven never to cause shame or misery to attend the grey hairs of my Parents nor myself, but on the contrary to *glad* your declining years with happiness and that you may never have cause to rue the day that gave me existence. My heart feels no attachment except to my family. I respect many of my friends but *love* none but my Parents. Your letter shall be my guide from home, and when I again behold our own

peaceful mansion then will I again be guided by my Parents' happiness,—their happiness shall be my pursuit. My heart overflows with gratitude toward you and my good Mother. I am sensible of the innumerable obligations that I am under to you. You mention in your letter about my pieces, which you say you imagine are purloined; I am very sorry if they are, for I set more by them than any of my pieces; one was the Mariner's Compass, and the other was a Geometrical piece. I spent Thanksgiving at Mrs. Little's and Christmas here. I have finished my large Manuscript Arithmetic and want to get it bound, and then I shall send it to you. I have done a small Geometry book and shall begin a large one to-morrow, such a one as you saw at Mr. Wyman's if you remember. It is the beginning of a new year; allow me then to pay you the compliments of the season.—I pray that this year to you may prove a year of health, prosperity, and love. My quarter will be out the 8th day of next month, it will be in about four weeks. I wish you would write me soon how I am to come home—for I wish to know.

I should be very glad if *you* could make it convenient to come for me, for I wish *you* to come. Give my love to Irene and tell her I believe she owes me a letter; if you please you may tell her that part of my letter which concerns school affairs.

My love is due to all who will take the trouble to ask after me. Tell Mamma I have begun the turban and will send it as soon as I finish it. When I see her I will tell her why I did not do it before.

Accept my sincere wishes that My Parents may enjoy all the happiness that ever mortals know.

<div style="text-align: right">

Still I hope I am
Your *dutiful* Daughter,
ELIZA SOUTHGATE.

</div>

<div style="text-align: right">

Boston, February 13, 1798.

</div>

Hon. Father:

I am again placed at school under the tuition of an amiable lady, so mild, so good, no one can help loving her; she treats all her scholars with such a tenderness as would win the affection of the most savage brute, tho' scarcely able to receive an impression of the kind. I learn Embroidery and Geography at present and wish your permission to learn Musick. You may justly say, my best of Fathers, that every letter of mine is one which is asking something more; never contented—I only ask, if you refuse me, I know you do what you think best, and I am sure I ought not to complain, for you have never yet refused me anything that I have asked, my best of Parents, how shall I

repay you? You answer, by your good behaviour. Heaven grant that it may be such as may repay you. A year will have rolled over my head before I shall see my Parents. I have ventured from them at an early age to be so long a time absent, but I hope I have learnt a good lesson by it—a lesson of experience, which is the best lesson I could learn.

I have described one of the blessings of creation in Mrs. Rawson, and now I will describe Mrs. Wyman as the reverse: she is the worst woman I ever knew of all that I ever saw; nobody knows what I suffered from the treatment of that woman—I had the misfortune to be a favorite with Miss Haskell and Mr. Wyman, she said, and she treated me as her own malicious heart dictated; but whatever is, is right, and I learnt a good lesson by it. I wish you, my Father, to write an answer soon and let me know if I may learn music.—Give my best respects to my good Mother, tho' what I say to my Father applies to my Mother as much as to my Father. May it please the disposer of all events to return me safe home to the bosom of my friends in health safely. I never was happier in my life I think, and my heart overflows toward my heavenly Father for it; and may it please him to continue it and afford it to my Parents, is the sincere wish of

<div align="right">Your
ELIZA SOUTHGATE.</div>

[to her mother, Mary Southgate]

<div align="right">July 3rd, 1800.</div>

I believe, my Dear Mother, that you meant to give me a very close lesson in Economy—when you cut out the shirts for me to make. You had measured off the bodies of two and cut them part way in—and also the sleeves were marked,—after I had cut them off there was a quarter of a yard left. I now wanted the collars and all the trimmings. I made out after a great deal of planning to get out the shoulder pieces,—wrist-bands, 1 pair of neck gussets and one of sleeve do., are still wanting. I shall send this on by Mrs. Smith, and if you can find out when she returns I wish you would send some linen and some more shirts to make as I shall soon finish these, and can as well finish making up the piece here as at home. I was very sorry I did not wear my *habit* down as I shall want it when I go to Wiscassett. If you can possibly find an opportunity, I wish you would send it to me. Aunt Porter's child is one of the most troublesome ones I ever saw, he cries continually, and she is at present destitute of any help except a little girl about 12 years old. I wish, my Dear Mother, that you would forward all letters that come to Scarborough for me immediately. I hope you will enjoy yourself in Portland this week. I was almost

tempted to wish to stay a week there,——there were so many parties, and so gay every body appeared——that I longed to stay and take part. I forgot all about it before I got to Topsham,——much as I enjoy society I never am unhappy when without it,——I cannot but feel happy that I was brought up in retirement,——since from habit at least, I have contracted a love for solitude, I never feel alone when I have my pen or my book. I feel that I ought to be very happy in the company of such a woman as Aunt Porter, for I really don't know any one whose mind is more improved, and which makes her both a useful and instructing companion. Her sentiments and opinions are more like those I have formed than any person I know of. I think my disposition like hers, and I feel myself drawn towards her by an irresistible impulse, not an hour but she reminds me of you and I sincerely think her more like you than your own sister. I shall write you when I go farther East. I don't know what I shall do about writing Octavia, as Mrs. Rawson told her I wrote on an improper subject when I asked her in my letter if Mr. Davis was paying attention to Eleanor Coffin, and she would not let her answer the question. This is *refining* too much, and if I can't write as I feel, I can't write at all. Now I ask you, Mamma, if it is not quite a natural question when we hear that any of our friends are paid attention to by any gentleman, to ask a confirmation of the report from those we think most likely to know the particulars. Never did I write a line to Octavia but I should have been perfectly willing for you or my Father to have seen. You have always treated me more like a companion than a daughter, and therefore would make allowance for the volatile expressions I often make use of. I never felt the least restraint in company with my Parents which would induce me to stifle my gaiety, and you have kindly permitted me to rant over all my nonsense uncorrected, and I positively believe it has never injured. I must bid you good-night.

<div align="right">ELIZA</div>

Pray don't forget to send some more shirts.

[to her sister, Octavia Southgate]

<div align="right">Scarborough, Sept. 14, 1800.</div>

I suppose I ought to commence my letter with an humble apology, begging forgiveness for past offences and promising to do better in future, but no, I will only tell you that I have been so much engaged since I got home from Topsham that I could not write you. Martha tells us you were in Boston last Sunday. Mamma thinks, Octavia, you are there too much, we do not know how often, but we hear of you there very often indeed. I think, my dear sister, you ought to improve

every moment of your time, which is short, very short to complete your education. In November terminates the period of your instruction. The last you will receive perhaps ever, only what you may gain by observation. You will never cease to learn I hope, the world is a volume of instruction, which will afford you continual employment,—peruse it with attention and candor and you will never think the time thus employed misspent. I think, Octavia, I would not leave my school again until you finally leave it. You may—you will think this is harsh; you will not always think so; remember those that wish it must know better what is proper than you possibly can. Horatio will come on for you as soon as your quarter is out. We anticipate the time with pleasure; employ your time in such a manner as to make your improvements conspicuous. A boarding-school, I know, my dear Sister, is not like home, but reflect a moment, is it not necessary, *absolutely necessary* to be more strict in the government of 20 or 30 young ladies, nearly of an age and different dispositions, than a private family? Your good sense will easily tell you it is. No task can be greater than the care of so many girls, it is impossible not to be *partial,* but we may conceal our partiality. I should have a poor opinion of any person that did not feel a love for merit, superior to what they can for the world in general. I should never approve of such general love. I say this not because I think you are discontented, far from it— your letters tell us quite the reverse and I believe it. Surely, Octavia, you must allow that no woman was ever better calculated to govern a school than Mrs. Rawson. She governs by the love with which she always inspires her scholars. You have been indulged, Octavia, so we have all. I was discontented when I first went from home. I dare say you have had some disagreeable sensations, yet your reason will convince you, you ought not to have had. You had no idea when you left home of any difference in your manner of living. I knew you would easily be reconciled to it and therefore said but little to you about it. Yesterday Miss Haskell's letter, which I so much wished for and so highly prize, was sent me; tell her to trust no more letters to the politeness of Mr. Jewett, for he will forget to deliver them; he has been studying in the same office with Horatio ever since he returned and never told him he had a letter for me till I told Horatio to ask him. I did get it at last and will answer it as soon as I have an opportunity, which I expect soon, my letters are of too little consequence to send by Post. Tell Miss Haskell how highly I am obliged to her for every letter, and how much it gratifies me to have her write thus. My love and esteem ever awaits our good Mrs. Rawson, and hope she does not intend my last letter shall go unanswered. Susan Wyman is still

remembered as the companion of my amusements in Medford. Irene joins me in love to her. Betsey Bloom my love to her likewise.—Family are all well, Octavia, Sister Boyd is here, been with us several days. Let us hear from you when you have an opportunity. I should like to know how many tunes you play, but you have never answered any of my enquiries of this kind, therefore I suppose I ought not to make them.

Your
ELIZA.

[to her cousin, Moses Porter]

Sunday, Scarborough, May—, 1801.

When one commences an action with a full conviction they shall not acquit themselves with honor, they are sure not to succeed; imprest with this idea I write you. I positively declare I have felt a great reluctance ever since we concluded on the plan. I am aware of the construction you may put on this, but call it *affectation* or what you will, I assure you it proceeds from different motives. When I first proposed this correspondence, I thought only of the amusement and instruction it would afford *me*. I almost forgot that I should have any part to perform. Since, however, I have reflected on the scheme as it was about to be carried into execution, I have felt a degree of diffidence which has almost induced me to hope you would *forget* the engagement. Fully convinced of my inability to afford pleasure or instruction to an enlarged mind, I rely wholly on your candor and generosity to pardon the errors which will cloud my best efforts. When I reflect on the severity of your criticisms in general, I shrink at the idea of exposing to you what will never stand the test. Yet did I not imagine you would throw aside the *critic* and assume the *friend*, I should never dare, with all my vanity (and I am not deficient), give you so fine an opportunity to exercise your favorite propensity. I know you will laugh at all this, and I must confess it appears rather a folly, first to request your correspondence and then with so much diffidence and false delicacy, apparently to extort a compliment, talk about my inability and the like. You will not think I intend a compliment when I say I have ever felt a disagreeable restraint when conversing before you. Often, when with all the confidence I possess I have brought forward an opinion, said all my imagination could suggest in support of it, and viewed with pleasure the little fabric, which I imagined to be founded on truth and justice, with one word you would crush to the ground that which had cost me so many to erect.

These things I think in time will humble my vanity, I wish sincerely that they may.

Yet I believe I possess decent talents and should have been quite another being had they been properly cultivated. But as it is, I can never get over some little prejudices which I have imbibed long since, and which warp all the faculties of my mind. I was pushed on to the stage of action without one principle to guide my actions,—the impulse of the moment was the only incitement. I have never committed any grossly imprudent action, yet I have been folly's darling child. I trust they were rather errors of the head than the heart, for we have all a kind of inherent power to distinguish between right and wrong, and if before the heart becomes contaminated by the maxims of society it is left to act from impulse though it have no fixt principle, yet it will not materially err. Possessing a gay lively disposition, I pursued pleasure with ardor. I wished for admiration, and took the means which would be most likely to obtain it. I found the mind of a female, if such a thing existed, was thought not worth cultivating. I disliked the trouble of thinking for myself and therefore adopted the sentiments of others—fully convinced to adorn my person and acquire a few little accomplishments was sufficient to secure me the admiration of the society I frequented. I cared but little about the mind. I learned to flutter about with a thoughtless gaiety—a mere feather which every breath had power to move. I left school with a head full of something, tumbled in without order or connection. I returned home with a determination to put it in more order; I set about the great work of culling the best part to make a few sentiments out of—to serve as a little ready change in my commerce with the world. But I soon lost all patience (a virtue I do not possess in an eminent degree), for the greater part of my ideas I was obliged to throw away without knowing where I got them or what I should do with them; what remained I pieced as ingeniously as I could into a few patchwork opinions,—they are now almost worn threadbare, and as I am about quilting a few more, I beg you will send me any spare ideas you may chance to have that will answer my turn. By this time I suppose you have found out what you have a right to expect from this correspondence, and probably at this moment lay down the letter with a long sage-like face to ponder on my egotism.—'Tis a delightful employment, I will leave you to enjoy it while I eat my dinner: And what is the result, Cousin? I suppose a few exclamations on the girl's vanity to think no subject could interest me but where herself was concerned, or the barrenness of her head that could write on no other subject. But she is a *female,* say

you, with a *manly contempt*. Oh you Lords of the world, what are you that your unhallowed lips should dare profane the fairest part of creation! But honestly I wish to say something by way of apology, but don't seem to know what,—it is true I have a kind of natural affection for myself, I find no one more ready to pardon my faults or find excuses for my failings—it is natural to love our friends.

I have positively not said one single thing which I intended when I sat down; my motive was to answer your letter, and I have not mentioned my not having received it?—Your opinion of Story's Poems I think very unjust; as to the *man,* I cannot say, for I know nothing of him, but I think you are too severe upon him; a man who had not a "fibre of refinement in his composition" could never have written some passages in that poem. What is refinement? I thought it was a delicacy of taste which might be acquired, if not any thing in our nature,—true, there are some so organized that they are incapable of receiving a delicate impression, but we won't say any thing of such beings. I just begin to feel in a mood for answering your letter. What you say of Miss Rice—I hardly know how to refuse the challenge; she possesses no quality above mediocrity, and yet is just what a female ought to be. Now what I would give for a little *Logic,* or for a little skill to support an argument. But I give it up, for tho' you might not convince me, you would *confound* me with so many *learned* observations that my vanity would oblige me to say I was convinced to prevent the mortification of saying I did not understand you. How did you like Mr. Coffin? Write soon and tell me. We expect you to go to the fishing party with us on Tuesday. Mr. Coffin told us you would all come. You must be here by 9 o'clock (not before) (in the morning). My love to the girls, and tell them—no! I'll tell them myself.

<div align="right">ELIZA.</div>

[to Moses Porter, June? 28, 1802]
I hardly know what to say to you, Cousin, you have attacked my system with a kind of fury that has entirely obscured your judgment, and instead of being convinced of its impracticability, you appear to fear its justness. You tell me of some excellent effects of my system, but pardon me for thinking they are dictated by prejudice rather than reason. I feel fully convinced in my own mind that no such effects could be produced. You ask if this plan of education will render one a more dutiful child, a more affectionate wife, &c, &c., surely it will,—those virtues which now are merely practised from the momentary impulse of the heart, will then be adhered to from principle,

a sense of duty, and a mind sufficiently strengthened not to yield implicitly to every impulse, will give a degree of uniformity, of stability to the female character, which it evidently at present does not possess. From having no fixed guide for our conduct we have acquired a reputation for caprice, which we justly deserve. I can hardly believe you serious when you say that "the enlargement of the mind will inevitably produce superciliousness and a desire of ascendancy,"—I should much sooner expect it from an ignorant, uncultivated mind. We cannot enlarge and improve our minds without perceiving our weakness, and wisdom is always modest and unassuming,—on the contrary a mind that has never been exerted knows not its deficiencies and presumes much more on its powers than it otherwise would. You beg me to drop this crazy scheme and say no more about enlarging the mind, as it is disagreeable, and you are too much prejudiced ever to listen with composure to me when I write on the subject. I quit it forever, nor will I again shock your ear with a plan which you think has nothing for its foundation either just or durable, which a girlish imagination gave birth to, and a presumptuous folly cherished. I fear I have rather injured the cause than otherwise, and what I have said may have more firmly established those sentiments in you which I wished to destroy. Be it as it may, I believe it is a cause that has been more injured by its friends than its enemies. I am sorry that I have said so much, yet I said no more than I really thought, and still think, just and true. I beg you to say no more to me on the subject as I shall know 'twill be only a form of politeness which I will dispense with. You undoubtedly think I am acting out of my sphere in attempting to discuss this subject, and my presumption probably gave rise to that idea, which you expressed in your last, that however unqualified a woman might be she was always equipt for the discussion of any subject and overwhelmed her hearers with her "clack." On what subjects shall I write you? I shall either fatigue and disgust you with female trifles, or shock you by stepping beyond the limits you have prescribed. As I cannot pursue a medium I fear I shall be obliged to relinquish the hope of pleasing— of course of writing. Good night, I am sleepy and stupid. Morning. O, how I hate this warm weather, it deprives me of the power of using any exertion, it clogs my ideas, and I ask no greater felicity than the pleasure of doing nothing. I intended to amuse you with some of the trifles of the day, but I shall scarcely do them justice this morning. Friday night we had a ball,—the hall was decorated with much taste. 'Twas filled up for the *masons*. At the head of the room there was a most romantic little bower, four large pillars formed of

green and interspersed with flowers, supported a kind of canopy which was arched in front, with this inscription—"Here Peace and Silence reign," filled with a parcel of girls whining sentiment, and silly fellows spouting love, it produced a most laughable scene. The deities to whom it was dedicated withdrew from the sacred retreat, which was so profaned, and noise and folly reigned supreme,—so sweet a place,—so fine an opportunity for making speeches—'twas irresistible, even *you* would have caught a spark of inspiration from the surrounding glories,—and felt a degree of emulation at the flashes of genius that blazed from every quarter. Invention was on the rack, the stores of memory were exhausted and folly blushed to be so outdone. Mr. Symmes sat down to overwhelm me with a torrent of eloquence, yet his compassionate heart often prompted him to hesitate that I might recover myself. Such stores of learning did he display, such mines of wisdom did he open to my view, that I gazed with astonishment and awe and scarce believed "That one small head could carry all he knew." Mr. Kinsman with a countenance that beamed with benevolence and compassion gazed on all around, while a benign smile played round his mouth and dimpled his polished cheek, the laughing loves peeped from his eyes and aimed their never-failing darts—rash girl—too, too near hast thou approached this divinity—the poisoned dart still rankles in thy heart,—"The lingering pang of hopeless love unpitied I endure," and feel a wound within my heart which death alone can cure. Monday night—You will easily perceive that I am obliged to write when and where I can, I have not quite so much leisure as when at Scarborough, and though in the very place to *hear news,* I have no faculty of relating what I hear in a manner that could interest you. Last evening I spent in talking scandal (for which God forgive me) but was too tempting an occasion to be resisted. I wish you were acquainted with some of the Portland ladies, I would then tell you many things that might amuse. But I dare not introduce you to them, lest I should entirely mistake their character, and that when personally acquainted with them you would be confirmed in your opinion of my wanting penetration in studying characters. Yesterday I spent with Martha, I wish you were acquainted with her, she is truly an *original.* I never saw one that bore any resemblance to her. She despises flattery and is even above praise, beautiful without vanity, possessing a refined understanding without pedantry, the most exquisite sensibility connected with all the great and noble qualities of the mind. She knows that no woman in America ever was more admired, she has received every attention which could be paid and

yet is exactly as before she left Portland. The same condescension, the same elegance and unaffected simplicity of manners, the same independent and noble sentiments. Perhaps I am blinded to her faults, yet I think she deserves all I say of her, nay more, for she "outstrips all praise and makes it halt behind her." They have determined to go to England, in two months at farthest they will leave America, not to return for 2 years,—two years! how many, many events will have taken place. Perhaps ere that I shall rest in the tomb of my fathers forgotten and unknown!! Perhaps oppressed with care and borne down with misfortune, I shall have lost all relish for life—all hopes of pleasure may have ceased to exist and the grave of time closed over them forever. I grow gloomy, I wish I could write anything, but I have never felt a relish for writing since I have been in Portland,—at home it supplies the place of *society*, but here I need no such substitute.

ELIZA.

Write by the post if you have no other opportunity, the players will commence acting next Wednesday.

I believe it is the 28th.

Letters of Mary L. Hood, Pearl Hobart, and Nettie Conine, *St. Nicholas* (1876–1878)

Whereas letter writing is often a personal form of writing exchanged between family members and friends, the growth of the periodical press in the nineteenth century and the rise in national magazines designed for children created new opportunities for girls to exercise their epistolary talents and to address wider, less intimately known audiences.

The three letters below were published by the editors of St. Nicholas *in the late nineteenth century. Mary L. Hood's letter stands as an attempt to use epistolary practices as a means of broadening her educational opportunities. Hood's correspondence with* St. Nicholas *reveals how the magazine served as a surrogate teacher for her, and her description of early English literature merited editorial praise. "We consider your answer a very good one" was appended to Hood's letter when it appeared in the magazine*

Pearl Hobart chooses to share the story of her pet goose with her fellow readers of St. Nicholas. *Editors of the magazine may have chosen to publish Hobart's letter because her description of her kindness to the goose and her decision not to partake of the meal at which the goose was eventually served coincided nicely with widely circulating images of girls as caretakers and nur-*

turers. Jean Ferguson Carr notes in her essay in this volume that such stories of girls and their pets were popular in the late nineteenth century and can be seen as helping to prepare girls to participate in the antivivisection movement, just as other popular depictions of girls in textbooks and magazines reinforced the skills and attitudes girls might bring to bear in other philanthropic pursuits, social reform movements, and ladylike careers in teaching or social work.

The final letter included here, Nettie Conine's epistle of 1878, reinforces the message that the literacy practices engendered by children's magazines served to build relationships, even across vast distances. Not only does Conine reach a wide audience of other girls through her letter to the editor of St. Nicholas, she also reports on how the shared experience of reading the magazine allows for the formation of new friendships when she and her brother encountered strangers on a train.

Litchfield, Illinois.

EDITOR ST. NICHOLAS: As I am about to begin the study of English literature, I have written an answer to the first of the Harvard University questions published in the September SCRIBNER, getting my information from "Chambers' Cyclopædia of English Literature" (1847) and the "American Cyclopædia." I would like you to say how it would be received as an answer to the question if it was given in an examination. I did not feel sure whether I should go further back than Layamon, or whether to include the Scotch writers or not.

—Respectfully,

MARY L. HOOD (aged 14 years)

Question: What are the principal writings in the English language before Chaucer?

Answer: The beginning of English literature is generally accredited to the latter part of the twelfth century, when the Anglo-Saxon tongue began to be modified by the Norman-French. The oldest known book considered English is Layamon's translation of Wace's "Roman de Brut." This writer is considered the first of a series known as the "Rhyming Chroniclers." Among them, Robert of Gloucester wrote a rhyming history of England, and Robert Manning translated several French books. Besides these were metrical romances, generally reproduced from the Anglo-Norman, among which were "Sir Tristram," "Sir Guy," "The Squire of Low Degree," "The King of Tars," "Morte Arthure," etc. Among the immediate predecessors of Chaucer were Laurence Minot, a ballad writer, and Robert Langlande, the author of "Piers Plowman." Contemporary

with Chaucer were Sir John Mandeville, who wrote an account of his travels; John Wickliffe, the reformer, who translated the Bible and wrote several controversial works in English; and John Gower, the author of "Confessio Amantis."

San Francisco, 1877.

DEAR ST. NICHOLAS: I am ten years old, and of course am not expected to write as well as an old girl. I often see letters in your columns from little boys and girls, so I thought you might like to hear about a pet goose I had.

A little while before Christmas my uncle Charles gave my grandmother a goose. When he was brought to us his legs were tied up, and it hurt him very much. My cousin Ernest made a cage for him and he slept very nicely. In the morning when he woke up, he made such a racket that it woke us all up. For a while he was quite lonesome, and would call after everybody who passed his cage; but by-and-by he got over it and seemed quite contented. There being no pond for him to swim in, we gave him a bath in a tub as often as we could. I think you will laugh at his name. It was "Misery," because he loved company so much. The ants came in such numbers after his food that it became necessary to set a trap. My cousin Olive and I used to put him on a box and sit on each side of him and feed him, or we would sing to him. He was very fond of biting the buttons on our dresses, and one day he bit one off, and nearly swallowed it. We were very careful to protect our buttons after that.

But "Misery" grew thinner and thinner, and seemed so unhappy in spite of all we did for him, that my grandmother thought it would be best to kill him. So one morning before we were up she had him killed. We had him for dinner, but he was very tough. We are going to have a little dog soon, and perhaps I will tell you about him.

I like the ST. NICHOLAS better than any other magazine I ever read.—Yours truly,

PEARL HOBART.

P.S.—I did not eat any of the goose.

Two Rivers, Wis.

DEAR ST. NICHOLAS: I am not quite ten years old, but I am one of your oldest subscribers. We have every number from the very first. I have a brother Fred, two years older than I. We have always lived on the shores of Lake Michigan.

During the summer months, the steamer comes in from Chicago every morning. Fred and I like to get up early in the morning, and go down to the beach, before breakfast, to see the steamer go out; and, afterward, the morning train, for the station is near the beach. It is

lovely down there early in the morning; we dig wells, sail boats, and wade out after the waves that chase us back again.

We love the lake, and spend many happy hours down there. But sometimes it's a very wicked lake. Three weeks ago it blew very hard all night, and in the morning the waves were rolling up like mountains, and near the harbor pier there lay a wreck. Although they were so close to the town, and several other vessels were lying at anchor near, no one had heard, or seen, or knew anything about how it happened. It proved to be the "Magellan," of St. Catherine's, Ont. Since then nine bodies have washed ashore, among them the captain and his brother, the mate, both of them fine-looking young men, and not like ordinary rough sailors. The captain was a Knight Templar, and the Masons took charge of the body and sent it home, and some ladies made a beautiful cross of natural flowers, which they laid on his breast. But I will leave this sad subject, and tell you how we appreciate ST. NICHOLAS.

Last week we had a concert. There were several recitations from ST. NICHOLAS, besides the "Mother Goose Operetta" in the January number (1877). It was very pretty. There were fifteen children, all in handsome peasant costumes. I was Marie.

Last summer, when we came from the Centennial, in our Pullman car were two boys just Fred's age; one was from San Francisco and one from Chicago. Of course, the three were soon well acquainted, and had lots of fun together. And what do you think? They soon found out that each was a subscriber to ST. NICHOLAS! And how they enjoyed talking over the stories together! "Fast Friends" seemed to be the favorite; but I like "Eight Cousins" better.—

Respectfully yours,
NETTIE CONINE.

Letter Received by Mary Stuart (Robertson) Beard (1910)

Mary Stuart Robertson preserved in her scrapbook this note she received from her friend Eleanor. This note from the early years of the twentieth century reflects the ways in which girls use letter writing and note passing to build peer relationships. In this note, Eleanor is not only arranging to meet with Mary for tennis and sodas; she also reveals her strategy of using her epistolary talents to establish a friendship with another classmate, Christina, telling Mary that she "wrote another real lovely note" and that she hopes to receive "a nice one in return." Keenly aware of the power of words to bind together friendships, Eleanor also promises to share another product of her literacy—her memory book—

with Mary Stuart. This letter appears here courtesy of the Virginia Historical Society.

My Dearest Mary Stuart—

I am perfectly wild to play tennis this evening. Do you reckon it would be too wet to play? I bet you had a good time yesterday. I had a fine time. I wrote another real lovely note to Christina in which I told her that I loved to hear from her more than anything else on earth. I hope she will write me a nice one in return. Come up this evening with me at three to practice. I have to practice from three to half past and then we could go right on out to the park and meet Kimmy at the post office. If you are real good I will let you see my memory book sometime soon. I <u>love</u> to keep one. It is a good deal like a diary for I write all about how I got each thing in it. Lets go and get a soda this evening after we get through playing tennis or if we don't play after practice. I have now a plan to lay before your eyes. As soon as the quarter to two bell rings I will rush over and eat just as fast as possible and you stay here talking to Emma or Susan or someone and don't leave until the dinner bell at two and then I will try to be ready and go down home with you. See? I think old Miss Howard was a skunk to give you a task for a little thing like that. I never took the one Miss Simons gave me.

Your loving friend, ELEANOR

P.S. We simply have got to see Douglas! You know I am in love.

Letters of L.A. and L.B. (c. 1930s)

As well as solidifying relationships with families and friends, letters can also be a means by which girls make requests and seek action from those who wield control over their lives. Girls' letters allow literacy scholars to trace how writing affords girls a sense of agency as they seek specific ends and ask for permission or assistance.

The five letters below were written by two African American teenagers, L.A. and L.B., who had been remanded to a segregated state industrial home in the rural Midwest during the 1930s. In her research on this particular industrial home, Abby M. Dubisar discovered that many girls were placed there because their only parent—usually a mother—was employed as a live-in domestic servant and could not make a home for her own children. Other girls were remanded to the home for crimes ranging from vagrancy to theft.

In their letters, L.A. and L.B. write to "Mother," the home's superintendent. Astute rhetoricians, these young women often express their appreciation for the training that home has provided them, acknowledging the wisdom of "Mother dear" as she sought to improve their characters. In remorseful tones that are painful to read even today, the girls confess their perceived shortcom-

ings. Such demonstrations of gratitude and penance are intriguingly inter-twined with the girls' requests for greater privileges and more freedom.

It is also important to note, however, that just as literacy and letters can be a means by which girls can achieve their own desires, writing can also be used as punishment. Girls can be coerced into acknowledging transgressions and expressing their sorrow. L.A. defiantly announces at the opening of her first letter, "I am writing this against my will," and L.B.'s third letter is a desperate apology for an unnamed infraction against the rules of the home.

These two young women are identified here only by their initials to protect their privacy, and other names and identifying markers have been deleted. For more on the ways in which girls use letters to make requests and assert their agency, see in this volume Amy Goodburn's discussion of letters written by students at the Genoa Indian School. These letters appear courtesy of the Missouri State Archives.

LETTERS FROM L.A.

No Date.

Dear Mother,

I'm writing this against my will, but not for my benefit, but for the benefit of others I have gotten in trouble with. You have talked to me, you have beat me, and you have done everything that you could do to break me of the most disgraceful habit that one could have. And every time that I get in trouble it is the same thing. And I know you wonder why that ever time you put the least bit of faith in me that I let you down. And why you can't help me. Well Mother there are reason that I have kept from you as I have kept from others. And I haven't told a soul. I haven't had the courage to do so. And there haven't been anyone that I thought would understand.

Mother I remember once you told me I thought I was cleaner, and that I always tried to hide my dirty. Well I do not think that I'm cleaner, but I have always tried to keep that one thing away from you. And your matrons for I've reasons to do so. There are a few matrons here that I care a great deal for. And you know what it means to be disgraced in the presence of someone that would be ashamed of you, but that's my case and more. Mother, I'm not going to explain my past to you for I can't. But I'm going to try and let you read between the lines what I'm ashamed to say in these few words. <u>I didn't learn it here</u>. I knew it when I came, but that IS my trouble, and I can't help myself. I know you can't, Mother please don't tell anyone else. I told Mother _____ some, but I can't tell anyone all. So Mother please lock me up forever, I'm can't live like this and I

don't want too, you can help the others. But it is different with me. I've tried but I never go any length of time before I fall again for the same thing. So let me go, you have wasted too much precious time on me. It is in me and I know it but you don't know and I try to have some respect for myself.

<div align="right">L.A.</div>

June 15, 1936
Dear Mother,

I hope you will not misunderstand my letter or think of me as ungrateful. For I don't mean to be. For I am more than grateful for everything that you have done for me knowing that my conduct all along has not been worthy. So you see mother I'm more than grateful but I do want to go home to my father, tho I know nothing of his surroundings but I do know something is wrong somewhere for him to disregard me as he has done, but he is all that I can really say is my own and I will have to learn to keep out of trouble and stand on my own feet and now that I'm of age there must be some way, I have not seen my father in a long time and there must be something wrong that he has been so unconcerned about me and if anything happens I can say that I've tried to make my daddy see that I love him because he is all I have and the longer I stay here, the worst I feel as tho there is nothing for me to live for but I know there must be something and maybe Mr. and Mrs. _____ doesn't want me now and I could at least finish my other year of high school at home if I still wanted to go in Sept. but I'm just upset and worried. And Mr. and Mrs. _____ are the only people that I have been convinced [?] in, that I would have like to stayed with except my father and if they couldn't take me or wouldn't want to I have decide to go home to make the best of whatever I will have to face. But I will always be grateful to you with all my heart.

<div align="right">Yours gratefully,
L.A.</div>

<div align="center">LETTERS FROM L.B.</div>

No date
Dear Mother:

You told me I could talk to you as tho' you were my own mother. Mother, I realize that you're trying to do all that is within in power for me & I appreciate it greatly, but Mother couldn't I just be free like_____ or _____, they seem to have so much fun. Just let me be free, I could help around here & like that—anything so that I could

be free & could have good times as _____ & _____. Tomorrow I'll be 19—I love my cooking & I want to continue to learn to cook new things, but Mother isn't there someway I could be free & help around here & make a little money of my own? _____, _____, _____, & I have so much fun together I often wonder what it would be like to be free & could stay up as long as you like & se a movie or go in swimming or something like that. Please answer.

<div align="right">

Your daughter,

L.

</div>

No date

Dearest Mother:

Not meaning to worry you but I am writing to ask you if I will be ready to go by Monday—the first of Oct. so that I will be able to make up for the lessons I have missed so far in school. I appreciate greatly the interest you have taken in me, never in words will I be able to thank you enough. Only in deeds. Mother dear, I shall always re-member your training in which I have been taught & shall never wan-der from it. You have shown such a motherly interest in me. I'm sorry for all my past mistakes & shall try to profit by them. I shall never miss a Sunday service. It has helped me greatly with a nasty disposi-tion I have & it seems that as the days pass it is passing too. I <u>know</u> I can be good & I will. Hoping you'll let me know the date. So I'll be get my little petty things together (smile).

<div align="right">

I am

Your Loving Daughter

L.B.

</div>

[Writing on back side of letter]

When I leave could I go by_____ [different name]? See my fa-ther's name was _____ but as I was staying with my uncle—Mr. _____ _____ before coming here he had me go by _____. Do you think I could go by _____ instead of _____ being my right name.

<div align="right">

Thanks.

L.

</div>

No date

Dearest Mother:

I'm sorry that the trouble came up. I know you feel like not plac-ing trust in any of us. Please don't give up! Maybe such things occur sometimes for the best. Who knows? I see after many months of you repeating and scolding the points that you were driving at. Trust yourself. Trust yourself. Place it there within your own self. Have

faith. Trust is not what you can do when you are in the sight of a superior, but when you are alone without being watched, that's the time to be on your best behavior. Maybe you think that it's time I learned this, but mother dear, I'm really sorry for all the trouble that I've ever given you and I hope to be a lot better in the future—I want you to love and trust me. I do not want to be a parasite. Mother, don't give up hope with all the girls, that's what we have the Student Council for, to help you out; If it isn't any good, then do away with it! It's no help at all. Mother, please let me be a help around here—just give me a chance to prove to you that I can be SOMETHING in spite of the many mistakes that I have made. Let me free! And help out. I KNOW I could do. I want to get loose to see people and mingle with them. I really think I need a change. I've tried to grasp every opportunity that came my way although I may have missed many. Please don't keep me any longer; Mother, if only you could understand; I yearn for Freedom, not the freedom that most girls want but just to be Free. I could stay here and still be free. I could help here and do small odd jobs for you. But the constant grind of things, day after day and year after years is really getting me. Mother, please!

<div align="right">

Your Daughter,

L.

</div>

E-mail to Miriam Forman-Brunell from Martina Tepper (2002)

Today's girls are perhaps more likely to eschew pen and paper and use e-mail to correspond electronically with distant family members as well as with classmates and friends they see on a daily basis. Though e-mail communications are often brief and filled with a variety of recently spawned abbreviations and codes (e.g., f2f [face to face]; btw [by the way]; lol [laughing out loud]; and :) [smiley face]), this e-mail from a teenager in Philadelphia to her aunt reflects how girls can creatively fuse new forms of communication with older styles of speaking and writing. An avid reader of Jane Austen's novels, Martina Tepper adopts the nineteenth-century epistolary conventions deployed by characters like Elizabeth Bennet, Elinor and Marianne Dashwood, and Anne Elliot as she arranges a spring break trip to visit her aunt in 2002.

Date: Wed, 13 Mar 2002 19:42:24-0800 (PST)
From: Martina Tepper <shakenmartinii@yahoo.com>
Subject: Break!
To: Miriam Forman-Brunell <forman-brunellm@umkc.edu>
X-OriginalArrivalTime: 14 Mar 2002 04:09:12.0178 (UTC) FILE-

TIME=[FF53CD20:01C1CB0D]

My most esteemed aunt, Maple Avenue

Upon our last correspondance in which an invitation was so obligingly extended by you to spend the greater part of my spring vacations in the midst of your family and society in _____shire, I have been looking into changing the plans into reality. I am pleased to have procured for myself respectable means by which to travel thither and return, with the smallest possible pecuniary concern. Indeed, I seem to have a little of that tendency to economy that is so prevalent in our family. Oh, dear aunt, you shall wonder at my ever having found a price so low! But I shall keep you no longer in the dark: $206.00! Are not you amazed?

I hope I have not been so assuming as to plan to stay too long within your hospitality. Yet, I beg you, let me take leave to imagine that our friendship, excellent understanding, and sameness of mind may make us closer still, and let us prove false with this visit all that Mr. Benjamin Franklin could ever possibly have to say on the subject of guests. Now, that said, I have fixed the dates of my visit as March 28th to April 7th. I hope this will not be encroaching on your kindness for too long. If so, please, give me the smallest hint and I shall alter my plans in whatever manner you choose to best advise me. I entreat you to respond at your first leisure, so that I shall be made aware of your wishes as rapidly as is possible.

I am, etc., etc.

Do You Yahoo!?
Yahoo! Sports - live college hoops coverage
http://sports.yahoo.com/

Diaries

Diary of Anna Green Winslow, edited by Alice Morse Earle (1772)

Like all textual genres, diaries are continually developing new dimensions as writers revise the literacy traditions they have inherited. The history of diaries is particularly interesting: journal writing has in many ways come full circle, and the newest forms of web diaries have much in common with the diaries kept by girls in the eighteenth century. Young female diarists in earlier centuries regarded their journals as public documents to be scrutinized by parents and other authority figures. Only in the late nineteenth century did diaries become the most private of documents, quite literally kept under lock and key. In the twenty-first century, many girls create on-line journals and once again invite public response. Whether diaries are viewed as public or private documents, it is crucial to keep in mind that they, like other forms of girls' writing, are highly performative and are composed in complex cultural contexts that both enable and constrain what can be read and written.

Anna Green Winslow is the first diarist whose work is included here. While living in Boston with her Aunt Deming, Anna Green Winslow was placed under the tutelage of some of the most well-known educators in colonial America. She learned needlework from Mrs. Smith and attended Master Turner's dancing school. Her formal training in penmanship and writing was overseen by Master Samuel Holbrook of Boston's South Writing School, which Anna attended "after hours" when boys were not present.

Though twelve-year-old Anna's spelling is at times idiosyncratic and her aunt must occasionally "intreat" her to "do always as well" as she can with her pen, these excerpts from Anna's diary reveal how this young girl used reading and writing to draw together family and friends. Not a private document, Anna's diary was a way to inform her parents of her activities in Boston and to share family news and community events with them. She frequently mailed installments of the diary to her parents and younger brother in Cumberland, Nova Scotia, and eagerly anticipated their responses. See E. Jennifer Monaghan's essay on girls' reading and writing practices during the colonial period for more on Anna Green Winslow and her diary.

BOSTON January 25 1772.

Hon'd Mamma, My Hon'd Papa has never signified to me his approbation of my journals, from whence I infer, that he either never reads them, or does not give himself the trouble to remember any of their contents, tho' some part has been address'd to him, so, for the future, I shall trouble only you with this part of my scribble—Last

Original cover of Anna Green Winslow's diary, which was then published in 1896 by Houghton and Mifflin, the Riverside Press in Cambridge, MA, edited by Alice Morse Earle. Courtesy of Cornell University Library, Making of America Digital Collection.

thursday I din'd at Unkle Storer's & spent the afternoon in that neighborhood. I met some adventures in my way viz. As I was going, I was overtaken by a lady who was quite a stranger to me. She accosted me with "how do you do miss?" I answer'd her, but told her I had not the pleasure of knowing her. She then ask'd "what is your name miss? I believe you think 'tis a very strange questian to ask, but have a mind to

I hope aunt won't let one wear the black hatt with the red Dominie — for the people will ask one what I have got to sell as I go along street if I do. or, how the folk at Newgu nie do? Dear mamma, you dont know the fation here — I beg to look like other folk. You dont kno what a stir would be made in sudbury street were I to make ony appearance there in my red Domi nue & black Hatt. But the old cloak & bonnett together will make one a decent Bonnet for common scation (I like that aunt says, its a pitty some of the ribbin you sent wont do for the Bonnet — I must now close up this Journal. With Duty, Love, & Compli ments as due, perticularly to my Dear little brother, (I long to se him) & Mrs Law, I will write to her soon I am, Honr. Poppa & mama, Yr. ever Dutiful Daughter Anna Green Winslow.

N.B. my aunt Deming, dont approve of my English. tt has not the fear that you will think her concernd in the Dictons

know." Nanny Green—She interrupted me with "not Mrs. Winslow of Cumberland's daughter." Yes madam I am. When did you hear from your Mamma? how do's she do? When shall you write to her? When you do, tell her that you was overtaken in the street by her old friend Mrs Login, give my love to her & tell her she must come up soon & live on Jamaca plain. we have got a nice meeting-house, & a charming minister, & all so cleaver. She told me she had ask'd Unkle Harry to bring me to see her, & he said he would. Her minister is Mr Gordon. I have heard him preach several times at the O. South. In the course of

my peregrination, as aunt calls it, I happen'd in to a house where D—— was attending the Lady of the family. How long she was at his oppera-tion, I know not. I saw him twist & tug & pick & cut off whole locks of grey hair at a slice (the lady telling him she would have no hair to dress next time) for the space of a hour & a half, when I left them, he seeming not to be near done. This lady is not a grandmother tho' she is both old enough & grey enough to be one.

Jany 31.——I spent yesterday with Aunt Storer, except a little while I was at Aunt Sukey's with Mrs Barrett dress'd in a white bro-cade, & cousin Betsey dress'd in a red lutestring, both adorn'd with past, perls marquesett &c. They were after tea escorted by Mr. New-ton & Mr Barrett to ye assembly at Concert Hall. This is a snowy day, & I am prevented going to school.

Feb. 9th.——My honored Mamma will be so good as to excuse my useing the pen of my old friend just here, because I am disabled by a whitloe on my fourth finger & something like one on my middle fin-ger, from using my own pen; but altho' my right hand is in bondage, my left is free; & my aunt says, it will be a nice oppertunity if I do but improve it, to perfect myself in learning to spin flax. I am pleased with the proposal & am at this present, exerting myself for this pur-pose. I hope, when two, or at most three months are past, to give you occular demonstration of my proficiency in *this art,* as well as several others. My fingers are not the only part of me that has suffer'd with sores within this fortnight, for I have had an ugly great boil upon my right hip & about a dozen small ones—I am at present swath'd hip & thigh, as Samson smote the Philistines, but my soreness is near over. My aunt thought it highly proper to give me some cooling physick, so last tuesday I took 1–2 oz Globe salt (a disagreeable potion) & kept chamber. Since which, there has been no new erruption, & a great al-teration for the better in those I had before.

I have read my bible to my aunt this morning (as is the daily cus-tom) & sometimes I read other books to her. So you may perceive, I *have the use of my tongue* & I tell her it is a good thing to have the use of my tongue. Unkle Ned called here just now—all well—by the way he is come to live in Boston again, & till he can be better accomodated, is at housekeeping where Mad^m Storer lately lived, he is looking for a less house. I tell my Aunt I feel a disposician to be a good girl, & she pleases herself that she shall have much comfort of me to-day, which as cousin Sally is ironing we expect to have to ourselves.

Feb. 10^th.——This day I paid my respects to Master Holbrook, after a week's absence, my finger is still in limbo as you may see by the writing. I have not paid my compliments to Madam Smith, for, altho'

I can drive the goos quill a bit, I cannot so well manage the needle. So I will lay my hand to the distaff, as the virtuous woman did of old— Yesterday was very bad weather, neither aunt, nor niece at publick worship. . . .

March 4th.—Poor Mrs Inches is dead. Gone from a world of trouble, as she has left this to her poor mother. Aunt says she heartyly pities Mrs Jackson. Mr. Nat. Bethune died this morning, Mrs Inches last night.

We had the greatest fall of snow yesterday we have had this winter. Yet cousin Sally, miss Polly, & I rode to & from meeting in Mr Soley's chaise both forenoon & afternoon, & with a stove was very comfortable there. If brother John is as well and hearty as cousin Frank, he is a clever boy. Unkle Neddy continues very comfortable. I saw him last saturday. I have just now been writing four lines in my Book almost as well as the copy. But all the intreaties in the world will not prevail upon me to do always as well as I can, which is not the least trouble to me, tho' its a great grief to aunt Deming. And she says by writing so frightfully above.

March 6.—I think the appearance this morning is as winterish as any I can remember, earth, houses, trees, all covered with snow, which began to fall yesterday morning & continued falling all last night. The Sun now shines very bright, the N. W. wind blows very fresh. Mr Gannett din'd here yesterday, from him, my unkle, aunt & cousin Sally, I had an account of yesterday's publick performances, & exhibitions, but aunt says I need not write about 'em because, no doubt there will be printed accounts. I should have been glad if I could have seen & heard for myselfe. My face is better, but I have got a heavy cold yet.

March 9th.—After being confined a week, I rode yesterday afternoon to & from meeting in Mr Soley's chaise. I got no cold and am pretty well today. This has been a very snowy day today. Any body that sees this may see that I have wrote nonsense but Aunt says, I have been a very good girl to day about my work however—I think this day's work may be called a piece meal for in the first place I sew'd on the bosom of unkle's shirt, mended two pair of gloves, mended for the wash two handkerchiefs, (one cambrick) sewed on half a border of a lawn apron of aunts, read part of the xxi[st] chapter of Exodous, & a story in the Mother's gift. Now, Hon[d] Mamma, I must tell you something that happened to me to-day, that has not happen'd before this great while, viz My Unkle & Aunt both told me, I was a very good girl. Mr Gannett gave us the favour of his company a little while this morning (our head). I have been writing all the above gibberish while

aunt has been looking after her family—now she is out of the room—now she is in—& takes up my pen in *my* absence to observe, I am a little simpleton for informing my mamma, that it is *a great while* since I was prais'd because she will conclude that it is *a great while* since I deserv'd to be prais'd. I will henceforth try to observe their praise & yours too. I mean deserve. It's now tea time—as soon as that is over, I shall spend the rest of the evening in reading to my aunt. It is near candle lighting.

March 10, 5 o'clock P.M.—I have finish'd my stent of sewing work for this day & wrote a billet to Miss Caty Vans, a copy of which I shall write on the next page. To-morrow if the weather is fit I am to visit. I have again been told I was a good girl. My Billet to Miss Vans was in the following words. Miss Green gives her compliments to Miss Vans, and informs her that her aunt Deming quite misunderstood the matter about the queen's night-Cap. Mrs. Deming thou't that it was a black skull cap linn'd with red that Miss Vans ment which she thou't would not be becoming to Miss Green's light complexion. Miss Green now takes the liberty to send the materials for the Cap Miss Vans was so kind as to say she would make for her, which, when done, she engages to take special care of for Miss Vans' sake. Mrs. Deming joins her compliments with Miss Green's—they both wish for the pleasure of a visit from Miss Vans. Miss Soley is just come in to visit me & 'tis near dark. . . .

March 21.—I din'd & spent the afternoon of Thursday last, at Mrs Whitwell's. Mrs Lathrop, & Mrs Carpenter din'd there also. The latter said she was formerly acquainted with mamma, ask'd how she did, & when I heard from her,—said, I look'd much like her. Madam Harris & Miss P. Vans were also of the company. While I was abroad the snow melted to such a degree, that my aunt was oblig'd to get Mr Soley's chaise to bring me home. Yesterday, we had by far the gratest storm of wind & snow that there has been this winter. It began to fall yesterday morning & continued falling till after our family were in bed. (P.M.) Mr. Hunt call'd in to visit us just after we rose from diner; he ask'd me, whether I had heard from my papa & mamma, since I wrote 'em. He was answer'd, no sir, it would be strange if I had, because I had been writing to 'em today, & indeed so I did every day. Aunt told him that *his name* went frequently into my journals together with broken & some times whole sentences of his sermons, conversations &c. He laugh'd & call'd me Newsmonger, & said I was a daily advertiser. He added, that he did not doubt but my journals afforded much entertainment & would be a future benefit &c. Here is a fine compliment for me mamma. . . .

April 15th.—Yesterday I din'd at Mrs. Whitwell's & she being going abroad, I spent the afternoon at Madm Harris's & the evening at home, Unkle Harry gave us his company some part of it. I am going to Aunt Storer's as soon as writing school is done. I shall dine with her, if she is not engaged. It is a long time since I was there, & indeed it is a long time since I have been able to get there. For tho' the walking has been pretty tolerable at the South End, it has been intolerable down in town. And indeed till yesterday, it has been such bad walking, that I could not get there on my feet. If she had wanted much to have seen me, she might have sent either one of her chaises, her chariot, or her babyhutt, one of which I see going by the door almost every day.

April 16th.—I dined with Aunt Storer yesterday & spent the afternoon very agreeably at Aunt Suky's. Aunt Storer is not very well, but she drank tea with us, & went down to Mr Stillman's lecture in the evening. I spent the evening with Unkle & Aunt at Mrs Rogers's. Mr Bacon preach'd his fourth sermon from Romans iv. 6. My cousin Charles Storer lent me Gulliver's Travels abreviated, which aunt says I may read for the sake of perfecting myself in reading a variety of composures. she sais farther that the piece was desin'd as a burlesque upon the times in which it was wrote,—& Martimas Scriblensis & Pope Dunciad were wrote with the same design & as parts of the same work, tho' wrote by three several hands.

April 17th.—You see, Mamma, I comply with your orders (or at least have done father's some time past) of writing in my journal every day tho' my matters are of little importance & I have nothing at present to communicate except that I spent yesterday afternoon & evening at Mr Soley's. The day was very rainy. I hope I shall at least learn to spell the word *yesterday,* it having occur'd so frequently in these pages! (The bell is ringing for good friday.) Last evening aunt had a letter from Unkle Pierce, he informs her, that last Lords day morning Mrs Martin was deliver'd of a daughter. She had been siezed the Monday before with a violent pluritick fever, which continued when my Unkle's letter was dated 13th instant. My Aunt Deming is affraid that poor Mrs Martin is no more. She hopes she is reconcil'd to her father—but is affraid whether that was so—She had try'd what was to be done that way on her late visits to Portsmouth, & found my unkle was placably dispos'd, poor Mrs Martin, she could not then be brought to make any acknowledgements as she ought to have done.

April 18th.—Some time since I exchang'd a piece of patchwork, which had been wrought in my leisure intervals, with Miss Peggy

Phillips, my schoolmate, for a pair of curious lace mitts with blue flaps which I shall send, with a yard of white ribbin edg'd with green to Miss Nancy Macky for a present. I had intended that the patchwork should have grown large enough to have cover'd a bed when that same live stock which you wrote me about some time since, should be increas'd to that portion you intend to bestow upon me, should a certain event take place. I have just now finish'd my Letter to Papa. I had wrote to my other correspondents at Cumberland, some time ago, all which with this I wish safe to your & their hand. I have been carefull not to repeat in my journal any thing that I had wrote in a Letter either to papa, you, &c. Else I should have inform'd you of some of Bet Smith's abominations with the deserv'd punishment she is soon to meet with. But I have wrote it to papa, so need not repeat. I guess when this reaches you, you will be too much engag'd in preparing to quit your present habitation, & will have too much upon your head & hands, to pay much attention to this scrowl. But it may be an amusement to you on your voyage—therefore I send it.

Pray mamma, be so kind as to bring up all my journal with you. My Papa has promised me, he will bring up my baby house with him. I shall send you a droll figure of a young lady, in or under, which you please, a tasty head Dress. It was taken from a print that came over in one of the last ships from London. After you have sufficiently amused yourself with it I am willing . . .

Boston April 20, 1772.—Last Saterday I seal'd up 45 pages of Journal for Cumberland. This is a very stormy day—no going to school. I am learning to knit lace.

Diary, Elizabeth Ann Cooley McClure (1842–1844)

Elizabeth Ann Cooley McClure was born in 1825 and grew up in rural Virginia. In these excerpts from her journal, seventeen-year-old Elizabeth expresses her chagrin at the lack of educational opportunities available to her, and she writes poignantly of her longing to know more of the world beyond her family's farm and her Quaker community.

Though Elizabeth's journal entries reveal her anxiety about the lack of romance in her life and her desire to "have some fond heart to beat in unison with," she did marry James McClure on February 25, 1846. The newly wed couple then moved West. At the age of twenty-two, Elizabeth contracted a fever and died. Her husband made a few final entries in her diary, recording his love for her and documenting her death. Excerpts from the journal Elizabeth Ann Cooley McClure kept after her marriage have been printed in the Missouri His-

torical Review *60 (1966): 162–206. The excerpts printed here appear courtesy of the Virginia Historical Society.*

Sept. the 4th: For sometime I have not wrote any. During that time I have seen but little for I have not went anywhere much—though I went to meeting last Sunday and to Coxes the Sunday before—and nobody has been here. I feel like a isolated being living alone and neglected by all but those I live with. I have been very busy spinning and weaving. All the wool is spun up. Of course I read all Sundays. I have read Marriatts novels and most through Bullwers. It is very warm today; the garden looks pretty but it seems almost useless to have it and no eyes but ours to gaze on its loveliness. I wonder how long things will remain in such a state and if I always must stay here doing nobody good.

Sept. 24th: I have written the first piece of poetry I ever attempted to make this day. Dr. Stoneman and J. W. McClure stayed here last night and till the afternoon. We passed the time in writing, in singing, and talking English Grammar etc. but they are left here now and perhaps to return no more. It is hard to part with those we have been intimate with for years but it must be so. It appears that almost everybody will go to the West. James is going to, and we are to be left all alone like isolation had spread its darkness over all.

Nov. 20th, 1842: My time is not spent to my satisfaction along of late. I am busy as can be but it is still work in the house, such as sewing or something of the kind, I would prefer a more busy life. I would sacrifice most anything to gain my livlihood by my own work and to know that I lived altogether on my own exertions. It would be a satisfaction beyond description. James has commenced to learn to Last Monday which was the 14th of November was the first time they fed the cows this year. It is very cold today. We have had two snows this year, and according to prophecy we will have eight more.

Jan. 22nd, 1843: I came home last Saturday from J. P. W.'s where I had spent six of the last weeks. The time passed rapidly on. I worked and nursed and talked or was gone somewhere, or something, it constantly kept my bodily and mental faculties in operation. I love a busy life a great deal the best, but I like solitude and retirement sometime better than any company. Here it is a death-like stillness most all the time. There is but seven in the family here now. A J C is gone home with Rebecca. James he is in the brown studies or something worse and all seems tending to the same point—that is to sour and embitter our moments. It should be spent in peace, love and harmony with each other here. It seems like duller times than anywhere else. There

is no trading or association carried on in this settlement; the people are all too selfish and careless about schools to assist in any such improvement on the minds of their children. While I was gone I seen several young men I never had seen before but loved none of them. but highly respected them for their honest and industrious qualities and one I thought with further acquaintance I could love, but alas, "I had as well court some bright and particular star and hope to wed it." Therefore I dropped the idea at once and remain selfish and dormant still.

Jan. 29th. This day James went to meeting. I could have went if I had wished it—but it was cold and I had some newspapers I wished to peruse—the Western Missouri and Brother Jonathan. Mother went to Thomas Williams to see his wife who is at the point of death. Last Monday we received a letter from Brother Martin. He is in Charleston South Carolina and expects to go to Missouri in the spring, and also received one from Wm. stating that they were all enjoying good health. I wish I was there, or had the chance to go to see some of the wide and broad world more than I ever have seen for I live in seclusion and I reckon a moderate portion of happiness. No one has been here today except H. Kenny came here last night to get Mother to go to Silases to the birth of his second son.

Feb. the 19th. It is a very pretty day and I expect Julian and Ika & myself will go to Coxes this evening. Amanda has gone to Jesse's and has been there five weeks. James is gone rabbit hunting. All the rest is here.

I now have kept my journal one year lacking one day. A great many things have happened but nothing of importance. I wish I could only glance over a detail of the next year even in as rude manner as this scrap gives. . . .

October the 1st, 1843. September is gone, peaceful as the evening shade of summer. Today has been a beautiful day. This morning James started to Jesse's and took the little wagon to bring home the bedstead and Creas Higgins and Fannie stayed here last night. I last week handed in a piece and spun blanket. Amanda has been weaving Rebecca's jeans. John South was here today and traded for Mother's butter and perhaps we will get to send our cloth to Salem to get it colored. If so, James is to take it to him when he comes from court. All of us gang that travels togathers of Sundays went to Nathan Davises to get a large crock to put honey in. We took up our bees last week. All is busy these days, but we will soon be through with our work and then my <u>hope</u> is all concentrated on going to <u>school</u>.

October 8th. I went to the school house to a disappointment,

and then I went after chestnuts but without success. Last week I piddled about drying fruit & c. Amanda wove. It is planed off for Amanda and Julian to go to H.V. next week. We have sent our cloth off to get it colored. My hope now is school from Rosenbaum or Campbell.

October 15th. I have been weaving Julian and Mother and myself some dresses. Amanda and Julian started to Carrolton this morning. I have been at home all day reading Hydro statics, etc. Frost has come at last, it made its appearance on the 10th. We have taken up our fall flowers.

October 22nd. Another week is passed, another Sunday passing and I am still here longing and constantly desiring something to enlighten my contracted and perplexed mind, for what can I do? My only and best chance is to hoard up learning sufficient to allow me to teach a school, and I lack so much it perplexes me to think of it, to get Grammar and Arithmetic and how to govern a school &c. Last week we put away apples for winter and I wove some and made my cotton dress. All is busy now and doing well at present, and Heaven forbid that there shall be any brawls and contentions in this innocent family. . . .

November, Sunday 5th, 1843. Last Monday I went to Mill and to John * * and to Mrs. Stoneman's. There I found a book entitled Biglands History of Animals and Birds. They lent it to me and I have been reading it. Tuesday Amanda and myself went to Aunt Mary's to a sewing. I there was truly disgusted at the crafty meaness of the worldly people, and Wednesday I wove on Polly Ward's counterpane and I want to put in a piece of table cloth for Jestin. Thursday Julian and me went to Delia Hankses to a quilting. There were a gang of ignorant fools. and Saturday our corn was husked. They got done by 3 o'clock and then foot racing, wrestling and dancing and debating and blowing the fire coal had to be done. N.I. King had a book here, the Parlor Letter writer. John Fulks stayed all night here. James is gone to Carroll Court, Father reading geography, Mother Biglands History, Julian dictionary, Amanda journalizing! Ika gadding about the house. Jincy spelling. The trees of the forest are changed to a hard grim red to aid in painting the chilly gloom of Autumn, but oh, the Fall Flowers are too beautiful, too sweet and delicate to be mingled with the balance of this contaminated world where guilt often meets applause and virtues by diffidence are lost in the dark shades of oblivion. Like me the Flowers are kept close from the resplendent beauty of light, likewise from the icy frosts and also from the beaming love, streaming from the eyes of the fond Florist whose very soul could melt in tears for their sake. . . .

Dec. 10th. We have finished Amanda's dress, put in and quilted my quilt and made James a wescoat. Lowell Shoat was here Saturday, and James came home that evening and next day went to Carroll Court, him and Frank. Amanda and myself went to Joshua Hankses a visiting. We made Stephen Sink a blue coat and James a pair of coarse pair of pantaloons. I have finished my flax hose, and knitting one pair of gloves. Frank and James has been choping; last Thursday Mr. Banner was here and sold Papa some leather. Yesterday I went and got Abner to come and cut out our shoes. Today Calvin Jones is to be buried. I had liked to have went but Fate, Alas forbade the trip, it bade me do as usual, stay at <u>home</u>, read, fret, study, grieve and journalize. But even now me thinks amidst the gloominess of thought perhaps it is for the best; perhaps it is for some design of the All wise Creator that I was born in this lone and solitary spot to accomplish some ends.. I otherwise would be unfit; but for all this I have no real proof, No! it is the silent whisperings of prophetic hope, blest consoling word, my staff of life my all is <u>hope</u>.

Nobody has been here today but Tom Thorp and Ben. None of us has been anywhere today, but James and Ika went to the schoolhouse to debate but no one attended, so James and Frank went off with Ben. I have tried to make poetry but all in vain. Oh God of Mercy be with me, guide me through the mazes of this ever varying world, let me not fall in the gulf of annihilation without one dubious hope of Heaven, and if my happiness is all to be measured out on this earth, oh could have some fond heart to beat in unison with my own. not live in a world of my own, nobody knowing, nobody caring for me. But oh me, why do I repine, why is it not the will of God. Yes, oh God, have I offended thee? I ask, I pray for forgiveness, for my heart and mind is carnal.. not my will but thine be done. . . .

Dec. 31st. Last week we made James Williams a coat and Dr. McCament came here Friday to get Amanda to cut him out a pair of pants and coat to make. We sat up at Coxes another night, and nobody but Ben and Solomon with us. We are getting very intimately acquainted with them all. Campbell came last Thursday, James and him tried all day to get a school but with poor success. I am fearful he will not make it up, if he does. It will either make or break my happiness, for all my hopes are concentrated in that school. Julian and myself went yesterday to Jincy Hankses to a quilting and strange doings happened. Mr. Charles Malory and Robert Dobson came with us across Coal Creek. It was a long and interesting walk. Dobson says he wants to go to school to E. Campbell, but I am very fearful he cannot get anywhere to board. Strange world this is.

Jan. 7th, 1844: Oh Journal sweet Journal I come unto thee my head full of romance.. my bosom is free; I long for a lover but I long in vain, I long for to love and be loved again. But hoping and wondering I still must remain uneasey, unsettled, foolish and vain; Last week we made Elige Low a coat. Wednesday Charles Mallory came here going to N.D.'s sale, got Julian some candy. They killed hogs that day. J.P.W. came home with James from court and wants Amanda to go to his house to make him some coats. She is going Tuesday. Campbell is gone.. no school, but I do not feel so bad about as I expected I would. Several persons has been here last week. Jiny Davis & Polly Cox is both getting well. A change of things I think is taking place or a "change came o'er the spirit of my dream." I scarce know how I feel. I don't know what plan to next adopt. for to keep school I am not adequate. I want something, I do not know what. We were all weighed last Sunday. I weighed 121, Amanda 140. No person but Alexander McCament came after the Doctor's coat and Jerry Ward after his watch. We have all stayed at home but James and Frank went to Clay's schoolhouse to a debate. My hair is platted and tied up today. . . .

Aug. 4th, Sunday after dinner. Mother and James are started to Jesse's. Father & Julian & Ika are gone to the new ground. I am here this still old place, no person coming, no where to go, nothing to divert but read some <u>borrowed</u> newspapers. What—Oh! what I am living for, to drag out few miserable years in solitude, to struggle on from time to time to raise myself in this world, and for what? To be more unhappy? And for what am I keeping this tedious old Journal for? No purpose—no good. no nothing but the present past time, the pleasure of pouring out my whole soul, for this journal will never tire of my presence and abruptly leave me like human mortals do, neither will it abuse me for complaining of hard times etc. Sometimes it appears that I ought to be happy, but it is <u>hard</u> to be, so confined by body and mind to be so lonesome, so odd and so distant from all my fellow travellers in this fantastic world of ours.

We have been spinning wool and putting in a piece of jeans, raking hay and everything, busy etc.

Diary, Helen Stewart (1853)

Born in Pennsylvania in 1835, seventeen-year-old Helen Stewart set out with her family for Oregon in 1853. Though Stewart's spelling and punctuation are unconventional, her diary records with elegant simplicity the hardships girls experienced as they crossed the North American continent in wagon trains. Stewart describes terrifying thunderstorms, dangerous river crossings, and live-

stock accidents as well as the monotony of making camp, gathering wood, locating potable water, and preparing meals.

Though westward emigration in the mid-nineteenth century was a tremendously challenging endeavor, it could also be a liberating experience as many genteel norms and domestic proprieties were left behind on the eastern seaboard. While Helen laments that the travelers no longer keep the Sabbath as a day of rest and worship, she also seems to relish that she is able to indulge her wish to go swimming with the boys. Just as gender roles may have become more flexible, so too were racial stereotypes revised as a result of new encounters. Not the screaming Indians who haunted Helen's dreams during the early stages of her journey, the Native Americans who approached the Stewart wagon train were interested in a peaceable trading relationship, and Helen meets some of the "prittyist girls . . . drest so nice after their own fashion."

Despite the many demands on her time and energies, Helen Stewart was a dedicated diarist, often writing and reading by lantern light in the cramped confines of a wagon at night. These excerpts appear here with the permission of the Bancroft Library, University of California, Berkeley.

April the 1
we took pasage in the steamer arctic at pittsburg for oregon and started for oregon and started the 2 I enjoyed myself as well as could be expected the people were all very agreeable indeed I was sorrow when I had to leave some of them I never went out to see eny of the places that we stoped at but there is some splended scenry along the banks of the river the Misouri looks very strange beside the clear waters of the Ohio

there was no moonlight while we was coming up to st. louis which I was very sorrow for, as the arctic was not going eny farther we have to go on the honduras to st. Joseph it was not neer so pleasant as the arctic it was very nice comeing up the Misouri there was such romantic looking rock towering away up it brought me in mind of some old runned castle I have read about and the shot tower look so strang siting away up on the top of thoes high rocks

one eavening we past where there was a fire kindled in the woods and it was winding and spreading along the side of the hills it indeed looked beatiful and oh you could see it so far it was so beautiful on the water then the moon was shineing bright, it aded more beauty to the romantic sceniry round there was some terable storms, we got to St. Joseph on wed the 20 in the night and we staid on board all night but with all the moonshine and stormes we arive all well and we was glad to see each other again after the short seperation we are camping about two miles out from town by black snake creek

Aprile 29

nothing particular has happened today just the old round of hunting cattle and trailing about I have been trying to fish but cannot catch eny onely little ones

Aprile 30

part of our company has started and we are to meet them at the ferry the whippoorwills are chirping and they bring me in mind of our old farm in pensillvania the home of my childhood where I have spent the happiest days I will ever see again

May 1

this is sabeth it has been very stormy but it has past over and all nature seems revived everybody is rapt in there own immagination some is writing some reading and some is stroleing about I feel rather lonesome today oh solitude solitude how I love it if I had about a dosen of my acquaintances to enjoy it with me . . .

May 3

I think we will get started today I will not say much about the road we came eny more than we had a great deal of trouble we was within three miles of the ferry when the ferry boat sunk and dround three men one of them was an imigrant his widow and family is in our companey now we will have to go to Iowa point

May 4

we are getin along pretty well stiking in mud holes and dubling teames all the time we pass two little towns they ware nice little places oregon and savanna oregon has a very nice courthouse in it the houses in them is nearly all one story and a half high

this is sabeth day we are going to cross the nodaway river today it is a beautiful small stream clear water then there is a long hill to go up then the road winds along the top of the hill it is a good road all the way there is some good looking farmes as far as you can see

we come now to the Missouri and cross we travel a peace when Stewart broke his wagon he will have to wait and get it mended we are going and is to wait at the big blue for them there was a little boy died belonging to one of the company there is a good many laid by the rode side who no doubt have dear loving friends to mourn their loss

there is nothing for your eye to meet but far spreading prairie and now and then a few wagons and some droves there is one hill after another it looks beautiful to look around and see the groves of trees winding among the hills and the clear water murminding along in the fragnant shade indeed it looks so inviting one can not withstand the temptation of enjoying it a little while

This is 14

we have got to the minehaw creek it is bad crossine but midling good grass we camp here there is some of the streams bridge and we paid tole but ther was some that would not do it and the Indians followed them two days and we heard that there was some that had all there horses and cattle stolen I believe it was the same ones . . .

May 17

it is fine this forenoon and Agnes and I have been walking and have passed the wagon and we are good peace before them so we have sat down at the side of a little run to waid untill they come up it has been rather stormy this afternoon they had just got the oxen waterd and well started again when there came up a hailstorm and some of the oxen was unhiched quicker then ever they ware but it has turned to rain and the sun is shineing out through the clouds and is seting lovely al the cattle are eating buisly there are very tired tonight we heard the wolves hollowing one night which makes me feel very eary it is lightning all round and the face of the moon is obscured under dark clouds and the wind is blowing and I am in the wagon trying to write a little the lantern is tied to the ridge pole every body is in bed but agnes and myself i believe and we would be there to but we have to wait till the apples are stewed enough the watch are walking about to see if all is write

May 18

it is dreadful cold and the wind is blowing so hard and so cold that we cannot get any breckfast indeed I never got out of the wagon atall three wagons past us to that had the covers torn of them I fear they suffered from the hail and wind

we stopt at a place where there is a small creek and some wood and we breckfast and dinner all at one we camped by a small creek I do not know the name of it it is a beautiful night the moon is shineing very clear and I onely see one white cloud in the sky we hear the Indians are very troublesome before but we have not had any trouble with them yet there is 10 wagons in the company now and we are all well but Lizzy and she has the erisipelis and the children has the houghpin cough . . .

May 21

oh it is warm it is lightening round and round as the appearance of _____ at last the thunder begins to role the lightning flash and the erefick black clouds moves in all there terrifying grand _____ that I think evry minit the covers will be torn of or the wagons upset I sit in the wagon in despair and hold the door shut which was no easy job and indeed it was laughable to look out and see the fellows that was

sleeping in the tent for it blew over and they crawled out under it they stood and tried to hold it but they could not . . .

May 23

we have had a long days travel today we past three graves neer the road two of them died the same day and both buried in one grave we have crossed big sandy and little sandy creeks which were nothing but sand we come to the little blue it is a beautiful clear water and not so good for drinking being very warm we follow this water a long peace there is trees and bushes growing on each side all cotton wood and willows

we camp very bad grass we passed many dead oxen and some living calves and sheep I have so little time to write that I have missed from 23 to 27 but it is no difference for we have not been traveling for two day it being raining the road is extremely slippy and there is very steep hills to go up and down and that makes it very difficult and hard

there was neer us a grave that had been dug open and a women head was layin and a come sticking in her hair it seems rather hard

May 26

it has been raining all forenoon but it has cleared of now the boys are playing ball and they have had a fine game at leap the frog a play which I have often heard of but I never saw it I realy thought it be end. I never was so much diveited in my life . . .

28

looks very rainy this morning they had to take the cattle over the creek for to get any grass atall and they have had a har job geting them back a sad accident mother fell as she was geting in to the wagon and the front wheel ran over her she was bruised but none of her bones is broke as she might have been hurt a great deal worse then she was we ought to be very thankful indeed the place she fell was sandy we come to a dreadful bad place there is a creek to cross there is four crossing and not one to mend another there was one wagon in a hole and another had just got out and there was upset and broke we was directed to one place as being the best so we try it but odear odear and wagon goes down to the hub and takes its stand the cattle gets discourage and tangled and one fell down so they unhiched and put in other ones so they got out with some trouble but I think they ought to double teams before ever they try such bad places it comences raining and we soon camp toleable good grass no wood plenty of water come about 15 miles

sab 29

it commenced raining last eavening and it thundered the hole night and ahd forke lightning flew through heavens in a most terifick manner indeed a thunder storm on the prairie makes a person feel

very lonesome I never felt so afraid of the Indians as I was before that night but I was not so afraid as to keep me from sleeping

we come to a creek but it was so swollown with the we cannot cross we have to camp come but about 8 miles not very good grass no wood we see no game except one hare wich was shot

I found a pocket book contain ____ friendship cards and some poetry and some other things no doubt but the one that lost it would be very sorrow . . .

tews 31

we started early this morning had to take milk instead of coffee for breckfast have come in site of fort carney there was a very hard rain this morning which makes very hard pulling for the water all stands in it and the ground is sandy and the wheels cut down and it is very hard work

two droves of cattle passes us today we pass fort carney there was a sholdier came and got the number of all of us and our cattle and he told us that there was a thirteen thousand head of people and ninty thousand head of stock the largest emigration has ever past yet we camp not very good grass no wood except a few willows it is comeing up another storm . . .

Sab 5

this is sabath it is a beautiful day but indeed we do not use it as such for we have not traveled far when we stop in a most lovely place oh it is such a beautiful spot and take every thing out of our wagon to air them and it is well we done it as the flower was damp and there was some of the other ones flower was rotten on the lower side and we baked and boiled and washed oh dear me I did not think we would haved abuse the sabeth in such a manner I do not see how we can expect to get along but we did not intend to do so before we started . . .

thirs 9

we started early this morning oh it is extremely hot the sun is sending down his burning rays there was three of the company out hunting but got nothing only one and he brought too liveing antelopes oh there are the dearest little things I ever saw we have stopt to eat dinner five of the boys are in swimming I wish I could go to so I do

we are ready to start again I am walking on before over the bluffs I never saw such a place for flowers of all kinds colers and sizeses we pass a good many little dog towns with the inhabitent sitting on the roof of each barking at us I did not see any of them neer to me we camp within a short distance of the second ford

frid 10

we got to the fording today and there was a good many wagons

and cattle and sheep waitang to go over the sheep they ware takeing in the wagons but oh dear me it loked like a very bad crossing for some of the wagons went down over the beds some were just on the eav of turning over the cattle swimming and the men hanging to the ox yoke and the ox horns there is a place above and a place below some of the men has been to see them both and they think they will go up to the upper one

there was one dog dround and two hats lost here we have got to the upper fording and raised the wagon beds some inch and moved all the flower upon the slats we are taking over three today I am in the second one I was not afraid for myself but the poor fellows have a hard job waiding in up to the neck and swiming some place tuging at the lead cattle with a rope round there head and hollowing and weiding a long whip about it was a dreadful hard job I was so afraid they would cramp they looked like dround rats when they come out of the water

we are divided tonight some is on one side and we on the other I fell some what eary tonight

the fellows all go to bed and Mary, Agnes and the children and my own dear self was in the out side wagon we was afraid to go to sleep and we had a notion to read all night but after we read awhile we thought that the light might attract atention so we put it out and deasnt went to sleep but the gallenippers was so badd I could not sleep I fancied I herd wolves houling and Indians screaming and all sorts of noises . . .

thirs 16

it is cool this morning and we have just got breckfast and the boys has gone out to gether in the cattle

Charles was ride _____ as fast as the beast would go and it stept in to a hole or tript on something but it piched him of and turned clean over on him hurting him very much his senses gone he talked bout running on the mair and the chase all the time poor fellow I am afraid he is worse then we know yet I am very sorry for him for he is such a nice study quiet fellow if it had been of a wild wicked careless lazy fellow I would not have cared for him one bit but he dose not us to stop so we waited about one hour and then we started come about two miles but the rideing makes him worse so we are stopt again till see if he gets any better.

they sent for a docker that was about seven or eight miles on before us he come but with a very ill will and did not do anything more for him then was doing but he said he was not dangerourly hurt through care he will better

it excedly hot the cattle is spread all around some of the men is out hunting and some of them sleeping we heard of Stewart today that he had sold his little wagon and ware all well and geting along very well I do wish they could ketch up with us the children is grumbling and crying and laughing and hollowing and playing all round all round while I am in the tent and it is far warmer in here then it is out for the lovely berse cannot get in here but the sun is shineing so hot little byron is linging beside me enjoying sweet repose

we all went fishing this eavening there was 11 in number of us I believe they all caught some thing me I got two little wee things that was not worth ceaping and threw them in to the water again

fry 17

we started this morning at the usual time we got to court house rock we eat dinner neerly opisite to it and in site of chimney rock

to day we hear great word of the indians they say that there is five hundred of them going to fight we hear that they have laid down blankets that is the sine for the emigrants not dare govern them we shall see when we come up to the place whether it is true or not and that they have sent over the river to gether up more

there was one old bachlier poor old fellow that was dreadful afraid he looked as if he wished his eyes might go ahead a peace to se if it was true or not I had to laugh at him while his legs were running backward for he said that if the emigrants was stopt untill more would come up he thought it would be best just to have enough men with the wagons to mind them and the rest to go and kill every one men weamon and children and he would kill little sucking baby so he would for if they could not fight not they would kill white peoples babys when they got big enough so they would by G swearing all the time at a great rate poor little soul he has a toleable big body but a very little soul but old bachaliars ought to be excused a little all ways for they are not always accountable

but the great army that frightened him so proved to be an Indian camp and in deed they were very friendly with us for they was one come first and shuck hands with us all showed us a peace of paper that had the name of evry thing he wanted such as tobacco flower coffe and whole lot of other things he told to that his was the best family among them and that he had ten children I saw some of the prittyist girls to and they ware drest so nice after their own fashion of course though I do not know wether old John has got over his panic yet or not

sat 18

we have had good luck so far one of our oxen was sick last night but better this morning the indians followed us so far today oh it is

beautiful there is such romantic sereneary we can see scots bluffs and a rang on the opste side that is far more beautiful o deare me it is so warm the dust is flying in a cloud

sabeth 19

it is a very fine day extremely windy the dust is flying the poor oxen I do pity them so I wish they had goggles we come to an exslent spring of water but required some diging out it if runing out of a very mountain neer this spring is the hill that if you go up on it you can larimie peak I went up but it was such a dull dusty day we could not see any distance . . .

tews 21

this morning is a beautiful after the rain the road is leavel and good we past three dead oxen no a great distance apart what death they died I know not poor things we are nearing for laramie it is about five miles to it yet there is so many that is there before us waiting to get across that there is no grass neer it so we have to wait here awhile

wed 22

this is my birthday my eighteenth birthday I feel myself geting older but not any wiser

Diaries, Dorothy Allen Brown Thompson (1911–1914)

For most of her diary keeping, Dorothy Allen Brown Thompson used four copies of The Little Colonel's Good Times Book, *a hard-cover volume whose blank pages were bordered with exquisitely stylized flowers and inspirational sayings. Addressing would-be diarists at the beginning of* The Little Colonel's Good Times Book *was Annie Fellows Johnston, author of the popular nineteenth-century children's book series about Mary Ware, the fictional "little colonel" who managed to exemplify proper Victorian girlhood despite her quick temper. In her instructive introduction, Johnston urged boys and girls to keep a record of pleasant events in their lives and to avoid "feelings and self-analysis." As Johnston explains, "Any game would be a failure in which the players kept a finger on their pulses and stopped at intervals to take their temperature. The game of Life is no exception. You miss the goals you're after when you stop to be self-conscious."*

Taking Johnston's advice to heart, Thompson records her own "good times"—the arrival of birthday presents in the mail, church socials, new fashions, family vacations, classroom escapades with her schoolmates, and significant markers of her progress toward womanhood, such as the letting down of her skirts and her eighteenth birthday.

For Thompson, though, many of her most pleasurable experiences involved literature. In her diary, she rhapsodizes about performances of Shakespeare's

In addition to keeping a journal, Dorothy Allen Brown Thompson used photography and her skills as an artist to construct a public identity. (Western Historical Manuscript Collection, Kansas City.)

plays and provides detailed summaries of her favorite novels. As can be seen in the excerpts included here, the imaginative Thompson even founded her own secret literary society, The Order of the Scroll, whose members included Maid Marian, Joan of Arc, Lady Jane Grey, and Rebecca of Sunnybrook Farm. Though Johnston imagined a "good times" diary could serve as a "priceless Rosary of Remembrance" during moments of misfortune, Thompson's record of her good times—literary and otherwise—can also be read as an early exercise book for an aspiring artist and writer who would eventually see her own poetry appear in a variety of serial publications during the middle decades of the twentieth century. Excerpts from Dorothy Allen Brown Thompson's diaries are reprinted with permission of the University of Missouri–Kansas City Libraries, Special Collections Department.

VOL. I

May 14, 1911.

I am fifteen years old to-day. Yesterday afternoon I wore my new dress to the Mission Circle and Mamma gave me my bag, her present, a day sooner, so that I could carry it then. It is a perfect beauty, about eight inches square, gold, embroidered with pink and blue and green, lined with silk, with a long grey cord.

The circle meeting was at Mildred Northrop's. Mrs. Peters, formerly Miss Lowe, was there. Annie and I went together. Mildred's little sister and another little girl sang, and Mildred and Lorna sang Jack's song, "Pilgrims of the Night." There were only about fifteen there altogether. We went on reading "The Trail of the Lonesome Pine." Winnie read one chapter and I read one. If the mountain girl our circle supports lives in such surroundings as those the book describes, she needs all the help we can give her. Elsie played a march she had composed herself, and it is splendid. We had hot chocolate and cake for refreshments. Mrs. Brown came just after Mrs. Peters left, to speak about the supper that will be given our circle by the C.W.B.M. on May the twenty-fourth, Wednesday. Miss Miller, now in the Jubilee work, but formerly a teacher in the mountain schools, is to talk to us. On the night following, there is to be a union meeting of the four circles of the city at the Linwood church. Elsie and I are to be the ushers from our church.

This morning Mrs. Ray was absent, and as I am class president and the substitutes were busy, they made me teach. I shall have a lasting sympathy for substitutes, though it might have been many times worse. Annie came home with me from church for dinner. She gave me a handkerchief, with a corn-flower embroidered in one corner. We had broiled chickens on toast, creamed new potatoes, tomatoes

and cucumbers on lettuce with both boiled dressing and oil, stuffed peppers, currant jelly, hot rolls, strawberries, iced angel-food cake and candy. Oh, but that cake was fine.

Mamma and I are going to Steilacoom for the summer. Aunt Loulie has taken a cottage and we will pitch our tents in a grove and have a lovely beach. Mrs. Perry will take this house for the summer. Mrs. Perry and Virginia came over this afternoon and brought me a traveling case for toilet articles. It is so pretty. Leon brought me a box of Creme's letter paper, pink, with a darker edge, which with Grandma's dollar, makes seven presents so far. All of them have not come. Grandma's initial paper and Leon's are both so nice. To-night Mr. and Mrs. Keelman brought the baby over for us to see. She is a little dear and so pretty. I wrote to Aunt Mamie this evening and it is bedtime now. . .

May 27, 1911.
Saturday.

Last Wednesday a banquet was given by the C. W. B. M. to the Circle girls and the other girls in the church and Sunday School. Miss Miller from Hazel Green, Kentucky talked to us. She told us something about the conditions existing in the Kentucky mountains, where the little cabins are two or three miles apart, where the girls are married at eleven, twelve, and thirteen years old, and of the life of loneliness and drudgery. There the girls have beautiful hair and skin but no pretty clothes, no spending money, no pleasures, nothing but work from morning till night, day after day, month after month, year after year. Their hands are hardened by work, for they work so hard there. They at the school have only a certain amount of money and can not take many who come to them. One woman with consumption, wanted them to take her boy and teach him something, for he had longed so to learn. But there is no room for many who come to them in desperate need. One girl was an orphan with a brother and sister to support, with no way but to teach, and so anxious to come. Many of them send to know if they can come, and walk miles to get the answer. Perhaps they must ask the post-master to read the letter to them, and then go away discouraged, their only chance gone because they cannot be admitted. Those in school realize their opportunities and work hard. The girls get up at five prepare breakfast, clean up the dormitories and their rooms and are in the class-room at, I think, seven forty-five. At noon dinner must be prepared, the dishes washed, and then school again. Then those who work their way entirely sew until six, then supper and more dishes to wash, and they study till ten.

If they can club together, buy fifteen or twenty cents worth of sugar, and make fudge, it is a great treat. The boys do all the repair work of the buildings. The rooms all open on porches, which are connected by ladders in case of fire. The boys, on Saturday nights, I am not sure of the school boys, but the others mount horses, get all the guns they can, and ride hard, whooping and yelling and firing shots into the hills. . .

June 18, 1911.
Sunday.

This morning we went to church with the Aunties. The sermon was on "The Voice of God" and I thought it was very good, I think some things it suggested did me good. The memorial windows are beautiful, particularly the Stuvé [?] and Betty Stuart windows. There has been singing this evening in the church outside and it is beautiful, stealing in through the silence and darkness. We went to Cousin Ed's for dinner and he showed us his curios. They are _so_ interesting, the arrow-heads, tomahawks, axes, mortars [?], hoes, war clubs, pipes, bow and arrow and so on. The Navajo blanket on the floor in tiling, the copper ceiling and electrik lights, the fine show cases, his expensive fishing tackle, his picture of Lincoln, his ivory carving, his vases, his petrified wood, his Confederate and wild-cat money and his coconut face are all so interesting. He has enough boxes unopened for twelve show cases I think. He has a letter in Lincoln's own handwriting and everything is so interesting. According to his scales, I weigh one hundred eleven and a half.

Their grounds cover a whole block and Elida has a fine swing and teeter-board and so on. Oh, it is lovely.

I wrote to Annie to-night. Dear girl, how I would love to see her! I wrote eight pages and could have gone farther yet but for postage. I write like I talk—extensively.

We went to Oak Ridge this afternoon. It is beautiful there, I think.

I wonder what I will look like when I am an old lady. I imagine I shall be rather stout and look something like Grandma Brown and have snow white hair. I wonder if I shall be married or single. I wonder lots of things but the silliest is worse than "Why is a small potatoe?" The thing that bothers me most is why am I, _I_, and not someone else, why can _I_ think for _myself_, why, why—why? everything. . .

December 23, 1911.
Saturday.

I am woefully behind in my record but I have had _so_ much read-

ing. We have had a good deal of Shakespeare and I am now reading "The Last of the Barons." I have "When Knighthood Was in Flower" waiting for me and after that "Henry VIII." Mamma gave me a Victrolla for Christmas and I gave her records. We got some new ones today, two of them red seal. I have spent most of my spare time studying the catalogue.

Our class at Sunday School are each stuffing a stocking for some youngster and mine is _so_ cute. It has red and white pattern like mine and is stuffed with little doll things mostly, with a muffler and mittens for use. It is _so_ cute. Christmas presents are coming in fast. I have had fourteen already.

January 27, 1912.

I have been so busy and am still, that I scarcely have time to breathe, much less write in my good times book. My Christmas was lovely and such nice presents. Mildred came home with me after history examination several days ago. She won the New Year Nautilus cover. I went to see Robert Mantell Christmas week, in "Julius Caesar." He was Brutus, and truly "This was the noblest Roman of them all." I learned that speech, every word of Antony's address to the Romans, and most of Brutus speech. I shall never forget Brutus where he said "I would rather be a _dog_ and bay the moon, than such a Roman!" nor Lucius, where he said "M'lord, March has wasted fourteen days," nor Cassius when he cried, "Cassius, that refused you gold, will give his heart!" nor Antony's "Now let it work! Mischief, thou art afoot! Take thou what course thou _wilt_!" Caesar's "Ay, at Philippi" will always come back to me when I think of a Roman camp and at the word battle I can hear Brutus say, "If not, this parting was well made." I shall always think of Brutus as wearing a toga with a tan Grecian border, of Portia walking on her train, of Calphuria in her "almost hobble," of Lucius in white with his instrument, of Caesar's manner of stroking his wife's hair and the shortness of his casket, the hurried speech of Mark Antony's servant and the clear silvery voice of Lucius, and above all, of their precise manner of dying. Yet, it was wonderful. I was held perfectly rigid when Caesar was stabbed, and the suspense looking for the ghost and the death of Brutus will be scenes I will always remember. Antony's speech was masterly and Brutus's scarcely less so.

Yesterday evening we went to "The Suffragette Convention" at the church. It was very funny, especially Calvin Magee, Miss Hale's laugh, Mrs. Frisbie, Mrs. Runyon, the deaf lady, Mrs. Brigham Young, Mrs. Henpeck from the State of Matrimony, the band, Will Norman, and Mrs. Casey. One of the funniest things in it was Mr. Hahn's

"Ladies' Home Journal" patterns and his side frill and parasol. His Black was funny, too was his crochet for an "after-dinner Tuxedo Jacket," and Lee Swope with his embroidery.

I am studying and reading and trying to catch up with things. I have hardly read anything for three days. History is so interesting. By the way, that reminds me. I intend to establish a secret society. This one is something new and <u>extremely</u> secret. No one, in fact knows anything about it but me and of course my good times book. Even the other members are not to know of their membership, especially as some are dead. It is something like the brotherhood of the Knights of the Golden Spur. I think I shall call it The Order of the Scroll because it is through books and reading that we know each other. I want one member from each century, at least one. She may have any country or any station. She may be a queen or a scrubwoman. The character may be real or fictitious. The only requirement is that she be one who has done some one thing that "helped." The number who may belong is unlimited. The watch-word of the Order is that which is said of Dorcas, "She hath done what she could." If a candidate for membership fails to meet that, she is not admitted. No one knows who the members are or of the very existence of the order, except myself. Mamma may, if she likes. Some of the members are to be initiated one day and others the next.

January 29, 1912.

As Betty says, "I have only the tail-feathers of my idea" as yet and I am not sure how it will go yet, until I have thought about it more. I think I shall have the initiation fee a book telling something about that one. Those who cannot provide a book may furnish an article or clipping. Those who can furnish neither, but who qualify for membership, are honorary members. The dues will be, I think, bits of information and photographs or pictures associated with the member. There will be no meetings, no especial regularity, it will be simply a number a friends brought together in an Order, for the purpose of knowing each other better.

February 9, 1912.

I am sure the Order when fully completed will be splendid. I intend to start a picture gallery of the members. The Order will be something like the verse at the top of this page,

"The measure of friendship sets for thee

That stature thou will try to be."

I think I will have that the motto. Among my first members are Joan of Arc, Rebecca of Sunnybrook Farm, Maid Marian, Evangeline, Lady

Jane Grey, Sella, Ellen of Ellen's Isle, Anne daughter of Warwick, Lady Jane Bolingbroke, Victoria, Queen of England, and Mary Ware. Of course I will probably add others later.

I am reading "Rebecca" now, and she is simply rich. I am going to see the play tomorrow afternoon. Mrs. Wing is going with me. Rebecca and Maid Marian are not full members yet, but the program will qualify Rebecca. I think Maud Adams will also be a member. . . .

March 27 is a red letter day, for it was then that I saw "Macbeth," played by Sothern and Marlowe. They were wonderful. Miss Marlowe gave what was my idea of Lady Macbeth, only far better than I had been able to imagine. The witches' scene was wonderful the green light on their faces, their vanishing on the rocks, the fire showing through their rags in the caldron scene and their cracked voices and wierd laughter. Mr. V. L. Granville acted the part of Malcolm and he was so handsome. I kept the glasses on him the entire time and when he came out once Mrs. Wing sighed "Oh, my, isn't he <u>handsome</u>!" and another time she said "Oh, isn't he the sweetest thing!" I teased her about it and threatened to tell Mr. Wing but she said he would only laugh at her. But he was right. He really was <u>overwhelmingly</u> handsome. He was kingly in the last scene when he stood high above them all, held up by his followers with banners streaming and soldiers shouting and on his face a proud smile of conquest.

The costumes were beautiful and especially gay at the banquet scene. Mildred's idea was <u>too</u> funny of Lady Macbeth's little pages racing wildly after her.

I went out to Mildred's for lunch the other day, her birthday, and we sat and fired quotations and riddles at each other the entire time. We croaked those witches' speeches at each other time we were worn out and every so often Mildred would give one of those ghastly laughs. Ross began to get the idea and croaked a little, too. They are brilliant at guessing riddles.

Everything is happening these days, just because I'm living, I suppose. Every few days or so Miss Steele says impressively "You are living in an age of <u>history</u>, young people." It <u>will</u> be interesting to brag to my grandchildren that I can remember Queen Victoria's death, King Edward's death and George V's coronation, the Portugese revolution, the Chinese revolution, the discovery of the North and South Poles, (I have seen Dr. Cook, too, by the way), the death of Tolstoy, Halley's comet, the fall of Diaz, the sinking of the "Main," the Turkish-Italian war, the Russian Japanese war, the assassination of McKinley, the building of the Panama Canal, the disappearance of Mona Lisa, the hundredth birthdays of Dickens and Lincoln and many, many others.

July 23, 1913.

Wednesday

It is almost a year since I wrote last in my Good Times Book, and how I have changed in that year! My skirts are down to my ankles and my school days are over; I am treated as a young lady I'm rather pleased with the treatment. Since I saw Chauncey Olcott I have seen "Romeo and Juliet" and other plays a trifle less interesting. I have surely been going <u>hard</u> and with a different crowd from those I've been with.

I got acquainted with a mighty nice crowd at Mildred's party, that made all the rest of the year more interesting. And then graduation! That was perfect! And since then I have gotten to know the older Endeavor crowd at the church, until I am with a different group up there too, especially since I have been helping Lelia with her Sunday School class. It seems that I have changed from a little girl to a young lady all in about six months. It all began with lengthening my dresses, too. It is astonishing the difference in people's attitude toward you because of a few inches added to your skirts.

Since Commencement, when I no longer have my "Girl Graduate" to record my good times, I shall have to turn back to this book.

Last night I attended a performance of Ringling Bros. "Greatest Show on Earth" with "Sublime Spectacle of Joan of Arc."

Sept. 12, 1913.

Just here I was interrupted—I'm always so rushed. As I was saying, the Circus was grand, etc., etc.

I have begun to save things to start a new "Memory Book" and Art Institute so perhaps this book will be consigned to oblivion again. I believe the Fates are against it any-way for I have had two phone calls, a bill to pay, and two callers, since I began writing.

Miss Stittsworth stopped on the way home from school to tell me about some friends of Miss Twitchell's who might want to rent the flat; while she was here the boy from the Star came to collect for an advertisement, then while I was paying him Mrs. Wing arrived. She had on her new linen suit and she wanted to use the phone. She has just left, lifted to celestial heights of bliss because I put a drop of "Mary Garden" perfume on her coat—it <u>is</u> a heavenly scent.

Yesterday it rained and <u>rained</u> and <u>Rained</u>! This book, which marks only the "hours that shine" can surely make a place for this, for it was more welcome than all the weeks of sunshine we have been having. It is quite cool, today, and it is certainly a relief. I took my seventh guitar lesson yesterday, and started on my second book.

It is interesting I think—and fun—but I do hate to get my fingers calloused!

This morning I cleaned the middle bedroom thoroughly—swept and dusted and generally straightened. I looked like an Egyptian in my Gretchen cap—it has wonderful possibilities for changing the nationality. Then we went to Mrs. McMillen's to see about having my hat retrimmed. It is going to be quite stylish and "chic," I think.

Sunday the boys are going to Sunday School with us! That is really a triumph, although it sounds tame enough. It is "Home-Coming Day" and they are making a special effort to have a crowd there. I had to teach last Sunday—second year Juniors, on the "Death of Samson." It's not easy, either, when it is dropped on one all at once.

VOL. 3

May 14, 1914.
Thursday.

The first entry of my first good-times book was made on my fifteenth birthday, so, though I have had this book several days, and my good times have not been lacking, I decided to wait until to-day, my eighteenth birthday, for this book's first entry.

My eighteenth birthday! Like Mary, I have always looked forward to this as a very important day in my life. I don't feel any older, except that it is rather a responsibility to be of "legal age." "A woman grown"—I wonder? Hardly, I think. Still, to be eighteen is perilously near it. I surely have only a few more years until I will be counted a woman. I wish I could be just a happy carefree girl for a long time yet. Not that I never want to grow up, but just that I have reached a very pleasant milestone at eighteen, and one that I never can return to, once passed.

But this is not a record of good times. I must begin with Friday of last week, when we went sketching on Cliff Drive. Six of the Art Institute girls: Mildred, Margaret Metsinger, Letha Churchill, Miss Alexander and Miss Fowler had a sketching party. (I forgot to include myself, but I was "among those present.") Miss Whitezel took us all out to Mrs. Fowler's in a car, but didn't stop herself. We surely had fun on that ride. Mildred and I were very much up in the world, as we were obliged to sit on the laps of Margaret and Letha. I believe it is the first time we were ever guilty of "mashing," but those poor girls will testify that the charge was justifiable. The only comfort they received from us was that we acted as wind-shields. Each of us had bundles—sandwiches, cake, pickles, etc. which we turned over to Mrs.

Fowler for lunch. She gave us lovely fruit salad, cake, chocolate and coffee. She made a charming hostess, showing us all her curios and heirlooms, and letting us explore as we pleased. She showed us her Dickens corner, where she keeps all her books of Dickens, with his bust on the book-shelves, and pictures of Dickens scenes and so on. I don't think I care enough for Dickens to copy that, but it did fire me with the ambition to have a "Poets' Corner." I want a very nice bust of Shakespeare, small, but very good, and no doubt there will be other things that will add to its interest and charm.

We saw a book, too, that was about a hundred and fifty years old, and had the s's printed like f's.

After we had raved over the things for a sufficient time we had lunch and how we ate! Then Mrs. Fowler read us some of her verses and gave Mildred and me each a little book of six of them. About that time we heard the auto horn outside, and, after clearing the table, we all trooped downstairs with our sketching paraphenalia and piled into the car. We literally fitted ourselves in by nice calculation. I had to kneel on the floor this time and it was great fun. We finally selected a spot just below the castle to sketch, and we disposed ourselves in various places and fairly wrestled with it. Most of us were working in an entirely new medium, and the results—well the less said about them the better! Miss Alexander was the only one who did anything half-way respectable.

Mrs. Fowler and I left before the others and the chauffeur took us as far as her house in the car. I went up for one last look at her quaint, interesting things, and then she walked with me as far as the Northeast car line, and I walked the rest of the way alone.

Anonymous Diary, High School Girl (1943)

This brief excerpt from the diary of an anonymous high school girl in the Colorado River Relocation Center in Poston, Arizona, has much in common with the diaries of other teenage girls in the middle decades of the twentieth century. The diarist describes doing household chores, irritating her teachers, visiting with friends, going to the movies, and just "loafing." These typical activities stand in sharp contrast to the extraordinary circumstances in which this girl lived—the breakfast gong that sounded across the camp every morning; the unappetizing meals in the mess hall; and the social pressure to do one's part in the war effort by helping to make the camps livable, functional communities. For more on Japanese American girls who were interned in camps during World War II, see the Girl's League Gazette *and the poems of Mary Matsuzawa and June Moriwaki in this volume. This excerpt appears courtesy of the Bancroft Library, University of California, Berkeley.*

Block 45
June 19, 1943

Saturday

Woke up as usual when the breakfast gong rang. I hurriedly dressed and went to the mess hall. The breakfast consisted of one half of a weiner, fried rice and toast. After cleaning the hous, I went to the post office to mail a package. On the way home, I stopped at my aunt's to get my grandfather's new address. Came home and washed my hair. Soon after, the lunch gong rang. The lunch was most unappetizing. It consisted of squids, squash and rice. I just ate the rice and a few pieces of Japanese pickles, since I dislike squids and I don't care for squash. After resting, I went to the library and checked out two books. I came home and finished reading the book. The dinner gong rang, so I walked to the mess hall slowly with my sister. After eating dinner, which was better than the previous meals, I went to Block 2 to see my girl friend, who had moved there recently from our block. Because of a scandal her parents couldn't stand living in our block. I told her all the block news. Then I came home and went to sleep.

June 20, 1943

Sunday

I woke up, when the breakfast gong rang, but I wondered if I should get up. The breakfast wouldn't probably be good. I finally decided to wake up. And for a change we had fresh plums for breakfast. My firends came to call me, so I went to church. I was bored. The teacher glared at me, because I didn't memorize the Beatitudes. I came home and listened to my girl friend explain the Catholic religion to some other friends. We ate lunch at home and everything tasted good. I read a little. Then I decided to wash my clothes. Took a nap after washing. We had stew for dinner. After dinner, I studied. I went to bed late and was scolded by parents for not studying earlier in the day.

June 21, 1943

Monday

Woke up late and hurriedly dressed. I reached the mess hall late, so I sat on the last part of the last table, I ate so slow that my sister left me behind and went to school. I reached school just in time. In algebra, we had our finals. It was easy. Then I walked a block to my Latin class. We reviewed the declensions, conjugations, etc. After Latin I

walked five blocks to Radio Drama. There I learned the correct way of walking and we listened to a lecture on Human Behavior. I came home and read. Lunch was unappetizing. After lunch, I went to my Core class and irritated the teacher by talking when I wasn't supposed to. It was so hot that we didn't accomplish much. Came home and did my homework for algebra. Then I took a nap. I overslepted. Dinner consisted of macaroni only. Then I went to the post office with my sister to see our girl friend off. I went to the show with my sister and her friend. Came home late and went to bed.

June 22, 1943

Tuesday

Woke up when the gong rang. The breakfast was two French toasts and a cup of cocoa. I went to Algebra. While the rest of the class took their finals, I loafed, because the teacher said, I didn't have to take the finals. In Latin, we just translated a story and reviewed the syntax. In Radio Drama, we heard a lecture on Democracy. Came home and loafed. Then I ate lunch which consisted of some mixed vegetables and meat. I went to Core and irritated the teacher. After I came home, I loafed and read. Because it was our turn, I helped with the children's snacks. Supper was stew. It seems as if all the cook knows is how to make stew and mixed things. After supper, I studied and went to bed early.

June 23, 1943

Wednesday

Woke up when the gong rang. Strangely, I reached the mess hall earlier than most of the people I went to algebra. Then I went to Latin. We wrote an evaluation of Latin II. I hurried to Radio Drama, and gave a speech on Democracy. Came home and read. After lunch, I went to Core. I studied hard, so that I wouldn't have to study at all the next day. I came home and finished my Core homework. After dinner, I went to Block 2, to see my girl friend again. Came home early and darned my socks. After darning, I went to sleep.

June 24, 1943

Thursday

Woke up late. Went to breakfast late. But I reached my algebra class strangely early. I loafed the whole period in algebra. In Latin, we had a party. The teacher said it was a typical Japanese party, because all the boys stayed on one side, and all the girls stayed on the other side. I went to Radio Drama and the rest of the class gave their

speeches. I came home and loafed. I didn't go to lunch, because I knew it wouldn't be anything good and because I wasn't hungry. In Core I loafed and irritated the teacher. I came home and took a nap. We had fish for dinner. I dislike fish next to squids. I went to the library and checked out one book. I came home and my girl friend talked me into working in the mess hall. She said that there weren't enough workers and that it was my duty to work where I'm needed most after that I went to sleep.

June 25, 1943

Friday

I woke up when the gong rang, I hurried to the mess hall. In algebra after class was dismissed, the teacher kept four girls and told one of the girls and me that we were the noisiest in the class. I went to Latin and talked with the teacher. Then I went to Radio Drama and the teacher gave us a summary on the course. Then I came home and read. After lunch I went to Core and filled in a blank. I came home and loafed. After dinner, I went to my girl friends house and later we came to my house and sat on the porch watching the students go to the Student Body Dance.

The mosquitoes became too numerous, so I went inside and read. Then I went to sleep after ordering various things from the Sears' catalog for my mother. I went to sleep soon after.

Internet Diary, bacon4u (2002)

The internet has created new opportunities for girls interested in keeping diaries or journals, and numerous hosting services, including DiaryLand, DearDiary.Net, and The Open Diary, offer users the opportunity to compose and publish journal entries on-line. Typically, on-line diaries consist of a "front page" where the diarist introduces herself to readers. A title/date list of entries allows visitors to the web diary to choose which parts of the diary to read. There's also an opportunity for readers to leave notes. Clicking on the screen name of someone who has left a note opens a link to the on-line diary of the person who has left a note.

The excerpts below come from the on-line diary of "bacon4u," a sixteen-year-old girl who lives in the suburbs of a large, midwestern city. Most of the responders are friends of bacon4u, and while their notes often comment on the diary entries, the note-taking feature also becomes a means by which teenagers arrange their social lives, make amends for transgressions, and leave other messages.

Current Title and Name: *Anne* by bacon4u
Front Page of bacon4u's Diary

I'm Bacon. Not literally, of course. Real bacon don't have fingers. And yes bacon, is the plural form of bacon. You don't have a bunch of bacons sizzling up do you?

Pretty much, I'm a teenage outcast like many. I do what I love though I am looked down apon. I play the stand up bass/contrabasso/upright bass, however you say it, I play the bass. I love it so much. It's undescribable, the feeling I get when I play. It's a total out of body experience. Something overwhelms me and takes over my body.

I'm a single, sophomore. This year has been rough so far and it's only half over, but I've learned a lot, especially stuff they don't teach in books.

I love my friends to death. I have two sets of friends. The Orch. Dorks, and the others. Orch Dorks are my group of friends all in orcestra. The name Orch. Dorks, is derived from the latin word, orchus dorkus, which means any orchestral person that goes beyond the call of duty. I'm a proud server of my orchestra.

I strive to be a great musician and lately to be a great poet. I try with both of them. When I grow up I want to go to Julliard and I want to be in the symphony and then when I retire I want to be a Luthier.

=sab=

Diary Entry from 3/6/02 Title: No Title

Today, I feel like my life is turning around a little. I'm not happy, but I'm not sad. I'm just here. And that's better than sad.

I walk down the halls and people wave at me. I like that. High school is so much better than anything, besides college. I have friends: Ashley's, Justin, Patrick, Debbie, Hannah, Sarah, Carl, Danny, Lauren, Theresa, Sean, Vivienne, David. Man I can't even think of everyone.

Here's a poem I wrote while I was in the bath tub:

Random Bath Thoughts

I like being clean
but I dislike baths—
I dislike the inconvenience—
I dislike trying to squeeze
my head through the layers
of clothes in the winter—
I dislike the feeling,

that everyone is listening
to me while I sing—
I dislike the confinement of the
bath-tub—I dislike
the random pubic hair
that somehow finds itself
beached on the last sliver of
MY bar of soap—
I like the feeling that my
legs get when cleanly shaven—
like a dirty layer of
skin was peeled away—
I like the way my
glasses stick firmly to
my nose—free from grease—
I like the feeling of hurriedness
on the sprint from the warm water—
through the icy air—and to my warm bed—
I like the feeling of
slicknes my body gets
all over—when it is
air dried nude—The sense
of freedom
from the world—

Z. Franco
S. Anne B.

Notes from Readers:
I like that a lot. Especially the pubic hair part.
Please don't be upset with me. I really wanted to go this time.
[Valium Milkshake]

Diary Entry from 3/27/02 Title: My Little Violin Dancer

I'm going to try writing about what's going on in my life. Usually I try to make it sound all nice, but I just want to talk.

Contest. My solo is going alright. I'm thinking about dropping one of he movements. I don't have enough time allotted to play both, so I'll play the longer of the two. Duet—going alright also. We haven't actually played the whole thing through perfectly yet, but we have figured out our mistakes and they will be fixed by contest.

I haven't had homework lately, and I find it difficult to fill my time. That strikes me as somewhat odd.

I love that school is coming to a close. Spring sports have started, MAP tests are only a week and a half away. That's a good week, not a lot of homework. I can't wait until the orchestra/track banquets. I like getting awards, and letters.

This summer, I plan on doing a lot of practicing, and a lot of enlightening. I've already found the key to "Self discovery"—and have created a quote. "One cannot find oneself, until one realizes that they were never lost." . . .

Thank you. *bows*

I have to go to the hospital on Monday. I have to get an EMG done on my arm. They stick needles in my arm and run an electric current through it and test my nerves, I guess.

I hate to go onto this subject, because I've been trying to get away from it for awhile. Cutting. Those people with whom I've talked before, that said they would quit, or that have, also say not to believe them. I've gathered that I can't trust anyone. People *are* two faced, and people do change.

I miss our talks. One time we talked for a few hours. Now we hardly speak, other than greetings. I feel as if we speak through our thoughts. I know what he is thinking, he knows what I am. I'm busy, and we don't get to talk much. When we do talk, he tells me that he has thought about me, but we have been busy. Wonderful person, talk to me please.

I hope we all do so wonderful at contest. Road Trip to State! I hope I do well. Please God, let it be a I. 0:). . . .

Notes from Readers:
Fake bacon rulz [curiouschick]

Or do they stay the same? Meh.
tuesday
[*Star_Girl*]

Ah, I got nothin.
[Lucy Code]

I haven't had too much homework lately, either. Maybe it's a weird conspiracy. They let us think we don't have to do much and BOOM! give us a ton so we struggle with our grades. [doublethink]

Hey . . . im sitting right next to you how weird is that?

References

Anderson, Mary Betty. [c. 1930s] 1945. "I Never Knew." *Young Voices: A Quarter Century of High School Student Writing Selected from the Scholastic Awards.* Edited by Kenneth M. Gould and Joan Coyne. New York: Harper Brothers.

bacon4u. 2002. Internet Diary on http.www.opendiary.com.

Booth, Lucille. 1954. *The Tiger.* Elkins High School. Elkins, West Virginia.

Bowne, Eliza Southgate. 1887. *A Girl's Life Eighty Years Ago: Selections from the Letters of Eliza Southgate Bowne.* Introduction by Clarence Cook. New York: Charles Scribner's Sons.

Brinson, Thelma M. 1925. "Class History." *Lincolnian,* Lincoln High School, Kansas City, MO: Black Archives of Mid-America.

Brown, Mary Virginia (Early). 1840. Friendship Album. Early Family Papers, 1798–1930. Mss1 Ea 765 a 178. Virginia Historical Society, Richmond, Virginia.

Cannell, Lauren. 2002. "I Am." Unpublished poem.

Carson, Albana C. 1851. "Imperfections of Female Education." Science Hill Female Academy Records, 1825–1975. BI5416. Filson Historical Society, Louisville, Kentucky.

Childs, Morgan. 2000. "Busy Betty." Unpublished poem.

Colman, Benjamin. 1735. *Reliquiae Turellae, et Lachrymae Paternae. Two Sermons Preach'd at Medford, April 6. 1735. By Benjamin Colman, D. D. The Lord's Day after the Funeral of His Beloved Daughter Mrs. Jane Turell. To Which Are Added, Some Large Memoirs of Her Life and Death, by Her Consort, the Reverend Mr. Ebenezer Turell.* Boston: J. Edwards and H. Foster.

Conine, Nettie. 1878. Letter. *St. Nicholas* 5 (February): 301.

Daly, Maureen. [1938] 1962. "Sixteen." *Saplings* 13:1–6. Reprint, pp. 13–21 in *Sixteen and Other Stories.* New York: Dodd, Mead.

Davis, Mabel. 1915. "Cotton." *The Indian News* (September): 5–6.

Farrar, Eliza W. R. 1836. *The Young Lady's Friend. By a Lady.* Boston: American Stationers' Company.

First, Helen G. 1960. "Write a Better Book Review This Semester." Curl Up and Read Column. *Seventeen* (September): 28.

Gipson, Carrie, and Hermena Clay. 1922. "Class Prophecy." Pp. 28–30 in *The Lincolnian,* Lincoln High School, Kansas City, MO: Black Archives of Mid-America.

The Girls' League Gazette. 1944. Butte High School, Gila Relocation Center, Arizona. 2, no. 1 (April 15): 1–2. Japanese American Evacuation and Resettlement Records, 1930–1974. BANC MSS 67/14c. Reel 272, frames 315–316. Bancroft Library, University of California, Berkeley.

Goldsmith, Sophie L. 1932. "Books for Varying Tastes." *The American Girl* 15, no. 4 (April): 40–41.

Goodale, Dora Read. 1877. "Some Verses." *St. Nicholas* 5 (December): 109.

Green, Alma. 1937. "Irresistable Charm." *The Coles Pilot* (June): 14. R.T. Coles Vocational and Junior High School, Kansas City, Missouri: Black Archives of Mid-America.

Griffith, Laura (pseudonym). c. 1999–2000. "Recommendation to Patient." Unpublished essay. Midwestern Girls School.

High School Girl's Diary. 1943. Japanese American Evacuation and Resettlement Records, 1930–1974. BANC MSS 67/14c. Reel 272, frames 178–179. Bancroft Library, University of California, Berkeley.

Hinds, Beth. 1961. "Awakening." *Seventeen* (January): 64.

Hobart, Pearl. 1877. Letter. *St. Nicholas* 4 (July): 636.

Hood, Mary L. 1876. Letter. *St. Nicholas* 4 (November): 60.

Jerome, W. S. 1878. "How to Keep a Journal." *St. Nicholas* 5 (October): 789–791.

L.A. c. 1930s. Undated Letters. State Industrial Home for Negro Girls, Tipton, MO. Missouri State Archives, Jefferson City.

L.B. c. 1930s. Undated Letters. State Industrial Home for Negro Girls, Tipton, MO. Missouri State Archives, Jefferson City.

Letter Received by Mary Stuart (Robertson) Beard. April 20, 1910. Robertson Family Papers, 1786–1930. Mss1 R5498 b 958. Virginia Historical Society, Richmond, Virginia.

Matsuzawa, Mary. 1945. "My Plea." *Cactus Blossoms*. Butte High School, Gila Relocation Center, Arizona. Japanese American Evacuation and Resettlement Records, 1930–1974. BANC MSS 67/14c. Reel 272, frame 307. Bancroft Library, University of California, Berkeley.

McClure, Elizabeth Ann Cooley. 1842–1848. Diary. MSS 10: no. 99. Virginia Historical Society, Richmond, Virginia.

McGuffey, William. 1879. "The Good Reader." Pp. 39–43 in *McGuffey's Fifth Eclectic Reader*. Rev. ed. New York: Van Antwerp, Bragg & Co.

Meredith, Margaret. 1886. "Keeping the Cream of One's Reading." *St. Nicholas* 13 (May): 537.

Moriwaki, June. 1945. "The Bend in the Road." *Cactus Blossoms*. Butte High School, Gila Relocation Center, Arizona. Japanese American Evacuation and Resettlement Records, 1930–1974. BANC MSS 67/14c. Reel 272, frame 299. Bancroft Library, University of California, Berkeley.

The New-England Primer. 1777. Facsimile edition of 1843. Hartford, CT: Ira Webster.

Phelps, LouAnn. 1971. *Clarion*. University High School. Normal, Illinois.

Quackenbos, G. P. 1851. *First Lessons in Composition*. New York: D. Appleton & Co.

R., Mary. c. 1960s. "All About Me"; "Dear Elizabeth"; "What America Means to Me." Nellie J. Hall Williams Collection. KC 141. Folders 31, 22, and 24. Western Historical Manuscript Collection, Kansas City, Missouri.

Riley, Ellen. 1856. "My Will." Science Hill Female Academy Records, 1825–1975. BI5416. Filson Historical Society, Louisville, Kentucky.

Sherman, Rosalie. 1907. "Our Class History '07." *The Indian News* (June): 7–8.

Sibley, Grace. 1926. "Too Young." *Saplings* 1: 23.

Stewart, Helen. 1853. Diary. Oregon Pioneer Records, BANC MSS P-A 337, vol. 15. Bancroft Library, University of California, Berkeley.

Stewart, Mamie. 1915. "From Field to Kitchen." *The Indian News* (September): 6.

Stewart, Sallie W. 1933. "Books for the Older Girls." *Girls' Guide*. National Association of Colored Girls. *Records of the National Association of Colored Women's Clubs, 1895–1992*. [Microform.] Reel 20. Edited by Lillian Serece Williams and Randolph Boehm. Bethesda, Maryland: University Publication of America.

Stout, Eugenia. 1853. "Mystery." Science Hill Female Academy Records, 1825–1975. BI5416. Filson Historical Society, Louisville, Kentucky.

Tepper, Martina. 2002. E-mail to Miriam Forman-Brunell, March 13.

Thompson, Dorothy Allen Brown. Diaries, 1911–1928. 4 vols. Uncatalogued Materials. Special Collections Department, Miller Nichols Library, University of Missouri, Kansas City.

Thornwell, Emily. 1856. *The Lady's Guide to Perfect Gentility, in manners, dress, and conversation, in the family, in company, at the piano forte, the table, in the street, and in gentlemen's society. Also a Useful Instructor in letter writing, toilet preparations, fancy needlework, millinery, dressmaking, care of wardrobe, the hair, teeth, hands, lips, complexion, etc.* New York: Derby and Jackson.

Turner, Edna L. 1920. "Lines to My Classmates." P. 24 in *The Lincolnian*. Lincoln High School, Kansas City, MO, Black Archives of Mid-America.

Tyng, Florence E. 1879. "The Young Hunter." *St. Nicholas* 6 (February): 300.

Walker, John. [1801] 1808. *The Teacher's Assistant in English Composition or Easy Rules for Writing Themes and Composing Exercises on Subjects Proper for the Improvement of Youth of Both Sexes at School.* Carlisle: George Kline.

Washington, Priscilla. 1904. "The History of the Lygaeum." *Lincoln High School Annual.* Lincoln High School, Kansas City, MO, Black Archives of Mid-America.

Wells, Doris Mae. 1916. "Are You Building a House or Shack?" *The Lincolnian* (October): 1–2. Lincoln High School, Kansas City, MO, Black Archives of Mid-America.

Wheatley, Phillis. 1989. "On Virtue" [1766]; "To the University of Cambridge, in New-England" [1767]; "On Being Brought from Africa to America" [1768]; "On the Death of a Young Lady of Five Years of Age" [1770]. *The Poems of Phillis Wheatley,* revised and enlarged edition. Edited by Julian D. Mason, Jr. Chapel Hill: University of North Carolina Press.

Williams, Frances Royster. 1915. "The Circulation of the Blood" and "Surf Bathing." Frances Royster Williams Collection. KC249, Box 38, Folder 2. Western Historical Manuscript Collection, Kansas City, Missouri.

Winslow, Anna Green. 1894. *Diary of Anna Green Winslow: A Boston School Girl of 1771.* Edited by Alice Morse Earle. Boston: Houghton, Mifflin.

Withers, Prudence. 1898. "Editorials." *The School Paper* 1, no. 2 (February): 19. Kansas City Day and Home School. Kansas City, Missouri. Barstow School Records, KC277. Vol. 1. [Microfilm.] Western Historical Manuscript Collection, Kansas City, Missouri.

Woodward, Elizabeth. 1935. "Dear Diary." The Sub-Deb Column. *Ladies' Home Journal* 52 (February): 69.

———. 1936. "How to Be Popular Tho' Teacher's Pet." The Sub-Deb Column. *Ladies' Home Journal* 53 (November): 129.

Worth, Nettie. 1907. "The Mouse." *The Indian News* 11 (March): 23.

Bibliography

Abbot, A. W. 1851. "Female Authors." *North American Review* 72 (January): 151–178.

Adams, David Wallace. 1995. *Education for Extinction: American Indians and the Boarding School Experience, 1875–1928*. Lawrence: University Press of Kansas.

Adams, Hannah. 1832. *A Memoir of Miss Hannah Adams, Written by Herself*. Boston: Gray and Bowen.

Adams, Katherine H. 2001. *A Group of Their Own: College Writing Courses and American Women Writers, 1880–1940*. Albany: State University of New York Press.

Adler, Bill, ed. 1967. *Love Letters to the Monkees*. New York: Popular Library.

Adler, Emily Stier, and Roger Clark. 1991. "Adolescence: A Literary Passage." *Adolescence* 26: 757–768.

Alband, Jo Della. 1934. "A History of Education of Women in Kentucky." M.A. thesis, University of Kentucky.

Albany Female Academy. [1836] 1973. *Circular and Catalogue of the Albany Female Academy, 1836*. Pp. 1591–1594 in *Education in the United States: A Documentary History*. Vol. 3. Edited by Sol Cohen. New York: Random House.

Alcott, Louisa May. 1868–1869. *Little Women*. Boston: Roberts Brothers Press.

Alexander, Ruth M. 1992. "'The Only Thing I Wanted Was Freedom': Wayward Girls in New York, 1900–1930." Pp. 275–295 in *Small Worlds: Children and Adolescents in America, 1850–1950*. Edited by Elliott West and Paula Petrik. Lawrence: University Press of Kansas.

———. 1995. *The "Girl Problem": Female Sexual Delinquency in New York, 1900–1930*. Ithaca, NY: Cornell University Press.

Alvermann, Donna E., Kathleen A. Hinchman, David W. Moore, Stephen F. Phelps, and Diane R. Waff, eds. 1998. *Reconceptualizing the Literacies in Adolescents' Lives*. Mahwah, NJ: Lawrence Erlbaum Associates.

Alvine, Lynne B., and Linda E. Cullum, eds. 1999. *Breaking the Cycle: Gender, Literacy and Learning*. Portsmouth, NH: Boynton-Cook.

American Association of University Women. 1991. *Shortchanging Girls, Shortchanging America*. Washington, DC: American Association of University Women.

———. 1992. *How Schools Shortchange Girls*. Washington, DC: American Association of University Women Educational Foundation.

———. 1999. *Gender Gaps: Where Schools Still Fail Our Children*. New York: Marlowe and Company.

———. 2000. *Tech-Savvy: Educating Girls in the New Computer Age.* Washington, DC: American Association of University Women Educational Foundation.

———. 2001. *Beyond the "Gender Wars": A Conversation about Girls, Boys, and Education.* Washington, DC: American Association of University Women Educational Foundation.

Amory, Hugh, and David D. Hall, eds. 2000. *The Colonial Book in the Atlantic World.* Vol. 1 of *A History of the Book in America.* Cambridge, UK: American Antiquarian Society and Cambridge University Press.

Apple, Michael W., and Linda K. Christian-Smith, eds. 1991. *The Politics of the Textbook.* New York: Routledge.

Appleby, Joyce. 2000. *Inheriting the Revolution: The First Generation of Americans.* Cambridge, MA: Harvard University Press, Belknap Press.

Appleman, Deborah. 1999. "Alice, *Lolita* and Me: Learning to Read 'Feminist' with a Tenth-Grade Urban Adolescent." Pp. 71–88 in *Breaking the Cycle: Gender, Literacy and Learning.* Edited by Lynne B. Alvine and Linda E. Cullum. Portsmouth, NH: Boynton/Cook.

Arksey, Laura, Nancy Pries, and Marcia Reed. 1983. *American Diaries: An Annotated Bibliography of Published American Diaries and Journals.* 2 vols. Detroit: Gale.

Armes, Ethel, ed. 1968. *Nancy Shippen, Her Journal Book: The International Romance of a Young Lady of Fashion of Colonial Philadelphia with Letters to Her and about Her.* New York: Benjamin Blom.

Arthur, Linda L. 2000. "A New Look at Schooling and Literacy: The Colony of Georgia." *Georgia Historical Quarterly* 84: 563–588.

Ashworth, Suzanne M. 2000. "Susan Warner's *The Wide, Wide World,* Conduct Literature, and Protocols of Female Reading in Mid-Nineteenth-Century America." *Legacy* 17, no. 2: 141–164.

Atkin, S. Beth. 1993. *Voices from the Fields: Children of Migrant Farmworkers Tell Their Stories.* Boston: Little, Brown.

———. 1996. *Voices from the Streets: Young Former Gang Members Tell Their Stories.* Boston: Little, Brown.

Austin, Joe. 2001. *Taking the Train: How Graffiti Art Became an Urban Crisis in New York City.* New York: Columbia University Press.

Auwers, Linda. 1980. "Reading the Marks of the Past: Exploring Female Literacy in Colonial Windsor, Connecticut." *Historical Methods* 13: 204–214.

Avery, Gillian. 1994. *Behold the Child: American Children and Their Books, 1621–1922.* Baltimore: Johns Hopkins University Press.

Baghban, Marcia. 1984. *Our Daughter Learns to Read and Write: A Case Study from Birth to Three.* Newark, DE: International Reading Association.

Bakerman, Jane S., and Mary Jean DeMarr. 1983. *Adolescent Female Portraits in the American Novel, 1961–1981.* New York: Garland.

Barbieri, Maureen. 1995. *Sounds from the Heart: Learning to Listen to Girls.* Portsmouth, NH: Heinemann.

Baumgardner, Jennifer, and Amy Richards. 2000. *Manifesta: Young Women, Feminism, and the Future.* New York: Farrar, Straus, and Giroux.

Baym, Nina. 1992. *Feminism and American Literary History: Essays.* New Brunswick, NJ: Rutgers University Press.

———. 1998. "Women's Novels and Women's Minds: An Unsentimental View of Nineteenth-Century American Women's Fiction." *Novel* 31: 335–350.

Beales, Ross W., Jr. 1978. "Studying Literacy at the Community Level: A Research Note." *Journal of Interdisciplinary History* 9: 93–102.

Beales, Ross W., Jr., and E. Jennifer Monaghan. 2000. "Literacy and School-books." Pp. 380–387 in *The Colonial Book in the Atlantic World.* Vol. 1 of *A History of the Book in America.* Edited by Hugh Amory and David D. Hall. Cambridge, UK: American Antiquarian Society and Cambridge University Press.

Beecher, Catharine. 1829. *Suggestions Respecting Improvements in Education, Presented to the Trustees of the Hartford Female Seminary, and Published at Their Request.* Hartford, CT: Packard and Butler.

———. 1850. *Treatise on Domestic Economy, for the Use of Young Ladies at Home or at School.* New York: Harper and Brothers.

Beecher, Catharine, and Harriet Beecher Stowe. [1869] 1987. *American Woman's Home.* Reprint, Hartford, CT: Stowe-Day Foundation.

Begos, Jane DuPree. 1987. "The Diaries of Adolescent Girls." *Women's Studies International Forum* 10: 69–75.

Benavot, Aaron, and Phyllis Riddle. 1988. "The Expansion of Primary Education, 1870–1940: Trends and Issues." *Sociology of Education* 61: 191–210.

Berger, Josef, and Dorothy Berger. 1966. *Small Voices.* New York: P. S. Eriksson.

Berlin, James A. 1984. *Writing Instruction in Nineteenth-Century American Colleges.* Carbondale: Southern Illinois University Press.

———. 1987. *Rhetoric and Reality: Writing Instruction in American Colleges, 1900–1985.* Carbondale: Southern Illinois University Press.

Berrol, Selma. 1992. "Immigrant Children at School, 1880–1940." Pp. 42–60 in *Small Worlds: Children and Adolescents in America, 1850–1950.* Edited by Elliott West and Paula Petrik. Lawrence: University Press of Kansas.

Bettelheim, Bruno. 1976. *The Uses of Enchantment: The Meaning and Importance of Fairy Tales.* New York: Knopf.

Biklen, Sari Knopp. 1978. "The Progressive Education Movement and the Question of Women." *Teachers College Record* 80: 327–328.

Billman, Carol. 1986. *The Secret of the Stratemeyer Syndicate: Nancy Drew, the Hardy Boys, and the Million Dollar Fiction Factory.* New York: Ungar Publishing.

Bing-Canar, Jennifer, and Mary Zerkel. 1998. "Reading the Media and Myself: Experiences in Critical Media Literacy with Young Arab-American Women." *Signs* 23: 735–744.

Bizzell, Patricia. 1992. "Opportunities for Feminist Research in the History of Rhetoric." *Rhetoric Review* 11: 50–58.

———. 2000. "Feminist Methods of Research in the History of Rhetoric: What Difference Do They Make?" *Rhetoric Society Quarterly* 30, no. 4: 5–17.

Blandin, I. M. E. [1909] 1975. *History of Higher Education of Women in the South Prior to 1860.* Washington, DC: Zenger.

Block, Francesca Lia, and Hillary Carlip. 1998. *Zine Scene: The Do It Yourself Guide to Zines*. Los Angeles: Girl Press.

Bolton, Sarah Knowles. 1885. *How Success Is Won*. Boston: D. Lothrop.

———. 1886. *Lives of Girls Who Became Famous*. New York: T.Y. Crowell.

Borman, Kathryn M., Elaine Mueninghoff, and Shirley Piazza. 1988. "Urban Appalachian Girls and Young Women: Bowing to No One." Pp. 230–248 in *Class, Race, and Gender in American Education*. Edited by Lois Weis. Albany: State University of New York Press.

Bottigheimer, Ruth B., ed. 1986. *Fairy Tales and Society: Illusion, Allusion and Paradigm*. Philadelphia: University of Pennsylvania Press.

Bowne, Eliza Southgate. 1887. *A Girl's Life Eighty Years Ago: Selections from the Letters of Eliza Southgate Bowne*. Edited by Clarence Cook. New York: Charles Scribner's Sons.

Boydston, Jeanne. 1997. "The Woman Who Wasn't There: Women's Market Labor and the Transition to Capitalism in the United States." Pp. 23–47 in *Wages of Independence: Capitalism in the Early American Republic*. Edited by Paul A. Gilje. Madison, WI: Madison House.

Brady, Marilyn Dell. 1991. "The New Model Middle-Class Family (1815–1930)." Pp. 83–123 in *American Families: A Research Guide and Historical Handbook*. Edited by Joseph M. Hawes and Elizabeth I. Nybakken. New York: Greenwood Press.

Brandt, Deborah. 1995. "Accumulating Literacy: Writing and Learning to Write in the Twentieth Century." *College English* 57: 648–668.

———. 1998. "Sponsors of Literacy." *College Composition and Communication* 49 (May): 165–185.

———. 2001. *Literacy in American Lives*. Cambridge, UK: Cambridge University Press.

Brenzel, Barbara. 1980. "Domestication as Reform: A Study of the Socialization of Wayward Girls, 1856–1905." *Harvard Educational Review* 50: 196–213.

Brickley, Lynn Templeton. 1985. "Sarah Pierce's Litchfield Female Academy, 1792–1833." Ph.D. diss., Harvard University.

Briggs, Le Baron. 1911. *Girls and Education*. Boston: Houghton Mifflin.

Broaddus, Dorothy C. 1999. *Genteel Rhetoric: Writing High Culture in Nineteenth-Century Boston*. Columbia: University of South Carolina Press.

Brooks, David. 2001. "The Organization Kid." *Atlantic Monthly* 287, no. 4 (April): 40–54.

Brown, Charles. 1961. "Self-Portrait: The Teen-Type Magazine." *Annals of the American Academy of Political and Social Science*, Vol. 338, *Teenage Culture* (November): 14–21.

Brown, Lyn Mikel. 1998. *Raising Their Voices: The Politics of Girls' Anger*. Cambridge, MA: Harvard University Press.

Brown, Lyn Mikel, and Carol Gilligan. 1992. *Meeting at the Crossroads: Women's Psychology and Girls' Development*. Cambridge, MA: Harvard University Press.

Brown, Richard D. 1989. *Knowledge Is Power: The Diffusion of Information in Early America, 1700–1865*. New York: Oxford University Press.

Brumberg, Joan Jacobs. 1997. *The Body Project: An Intimate History of American Girls.* New York: Random House.

———. 1998. "The 'Me' of Me: Voices of Jewish Girls in Adolescent Diaries of the 1920s and 1950s." Pp. 53–67 in *Talking Back: Images of Jewish Women in American Popular Culture.* Edited by Joyce Antler. Hanover, NH: University Press of New England.

Brumberg, Stephan F. 1986. *Going to America, Going to School: The Jewish Immigrant Public School Encounter in Turn-of-the-Century New York City.* New York: Praeger.

Bunkers, Suzanne L. 1986. "Reading and Interpreting Unpublished Diaries by Nineteenth-Century Women." *a/b Auto/biography Studies* 2, no. 2 (Summer): 15–17.

———. 1987. "'Faithful Friends': Nineteenth-Century Midwestern Women's Unpublished Diaries." *Women's Studies International Forum* 10: 7–17.

———. 1990a. "Diaries: Public *and* Private Records of Women's Lives." *Legacy* 7 (Fall): 17–26.

———. 1990b. "Subjectivity and Self-Reflexivity in the Study of Women's Diaries as Autobiography." *a/b Auto/biography Studies* 5, no. 2 (Fall): 114–123.

———. 1993. "'What Do Women *Really* Mean'? Thoughts on Women's Diaries and Lives." Pp. 207–221 in *The Intimate Critique: Autobiographical Literary Criticism.* Edited by Diane P. Freedman, Oliva Frey, and Frances Murphy Zauhar. Durham, NC: Duke University Press.

———, ed. 1993. *"All Will Yet Be Well": The Diary of Sarah Gillespie Huftalen, 1873–1952.* Iowa City: University of Iowa Press.

———. 2001. *Diaries of Girls and Women: A Midwestern American Sample.* Madison: University of Wisconsin Press.

Bunkers, Suzanne L., and Cynthia Huff, eds. 1996. *Inscribing the Daily: Critical Essays on Women's Diaries.* Amherst: University of Massachusetts Press.

Burgess, Marianna. 1891. *Stiya.* Cambridge: Riverside Press.

Burgett, Bruce. 1998. *Sentimental Bodies: Sex, Gender, and Citizenship in the Early Republic.* Princeton, NJ: Princeton University Press.

Burris, Gladys Tolar. 1953. "Help Your Child Enjoy Writing Letters." *Parents' Magazine* 28 (December): 52–53.

Burstall, Sara A. 1894. *The Education of Girls in the United States.* London: Swan Sonnenschein; New York: Macmillan.

———. 1909. *Impressions of American Education in 1908.* London: Longmans, Green and Company.

Bybee, Rodger W. 1997. *Achieving Scientific Literacy: From Purposes to Practices.* Portsmouth, NH: Heinemann.

Calhoun, Arthur W. [1917] 1973. *A Social History of the Family from Colonial Times to the Present.* Reprint, New York: Arno Press.

Campbell, Joann. 1996. "Freshman [sic] English: A 1901 Wellesley College 'Girl' Negotiates Authority." *Rhetoric Review* 15: 110–127.

Canaan, Joyce E. 1990. "Passing Notes and Telling Jokes: Gendered Strategies among American Middle School Teenagers." Pp. 215–231 in *Uncertain Terms: Negotiating Gender in American Culture.* Edited by Faye Ginsburg and Anna Lowenhaupt Tsing. Boston: Beacon Press.

Carlip, Hillary. 1995. *Girl Power: Young Women Speak Out.* New York: Warner Books.

Carroll, Gladys Hasty. 1963. *To Remember Forever, the Journal of a College Girl, 1921–23.* Boston: Little, Brown.

Cassidy, Carol. 2000. *Girls in America: Their Stories, Their Words.* New York: TV Books.

Chase, Horace R. 1887. "Reports of Indian Schools." *Annual Report of the Commissioner of Indian Affairs to the Secretary of the Interior, United States Bureau of Indian Affairs.* Washington, DC: Government Printing Office.

———. 1888. "Reports of Indian Schools." *Annual Report of the Commissioner of Indian Affairs to the Secretary of the Interior, United States Bureau of Indian Affairs.* Washington, DC: Government Printing Office.

Child, Lydia Maria. 1831. *The Girl's Own Book.* Boston: Carter, Hendee, and Babcock.

Christian-Smith, Linda K. 1990. *Becoming a Woman through Romance.* New York: Routledge.

———, ed. 1993. *Texts of Desire: Essays on Fiction, Femininity, and Schooling.* London: Falmer Press.

———. 1998. "Young Women and Their Dream Lovers: Sexuality in Adolescent Fiction." Pp. 100–111 in *Women's Bodies: Sexuality, Appearance, and Behavior.* Edited by Rose Weitz. New York: Oxford University Press.

Cirtautas, K. C. 1962. *The American College Girl.* New York: Citadel Press.

Clark, Beverly Lyon, and Margaret R. Higonnet, eds. 1999. *Girls, Boys, Books, Toys: Gender in Children's Literature and Culture.* Baltimore: Johns Hopkins University Press.

Clark, Gregory, and S. Michael Halloran, eds. 1993. *Oratorical Culture in Nineteenth-Century America: Transformations in the Theory and Practice of Rhetoric.* Carbondale: Southern Illinois University Press.

Clark, Roger, and Heidi Kulkin. 1996. "Toward a Multicultural Perspective on Fiction for Young Adults." *Youth and Society* 27: 291–312.

Clark, Roger, Rachel Lennon, and Leanna Morris. 1993. "Of Caldecotts and Kings: Gendered Images in Recent American Children's Books by Black and Non-Black Illustrators." *Gender and Society* 7: 227–245.

Clark, Suzanne. 1991. *Sentimental Modernism: Women Writers and the Revolution of the Word.* Bloomington: Indiana University Press.

Clement, Priscilla Ferguson. 1997. *Growing Pains: Children in the Industrial Age, 1850–1890.* New York: Twayne Publishers.

Cline, Cheryl. 1989. *Women's Diaries, Journals, and Letters: An Annotated Bibliography.* New York: Garland.

Cochran-Smith, Marilyn. 1984. *The Making of a Reader.* Norwood, NJ: Ablex.

Cogan, Frances. 1989. *All-American Girl: The Ideal of Real Womanhood in Mid-Nineteenth Century America.* Athens: University of Georgia Press.

Cohen, Jody, and Jukey Blanc. 1996. *Girls in the Middle: Working to Succeed in School.* Washington, DC: American Association of University Women Educational Foundation.

Cohen, Patricia Cline. 1982. *A Calculating People: The Spread of Numeracy in Early America.* Chicago: University of Chicago Press.

Cohen, Rosetta Marantz, and Samuel Scheer, eds. 1997. *The Work of Teachers in America: A Social History through Stories.* Mahwah, NJ: Lawrence Erlbaum Associates.

Coleman, Michael C. 1993. *American Indian Children at School, 1850–1930.* Jackson: University Press of Mississippi.

———. 1994. "American Indian School Pupils as Cultural Brokers: Cherokee Girls at Brainerd Mission, 1828–1829." Pp. 122–136 in *Between Indian and White Worlds: The Cultural Broker.* Edited by Margaret Connell Szasz. Norman: University of Oklahoma Press.

Colman, Benjamin. 1735. *Reliquiae Turellae, et Lachrymae Paternae. Two Sermons Preach'd at Medford, April 6, 1735 . . . To Which Are Added, Some Large Memoirs of Her Life and Death, by Her Consort, the Reverend Mr. Ebenezer Turell.* Boston: J. Edwards and H. Foster.

Connors, Robert J. 1981. "The Rise and Fall of the Modes of Discourse." *College Composition and Communication* 32: 444–455.

———. 1997. *Composition-Rhetoric: Backgrounds, Theory, and Pedagogy.* Pittsburgh: University of Pittsburgh Press.

Cook, Anna Maria Green. 1964. *The Journal of a Milledgeville Girl, 1861–1867.* Edited by James C. Bonner. Athens: University of Georgia Press.

Cornelius, Janet Duitsman. 1991. *"When I Can Read My Title Clear": Literacy, Slavery, and Religion in the Antebellum South.* Columbia: University of South Carolina Press.

Cott, Nancy F. 2000. *Public Vows: A History of Marriage and the Nation.* Cambridge, MA: Harvard University Press.

Cowles, Julia. 1931. *The Diaries of Julia Cowles; a Connecticut Record, 1797–1803.* Edited by Laura Hadley Moseley. New Haven, CT: Yale University Press.

Cremin, Lawrence A. 1961. *The Transformation of the School: Progressivism in American Education, 1876–1957.* New York: Alfred A. Knopf.

———. 1970. *American Education: The Colonial Experience, 1607–1783.* New York: Harper and Row.

———. 1980. *American Education: The National Experience, 1783–1876.* New York: Harper and Row.

Crowley, Sharon. 1998. *Composition in the University: Historical and Polemical Essays.* Pittsburgh: University of Pittsburgh Press.

Crowther, Barbara. 1999. "Writing as Performance: Young Girls' Diaries." Pp. 197–220 in *Making Meaning of Narratives.* Vol. 6 of *The Narrative Study of Lives.* Edited by Ruthellen Josselson and Amia Lieblich. Thousand Oaks, CA: Sage.

Culley, Margo, ed. 1985. *A Day at a Time: The Diary Literature of American Women from 1764 to the Present.* New York: Feminist Press.

Currie, Dawn H. 1999. *Girl Talk: Adolescent Magazines and Their Readers.* Toronto: University of Toronto Press.

Cushman, Mary Ames. 1936. *She Wrote It All Down.* New York: Scribner's Sons.

Daddario, Wilma. 1992. "'They Get Milk Practically Every Day': The Genoa Indian Industrial School, 1884–1934." *Nebraska History* 73, no. 1 (Spring): 2–11.

Daly, Maureen. [1938] 1962. "Sixteen." *Saplings* 13: 1–6. Reprint, pp. 13–21 in *Sixteen and Other Stories*. New York: Dodd, Mead.

Davidson, Cathy N. 1986. *Revolution and the Word: The Rise of the Novel in America*. New York: Oxford University Press.

Davidson, Cathy N., ed. 1989. *Reading in America: Literature and Social History*. Baltimore: Johns Hopkins University Press.

Davis, Gayle R. 1987. "Women's Frontier Diaries: Writing for Good Reason." *Women's Studies* 14: 5–14.

Dawson, Sarah Morgan. 1913. *A Confederate Girl's Diary*. Boston: Houghton Mifflin.

de Jesús, Melinda L. 1998. "Fictions of Assimilation: Nancy Drew, Cultural Imperialism, and the Filipina/American Experience." Pp. 227–246 in *Delinquents and Debutantes: Twentieth-Century American Girls' Cultures*. Edited by Sherrie A. Inness. New York: New York University Press.

de Ras, Marion, and Mieke Lunenberg, eds. 1993. *Girls, Girlhood, and Girls' Studies in Transition*. Amsterdam: Het Spinhuis.

Decker, William Merrill. 1998. *Epistolary Practices: Letter Writing in America before Telecommunications*. Chapel Hill: University of North Carolina Press.

Dellmann-Jenkins, Mary, Lisa Florjancic, and Elizabeth Blue Swadener. 1993. "Sex Roles and Cultural Diversity in Recent Award Winning Picture Books for Young Children." *Journal of Research in Childhood Education* 7: 74–82.

DeMarr, Mary Jean, and Jane S. Bakerman. 1986. *The Adolescent in the American Novel since 1960*. New York: Ungar.

Dierks, Konstantin. 1999. *Letter Writing, Gender, and Class in America, 1750–1800*. Ph.D. diss., Brown University.

Dillon, Deborah R., and Elizabeth B. Moje. 1998. "Listening to the Talk of Adolescent Girls: Lessons about Literacy, School, and Life." Pp. 193–224 in *Reconceptualizing the Literacies in Adolescents' Lives*. Edited by Donna E. Alvermann, Kathleen A. Hinchman, David W. Moore, Stephen F. Phelps, and Diane R. Waff. Mahwah, NJ: Lawrence Erlbaum Associates.

Dodge, Grace Hoadley. 1887. *A Bundle of Letters to Busy Girls on Practical Matters*. New York: Funk and Wagnalls.

Dodson, Lisa. 1998. *Don't Call Us Out of Name: The Untold Lives of Women and Girls in Poor America*. Boston: Beacon Press.

Donawerth, Jane. 2002. "Nineteenth-Century United States Conduct Book Rhetoric by Women." *Rhetoric Review* 21: 5–21.

Douglas, Susan J. 1994. *Where the Girls Are: Growing Up Female with the Mass Media*. New York: Times Books.

Driscoll, Catherine. 2002. *Girls: Feminine Adolescence in Popular Culture and Cultural Theory*. New York: Columbia University Press.

Dubisar, Abby M. 2002. "Writing Bad Girls/Bad Girls Writing." Unpublished Research Paper. University of Missouri, Kansas City.

Duncombe, Stephen. 1997. *Notes from Underground: Zines and the Politics of Alternative Culture*. New York: Verso.

———. 1998. "Let's All Be Alienated Together: Zines and the Making of Underground Community." Pp. 427–451 in *Generations of Youth: Youth Cultures and*

History in Twentieth-Century America. Edited by Joe Austin and Michael Nevin Willard. New York: New York University Press.

Dye, Nancy S. 1991. "Introduction." Pp. 1–9 in *Gender, Class, Race, and Reform in the Progressive Era.* Edited by Noralee Frankel and Nancy S. Dye. Lexington: University Press of Kentucky.

Dyson, Anne Haas. 1989. *Multiple Worlds of Child Writers: Friends Learning to Write.* New York: Teachers College Press.

Earle, Alice Morse. [1899] 1976. *Child Life in Colonial Days.* Reprint, Norwood, PA: Norwood Edition.

Edmonds, Mary Jaene. 1991. *Samplers and Samplemakers: An American Schoolgirl Art, 1700–1850.* New York: Rizzoli.

Eldred, Janet Carey. 2001. "Modern Fidelity." *Fourth Genre* 3, no. 2: 55–69.

Eldred, Janet Carey, and Peter Mortensen. 1993. "Gender and Writing Instruction in Early America: Lessons from Didactic Fiction." *Rhetoric Review* 12: 25–53.

———. 2002. *Imagining Rhetoric: Composing Women of the Early United States.* Pittsburgh: University of Pittsburgh Press.

Elson, Ruth Miller. 1964. *Guardians of Tradition: American Schoolbooks of the Nineteenth Century.* Lincoln: University of Nebraska Press.

Enoch, Jessica. 2002. "Resisting the Script of Indian Education: Zitkala Sa and the Carlisle Indian School." *College English* 65: 117–141.

Enstad, Nan. 1999. *Ladies of Labor, Girls of Adventure: Working Women, Popular Culture, and Labor Politics at the Turn of the Twentieth Century.* New York: Columbia University Press.

Esquibel, Catrióna Rueda. 1998. "Memories of Girlhood: Chicana Lesbian Fictions." *Signs* 23: 645–682.

Farrar, Eliza W. R. 1836. *The Young Lady's Friend, by a Lady.* Boston: American Stationers' Company.

Fern, Fanny. [1855] 1986. *Ruth Hall.* Pp. 1–211 in *Ruth Hall and Other Writings.* Edited by Joyce W. Warren. New Brunswick, NJ: Rutgers University Press.

Finders, Margaret J. 1996. "Queens and Teen Zines: Early Adolescent Females Reading Their Way toward Adulthood." *Anthropology and Education Quarterly* 27: 71–89.

———. 1997. *Just Girls: Hidden Literacies and Life in Junior High.* New York: Teachers College Press.

Findlen, Barbara, ed. 1995. *Listen Up: Voices from the Next Feminist Generation.* Seattle: Seal Press.

Fine, Michelle. 1993. "Sexuality, Schooling, and Adolescent Females: The Missing Discourse of Desire." Pp. 75–100 in *Beyond Silenced Voices: Class, Race and Gender in United States Schools.* Edited by Michelle Fine and Lois Weis. Albany: State University of New York Press.

Fishman, Andrea. 1988. *Amish Literacy: What and How It Means.* Portsmouth, NH: Heinemann.

Fizer, Irene. 1993. "Signing as Republican Daughters: The Letters of Eliza Southgate and *The Coquette.*" *Eighteenth Century: Theory and Interpretation* 34: 243–263.

Fleisher, Mark S. 1998. *Dead End Kids: Gang Girls and the Boys They Know.* Madison: University of Wisconsin Press.

Foner, Philip S., ed. 1977. *The Factory Girls: A Collection of Writings on Life and Struggles in the New England Factories of the 1840s.* Chicago: University of Illinois Press.

Ford, Paul Leicester, ed. [1897] 1962. *The New-England Primer.* Reprint, New York: Teachers College Press.

Fordham, Signithia. 1993. "'Those Loud Black Girls': (Black) Women, Silence, and Gender 'Passing' in the Academy." *Anthropology and Education Quarterly* 24: 3–32.

Forman-Brunell, Miriam, ed. 2001. *Girlhood in America: An Encyclopedia.* 2 vols. Santa Barbara, CA: ABC-CLIO.

Formanek-Brunell, Miriam. 1993. *Made to Play House: Dolls and the Commercialization of American Girlhood, 1830–1930.* New Haven, CT: Yale University Press.

Foster, Hannah Webster. 1798. *The Boarding School.* Boston: Thomas and Andrews.

Foster, Shirley, and Judy Simons. 1995. *What Katy Read: Feminist Re-Readings of "Classic" Stories for Girls.* Iowa City: University of Iowa Press.

Franklin, Benjamin. 1747. *Proposals Relating to the Education of Youth in Pensilvania.* Philadelphia: n.p.

Frye, Sharon. 1998. "'What Does *She* Like?' Choosing a Curriculum for Girls." Pp. 17–28 in *"We Want to Be Known": Learning from Adolescent Girls.* Edited by Ruth Shagoury Hubbard, Maureen Barbieri, and Brenda Miller Power. York, ME: Stenhouse Publishers.

Furger, Roberta. 1998. *Does Jane Compute? Preserving Our Daughters' Place in the Cyber Revolution.* New York: Warner Books.

Franklin, Penelope, ed. 1986. *Private Pages: Diaries of American Women, 1830s–1970s.* New York: Ballantine Books.

Gannett, Cinthia. 1992. *Gender and the Journal: Diaries and Academic Discourse.* Albany: State University of New York Press.

———. 1995. "The Stories of Our Lives Become Our Lives: Journals, Diaries, and Academic Discourse." Pp. 109–136 in *Feminine Principles and Women's Experience in American Composition and Rhetoric.* Edited by Louise Wetherbee Phelps and Janet Emig. Pittsburgh: University of Pittsburgh Press.

Gateward, Frances, and Murray Pomerance, eds. 2002. *Sugar, Spice, and Everything Nice: Cinemas of Girlhood.* Detroit, MI: Wayne State University Press.

Gere, Anne Ruggles. 1987. *Writing Groups: History, Theory, and Implications.* Carbondale: Southern Illinois University Press.

———. 1994. "Kitchen Tables and Rented Rooms: The Extracurriculum of Composition." *College Composition and Communication* 45 (February): 75–92.

———. 1997. *Intimate Practices: Literacy and Cultural Work in U.S. Women's Clubs, 1880–1920.* Urbana: University of Illinois Press.

Gilbert, James. 1986. *A Cycle of Outrage: America's Reaction to the Juvenile Delinquent in the 1950s.* New York: Oxford University Press.

Gilbert, Pam. 1994. "'And They Lived Happily Ever After': Cultural Storylines

and the Construction of Gender." Pp. 124–142 in *The Need for Story: Cultural Diversity in Classroom and Community.* Edited by Anne Haas Dyson and Celia Genishi. Urbana, IL: National Council of Teachers of English.

Gilead, Sarah. 1991. "Magic Abjured: Closure in Children's Fantasy Fiction." *PMLA* 106: 277–293.

Gilbert, James. 1986. *A Cycle of Outrage: America's Reaction to the Juvenile Delinquent in the 1950s.* New York: Oxford University Press.

Gillespie, Joanna Bowen. 2001. *The Life and Times of Martha Laurens Ramsay, 1759–1811.* Columbia: University of South Carolina Press.

Gilligan, Carol. 1982. *In a Different Voice: Psychological Theory and Women's Development.* Cambridge, MA: Harvard University Press.

Gilligan, Carol, Nona P. Lyons, and Trudy J. Hanmer, eds. 1990. *Making Connections: The Relational Worlds of Adolescent Girls at Emma Willard School.* Cambridge, MA: Harvard University Press.

Gilmore, William J. 1982. "Elementary Literacy on the Eve of the Industrial Revolution: Trends in Rural New England, 1760–1830." *Proceedings of the American Antiquarian Society* 92: 87–178.

———. 1989. *Reading Becomes a Necessity of Life: Material and Cultural Life in Rural New England, 1780–1835.* Knoxville: University of Tennessee Press.

Ginorio, Angela B., and Michelle Huston. 2001. *¡Sí, Se Puede! Yes, We Can: Latinas in School.* Washington, DC: American Association of University Women Educational Foundation.

Giordano, Peggy C. 1995. "The Wider Circle of Friends in Adolescence." *American Journal of Sociology* 101: 661–697.

Goggin, Maureen Daly. 2002. "An *Essamplaire Essai* on the Rhetoricity of Needlework Sampler-Making: A Contribution to Theorizing and Historicizing Rhetorical Praxis." *Rhetoric Review* 21: 309–338.

Glenn, Cheryl. 1997. *Rhetoric Retold: Regendering the Tradition from Antiquity through the Renaissance.* Carbondale: Southern Illinois University Press.

Goldin, Barbara Diamond. 1995. *Bat Mitzvah: A Jewish Girl's Coming of Age.* New York: Viking Press.

Goodfriend, Joyce D. 1987. *The Published Diaries and Letters of American Women: An Annotated Bibliography.* Boston: G. K. Hall.

Gordon, Lynn D. 1987. "The Gibson Girl Goes to College: Popular Culture and Women's Higher Education in the Progressive Era, 1890–1920." *American Quarterly* 39: 211–230.

———. 1990. *Gender and Higher Education in the Progressive Era.* New Haven, CT: Yale University Press.

Gorham, Deborah. 1982. *The Victorian Girl and the Feminine Ideal.* Bloomington: Indiana University Press.

Gould, Kenneth M., and Joan Coyne, eds. 1945. *Young Voices: A Quarter Century of High School Student Writing Selected from the Scholastic Awards.* New York: Harper and Brothers.

Graff, Harvey J. 1987. *The Legacies of Literacy: Continuities and Contradictions in Western Culture and Society.* Bloomington: Indiana University Press.

————. 1995. *Conflicting Paths: Growing Up in America.* Cambridge, MA: Harvard University Press.

Grand, Sarah. 1894. "The Modern Girl." *North American Review* 158: 706–714.

Grauerholz, Elizabeth, and Bernice A. Pescosolido. 1989. "Gender and Representation in Children's Literature, 1900–1984." *Gender and Society* 3 (March): 113–125.

Graves, Karen. 1998. *Girls' Schooling during the Progressive Era: From Female Scholar to Domesticated Citizen.* New York: Garland.

Gray, Mary L. 1999. *In Your Face: Stories from the Lives of Queer Youth.* Binghamton, NY: Harrington Park Press.

Gregg, Edith E. W., ed. 1982. *The Letters of Ellen Tucker Emerson.* 2 vols. Kent, OH: Kent State University Press.

Green, Karen, and Tristan Taormino, eds. 1997. *A Girl's Guide to Taking Over the World: Writings from the Girl Zine Revolution.* New York: St. Martin's Press.

Greve, Janis. 1992. "Orphanhood and 'Photo'-Portraiture in Mary McCarthy's *Memories of a Catholic Girlhood*." Pp. 167–184 in *American Women's Autobiography: Fea(s)ts of Memory.* Edited by Margo Culley. Madison: University of Wisconsin Press.

Grimké, Charlotte Forten. [1854] 1988. *The Journals of Charlotte Forten Grimké.* Edited by Brenda Stevenson. New York: Oxford University Press.

Griswold, Rufus W. 1847. *The Female Poets of America.* Philadelphia: Carey and Hart.

Guzzetti, Barbara J., and Wayne O. Williams. 1996. "Gender, Text, and Discussion: Examining Intellectual Safety in the Science Classroom." *Journal of Research in Science Teaching* 33: 5–20.

Haag, Pamela, and the American Association of University Women Educational Foundation. 2000. *Voices of a Generation: Teenage Girls Report about Their Lives Today.* New York: Marlowe and Company.

Hall, David D. 1989. *Worlds of Wonder, Days of Judgment: Popular Religious Belief in Early New England.* New York: Alfred A. Knopf.

Harris, Sharon M., ed. 1996. *American Women Writers to 1800.* New York: Oxford University Press.

Hartog, Hendrik. 2000. *Man and Wife in America: A History.* Cambridge, MA: Harvard University Press.

Hawes, Joseph M., and N. Ray Hiner, eds. 1985. *American Childhood: A Research Guide and Historical Handbook.* Westport, CT: Greenwood Press.

Hayes, Kevin J. 1996. *A Colonial Woman's Bookshelf.* Knoxville: University of Tennessee Press.

Haynes, Carolyn A. 1998. *Divine Destiny: Gender and Race in Nineteenth-Century Protestantism.* Jackson: University Press of Mississippi.

Heartman, Charles F. 1934. *The New England Primer issued prior to 1830.* New York: R.R. Bowker.

Heath, Shirley Brice. 1981. "Toward an Ethnohistory of Writing in American Education." Pp. 25–45 in *Variation in Writing: Functional and Linguistic-Cultural Differences.* Edited by Marcia Farr Whiteman. Vol. 1 of *Writing: The Nature, Development, and Teaching of Written Communication.* Hillsdale, NJ: Lawrence Erlbaum Associates.

———. 1983. *Ways with Words: Language, Life, and Work in Communities and Classrooms.* Cambridge, UK: Cambridge University Press.

Henry, George H. 1947. "What's Wrong with High School?" *Ladies' Home Journal* (January): 28+.

Herndon, Ruth Wallis. 1996. "Research Note: Literacy among New England's Transient Poor, 1750–1800." *Journal of Social History* 29: 963–965.

Hersch, Patricia. 1998. *A Tribe Apart: A Journey into the Heart of American Adolescence.* New York: Fawcett Columbine.

Higginson, Thomas Wentworth. 1859. "Ought Women to Learn the Alphabet?" *Atlantic Monthly* 3: 137–150.

———. 1900. *Women and the Alphabet: A Series of Essays.* Boston: Houghton Mifflin.

Hiner, N. Ray, and Joseph M. Hawes. 1985. *Growing Up in America: Children in Historical Perspective.* Urbana: University of Illinois Press.

Hobbs, Catherine, ed. 1995. *Nineteenth-Century Women Learn to Write.* Charlottesville: University Press of Virginia.

Hobby, Elaine. 1989. *Virtue of Necessity: English Women's Writing, 1649–88.* Ann Arbor: University of Michigan Press.

Hodge, Susan Winslow, ed. [1835] 1985. *The Elfreth Book of Letters.* Philadelphia: University of Pennsylvania Press.

Hoff, Joan. 1991. *Law, Gender, and Injustice: A Legal History of U.S. Women.* New York: New York University Press.

Holliday, Laurel. 1978. *Heart Songs: The Intimate Diaries of Young Girls.* Guerneville, CA: Bluestocking Books.

Horner, Winifred Bryan. 1993. *Nineteenth-Century Scottish Rhetoric: The American Connection.* Carbondale: Southern Illinois University Press.

Horowitz, Helen Lefkowitz. 1984. *Alma Mater: Design and Experience in the Women's Colleges from Their Nineteenth-Century Beginnings to the 1930s.* New York: Alfred A. Knopf.

Hubbard, Ruth Shagoury, Maureen Barbieri, and Brenda Miller Power, eds. 1998. *"We Want to Be Known": Learning from Adolescent Girls.* York, Maine: Stenhouse Publishers.

Hunter, Jane. 1992. "Inscribing the Self in the Heart of the Family: Diaries and Girlhood in Late-Victorian America." *American Quarterly* 44: 51–81.

Inness, Sherrie A. 1995. *Intimate Communities: Representation and Social Transformation in Women's College Fiction, 1895–1910.* Bowling Green, OH: Bowling Green State University Popular Press.

———, ed. 1997. *Nancy Drew and Company: Culture, Gender, and Girls' Series.* Bowling Green, OH: Bowling Green State University Popular Press.

———. 1998. *Delinquents and Debutantes: Twentieth-Century American Girls' Cultures.* New York: New York University Press.

Jacobs, Harriet. [1861] 1987. *Incidents in the Life of a Slave Girl.* Edited by Jean Fagan Yellin. Reprint, Cambridge, MA: Harvard University Press.

Jenkins, Christine. 1998. "From Queer to Gay and Back Again: Young Adult Novels with Gay/Lesbian/Queer Content, 1969–1997." *Library Quarterly* 68: 298–334.

John, Richard R. 1995. *Spreading the News: The American Postal System from Franklin to Morse.* Cambridge: Harvard University Press.

Johnson, Nan. 1991. *Nineteenth-Century Rhetoric in North America.* Carbondale: Southern Illinois University Press.

———. 2002. *Gender and Rhetorical Space in American Life, 1866–1910.* Carbondale: Southern Illinois University Press.

Johnston, Bessie. 1886. "Reports of Indian Schools." *Annual Report of the Commissioner of Indian Affairs to the Secretary of the Interior, United States Bureau of Indian Affairs.* Washington, DC: Government Printing Office.

Jones, Alison. 1993. "Becoming a 'Girl': Post-structuralist Suggestions for Educational Research." *Gender and Education* 5: 157–166.

Jones, Helen L. 1969a. "The Part Played by Boston Publishers of 1860–1900 in the Field of Children's Books." *Horn Book Magazine* 45: 20–28.

———. 1969b. "The Part Played by Boston Publishers of 1860–1900 in the Field of Children's Books—Part II." *Horn Book Magazine* 45: 153–159.

———. 1969c. "The Part Played by Boston Publishers of 1860–1900 in the Field of Children's Books—Conclusion." *Horn Book Magazine* 45: 329–336.

Jonsberg, Sara Dalmas, Maria Salgado, and the Women of the Next Step. 1995. "Composing the Multiple Self: Teen Mothers Rewrite Their Roles." Pp. 211–229 in *Feminine Principles and Women's Experience in American Composition and Rhetoric.* Edited by Louise Wetherbee Phelps and Janet Emig. Pittsburgh: University of Pittsburgh Press.

Kaestle, Carl F. 1983. *Pillars of the Republic: Common Schools and American Society, 1780–1860.* New York: Hill and Wang.

Kaestle, Carl F., Helen Damon-Moore, Lawrence C. Stedman, Katherine Tinsley, and William Vance Trollinger, Jr. 1991. *Literacy in the United States: Readers and Reading since 1880.* New Haven, CT: Yale University Press.

Kaplan, Elaine Bell. 1997. *Not One of Our Girls: Unraveling the Myth of Black Teenage Motherhood.* Berkeley: University of California Press.

Kates, Susan. 2001. *Activist Rhetorics and American Higher Education, 1885–1937.* Carbondale: Southern Illinois University Press.

Katriel, Tamar, and Thomas Farrell. 1991. "Scrapbooks as Cultural Texts: An American Art of Memory." *Text and Performance Quarterly* 11: 1–17.

Kearney, Mary Celeste. 1998. "'Don't Need You': Rethinking Identity Politics and Separatism from a Riot Grrrl Perspective." Pp. 148–188 in *Youth Culture: Identity in a Postmodern World.* Edited by Jonathon S. Epstein. Oxford: Blackwell Publishers.

Keith, Lois. 2001. *Take Up Thy Bed and Walk: Death, Disability and Cure in Classic Fiction for Girls.* London: Women's Press.

Kelly, R. Gordon, ed. 1984. *Children's Periodicals of the United States.* Westport, CT: Greenwood Press.

Kenny, Lorraine Delia. 2000. *Daughters of Suburbia: Growing Up White, Middle Class, and Female.* New Brunswick, NJ: Rutgers University Press.

Kensinger, Faye Riter. 1987. *Children of the Series and How They Grew.* Bowling Green, OH: Bowling Green State University Popular Press.

Kerber, Linda K. 1980. *Women of the Republic: Intellect and Ideology in Revolutionary America*. Chapel Hill: University of North Carolina Press.

———. 1988. "'Why Should Girls Be Learn'd and Wise?' Two Centuries of Higher Education for Women as Seen through the Unfinished Work of Alice Mary Baldwin." Pp. 18–42 in *Women and Higher Education in American History: Essays from the Mount Holyoke College Sesquicentennial Symposia*. Edited by John Mack Faragher and Florence Howe. New York: W. W. Norton.

———. 1989. "'History Can Do It No Justice': Women and the Reinterpretation of the American Revolution." Pp. 3–42 in *Women in the Age of the American Revolution*. Edited by Ronald Hoffman and Peter J. Albert. Charlottesville: University Press of Virginia.

———. 1997. *Toward an Intellectual History of Women*. Chapel Hill: University of North Carolina Press.

Kersey, Shirley Nelson. 1981. *Classics in the Education of Girls and Women*. Metuchen, NJ: Scarecrow Press.

Kett, Joseph F. 1977. *Rites of Passage: Adolescence in America, 1790 to the Present*. New York: Basic Books.

———. 1994. *The Pursuit of Knowledge under Difficulties: From Self-Improvement to Adult Education in America, 1750–1990*. Palo Alto, CA: Stanford University Press.

Kiefer, Monica. 1948. *American Children through Their Books, 1700–1835*. Philadelphia: University of Pennsylvania.

King, Wilma. 1995. *Stolen Childhood: Slave Youth in Nineteenth-Century America*. Bloomington: Indiana University Press.

Knockwood, Isabelle. 1992. *Out of the Depths: The Experiences of Mi'Kmaw Children at the Indian Residential School at Shubenacadie, Nova Scotia*. Lockeport, N.S.: Roseway.

Konopka, Gisela. 1976. *Young Girls: A Portrait of Adolescence*. Englewood Cliffs, NJ: Prentice-Hall.

Kopelnitsky, Raimonda, and Kelli Pryor. 1994. *No Words to Say Goodbye: A Young Jewish Woman's Journey from the Soviet Union into America: The Extraordinary Diaries of Raimonda Kopelnitsky*. New York: Hyperion.

Kritzer, Amelia Howe. 1996. "Playing with Republican Motherhood: Self-Representation in Plays by Susanna Haswell Rowson and Judith Sargent Murray." *Early American Literature* 31: 150–166.

Krug, Edward A. 1964. *The Shaping of the American High School*. 2 vols. New York: Harper and Row.

Kunzel, Regina. 1993. *Fallen Women, Problem Girls: Unmarried Mothers and the Professionalization of Social Work, 1890–1945*. New Haven, CT: Yale University Press.

Lamb, Sharon. 2001. *The Secret Lives of Girls: What Good Girls Really Do—Sex Play, Aggression, and Their Guilt*. New York: Free Press.

Lambert, Frank. 1996. *Pedlar in Divinity: George Whitefield and the Transatlantic Revivals, 1737–1770*. Princeton, NJ: Princeton University Press.

Larcom, Lucy. [1889] 1986. *A New England Girlhood: Outlined from Memory*. Reprint, Boston: Northeastern University Press.

Leblanc, Lauraine. 1999. *Pretty in Pink: Girls' Gender Resistance in a Boys' Subculture.* New Brunswick, NJ: Rutgers University Press.

Lee, Alison. 1996. *Gender, Literacy, Curriculum: Re-writing School Geography.* London: Taylor and Francis.

Lesink, Judy Nolte. 1987. "Expanding the Boundaries of Criticism: The Diary as Female Autobiography." *Women's Studies* 14: 39–53.

Lewis, Dio. [1871] 1974. *Our Girls.* New York: Harper and Brothers. Reprint, New York: Arno Press.

Lieberman, Marcia R. 1972. "'Some Day My Prince Will Come': Female Acculturation through the Fairy Tale." *College English* 34: 383–395.

Littlefield, Alice. 1993. "Learning to Labor: Native American Education in the United States, 1880–1930." Pp. 43–59 in *The Political Economy of North American Indians.* Edited by John Moore. Norman: University of Oklahoma Press.

Littlefield, Daniel F., Jr., and James W. Parins. 1984. *American Indian and Alaska Native Newspapers and Periodicals, 1826–1924.* Westport, CT: Greenwood Press.

Lockridge, Kenneth A. 1974. *Literacy in Colonial New England: An Enquiry into the Social Context of Literacy in the Early Modern West.* New York: W. W. Norton.

Logan, Shirley Wilson. 1999. *"We Are Coming": The Persuasive Discourse of Nineteenth-Century Black Women.* Carbondale: Southern Illinois University Press.

Lomawaima, K. Tsianina. 1994. *They Called It Prairie Light: The Story of Chilocco Indian School.* Lincoln: University of Nebraska Press.

Losey, Kay M. 1997. *Listen to the Silences: Mexican American Interaction in the Composition Classroom and Community.* Norwood, NJ: Ablex.

Lundin, Anne H. 1994. "Victorian Horizons: The Reception of Children's Books in England and America, 1880–1900." *Library Quarterly* 64: 30–59.

Lunsford, Andrea A., ed. 1995. *Reclaiming Rhetorica: Women in the Rhetorical Tradition.* Pittsburgh: University of Pittsburgh Press.

Lystad, Mary. 1980. *From Dr. Mather to Dr. Seuss: 200 Years of American Books for Children.* Boston: G. K. Hall.

MacDonald, Ruth K. 1982. *Literature for Children in England and America from 1646 to 1774.* Troy, NY: Whitston Publishing.

MacLeod, Anne Scott. 1975. *A Moral Tale: Children's Fiction and American Culture, 1820–1860.* Hamden, CT: Archon Books.

———. 1994. *American Childhood: Essays on Children's Literature of the Nineteenth and Twentieth Centuries.* Athens: University of Georgia Press.

———. 1995. "Children's Literature in America from the Puritan Beginnings to 1870." Pp. 102–129 in *Children's Literature: An Illustrated History.* Edited by Peter Hunt. New York: Oxford University Press.

Macleod, David I. 1998. *The Age of the Child: Children in America, 1890–1920.* New York: Twayne Publishers.

Main, Gloria L. 1991. "An Inquiry into When and Why Women Learned to Write in Colonial New England." *Journal of Social History* 24: 579–589.

Malmsheimer, Lonna M. 1985. "Imitation White Man: Images of Transformation at the Carlisle Indian School." *Studies in Visual Communication* 11: 54–74.

Mangum, Teresa. 1997. "Sheridan Le Fanu's Ungovernable Governess." *Studies in the Novel* 29: 214–237.

Marchalonis, Shirley. 1995. *College Girls: A Century in Fiction.* New Brunswick, NJ: Rutgers University Press.

Mason, Bobbie Ann. 1975. *The Girl Sleuth: A Feminist Guide.* Old Westbury, NY: Feminist Press.

Mather, Cotton. 1717. *Victorina. A Sermon Preach'd on the Decease and at the Desire of Mrs. Katharin Mather, by Her Father. Wherunto There Is Added, a Further Account of That Young Gentlewoman, by Another Hand.* Boston: D. Henchman.

———. 1957. *Diary of Cotton Mather.* Vol. 2, *1709–1724.* Edited by Worthington Chauncey Ford. New York: Frederick Ungar.

Mathews, J. M. D. 1853. *Letters to School Girls.* Cincinnati, OH: Methodist Publishers.

Matthews, William. 1974. *American Diaries in Manuscript, 1580–1954: A Descriptive Bibliography.* Athens: University of Georgia Press.

Mattingly, Carol. 1998. *Well-Tempered Women: Nineteenth-Century Temperance Rhetoric.* Carbondale: Southern Illinois University Press.

———. 2002. *Appropriate[ing] Dress: Women's Rhetorical Style in Nineteenth-Century America.* Carbondale: Southern Illinois University Press.

Matyas, Marsha Lakes, and Linda Skidmore Dix, eds. 1992. *Science and Engineering Programs: On Target for Women?* Washington, DC: National Academy Press.

Mayhew, Experience. 1727. *Indian Converts: Or, Some Account of the Lives and Dying Speeches of a Considerable Number of the Christianized Indians of Martha's Vineyard, in New-England.* London: for S. Gerrish.

McClelland, Averil Evans. 1992. *The Education of Women in the United States: A Guide to Theory, Teaching, and Research.* New York: Garland.

McFadden, Margaret. 1990. "Boston Teenagers Debate the Woman Question, 1837–38." *Signs* 15: 832–847.

McGinn, Michelle K., and Wolff-Michael Roth. 1999. "Preparing Students for Competent Scientific Practice: Implications of Recent Research in Science and Technology Studies." *Educational Researcher* 28, no. 3: 14–24.

McGuigan, Dorothy Gies. 1970. *A Dangerous Experiment: 100 Years of Women at the University of Michigan.* Ann Arbor, MI: Center for Continuing Education of Women.

McHenry, Elizabeth. 1995. "'Dreaded Eloquence': The Origins and Rise of African American Literary Societies and Libraries." *Harvard Library Bulletin,* n.s., 6, no. 2: 32–56.

———. 1998. "Forgotten Readers: African-American Literary Societies and the American Scene." Pp. 149–172 in *Print Culture in a Diverse America.* Edited by James P. Danky and Wayne A. Wiegand. Urbana: University of Illinois Press.

———. 2002. *Forgotten Readers: Recovering the Lost History of African American Literary Societies.* Durham, NC: Duke University Press.

McHenry, Elizabeth, and Shirley Brice Heath. 1994. "The Literate and the Literary: African Americans as Writers and Readers, 1830–1940." *Written Communication* 11: 419–444.

McLaren, Arlene, and John Gaskell. 1995. "Now You See It, Now You Don't: Gender as an Issue in School Science." Pp. 136–156 in *Gender In/forms Curriculum: From Enrichment to Transformation*. Edited by Jane Gaskell and John Willinsky. Ontario and New York: OISE Press/Teachers College Press.

McMahon, Lucia, and Deborah Schriver, eds. 2000. *To Read My Heart: The Journal of Rachel Van Dyke, 1810–1811*. Philadelphia: University of Pennsylvania Press.

McRobbie, Angela. 1991. *Feminism and Youth Culture: From Jackie to Just Seventeen*. Boston: Unwin Hyman.

Middlekauff, Robert. 1963. *Ancients and Axioms: Secondary Education in Eighteenth-Century New England*. New Haven, CT: Yale University Press.

Mihesuah, Devon A. 1993. *Cultivating the Rosebuds: The Education of Women at the Cherokee Female Seminary, 1851–1909*. Urbana: University of Illinois Press.

———. 2000. "'Too Dark to Be Angels': The Class System among the Cherokees at the Female Seminary." Pp. 183–196 in *Unequal Sisters: A Multicultural Read in U.S. Women's History*. 3d ed. Edited by Vicki L. Ruiz and Ellen Carol DuBois. New York: Routledge.

Miller, Susan. 1991. "The Feminization of Composition." Pp. 39–53 in *The Politics of Writing Instruction: Postsecondary*. Edited by Richard Bullock and John Trimbur. Portsmouth, NH: Boynton/Cook, Heinemann.

———. 1998. *Assuming the Positions: Cultural Pedagogy and the Politics of Commonplace Writing*. Pittsburgh: University of Pittsburgh Press.

Mishler, Paul C. 1999. *Raising Reds: The Young Pioneers, Radical Summer Camps, and Communist Political Culture in the United States*. New York: Columbia University Press.

Mitchell, Sally. 1995. *The New Girl: Girls' Culture in England, 1880–1915*. New York: Columbia University Press.

Monaghan, E. Jennifer. 1987. "Readers Writing: The Curriculum of the Writing Schools of Eighteenth-Century Boston." *Visible Language* 21: 167–213.

———. 1989. "Literacy Instruction and Gender in Colonial New England." Pp. 53–80 in *Reading in America: Literature and Social History*. Edited by Cathy N. Davidson. Baltimore: Johns Hopkins University Press.

———. 1990. "'She loved to read in good Books': Literacy and the Indians of Martha's Vineyard, 1643–1725." *History of Education Quarterly* 30: 493–521.

———. 1991a. "Family Literacy in Early Eighteenth-Century Boston: Cotton Mather and His Children." *Reading Research Quarterly* 26: 342–370.

———. 1991b. "Literacy in Eighteenth-Century New England: Some Historiographical Reflections on Issues of Gender." Pp. 12–44 in *Making Adjustments: Change and Continuity in Planter Nova Scotia, 1759–1800*. Edited by Margaret Conrad. Fredericton, New Brunswick: Acadiensis Press.

———. 1998. "Reading for the Enslaved, Writing for the Free: Reflections on Liberty and Literacy." *Proceedings of the American Antiquarian Society* 108: 309–341.

Morgan, Edmund S. 1944. *The Puritan Family; Essays on Religion and Domestic Relations in Seventeenth-Century New England*. Boston: Trustees of the Boston Public Library.

Mott, Frank Luther. 1947. *Golden Multitudes: The Story of Best Sellers in the United States*. New York: Macmillan Press.

Motz, Marilyn Ferris. 1987. "Folk Expression of Time and Place: Nineteenth-Century Midwestern Rural Diaries." *Journal of American Folklore* 100, no. 396 (April–June): 131–147.

Murolo, Priscilla. 1997. *The Common Ground of Womanhood: Class, Gender, and Working Girls' Clubs, 1884–1928*. Urbana: University of Illinois Press.

Murphy, James E., and Sharon M. Murphy. 1981. *Let My People Know: American Indian Journalism, 1828–1978*. Norman: University of Oklahoma Press.

Murray, Gail Schmunk. 1998. *American Children's Literature and the Construction of Childhood*. New York: Twayne.

Murray, Judith Sargent. [1798] 1992. *The Gleaner*. Boston: Thomas and Andrews. Reprint (3 vols. in 1), with an introduction by Nina Baym. Schenectady, NY: Union College Press.

Myers, Mitzi. 1995. "Of Mice and Mothers: Mrs. Barbauld's 'New Walk' and Gendered Codes in Children's Literature." Pp. 255–288 in *Feminine Principles and Women's Experience in American Composition and Rhetoric*. Edited by Louise Wetherbee Phelps and Janet Emig. Pittsburgh: University of Pittsburgh Press.

Nash, Margaret A. 1997. "Rethinking Republican Motherhood: Benjamin Rush and the Young Ladies' Academy of Philadelphia." *Journal of the Early Republic* 17: 171–191.

National Research Council. 1996. *National Science Education Standards: Observe, Interact, Change, Learn*. Washington, DC: National Academy Press.

Nelson, Claudia. 2001. "Girls' Fiction." Pp. 327–333 in *Girlhood in America: An Encyclopedia*. Edited by Miriam Forman-Brunell. Santa Barbara, CA: ABC-CLIO.

Nelson, Claudia, and Lynne Vallone, eds. 1994. *The Girl's Own: Cultural Histories of the Anglo-American Girl, 1830–1915*. Athens: University of Georgia Press.

Newberry, Julia. 1933. *Julia Newberry's Diary*. Introduction by Margaret Ayer Barnes and Janet Ayer Fairbank. New York: W. W. Norton.

Newcombe, Harvey. 1843. *The Young Lady's Guide to the Harmonious Development of Christian Character*. Boston: Philips and Sampson.

Nin, Anaïs. 1978. *Linotte: The Early Diary of Anaïs Nin, 1914–1920*. Vol. 1 of 4. Translated by Jean L. Sherman. New York: Harcourt Brace Jovanovich.

North, Stephen M. 1987. *The Making of Knowledge in Composition: Portrait of an Emerging Field*. Portsmouth, NH: Boynton/Cook, Heinemann.

Norton, Mary Beth. 1980. *Liberty's Daughters: The Revolutionary Experience of American Women, 1750–1800*. Boston: Little, Brown.

Odem, Mary E. 1995. *Delinquent Daughters: Protecting and Policing Adolescent Female Sexuality in the United States, 1885–1920*. Chapel Hill: University of North Carolina Press.

O'Keefe, Deborah. 2000. *Good Girl Messages: How Young Women Were Misled by Their Favorite Books*. New York: Continuum, 2000.

"On Female Authorship." 1793. *Ladies' Magazine* 2: 68–72.

O'Neill, Kelly. 1998. "No Adults Are Pulling the Strings and We Like It That Way." *Signs* 23: 611–618.

Orenstein, Peggy. 1994. *School Girls: Young Women, Self-Esteem, and the Confidence Gap.* New York: Doubleday.

Our Famous Women: An Authorized Record of the Lives and Deeds of Distinguished American Women of Our Times. 1884. By Twenty Eminent Authors. Hartford, CT: A. D. Worthington.

Paine, Charles. 1999. *The Resistant Writer: Rhetoric as Immunity, 1850 to the Present.* Albany: State University of New York Press.

Palladino, Grace. 1996. *Teenagers: An American History.* New York: Basic Books.

Pawley, Christine. 1998. "What to Read and How to Read: The Social Infrastructure of Young People's Reading, Osage, Iowa, 1870–1900." *Library Quarterly* 68: 276–297.

Peirce, Kate. 1990. "A Feminist Theoretical Perspective on the Socialization of Teenage Girls through *Seventeen* Magazine." *Sex Roles: A Journal of Research* 23: 491–500.

———. 1993. "Socialization of Teenage Girls through Teen-Magazine Fiction: The Making of a New Woman or an Old Lady?" *Sex Roles: A Journal of Research* 29: 59–68.

Peirce, Kate, and Emily D. Edwards. 1988. "Children's Construction of Fantasy Stories: Gender Differences in Conflict Resolution Strategies." *Sex Roles: A Journal of Research* 18: 393–404.

Perebinossoff, Philipe. 1975. "What Does a Kiss Mean? The Love Comic Formula and the Creation of the Ideal Teen-Age Girl." *Journal of Popular Culture* 8: 825–835.

Perlmann, Joel, and Dennis Shirley. 1991. "When Did New England Women Acquire Literacy?" *William and Mary Quarterly,* 3d ser., 48: 50–67.

Perlmann, Joel, Silvana R. Siddali, and Keith Whitescarver. 1997. "Literacy, Schooling, and Teaching among New England Women, 1730–1820." *History of Education Quarterly* 37: 117–139.

Petrik, Paula. 1992. "The Youngest Fourth Estate: The Novelty Toy Printing Press and Adolescence, 1870–1886." Pp. 125–142 in *Small Worlds: Children and Adolescents in America, 1850–1950.* Edited by Elliott West and Paula Petrik. Lawrence: University Press of Kansas.

Phelps, Elizabeth Stuart. 1866. *I Don't Know How.* Boston: Henry A. Young.

———. 1867. *Gypsy's Year at the Golden Crescent.* Boston: Graves and Young.

Pinar, William. 1978. "The Reconceptualization of Curriculum Studies." *Journal of Curriculum Studies* 10: 205–214.

Pipher, Mary. 1994. *Reviving Ophelia: Saving the Selves of Adolescent Girls.* New York: Putnam.

Plante, Ellen M. 1997. *Women at Home in Victorian America: A Social History.* New York: Facts on File.

Pratt, Joanne. 1961. "I'll Tell You a Letter." *Parents' Magazine* 36 (Fall): 54–55.

Proweller, Amira. 1998. *Constructing Female Identities: Meaning Making in an Upper Middle Class Youth Culture.* Albany: State University of New York.

Prucha, Francis Paul. 1979. *The Churches and the Indian Schools, 1888–1912.* Lincoln: University of Nebraska Press.

Purcell, Piper, and Lara Stewart. 1990. "Dick and Jane in 1989." *Sex Roles* 22: 177–185.

Ramsay, Martha Laurens. 1814. *Memoirs of the Life of Martha Laurens Ramsay.* 2d ed. Boston: Armstrong.

Reed, Dorothy. 1932. *Leisure Time of Girls in a "Little Italy."* Thesis, Columbia University.

Repplier, Agnes. 1897. "The Deathless Diary." *Atlantic Monthly* 79 (May): 642–651.

Revzin, Rebekah. 1998. "American Girlhood in the Early Twentieth Century: The Ideology of Girl Scout Literature, 1913–1930." *Library Quarterly* 68: 261–275.

Rice, Edwin Wilbur. 1927. *The Sunday-School Movement and the American Sunday-School Union, 1780–1927.* 2d ed. Philadelphia: Union Press.

Richards, Caroline Cowles. 1913. *Village Life in America, 1852–1872, Including the Period of the American Civil War as Told in the Diary of a School-Girl.* New York: Henry Holt.

Richards, Phillip M. 1992. "Phillis Wheatley and Literary Americanization." *American Quarterly* 44: 163–191.

Richardson, Angela. 1996. "Come On, Join the Conversation! Zines as a Medium for Feminist Dialogue and Community Building." *Feminist Collections* 17, nos. 3–4 (Spring–Summer): 10–13.

Ring, Betty. 1993. *Girlhood Embroidery, American Samplers and Pictorial Needlework, 1650–1850.* 2 vols. New York: Alfred A. Knopf.

Riordan, Cornelius H. 1990. *Girls and Boys in School: Together or Separate?* New York: Teachers College Press.

Rittenhouse, Isabella Maud. 1939. *Maud.* Edited by R. L. Strout. New York: Macmillan.

Robbins, Trina. 1999. *From Girls to Grrrlz: A History of Comics from Teens to Zines.* San Francisco: Chronicle Books.

Robinson, Harriet H. [1898] 1976. *Loom and Spindle; or, Life among the Early Mill Girls.* Reprint, Kailua, HI: Press Pacifica.

Rogers, Annie G. 1993. "Voice, Play and a Practice of Ordinary Courage in Girls' and Women's Lives." *Harvard Educational Review* 63: 265–295.

Romalov, Nancy Tilman. 1996. "Unearthing the Historical Reader, or, Reading Girls' Reading." *Primary Sources and Original Works* 4, nos. 1–2: 87–101.

Romatowski, Jane A., and Mary L. Trepanier-Street. 1987. "Gender Perceptions: An Analysis of Children's Creative Writing." *Contemporary Education* 59: 17–19.

Rose, Jane E. 1995. "Conduct Books for Women, 1830–1860: A Rationale for Women's Conduct and Domestic Role in America." Pp. 37–58 in *Nineteenth Century Women Learn to Write.* Edited by Catherine Hobbs. Charlottesville: University Press of Virginia.

Rosenbach, A. S. W. 1933. *Early American Children's Books.* Portland, ME: Dover Books.

Rosenberg, Jessica, and Gitana Garofalo. 1998. "Riot Grrrl: Revolutions from Within." *Signs* 23: 809–841.

Rosenthal, Laura J. 1996. *Playwrights and Plagiarists in Early Modern England: Gender, Authorship, and Literary Property.* Ithaca, NY: Cornell University Press.

———. 1997. "The Author as Ghost in the Eighteenth Century." Pp. 29–56 in *1650–1850: Ideas, Aesthetics, and Inquiries in the Early Modern Era.* Vol. 3. Edited by Kevin L. Cope and Laura Morrow. New York: AMS Press.

Rosser, Sue V. 2000. *Women, Science and Society: The Crucial Union.* New York: Teachers College Press.

Rothman, David J., and Sheila M. Rothman. 1987. *The Dangers of Education: Sexism and the Origins of Women's Colleges.* New York: Garland.

Rowbotham, Judity. 1989. *Good Girls Make Good Wives: Guidance for Girls in Victorian Fiction.* Oxford: Basil Blackwell.

Rowson, Susanna. [1791] 1986. *Charlotte Temple.* Edited by Cathy N. Davidson. New York: Oxford University Press.

Royster, Jacqueline Jones. 2000. *Traces of a Stream: Literacy and Social Change among African American Women.* Pittsburgh: University of Pittsburgh Press.

Rubin, Joan Shelley. 1992. *The Making of Middlebrow Culture.* Chapel Hill: University of North Carolina Press.

Ruiz, Vicki L. 1992. "'Star Struck': Acculturation, Adolescence, and Mexican American Women, 1920–1950." Pp. 61–80 in *Small Worlds: Children and Adolescents in America, 1850–1950.* Edited by Elliott West and Paula Petrik. Lawrence: University Press of Kansas.

Rury, John L. 1984. "Vocationalism for Home and Work: Women's Education in the United States, 1880–1930." *History of Education Quarterly* 24: 21–44.

———. 1991. *Education and Women's Work: Female Schooling and the Division of Labor in Urban America, 1870–1930.* Albany: State University of New York Press.

Russell, Janet, Lisa Weems, Sarah K. Brem, and Mary Ann Leonard. 2001. "Fact or Fiction? Female Students Learn to Critically Evaluate Science on the Internet." *Science Teacher* 68, no. 3: 44–47.

Sadker, Myra, and David Sadker. 1994. *Failing at Fairness: How America's Schools Cheat Girls.* New York: Charles Scribner's Sons.

Salmon, Edward G. 1886. "What Girls Read." *Nineteenth Century* 20: 515–529.

Salvatori, Mariolina Rizzi, ed. 1996. *Pedagogy: Disturbing History, 1819–1929.* Pittsburgh: University of Pittsburgh Press.

Saxton, Ruth O. 1998. *The Girl: Constructions of the Girl in Contemporary Fiction by Women.* New York: St. Martin's Press.

Scheick, William J. 1998. *Authority and Female Authorship in Colonial America.* Lexington: University Press of Kentucky.

Scheiner, Georganne. 1998. "The Deanna Durbin Devotees: Fan Clubs and Spectatorship." Pp. 81–94 in *Generations of Youth: Youth Cultures and History in Twentieth-Century America.* Edited by Joe Austin and Michael Nevin Willard. New York: New York University Press.

Schultz, Lucille M. 1999. *The Young Composers: Composition's Beginnings in Nineteenth-Century Schools.* Carbondale: Southern Illinois University Press.

"Science Hill Female Academy." 1992. P. 803 in *The Kentucky Encyclopedia.* Edited by John E. Kleber. Lexington: University Press of Kentucky.

Scott, Anne Firor. 1979. "The Ever Widening Circle: The Diffusion of Feminist Values from the Troy Female Seminary, 1822–1872." *History of Education Quarterly* 19: 3–25.

Sedgwick, Catharine. [1830] 1985. "Cacoethes Scribendi." Pp. 41–59 in *Provisions:*

A Reader from 19th-Century American Women. Edited by Judith Fetterley. Reprint, Bloomington: Indiana University Press.

Segel, Elizabeth. 1986. "'As the Twig Is Bent . . .': Gender and Childhood Reading." Pp. 165–186 in *Gender and Reading: Essays on Readers, Texts, and Contexts.* Edited by Elizabeth A. Flynn and Patrocinio P. Schweickart. Baltimore, MD: Johns Hopkins University Press.

Seybolt, Robert F. [1925] 1971. *Source Studies in American Colonial Education: The Private School.* New York: Arno Press.

Shandler, Sara. 1999. *Ophelia Speaks: Adolescent Girls Write about Their Search for Self.* New York: Harper-Perennial.

Shaywitz, Sally E., Bennet A. Shaywitz, Jack Fletcher, and Michael D. Escobar. 1990. "Prevalence of Reading Disability in Boys and Girls: Results of the Connecticut Longitudinal Study." *Journal of the American Medical Association* 264: 998–1002.

Sheffer, Susannah. 1995. *A Sense of Self: Listening to Homeschooled Adolescent Girls.* Portsmouth, NH: Boynton/Cook.

Shields, David S. 2000. "Eighteenth-Century Literary Culture." Pp. 434–476 in *The Colonial Book in the Atlantic World.* Vol. 1 of *A History of the Book in America.* Edited by Hugh Amory and David D. Hall. Cambridge, UK: America Antiquarian Society and Cambridge University Press.

Shmurak, Carole B. 1998. *Voices of Hope: Adolescent Girls at Single Sex and Coeducational Schools.* New York: Peter Lang.

Shuman, Amy. 1986. *Storytelling Rights: The Uses of Oral and Written Texts by Urban Adolescents.* Cambridge, UK: Cambridge University Press.

Sicherman, Barbara. 1993. "Reading and Ambition: M. Carey Thomas and Female Heroism." *American Quarterly* 45: 73–103.

———. 1995. "Reading *Little Women:* The Many Lives of a Text." Pp. 245–266 in *U.S. History as Women's History: New Feminist Essays.* Edited by Linda K. Kerber, Alice Kessler-Harris, and Kathryn Kish Sklar. Chapel Hill: University of North Carolina Press.

Sigourney, Lydia H. 1837. *The Girl's Reading-Book.* New York: J. Orville Taylor.

Silcox, Harry C. 1973. "Delay and Neglect: Negro Public Education in Antebellum Philadelphia, 1800–1860." *Pennsylvania Magazine of History and Biography* 97: 444–464.

Simmons, Rachel. 2002. *Odd Girl Out: The Hidden Culture of Aggression in Girls.* New York: Harcourt.

Sims, Rudine. 1982. *Shadow and Substance: Afro-American Experience in Contemporary Children's Fiction.* Urbana, IL: National Council of Teachers of English.

———. 1993. "Strong Black Girls: A Ten Year Old Responds to Fiction about Afro-Americans." *Journal of Research and Development in Education* 16, no. 3 (Spring): 21–28.

Sinor, Jennifer. 2002. "Reading the Ordinary Diary." *Rhetoric Review* 21: 123–149.

Sklar, Kathryn Kish. 1993. "The Schooling of Girls and Changing Community Values in Massachusetts Towns, 1750–1820." *History of Education Quarterly* 33: 511–542.

Smith, Jane S. 1977. "Plucky Little Ladies and Stout-Hearted Chums: Serial Novels for Girls, 1900–1920." *Prospects* 3: 155–174.

Solomon, Barbara M. 1985. *In the Company of Educated Women: A History of Women and Higher Education in America*. New Haven, CT: Yale University Press.

Solomon, Clara. 1995. *The Civil War Diary of Clara Solomon: Growing Up in New Orleans, 1861–1862*. Edited by Elliott Ashkenazi. Baton Rouge: Louisiana State University Press.

Soltow, Lee, and Edward Stevens. 1981. *The Rise of Literacy and the Common School in the United States: A Socioeconomic Analysis to 1870*. Chicago: University of Chicago Press.

Southworth, E. D. E. N. [1859] 1997. *The Hidden Hand; or, Capitola, the Madcap*. Reprint, New York: Oxford University Press.

Sterner, Alice P. 1947. *Radio, Motion Picture and Reading Interests: A Study of High School Pupils*. New York: Teachers College Press.

Stevenson, Brenda, ed. 1988. *The Journals of Charlotte Forten Grimké*. New York: Oxford University Press.

Stuart, Dorothy Margaret. 1933. *The Girl through the Ages*. London: Harrap.

Szasz, Margaret Connell. 1974. *Education and the American Indian: The Road to Self-Determination since 1928*. 3d ed. Albuquerque: University of New Mexico Press, 1999.

———. 1988. *Indian Education in the American Colonies, 1607–1783*. Albuquerque: University of New Mexico Press.

Tanenbaum, Leora. 1999. *Slut! Growing Up Female with a Bad Reputation*. New York: Seven Stories Press.

Tappan, Samuel F. 1885. "Report of Indian Schools." *Annual Report of the Commissioner of Indian Affairs to the Secretary of the Interior, United States Bureau of Indian Affairs*. Washington, DC: Government Printing Office.

Tarbox, Gwen Athene. 2000. *The Clubwomen's Daughters: Collectivist Impulses in Progressive-Era Girls' Fiction, 1890–1940*. New York: Garland.

Tarbox, Katherine. 2000. *Katie.com: My Story*. New York: Dutton.

Tatar, Maria M. 1992. *Off with Their Heads! Fairy Tales and the Culture of Childhood*. Princeton, NJ: Princeton University Press.

Taylor, Jill M., Carol Gilligan, and Amy M. Sullivan. 1995. *Between Voice and Silence: Women and Girls, Race and Relationship*. Cambridge, MA: Harvard University Press.

Temple, Judy Nolte, and Suzanne L. Bunkers. 1995. "Mothers, Daughters, and Diaries: Literacy, Relationship, and Cultural Context." Pp. 197–216 in *Nineteenth-Century Women Learn to Write*. Edited by Catherine Hobbs. Charlottesville: University Press of Virginia.

Tevis, Julia A. 1878. *Sixty Years in a School-Room*. Cincinnati: Western Methodist Book Concern.

Theriot, Nancy M. 1996. *Mothers and Daughters in Nineteenth-Century America: The Biosocial Construction of Femininity*. Lexington: University Press of Kentucky.

Thomas, M. Carey. 1979. *The Making of a Feminist: Early Journals and Letters of*

M. Carey Thomas. Edited by Marjorie Housepian Dobkin. Kent, OH: Kent State University Press.

Thompson, Sharon. 1995. *Going All the Way: Teenage Girls' Tales of Sex, Romance, and Pregnancy.* New York: Hill and Wang.

Thorne, Barrie. 1993. *Gender Play: Boys and Girls in School.* New Brunswick, NJ: Rutgers University Press.

Thornton, Tamara Plakins. 1996. *Handwriting in America: A Cultural History.* New Haven, CT: Yale University Press.

Thwaite, Mary F. [1963] 1972. *From Primer to Pleasure in Reading.* American ed. Boston: Horn Book.

Tonkovich, Nicole. 1993. "Rhetorical Power in the Victorian Parlor: *Godey's Lady's Book* and the Gendering of Nineteenth-Century Rhetoric." Pp. 158–183 in *Oratorical Culture in Nineteenth-Century America: Transformations in the Theory and Practice of Rhetoric.* Edited by Gregory Clark and S. Michael Halloran. Carbondale: Southern Illinois University Press.

———. 1997. *Domesticity with a Difference: The Nonfiction of Catharine Beecher, Sarah J. Hale, Fanny Fern, and Margaret Fuller.* Jackson: University Press of Mississippi.

Trennert, Robert A., Jr. 1982. "Educating Indian Girls at Nonreservation Boarding Schools, 1878–1920." *Western Historical Quarterly* 13: 271–290.

———. 1988. *The Phoenix Indian School: Forced Assimilation in Arizona, 1891–1935.* Norman: University of Oklahoma Press.

Trimbur, John, ed. 2001. *Popular Literacy: Studies in Cultural Practices and Poetics.* Pittsburgh: University of Pittsburgh Press.

Tuttle, William M., Jr. 1992. "The Homefront Children's Popular Culture: Radio, Movies, Comics—Adventure, Patriotism, and Sex-Typing." Pp. 143–163 in *Small Worlds: Children and Adolescents in America, 1850–1950.* Edited by Elliott West and Paula Petrik. Lawrence: University Press of Kansas.

Tyack, David, and Elisabeth Hansot. 1990. *Learning Together: A History of Coeducation in American Schools.* New Haven, CT: Yale University Press.

U.S. Department of Commerce. 1976. *Historical Statistics of the United States: Colonial Times to 1970.* Washington, DC: GPO.

Valdés, Guadalupe. 1996. *Con Respeto: Bridging the Distance between Culturally Diverse Families and Schools: An Ethnographic Perspective.* New York: Teachers College Press.

———. 2001. *Learning and Not Learning English: Latino Students in American Schools.* New York: Teachers College Press.

Vallone, Lynne. 1995. *Disciplines of Virtue: Girls' Culture in the Eighteenth and Nineteenth Centuries.* New Haven, CT: Yale University Press.

———. 2001. *Becoming Victoria.* New Haven, CT: Yale University Press.

Vanderpoel, Emily Noyes. 1903. *Chronicles of a Pioneer School from 1792 to 1833, Being the History of Mrs. Sarah Pierce and Her Litchfield School.* Cambridge, MA: University Press.

———, comp. 1927. *More Chronicles of a Pioneer School.* New York: Cadmus Book Shop.

Varnum, Robin. 1992. "The History of Composition: Reclaiming Our Lost Generations." *Journal of Advanced Composition* 12: 39–55.

Venkatesh, Sudhir Alladi. 1998. "Gender and Outlaw Capitalism: A Historical Account of the Black Sisters United Girl Gang." *Signs* 23: 683–710.

Wald, Gayle. 1998. "Just a Girl? Rock Music, Feminism, and the Cultural Construction of Female Youth." *Signs* 23: 585–610.

Walkerdine, Valerie. 1990. *Schoolgirl Fictions.* London: Verso.

Warner, Marina. 1994. *From the Beast to the Blonde: On Fairy Tales and Their Tellers.* New York: Farrar, Straus, and Giroux.

Warner, Susan. [1850] 1987. *The Wide, Wide World.* Reprint, New York: Feminist Press.

Watters, David H. 1985–1986. "'I Spake as a Child': Authority, Metaphor, and *The New-England Primer.*" *Early American Literature* 20: 193–213.

Weiner, Gaby, ed. 1985. *Just a Bunch of Girls: Feminist Approaches to Schooling.* Philadelphia: Open University Press.

Weis, Lois. 1988. "High School Girls in a De-Industrializing Economy." Pp. 183–208 in *Class, Race, and Gender in American Education.* Edited by Lois Weis. Albany: State University of New York Press.

Weitzmann, Leonore J., Deborah Eifler, Elizabeth Hokada, and Catherine Ross. 1972. "Sex-Role Socialization in Picture Books for Preschool Children." *American Journal of Sociology* 77: 1125–1150.

Welch, D'Alté. 1972. *A Bibliography of American Children's Books Printed Prior to 1821.* Boston: American Antiquarian Society.

Wexler, Philip. 1992. *Becoming Somebody: Toward a Social Psychology of School.* London and Washington, DC: Falmer Press, 1992.

Wheatley, Phillis. 1989. *The Poems of Phillis Wheatley,* rev. and enlarged ed. Edited by Julian D. Mason, Jr. Chapel Hill: University of North Carolina Press.

White, Barbara A. 1985. *Growing Up Female: Adolescent Girlhood in American Fiction.* Westport, CT: Greenwood Press.

Whitefield, George. 1741. *An Extract of the Preface to the Reverend Mr. Whitefield's Account of the Orphan-House in Georgia. Together with an Extract of Some Letters Sent Him from the Superintendents of the Orphan-House, and from Some of the Children.* Edinburgh: T. Lumisden and J. Robertson.

Whitescarver, Keith. 1993. "Creating Citizens for the Republic: Education in Georgia, 1776–1810." *Journal of the Early Republic* 13: 455–479.

Whitney, Clara A. N. 1979. *Clara's Diary: An American Girl in Meiji, Japan.* Edited by M. William Steele and Tamiko Ichimata. New York: Kodansha International.

Wink, Amy L. 2001. *She Left Nothing in Particular: The Autobiographical Legacy of Nineteenth-Century Women's Diaries.* Knoxville: University of Tennessee Press.

Winslow, Anna Green. 1894. *Diary of Anna Green Winslow, A Boston School Girl of 1771.* Edited by Alice Morse Earle. Boston: Houghton Mifflin.

———. [1894] 1974. *Diary of Anna Green Winslow, A Boston School Girl of 1771.* Edited by Alice Morse Earle. Williamstown, MA: Corner House Publishers.

Wiseman, Rosalind. 2002. *Queen Bees and Wannabes: Helping Your Daughter Survive Cliques, Gossip, Boyfriends, and Other Realities of Adolescence.* New York: Crown Publishers.

Wishy, Bernard W. 1968. *The Child and the Republic; the Dawn of Modern Child Nurture.* Philadelphia: University of Pennsylvania Press.

Wolf, Shelby Anne, and Shirley Brice Heath. 1992. *The Braid of Literature: Children's Worlds of Reading.* Cambridge, MA: Harvard University Press.

Woloch, Nancy. 1994. *Women and the American Experience.* 2d ed. New York: McGraw-Hill.

Woods, Robert A., and Albert J. Kennedy, eds. 1913. *Young Working Girls: A Summary of Evidence from Two Thousand Social Workers.* Boston: Houghton Mifflin.

Woody, Thomas. 1929. *A History of Women's Education in the United States.* 2 vols. New York: Science Press.

———. [1929] 1966. *A History of Women's Education in the United States.* 2 vols. Reprint, New York: Octagon Press.

Zagarri, Rosemarie. 1992. "Morals, Manners, and the Republican Mother." *American Quarterly* 44: 192–215.

Zboray, Ronald J. 1989. "Antebellum Reading and the Ironies of Technological Innovation." Pp. 180–200 in *Reading in America: Literature and Social History.* Edited by Cathy N. Davidson. Baltimore: Johns Hopkins University Press.

———. 1993. *A Fictive People: Antebellum Economic Development and the American Reading Public.* New York: Oxford University Press.

Zitkala-Ša. [1921] 1985. *American Indian Stories.* Reprint, Lincoln: University of Nebraska Press.

About the Contributors

Jean Ferguson Carr is associate professor of English and women's studies at the University of Pittsburgh. Coeditor of the Pittsburgh Series in Composition, Literacy, and Culture and faculty adviser to the university's "Nineteenth-Century American Schoolbooks" digital collection, she coauthored (with Stephen Carr and Lucille Schultz) the forthcoming book, *Archives of Instruction: Rhetorics, Readers, and Composition Books in the Nineteenth-Century United States.*

Janet Carey Eldred is associate professor in the English Department at the University of Kentucky. She is the coauthor (with Peter Mortensen) of *Imagining Rhetoric: Composing Women of the Early United States* (2002). She has published articles and essays in *College Composition and Communication, College English,* and *Fourth Genre.*

Amy Goodburn is associate professor of English and women's studies and composition coordinator at the University of Nebraska at Lincoln. Her research focuses on school and community literacy practices and teacher research and pedagogy. She coauthored (with Deborah Minter) *Composition, Pedagogy, and the Scholarship of Teaching* (2002).

Jane Greer is associate professor of English and women's and gender studies at the University of Missouri at Kansas City. Her work has appeared in *College Composition and Communication, Women's Studies Quarterly,* and other journals and edited collections. She is currently completing a book-length manuscript on working-class women and literacy education in the nineteenth and early twentieth centuries.

Andrea A. Lunsford is professor of English and director of the Program in Writing and Rhetoric at Stanford University. She is the author or coauthor of thirteen books, among them *Singular Texts/Plural Authors: Perspectives on Collaborative Writing, The St. Martin's Handbook* (5th ed.), and *Everything's an Argument.* Her interests include issues of intellectual property and composition, women in the history of rhetoric, and technologies of style. She is currently completing the first of a five-year longitudinal study of student writing at Stanford.

Paul Miller teaches at Davidson College and specializes in rhetoric and composition, with particular interests in composition theory, writing across the curricu-

lum, film, literacy and technology, and critical theory. His most recent publications concern techniques for responding to writing and the uses of film in writing instruction. For more information, see http://www.davidson.edu/academic/english/faculty/miller.html.

E. Jennifer Monaghan, professor emerita at Brooklyn College of The City University of New York, has many publications on the history of American literacy instruction and has won "best article" awards from the American Studies Association and the History of Education Society. Her books include *A Common Heritage: Noah Webster's Blue-Back Speller.* She is currently completing a book on literacy acquisition and culture in colonial America.

Peter Mortensen is associate professor of English at the University of Illinois at Urbana-Champaign, where he directs the Freshman Rhetoric and Academic Writing Programs. He is coauthor of *Imagining Rhetoric: Composing Women of the Early United States* (2002) and coeditor of *Ethics and Representation in Qualitative Studies of Literacy* (1996).

Janet Russell has a Ph.D. in biochemistry and is Howard Hughes Medical Institute Science Education Coordinator at Earlham College in Richmond, Indiana. For more information, see http://www.earlham.edu/~biol/janet/home.htm.

Kelly Schrum is assistant director of the Center for History and New Media and visiting assistant professor in the Department of History and Art History at George Mason University. She received her Ph.D. from Johns Hopkins University in 2000. She is currently revising her dissertation, *Some Wore Bobby Sox: The Emergence of Teenage Girls' Culture, 1920–1950,* for publication. Other publications include "'Teena Means Business': Teenage Girls' Culture and *Seventeen* Magazine, 1944–1950," in Sherrie Inness, ed., *Delinquent Daughters: Twentieth-Century American Girls' Culture* (New York: NYU Press, 1998). Schrum has also worked extensively in the areas of new media, history content development, and teacher training.

Lisa Weems is assistant professor in curriculum and cultural studies at Miami University in Ohio, where she teaches curriculum theory, qualitative research methodology, and sociocultural studies in education. She has a passion for reading and writing about youth cultures, technology, and gender studies.

Index

Memoirs, 5

Memoirs of the Life of Martha Laurens Ramsay (Ramsay), 48(n.71)

Memorization, xviii, 71

Mentoria (Rowson), 31–32, 46(n.33), 70

Meredith, Margaret, 180, 183–84

Middle school girls, xx, 123

Middling families, 18

Midwestern Girls School (MGS), 125, 131, 216–18

Miller, Paul, xxvii, 124

Miller, Susan, 65

Monaghan, E. Jennifer, xxv, xxvi, 42–43(n.8)

Montgomery, Ellen (character), 57

Montgomery, Lucy, 61

Moral philosophy, 69

Moravian Female Seminary, 28

Morgan, Thomas, 82

Moriwaki, June, 268–69

Mortensen, Peter, xxv, xxvi

Mothers, unmarried, xxiii–xxiv

The Mouse (Worth), 90–91, 223–24

Murolo, Priscilla, xxix(n.6)

Murray, Judith Sargent, 23, 24, 28, 31, 36, 41(n.2)

"My Plea" (Matsuzawa), 268

"Mystery" (Stout), xxvii

Nancy Drew mysteries, xviii–xx, 106–7

National Association of Colored Girls (NACG), 188

National Association of Colored Women (NACW), 185

National Research Council, 128

National Science Education Standards, 128–30, 132, 139

Native American girls, xxv–xxvii, 2, 7, 79, 208, 313. *See also* Genoa Industrial Indian School

appropriation of literacy, 89–91, 96–97

conduct fiction and, 83–91

education as assimilation, 80–83, 93

English language and, 82, 88–89

essays, 87–95

extracurricular writing, 95–97

gender, race, and domestic science curriculum, 91–95

letters and requests to school administrators, 96–97

literary societies, 83, 90

manifest destiny rhetoric and, 93–94

writings by, 223–24, 231, 232–33

Nelly's First School-Days (Franklin), xxviii

Nelly's Silver Mine (Jackson), 64

Nelson, Claudia, xvii

New England colonies, 1–2, 42(n.8)

A New England Girlhood (Larcom), 74

New Haven, 3

New York Ledger, 59

Newbery, John, 14

The New-England Primer, xviii, xix, 149–52

Nineteenth century literacy, xxviii, 51

appropriation of, 65–66

behavioral boundaries, 57–58

composition instruction, 62–64

constraints on women's reading, 59–61

contexts, 64–65

depicted in novels, 54–55

higher education, 72–73

historical narratives, 58–59

illustrations, 54, 55

literacy materials, 56, 57

as measure of worth and character, 52, 58, 66–67, 68

performance of conventional femininity, 61–62

public sphere, 59–60

self-culture, 62–63

textbooks, 66–71

woman writer, figure of, 52–53

women authors, 59, 68

working class, 65, 73–75

North American Review, 59

North Church of Boston, 5

North Writing School (Boston), 3

Novels, 54–55, 71–72

conduct fiction, 83–91

Oakland Female Seminary, 70

Oberlin College, 73

Official voices, xxvii

"On the Death of a Young Lady Five Years of Age" (Wheatley), 231, 258

"On Virtue" (Wheatley), 256–57

Operatives Magazine, 74

Order of the Scroll, xvi, 322

Organization kids, 276

Orphans (Georgia), 4, 7

Our Famous Women: An Authorized Record of Their Lives and Deeds, 52

Pamela (Richardson), 57